BLACK PATIENCE

PERFORMANCE AND AMERICAN CULTURES

General Editors: Stephanie Batiste, Robin Bernstein, and Brian Herrera

This book series harnesses American studies and performance studies and directs them toward each other, publishing books that use performance to think historically.

Black Patience

Performance, Civil Rights, and the
Unfinished Project of Emancipation

Julius B. Fleming Jr.

NEW YORK UNIVERSITY PRESS
New York

NEW YORK UNIVERSITY PRESS
New York
www.nyupress.org

References to Internet websites (URLs) were accurate at the time of writing. Neither the author nor New York University Press is responsible for URLs that may have expired or changed since the manuscript was prepared.

Library of Congress Cataloging-in-Publication Data
Names: Fleming, Julius B., Jr., author.
Title: Black patience : performance, civil rights, and the unfinished project of emancipation / Julius B. Fleming, Jr.
Description: New York : New York University Press, [2022] | Series: Performance and American cultures | Includes bibliographical references and index.
Identifiers: LCCN 2021027740 | ISBN 9781479806829 (hardback) | ISBN 9781479806843 (paperback) | ISBN 9781479806850 (ebook) | ISBN 9781479806874 (ebook other)
Subjects: LCSH: African American theater—History—20th century. | African Americans—Civil rights—History—20th century. | Time—Philosophy—History—20th century. | United States—Race relations—20th century. | Theater and society—United States—History—20th century.
Classification: LCC PN2270.A35 F54 2022 | DDC 792.089/96073—dc23
LC record available at https://lccn.loc.gov/2021027740

New York University Press books are printed on acid-free paper, and their binding materials are chosen for strength and durability. We strive to use environmentally responsible suppliers and materials to the greatest extent possible in publishing our books.

Manufactured in the United States of America

10 9 8 7 6 5 4 3 2 1

Also available as an ebook

CONTENTS

Introduction

Impatient to Be Free

The history of blackness is at once a violent history of waiting and a radical refusal to wait. It is a testament to the global and cruel workings of a virtue-turned-tool of anti-blackness and white supremacy: what I name *black patience*. From enslaved people who were forced to wait in the hold of the slave ship to those who were forced to wait on the auction block, from those who were forced to wait for emancipation to those who were inundated by calls to "go slow" in the Civil Rights Movement, waiting has routinely been weaponized as a technology of anti-black violence and civic exclusion, one designed to contain the movements of black people throughout the precincts of global modernity. On November 28, 1964, the historical force of these dynamics was on the mind of Mississippi civil rights leader Fannie Lou Hamer as she partook in the drama of civil rights activism. Known for her electrifying performances of freedom songs, for speeches that stirred audiences into political action, the heroic civil rights leader was a consummate performer and certainly no stranger to the stage.[1] In this instance, however, Hamer was not on the stage but seated in the audience of what might, at first glance, appear a peculiar scene: a production of Samuel Beckett's *Waiting for Godot* (1952), staged at William Chapel Baptist Church in the small town of Ruleville, Mississippi—Hamer's overwhelmingly black, financially impoverished hometown in the Mississippi Delta. Though she had only a sixth-grade education—having been forced to abandon school to work as a sharecropper on a cotton plantation—the political and existential depth of Beckett's abstract meditation on waiting was not lost on Hamer. In fact, the play's central conceit of fruitless waiting so profoundly resonated with her that, during intermission, she rose from her seat and warned the audience, "You can't sit around waiting. Ain't nobody going to bring

you nothing. You got to get up and fight for what you want. Some people are sitting around waiting for somebody to bring in freedom just like these men [Vladimir and Estragon, Beckett's protagonists] are sitting here. Waiting for Godot."[2] Echoing these sentiments in a talkback that followed on the heels of this performance, Hamer urged the nearly all-black audience to "pay strict attention to the play because it's due to waiting that the Negro is as far behind as he is."[3]

I offer Hamer's attendance at this performance as a starting point for this book for two reasons. First, it signals the importance of theatrical performance to the cultural and political fronts of the Civil Rights Movement.[4] Whereas photography and television are routinely centered in civil rights historiography and cultural criticism, this book reorients and expands the field of civil rights studies by unfurling the significance of black theatre to the cultural and political itineraries of modern civil rights activism.[5] That this performance of *Waiting for Godot* was staged at William Chapel Baptist Church hints at the intimate relationship between theatre and civil rights activism in this era. It was during a civil rights meeting at William Chapel that Fannie Lou Hamer was inspired to join the movement, having heard speeches by civil rights activists James Foreman of the Student Non-Violent Coordinating Committee (SNCC) and James Bevel of the Southern Christian Leadership Conference (SCLC). A key staging ground for the local Civil Rights Movement in Mississippi, William Chapel had been bombed only five months before this performance.[6] But during this production of *Waiting for Godot*, an integrated troupe of theatre workers transformed this modest, one-room church into a radical site of civil rights activism and black theatrical performance—one whose political ambitions recall the civil rights meeting that inspired Hamer to join the movement. Thus, as other activists were using their bodies to stage marches, sit-ins, and other more well-known genres of embodied political performance, Hamer and this brave coterie of theatre-makers were likewise using the body in performance to advance the goals of the Civil Rights Movement, and to reconfigure the normative grounds of black politics, black being, and ultimately the racial order of modernity. Their brave and innovative performances index theatre's underrecognized importance to the movement while signaling its broader significance to the textures of black political and expressive cultures in this period.

Second, this production of *Waiting for Godot* illuminates how time underwrites the racial projects of modernity and inflects the shape of black politics, black aesthetics, and black being. The structural transformation of time into a tool of anti-black violence and political exclusion is a global phenomenon with which Fannie Lou Hamer was all too familiar. Having worked for eighteen years as a timekeeper on the Marlow Plantation near Ruleville, Hamer brought to this performance of *Waiting for Godot* a keen understanding of the historical relationship between blackness and time, or, more precisely, between black subjection and the global praxis of putting time in the service of racial domination. Tasked with logging sharecroppers' daily harvests, Hamer's job was, in essence, to determine if fellow sharecroppers had worked rapidly enough in the time allowed. The duties of plantation timekeeper had aroused in Hamer a sharp attunement to the tempos of black life as well as a deep consciousness of how time shaped racial being and how race, in turn, shaped the lived experience of time. Knowing that the Marlows of the world routinely defrauded black sharecroppers—thus ballooning their debts and extending the length of their service—she sometimes used an unapproved device (commonly referred to as a "p") to achieve more accurate measurements of sharecroppers' harvests. In this sense, Fannie Lou Hamer was already on the path to becoming a timekeeper for justice. Therefore, as she sat through this performance of *Godot*, she experienced the play with a pair of studied eyes and a critical consciousness well calibrated to the racialized violences of time. She recognized that even as the wheels of racial capitalism forced black sharecroppers to work at exhausting speeds, these same workers were warned to "go slow" in their fights for freedom and full citizenship.

Demonstrating a powerful commitment to the radical ethos of "freedom now" that galvanized the Civil Rights Movement, Hamer and this troupe of actors used the body in performance to unsettle modernity's racialized logics of waiting. For them, theatre, "a famously time-based art of the live," afforded a space to carry out the radical work of decolonizing time.[7] Their collective dissent to these time-based modes of racialized violence is captured in the rousing call to action that punctuates *Waiting for Godot*'s denouement: "Let us do something, while we have the chance . . . Let us make the most of it, before it is too late!"[8]

In this book, I reconsider the Civil Rights Movement from the perspective of black theatre. Black theatrical performance was a vital technology of civil rights activism and a crucial form of black artistic and cultural production. During this historical moment, black artists and activists turned to the coveted stages of Broadway. They produced plays in the Netherlands and performed in US prisons. They staged *Waiting for Godot* in the cotton fields of Mississippi, once dodging a bomb tossed from the audience to the stage.[9] Analyzing a largely unexplored, transnational archive of black theatre, this book charts a new cultural and political history of the Civil Rights Movement. In turning to the theatrical stage, it challenges a tendency in civil rights discourse to invoke theatre and drama as merely metaphors for conventional forms of embodied political action (e.g., sit-ins and jail-ins) or as convenient shorthands for the movement itself. We get a glimpse of this conception of civil rights drama from an article published in *Jet* magazine on March 25, 1965. Here, the writer observes that Dr. Martin Luther King Jr. "moves about on the world stage directing the civil rights drama."[10] On yet another occasion, the magazine carried an article proclaiming that "The strangest civil rights drama takes place on Maryland's Highway 40."[11] The "drama" in this case was the segregation of African diplomats at businesses along Maryland's Route 40. Alongside these types of "social dramas," the drama of civil rights activism also included an expansive, politically charged repertoire of theatrical performances.[12] *Black Patience: Performance, Civil Rights, and the Unfinished Project of Emancipation* begins to tell that story. Approaching black performance as a practice that exists "at the interstices of black life, politics, and cultural production," this book examines civil rights performances such as sit-ins and jail-ins but focuses primarily on theatrical performance and the complex, often radical, ways that theatre helped to shift the needle of social and political change in the postwar era of civil rights activism.[13]

In analyzing these connections between black political and expressive cultures, *Black Patience* focuses more directly on how black artists and activists used theatre to expose and reconfigure the fraught historical relationship between black being and time. What holds my attention in this regard is how time has been used to establish and concretize a violent and paradigmatic relationship between black being and modernity—a relation that strives to quarantine black people and black bod-

ies to an incessant ground of suffering through careful manipulations of time. A key dimension of the historical relationship between blackness and time coheres around and reproduces a historical condition that black performance theorist Harvey Young has called "the wait," or the forced suspension of black bodies in time and space.[14] Instituted at the onset of transatlantic slavery, the black body in waiting has been, and remains, constitutive of the political and ontological lineaments of black life. It has served as a key site for solidifying and rehearsing white racial power, for preserving the uneven distribution of capital, and for safeguarding the racial calculus that enables and sustains these imbalances.

Within this context, it makes sense that black anti-colonial theorist Frantz Fanon would describe the nature of black ontology in terms of the wait. "If I were asked for a definition of myself," Fanon writes, "I would say that I am one who waits."[15] Under the gratuitous violences of slavery, colonialism, and their afterlives, to be a black subject who waits in the manner that Fanon describes is to exist in the "the interval," a space between past and future in which "the terms of waiting have been preordained."[16] It is to dwell within a regulated spatiotemporal habitus in which racial and colonial violence collaborate to produce the "temporality of blackness."[17]

Even in the face of the world-making and world-destroying pressures of the wait, black people's insistent demands for "freedom now" in the Civil Rights Movement exposed, critiqued, and reinvested the trope of the black body in waiting. By fashioning this radical grammar of the now into novel styles of embodied political protest and innovative modes of aesthetic experimentation, they disrupted modernity's practice of conscripting black people into the wait and then using their forced performances of waiting to invigorate the global infrastructure of anti-blackness and white supremacy. These creative deployments of now-time were defining elements of black political and expressive cultures in the postwar era of civil rights activism. The theatrical stage was a key site for exposing and renegotiating the politics of racial time that have produced the trope and the historical phenomenon of the black body in waiting. Artists and activists used theatre and theatrical performance to unsettle an enduring constellation of logics, practices, and discourses that aimed to abrogate black freedom by suspending black people and black bodies in time and space, even as the pace of social life

was rapidly accelerating and the time-space of modernity was growing increasingly compressed. This race-based structure of temporal violence is *black patience*.

Race and the Politics of US Nation-Time

In the 1950s, the prevalence of the black body in waiting became especially apparent as the US nation-state faced two major geopolitical crises that were nothing less than struggles for dominance over time and space: the "Space Race," on the one hand, and the Civil Rights Movement, on the other hand. On October 4, 1957, against the backdrop of the tensions animating the Cold War, the Soviet Union shook the US nation-state when it launched the world's first artificial satellite, Sputnik 1. Startled by the technological feats of a Cold War foe, and emboldened by the hubris of a nation that envisioned itself as *the* superpower, President Dwight Eisenhower signed the National Aeronautics and Space Act on July 29, 1958, authorizing the birth of the National Aeronautics and Space Administration (NASA) and its hefty annual budget of one hundred million dollars. With this intense Cold War conflict on the rise, outer space became a new frontier in a heated scramble to expand the territory of nation and empire into geographies that were once beyond human contact, and to execute these spatial expansions at record speeds. By placing his seal of approval on this congressional act, Eisenhower not only endorsed a national program but sanctioned a national ideology as well. In other words, he used the gravity of US presidential power to shore up the nation's desires to move through space more quickly and freely.

But Eisenhower brought a strikingly different time-space thinking to bear on the Civil Rights Movement and black people's similar efforts to eliminate spatial barriers and to acquire freedom *now*. At a July 17, 1957, press conference, Eisenhower—an otherwise committed advocate of eliminating spatial and temporal barriers—lamented, "I personally believe if you try to go too far, too fast, in laws, in this delicate field, that has involved the emotions of so many millions of Americans, you're making a mistake."[18] Therefore, as civil rights activists were working to eradicate the temporal and spatial barriers imposed by anti-blackness and white supremacy, Eisenhower was trying to pump the brakes on

these spatiotemporal ambitions and thereby to cordon off black people from the national project of revolutionizing time and space in this postwar era of sociopolitical and technological transformation.

Eisenhower's demands for black people to wait—or to be patient—were routinely headlined in newspapers across the nation, with titles such as "Eisenhower Bids Negroes Be Patient about Rights" and "President Urges Patience in Crisis."[19] In a May 12, 1958, address to an audience of black media, community, and business leaders, the president reiterated his call for "patience and forbearance."[20] Asked for his reaction to Eisenhower's request, William O. Walker, then President of the National Newspaper Publishers Association (NNPA)—an umbrella organization for black newspapers—noted that "this was 'the kind of advice we have been getting' since the 1954 school integration decision of the Supreme Court."[21] Invoking the Court's decision in *Brown v. Board of Education* to integrate public schools with "all deliberate speed," Walker goes on to add, "today Negroes were asking the question: 'How long is deliberate speed?'"[22] Also in the room for Eisenhower's address, and no less peeved, was civil rights activist and baseball legend Jackie Robinson, the first African American to play in Major League Baseball. Taking issue with Eisenhower's demand for black patience, Robinson wrote to the President the next day:

> I was sitting in the audience at the Summit Meeting of Negro Leaders yesterday when you said we must have patience. On hearing you say this, I felt like standing up and saying, "Oh no! Not again." I respectfully remind you, sir, that we have been the most patient of all people. When you said we must have self-respect, I wondered how we could have self-respect and remain patient considering the treatment accorded us through the years. 17 million Negroes cannot do as you suggest and wait for the hearts of men to change. We want to enjoy *now* the rights that we feel we are entitled to as Americans.[23]

This was not Robinson's first missive to Eisenhower critiquing his calls for black patience. In September of the previous year, he wrote a letter to the President declaiming, "We are wondering to whom you are referring when you say we must be patient. It is easy for those who haven't felt the evils of a prejudiced society to urge it, but for us who as Americans have

patiently waited all these years for the rights supposedly guaranteed us under our Constitution, it is not an easy task."[24] As Robinson's letters and Walker's response demonstrate, at the same time that Eisenhower led an imperialist venture to eradicate any time-space barrier posing a threat to US global dominance, he worked to quell black people's attempts to alter the time and space of black freedom and citizenship. Outer space was not "too far," nor were the nation's spaceships "too fast." Yet black people's cries for "freedom now" went "too far," moved "too fast," and were, in the final analysis, "a mistake."

During this era, the nation's watershed innovations in space technology were matched by advancements in financial systems that sped up the turnover time of capital, by newly built interstates that reduced the time required to travel from one place to another, by television news cycles that modernized the international flow of information across time and space. This historical moment was deeply invested in reducing the time required for matter to move through space. And yet, as Eisenhower's remarks suggest, there existed a concomitant effort to reduce the speed at which black people would acquire freedom and full citizenship and a hard-fought battle to preserve the barriers of racial-spatial segregation. The acceleration ushered in by this iconic phase of technological modernity therefore stood in contradistinction to the racialized logics of spatial constriction, slowness, and stasis that inflected black people's political realities. Such glaring contradictions between national ideals of speed and slowness, movement and stillness underlie a formative aporia at the heart of US nation time and of global modernity more broadly: that is, a twinned attachment to the quick time of modern progress, on the one hand, and the slow time of black rights, on the other hand.

Situating theatre at the heart of the Civil Rights Movement, *Black Patience* argues that time was at the center of black political world-making, black performance, and revolutionary black thought in this postwar era of sociopolitical transformation. I demonstrate how black artists, activists, and organizations—like James Baldwin, Lorraine Hansberry, Duke Ellington, Alice Childress, Amiri Baraka, C. Bernard Jackson, Langston Hughes, Paul Carter Harrison, the Free Southern Theater, and Oscar Brown Jr.—used theatre to frame the problem of anti-blackness and white supremacy as a perpetual problem of time. They recognized that the "original task of a genuine revolution . . . is never merely to 'change

the world,' but also—and above all—to 'change time.'"[25] During the Civil Rights Movement, black theatre workers were critical to black people's global campaigns to "change" the time of blackness and black citizenship by demanding "freedom now." Their radical commitment to altering the timescale of modernity fostered moments like Fannie Lou Hamer's ecstatic critique of black patience during a production of *Waiting for Godot* in the heart of the Mississippi Delta. A wider focus on this period demonstrates theatre's under-recognized value to the movement, and to unsettling the violent operations of black patience.

Black Patience

In this book, *black patience* refers to a large-scale racial project that coerces performances of patience among black people as a way to invigorate and reinforce anti-blackness and white supremacy. A global system of gratuitous violence, black patience weaponizes time, specifically "the wait," as a means of racializing the modern world and of manufacturing the racial taxonomies that arrange our global relations of power. In addition to naming the workings of this violent world-system, the concept of black patience also functions as a hermeneutic for understanding how these strategies of racializing time are vital to the making of modernity, and to the modes of racial subjugation that animate black being in the modern world. In other words, black patience both names a racial project and functions as a conceptual framework that helps to make sense of that project.

Where patience has not been glossed over in analytic philosophy, it has often been explained away as a "minor" or "secondary" virtue, and thus regarded with less critical import than other, more celebrated virtues like courage.[26] But patience is a constitutive feature of black life, and has been since the onset of transatlantic slavery. And it remains critical to the relations of racial power that continue to structure the "unfinished project of modernity."[27] On this front, the etymological origins of the term "patience" are instructive. Derived from the Latin word *patientia*, "suffering," and the Latin verb *pati*, "to suffer," patience is at root a performance of suffering. Considered in relation to those tortured "grammars of suffering" that have besieged black life for more than four centuries—from slavery and Jim Crowism to lynching and

mass incarceration—the sign of suffering requires a more careful accounting of black suffering within critical evaluations of patience.[28] As scholars have recognized, patience is a locally situated and culturally constituted virtue. It evokes and accrues specific meanings, spawns particular performances, and generates distinctive codes of engagement across its various contexts of consideration. With few notable exceptions, scholarship that attends to patience—whether as a scientific or philosophical object of study—habitually excludes race, and more specifically blackness, as a meaningful cultural context or significant variable. And yet the history of blackness is a fruitful site of analysis for understanding the situatedness and particularities of the forms of suffering that unfold under the sign of patience. When Fannie Lou Hamer exclaimed on the heels of watching *Waiting for Godot* that "it's due to waiting that the Negro is as far behind as he is," she called attention to the racial fabric of patience—to those performances of deferral, endurance, and long-suffering that are staged in the name of virtue, which is also to say, in this instance, in the name of anti-blackness and white supremacy.

Famed black poet and dramatist Langston Hughes was among the black playwrights who used theatre in the Civil Rights Movement to expose and critique the longue durée of black patience. This engagement with black patience is evident in Hughes's 1964 civil rights play, *Jericho-Jim Crow*. Directed by dance legend Alvin Ailey and noted producer William Hairston, *Jericho-Jim Crow* opened at New York City's Sanctuary Theatre on January 12, 1964, and ran through April of that year. A thrilling three-act gospel musical consisting of political soliloquies, rousing performances of freedom songs (which audiences were invited to join), and exhilarating calls for black freedom, Hughes's play belongs to the sizable repertoire of black plays that situated themselves in relation to the Civil Rights Movement. Struggling to be accepted by a new generation of artists and activists, Hughes dedicated *Jericho-Jim Crow* to the "young people of all racial and religious backgrounds who are meeting, working, canvassing, petitioning, marching, picketing, sitting-in, singing and praying today to help make a better America for all, and especially for citizens of color."[29] Hughes donated proceeds from performances to the movement, and declined royalty payments from nonprofit organizations—like civil rights groups—that performed the play.[30] The

script notes on this front that productions should be "kept as simple as possible so that amateur groups, schools, or churches may present it."[31]

Set in "the present . . . with flashbacks of the past," the play's plot stretches from slavery to the Civil Rights Movement.[32] One benefit of Hughes's expansive temporal framework and his use of flashback is that they constantly orient audiences to the historical expanse of black patience while framing time itself as a key vector in the repeating violences of anti-blackness. In this vein, the play's white racial antagonist, Jim Crow, plays multiple roles, including Klansman, Auctioneer, Planter, Minister, Governor, Policeman, and Jailer, all iconic figures in the production of modernity's racial order and its transhistorical investment in anti-black oppression. Accompanied by multiple wardrobe changes, these character shifts are linked across time, space, and profession by an abiding demand for black patience. An exchange between Jim Crow and a character named Old Woman is telling in this regard:

> OLD WOMAN: Ever since slavery they been telling me:
> JIM CROW: WHY DON'T YOU ALL BE PATIENT?[33]

Although the play has, by this point, reached the Civil Rights Movement, Old Woman attempts to explain that the origins of black patience are rooted in slavery. Before she can finish her line, however, Jim Crow interrupts and, one hundred years after slavery, reinvigorates the historical demand for black patience.

And yet, in both form and content, Hughes's civil rights play critiques the racial project of black patience, and curates a performance environment imbued with the radical ethos of "freedom now." Concerning the "Speed of Production," the script notes, "The production should move swiftly, with nothing to cause halts or waits between scenes."[34] And as early as the first lines of the play, Hughes foreshadows *Jericho*'s investment in dismantling black patience by linking the play's two youngest characters to a long genealogy of black activists who have resisted the violent enclosures of black patience:

> BOY: My name is Nat Turner Frederick Douglass Du Bois Garvey
> Adam Powell Martin Luther King Shuttlesworth James Lewis Farmer
> Meredith Moses Holmes Jones—that's me. And I got a hundred

thousand more names, too—they're you. But for short, you can just call me Jones. And I'm on my way.

GIRL: My name is Harriet Tubman Sojourner Truth Mary Church Terrell Ida Wells Barnett Mary McLeod Bethune Autherine Lucy Rosa Parks Daisy Bates Dianne Nash Charlayne Hunter Juanita Malone Anniebelle Smith—that's me. But you can call me Anniebelle. And, folks, I'm on my way.[35]

Both Boy and Girl link themselves to an intergenerational web of black activists and a long history of black activism. On the one hand, Hughes's lack of punctuation maps a relationality that sutures past and present, demonstrating a profound refusal of black patience across the edges of history. On the other hand, the absence of a period, a comma, or any other punctuation mark grounded in a semiotics of the stop, the pause, or the wait invited live performances of these lines that were animated by speed. Rather than wait or be patient, Boy and Girl, like their ancestors before them, embrace a politics and aesthetics of movement, now. They both declare, "I'm on my way."

With these kinds of civil rights plays and racial histories in mind, I use the term *black patience* as a way of naming and elaborating a specific brand of patience: one that arises from and sustains a global system of waiting that produces black suffering by compelling black people to wait and to capitulate to the racialized terms and assumptions of these forced performances of waiting. Rooted in a violent web of practices and ideologies that strive toward the accumulation of capital and the crystallization of white racial power, black patience provides a useful framework for theorizing racial formation in the context of global modernity. And it names a particular genre of slavery's afterlives.[36] Taking the concept of black patience as its primary focus, this book plots a historical relation between blackness and time, and more precisely between black being and coerced performances of waiting. Examining these historical entanglements of race, patience, and power illuminates the enduring effects of time on the nature of black politics, black being, black performance, black freedom, and ultimately on modernity itself.

It is important to note, however, that although black patience works toward anti-black oppression, black people have routinely transformed black patience into strategies of black political engagement and cultural

innovation. In the final chapter of this book, I turn to civil rights plays that portray the 1960s sit-in and jail-in movements. Reading these works alongside nonviolence training manuals and curricula as well as prison writings, I trace how civil rights activists repurposed black patience by transforming the wait into a time and a performance of black political possibility. This refashioning of black patience serves as a reminder that black people have used patience constructively and often radically, whether as fugitive slaves who awaited the right time to escape or as jazz artists who are "sometimes behind" the beat.[37] Thus, when Fanon defines himself as "one who waits," he is also giving voice to a long history of black subjects who lie in wait as means of refusing the wait.

Black Time Studies

A major aim of this book is to urge a broader critical investment in time as a foundational basis of social theory and black studies theorizing. Attending to black patience illuminates how the modern world is a "playground of time,"[38] or more specifically how time has functioned as a "form through which we define . . . relations between the Self and the Other."[39] It is my contention that time should enjoy a greater presence in these fields of intellectual endeavor inasmuch as it furnishes a critical, if under-tapped, resource for theorizing race and power as well as the historical dynamics of slavery and its afterlives. Transatlantic slavery was critical to establishing the racial character of time and to temporalizing the modes of subjugation that fuel the historical project of anti-blackness. As literary critic Saidiya Hartman puts it, in the slave castle "time was at a standstill," and on the slave ship "time had stopped."[40] Implemented by transatlantic slavery and its afterlives, these transhistorical histories of stillness—the stillness of time, the stillness of the captive black body in time—index time's centuries-old import to the drives of global modernity and racial capitalism, and their uneven distributions of racial power.

In this vein, the work of French sociologist and philosopher Henri Lefebvre is instructive. Though most commonly associated with his insightful, field-defining work on the social production of space, Lefebvre was also an insightful theorist of time. Pursued most thoroughly in his 1992 book *Rhythmanalysis: Space, Time and Everyday Life*, Lefebvre was

invested in theorizing the temporal dimensions of everyday life. Admittedly, the critical influence of *Rhythmanalysis* pales in comparison to Lefebvre's 1985 magnum opus, *The Production of Space*. This unevenness is symptomatic of a wider imbalance in the critical attention that scholars have paid to the question of time in social theory and black studies, especially when compared to the healthy body of scholarship on space.

In focalizing time, *Black Patience* advances a burgeoning field of critical inquiry that I call Black Time Studies.[41] Building on recent scholarship in black studies by Daylanne English, Michael Hanchard, Michael Sawyer, Anthony Reed, Michelle Wright, Kara Keeling, Soyica Diggs Colbert, Shane Vogel, Carter Mathes, and Calvin Warren, for instance, my aim in naming and elaborating the field of Black Time Studies is to more thoroughly foreground the social, political, and aesthetic significance of time to black people, to black experience, and to the black cultural and political imaginations.[42] In foregrounding time, my goal is not to understate the importance of space to black life, but rather to suggest that if "black matters are spatial matters," as black geographer Katherine McKittrick has rightly argued, black matters are temporal matters as well. Or, as literary critic Michelle Wright explains, blackness is both a "when" and a "where."[43] Alongside the sizable, brilliant, and necessary body of scholarship on race and space, then, we need a more robust critical apparatus for studying how time contributes to the production of race and how race informs the production of time. Black Time Studies is offered in this vein.

Although my primary focus is on time, I approach time and space as interconnected categories of analysis and lived experience. "Everywhere there is interaction between a place, a time and an expenditure of energy," Lefebvre writes, "there is rhythm."[44] Paying attention to the rhythms that have animated black life reveals that the historical stillness of the black body in time—whether in the barracoon, in the hold of the ship, or on the auction block—is, at the same time, a forced performance of stillness in space. This profound imbrication of time and space is critical to the making of slavery and its afterlives. Further, in foregrounding these relationalities between time and space, Lefebvre contends that the body is a key resource, one that not only functions as an object of study but also "serves us as metronome."[45] What this means, on the one hand, is that the rhythms—or the timings—of the body are important

objects of analysis: things to be engaged, studied, and carefully analyzed. At the same time, the body itself serves as a heuristic for critically assessing the nature of its rhythms (from heart palpitations to its movements within the labor time of capitalist production) and a material agent that can alter the tempo of social life. Analyzing civil rights theatre reveals how the black body in performance is both an illuminating conceptual framework for understanding the rhythms of black life and an insurgent agent that disrupts the gratuitous violences of black patience.

During the Civil Rights Movement, activists like Dr. Martin Luther King Jr. routinely situated time, specifically black patience, at the center of black political thought and civil rights activism. This was the case in a talk that King delivered at Stanford University on April 14, 1967—almost one year before his assassination—entitled "The Other America." With his signature blend of vocal sonority and rhetorical finesse, King fiercely opposed the machineries of injustice that had produced what he called "two Americas": one "overflowing with the milk of prosperity and the honey of opportunity," while the "Other America" has a "daily ugliness about it that transforms the ebulliency of hope into the fatigue of despair."[46] The primary citizen of the "Other America," King explains, is "the American Negro."[47]

For King, this racialized system of two nations emerged from two "false notions": that legislation and, more importantly, *time* could solve the problem of racial injustice in America.[48] Considering King's extensive record of civil rights activism alongside his deep consciousness of global anti-racist and anti-colonial struggle, it is noteworthy that he identifies time, specifically black patience, as the primary culprit in the racialized production of "two Americas." On this front, I quote King at length:

> There are those, and they are often sincere people, who say to Negroes and their allies in the white community, that we should *slow up* and *just be nice and patient* and continue to pray, and *in a hundred or two hundred years* the problem will work itself out because *only time can solve the problem*. I think there is an answer to that myth. And it is that *time is neutral. It can be used either constructively or destructively*. And I'm absolutely convinced that the forces of ill-will in our nation, the extreme rightists in our nation, have often used time much more effectively than the forces of

good will. And it may well be that we will have to repent in this genera-
tion not merely for the vitriolic words of the bad people and the violent
actions of the bad people, but for the appalling silence and indifference
of the good people who sit around and say *wait on time*. Somewhere we
must come to see that social progress never rolls in on the wheels of in-
evitability. It comes through the tireless efforts and the persistent work of
dedicated individuals. And without this hard work time itself becomes an
ally of the primitive forces of social stagnation. *And so we must help time,
and we must realize that the time is always right to do right.*[49]

Detailing the workings of "racial time," King pinpoints how time (e.g.,
"slow up"), and black patience in particular, has come to function as a
weapon of anti-black violence and civic exclusion. With an analytical
acuity that emerges as much from his embodied experiences of blackness
(e.g., arrests, sit-ins, and civil rights marches) as his classical training in
philosophy, King arrives at moral and political conceptions of time that
understand time's ontology as inextricably linked to the social produc-
tion of race, to the making of civil society, and to the racialized modes of
governmentality that have engendered the problem of "two Americas."
King argues that black patience is an engine of anti-blackness that pow-
ers the performative production of the US nation-state. Taking specific
aim at pervasive calls for black people to "slow up," to "be nice and
patient," and to "wait on time," King articulates an incisive, historically
grounded critique of black patience that forcefully challenges its rituals
of using time to invigorate the repeating violences of anti-blackness.

Race and the Regulation of Black Affect

And yet, as King suggests, black patience is not only about the forced per-
formance of waiting or the racial manipulation of time. As central to black
patience is the regulation and management of black affective expression.
The *Oxford English Dictionary* defines *patience* as a mode of "calm, self-
possessed waiting," an "uncomplaining endurance of pain."[50] Situated at
the intersection of time and affect, black patience is invested in coercing
black bodies to wait but is as concerned with the affective tenor of the
wait and the implications of black people's refusal to wait. In his biting
analysis of "two Americas," King spotlights this powerful interconnection

among time, affect, and racial formation. He shows that alongside white supremacy's calls for black people to "slow up" is a parallel demand for black people to be "nice." This insistence on black niceness—in lieu of negative affects like black rage or black anger—unveils how the racial project of black patience relies on a governed repertoire of postures, sentiments, and dispositions; how it establishes a network of violent protocols that police and discipline black affective expression as a means of reinforcing modernity's uneven relations of racial power. In other words, black patience is deeply invested in *how* black people perform the act of waiting. Because one can wait without being patient, it is finally this *how* that serves as the moral and political basis for distinguishing which acts of waiting are elevated to the virtuous—or, in this instance, the violent—terrain of patience. Thus, the distinction between black patience and waiting hinges on a regulated repertoire of affects and gestures that have been culturally framed as styles of performing endurance and long-suffering that satisfy, or not, the affective demands of black patience.

The affective dimensions of black patience and their role in the making of black being surface in the black cultural imagination as early as Frederick Douglass's 1845 *Narrative of the Life of Frederick Douglass, an American Slave*. Recalling the relentless violence of Mr. Austin Gore, a plantation overseer, Douglass explains that Mr. Gore was "artful, cruel, and obdurate . . . He was one of those who could torture the slightest look, word, or gesture, on the part of the slave, into impudence, and would treat it accordingly. There must be no answering back to him; no explanation was allowed a slave."[51] Often hurled at enslaved people as a pretext for violence, the charge of impudence was a staple offense in the retributive infrastructure of slavery and a cherished tool of black patience. Elastic enough to encompass any "look, word, or gesture" that could remotely be perceived as an affront to white power, impudence was rendered a transgressive performance of the enslaved that breached the affective protocols of black patience.

In theorizing the affective dimensions of anti-blackness and white supremacy, this book contributes to an effort in the field of affect studies to reframe affect as a patently social rather than a "pre-social" phenomenon. Affect, as feminist theorist Clare Hemmings explains, is best analyzed "in the context of social narratives and power relations."[52] But even as scholars have begun to acknowledge that "attending to the affective

turn is necessary to theorizing the social," blackness continues to occupy a peripheral place in this scholarship.[53] The constitutive role of affect in the social arrangement of the modern world is nowhere more apparent than when approached through the record of black life and more specifically through the vicissitudes of black patience. As scholars have shown, affect has been a vital cog in the wheels of racial formation.[54] And race has been central to constructing the "affective economies" at the heart of global modernity.[55] Recognizing and wading into the critical lacuna that surrounds race in the field of affect studies, literary critic Tyrone Palmer poses a prescient question: "What does centering blackness's singular position vis-à-vis the social . . . do to theorizations of affect as social material?" Palmer concludes, in more forceful terms, that the "fundamental fact of blackness is lost in affect theory's (limited) engagement with race."[56] Alongside examining how time underwrites racial formation, my ambition in *Black Patience* is also to analyze how modernity's affective logics and practices help to produce the modern racial order and to shape the structural and experiential textures of black life.

Performance theorist Tavia Nyong'o has rightly called attention to what he refers to as the "aloofness of the term affect," a sentiment shared by a sizable contingent of scholars working in the field of affect studies.[57] So it is important that I explain my use of the term in this book. Against the backdrop of the long history of black patience, or of using feeling and emotion to manage and discipline black subjects, I understand *affect* in the sense of the capacity to affect and to be affected. But the advent of transatlantic slavery and the endurance of its afterlives require us to think these procedures of existing in the world as subjects and objects of affect through the frames of colonialism and racial slavery and in relation to the overlapping world systems of racial, gender, sexual, religious, and other forms of violence that have become synonymous with the term *modernity* itself. Seen this way, affects are not prior to intention, nor outside of sociality. Rather, they come to operate as social intensities that labor to move and compel the social subject—as forces that strive to trigger and discipline the body to act or to respond in a desired fashion. In brief, affects are foundational to the development of social subjectivity, which is also to say to the formation of racial subjectivity. Thus, to map the historicity of feeling, of emotion, of affect is, at the same time, to map the historicity of modernity's enduring commitment to racial violence.

Rethinking Civil Rights Historiography: Theatre, Radicalism, and the Archive

If Dr. Martin Luther King Jr. understood the dark and egregious workings of black patience, he also possessed a profound understanding of black people's efforts to challenge it, and the importance of black theatre to this political project. In a 1960 letter to performance virtuoso Sammy Davis Jr., King highlights the significance of art to the cultural and political fronts of the Civil Rights Movement. "Art," he suggests, "can move and alter people in subtle ways because, like love, it speaks through and to the heart."[58] King's optimism concerning the social and political uses of art followed on the heels of attending a live performance of Oscar Brown Jr.'s 1960 musical, *Kicks & Co.* Directed by prominent black playwright and civil rights activist Lorraine Hansberry—whose play *A Raisin in the Sun* opened on Broadway to much acclaim the previous year—*Kicks & Co.* is a riveting three-act musical comedy about the Civil Rights Movement, particularly the sit-ins that had begun to attract international attention as Brown completed and debuted *Kicks*. In Brown's musical, a coed group of college students at Freedman University for Negroes struggles to balance the demands of love, school, work, and civil rights activism. Evincing Brown's talents as musician and playwright, the script for *Kicks* was brilliantly conceived, its live performances entertaining, and for one contemporary viewer "like seeing (and hearing) a dream walking."[59]

As the play neared its debut, Brown took his backer's auditions on the road. He performed excerpts of the play in clubs, salons, and living rooms as a way to drum up interest in the work and to garner financial support. These promotional efforts earned a decisive boost when David Garroway—the NBC *Today Show* host who had heard Brown perform parts of *Kicks* at New York City's Village Vanguard—invited Brown on the show for a rather unconventional two-hour appearance, the show's full slot. Joined by actor Zabethe Wilde, a standout presence in the play and frequent collaborator during backer's auditions, Brown wowed television audiences across the nation. Describing the extraordinary attention that the duo generated through their performances of songs, dances, and other scenes from *Kicks*, Garroway observes, "I've had, in the last nine years, 11,600 guests—every name in music today. Never has any artist received as many telephone calls, telegrams, mail

and messages as Oscar did on his first appearance."[60] The payoff of these marketing strategies was enormous. Attracting $400,000 in backing and another $100,000 in advanced tickets sales, *Kicks & Co.* was well on its way, so it seemed. Highly anticipated by audiences and critics alike, the play was constantly dubbed "a surefire contender for Broadway."[61] It came as little surprise, then, that on opening night Brown's star-studded cast played to a sold-out audience of 5,000 at the Arie Crown Theater in Chicago's dazzling and newly built McCormick Place.

I will return to the plot of *Kicks & Co.* in the final chapter of this book. But here I want to focus on the circulation and reception of Brown's play, which was a hit not only among theatre and television audiences but also among well-known artists and civil rights activists like Dr. King and Sammy Davis Jr. Having learned of Davis's interest in the play, King wrote to him on December 20, 1960, adding his voice to the chorus of glowing reviews that *Kicks* had begun to receive:

> To my knowledge, rarely has there come upon the American scene a work which so perceptively mirrors the conflict of soul, the moral choices that confront our people, both Negro and white, in these fateful times. And yet a work which is at the same time, so light of touch, entertaining—and thereby all the more persuasive. This young man's work will, in its own special way, affect the conscience of vast numbers with the moral force and vigor of our young people.[62]

An acclaimed actor in the drama of civil rights activism, and close friends with black playwright-activists like Amelia Boynton Robinson—whose musical drama *Through the Years* (1936) helped to build a community center in Selma, Alabama—King was intimately familiar with how theatre and embodied political performance could reshape the trajectory of black political modernity. Just two months before he penned his letter to Davis, King was arrested, imprisoned, and sentenced to six months of hard labor for participating in an Atlanta sit-in. There is no paucity of documentation on the sit-ins. Nor is there a lack of archival evidence concerning King's participation in the drama of civil rights activism. But King's acknowledgment and glowing appraisal of Brown's play sheds light on one of this book's primary arguments: the Civil Rights Movement was acted out on the theatrical stage with the same creative verve, political

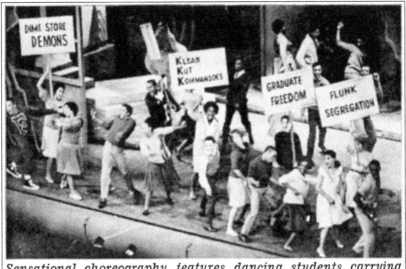

Sensational choreography features dancing students carrying anti-segregation signs marking 'Equal Opportunity Day.'

Figure I.1. Oscar Brown's *Kicks & Co.* Photo by Larry Stills, *Jet*, October 12, 1961, 59.

ambition, and embodied dexterity that were hallmarks of the more familiar "stages" that are routinely prioritized in civil rights historiography and cultural criticism: lunch counters, buses, prisons, and streets, to offer a few examples. King's assessment of *Kicks & Co.* underscores a key, if understudied, weapon of civil rights activism: black theatre.

By detailing the vital role of black theatrical performance in the Civil Rights Movement in this book, I aim to expand the purview of recent civil rights historiography and cultural criticism. According to literary critic Houston Baker Jr., civil rights "signifies the cultural work of a mass movement."[63] In recent years, scholars have begun to excavate and critically analyze this expansive archive of "cultural work," and to assess its relationship to the political imperatives of civil rights activism. In a string of incisive studies, these thinkers have demonstrated that the movement was not only significant to black politics, but was also a seminal era in black artistic and cultural production.[64] This growing body of scholarship, however, has yet to detail the importance of theatre to the "classical phase" of the movement, a trend that generates practical and theoretical questions about the archive of civil rights activism.[65] Whereas television and photography are conventional ways of regard-

ing the movement, this book asks: What other technologies were key to the movement's cultural and political fronts? And what, more specifically, is the status of theatre in the movement's archive and repertoire?[66] Finally, how can analyzing black theatre yield new knowledge about race, time, affect, performance, politics, modernity, and ultimately the Civil Rights Movement itself? Joining scholars like Waldo Martin, Mary Helen Washington, Erica Edwards, and Jeffrey Coleman, who have all done important work to explore the complex cultural apparatus at the heart of the movement, *Black Patience* contributes to this scholarship by offering the first sustained study of black theatre in the movement's "short" or "classical" phase. In doing so, it furnishes a new archival and epistemological basis for work in the field of civil rights studies.

In particular, this book contributes to a recent rethinking of civil rights historiography, and more specifically to a major critical turn now called the Long Civil Rights Movement Framework. In the last fifteen years, the Long Civil Rights Movement Framework has exposed and critiqued a tendency in civil rights historiography to overemphasize the "traditional" or "classical" phase of the movement, a period that spans broadly from the US Supreme Court's landmark *Brown v. Board of Education* (1954) decision to the Voting Rights Act of 1965. Scholars of the long movement argue that such a "simplified story" camouflages the movement's earlier historical origins, and thereby obscures its complex geographical and ideological parameters.[67] These thinkers have persuasively demonstrated that the movement was not confined to the Jim Crow South and that leftist politics were vital to its making. Advancing these among other propositions, these scholars aim to "make civil rights harder," or to expand and reelaborate the common sense of civil rights historiography: its methods, archives, and conceptual conventions.[68] Further, to make civil rights harder is to contest routine appropriations of civil rights history that contort these hard-fought battles into conservative platforms to advocate for color-blind modes of governance that serve as the centerpiece of a massive campaign to retrench the gains of the Civil Rights Movement.[69]

Among the most common methods that scholars have employed to make civil rights "harder" is to locate the movement's origins in the 1930s and '40s and to shift its geographical center beyond the US South. These gestures have considerably enriched civil rights historiography. In this, they often share a common and intriguing premise: by excavating

earlier, non-southern, and communist dimensions of the movement, we can uncover more radical histories of civil rights activism. *Black Patience* joins and builds on these efforts to make civil rights "harder" and to produce more complex and radical histories of the movement. It differs, however, in its methods for engaging in this critical pursuit. Rather than make an about-face away from the movement's classical phase, this book lingers in the break of the short period. Whereas the long-movement approach has generated a critical inclination to downplay the "classical phase" of the movement, and a penchant to frame the so-called "dominant narrative"[70] as the sum of this phase, the dilemma of emplotting radical histories of the movement, and of theorizing radicalism more broadly, is not primarily one of periodization or geography. It is instead a problem of limiting the archive and repertoire of civil rights activity to certain forms of evidence, and of allowing orthodox understandings of radicalism to overdetermine our conceptions of the radical.

Literary and performance theorist Koritha Mitchell has questioned our deep attachments to photography as the primary frame for considering lynching and its cultural logic.[71] Turning to African American lynching plays to reconsider the history of lynching, Mitchell shows how the very construction of archives is often an act of omission and of elevating certain ways of knowing over others. In a similar vein, *Black Patience* aims to uncover the value of black theatre to the archive of the Civil Rights Movement, and to the critical enterprise of making civil rights "harder." Situating this study within the increasingly aspersed framework of the "short" movement does not, at all, sideline critical ambitions to produce more radical and complex histories of the movement. To the contrary, the archival intervention made here by turning to black theatre fosters new possibilities for sussing out sites and styles of black radicalism that might not register in the conventional archives of civil rights historiography.

I make these claims while keeping in mind black political theorist Cedric Robinson's warning that the Black Radical Tradition is not "a biological reflex."[72] Here Robinson rightly highlights the limits of impulsively situating black thought, black behavior, and black culture within the domain of the Black Radical Tradition. Further, he goes on to define this tradition as a "reconstitution of historical, cultural, and moral materials, a transcendence which both transfers and edits earlier knowledges and understandings among the several African peoples enslaved."[73] Seen this

way, black radicalism is an exercise in revamping the boundaries of the norm. It entails a self-conscious commitment to reconstituting, editing, and transferring knowledges and materials that are relevant to the lives of African-descended peoples. With this concept of black radicalism in mind, I argue that black theatre in the Civil Rights Movement forwarded and energized the Black Radical Tradition—not by attaching itself to communism per se, but by working to disassemble the modern structures of racial time and racial affect that energize the violent cultures of black patience. The performances in this book illuminate how the Black Radical Tradition is always already a contextual problem for thought that cannot be confined to any fixed material or ideological location.

Not all of the plays in the chapters that follow announce their connections to the movement, especially in the explicit ways that *Jericho-Jim Crow* and *Kicks & Co.* do. Nor is the radical nature of their politics and aesthetics always clear-cut. But carefully considering the particularities of their production, reception, and circulation provides a clearer understanding of the radical drives that often propelled these innovative and courageous experiments in theatre and performance. According to historian Robin D. G. Kelley, in fact, the "most radical art is not protest art," but rather "works that take us to another place, envision a different way of seeing, perhaps a different way of feeling."[74] Black theatrical performance in the Civil Rights Movement fostered different ways of seeing, feeling, and ultimately of being black, posing a formidable challenge to the violent enterprise of black patience. More firmly incorporating black theatre into civil rights historiography and cultural criticism affords a more expansive view of the "short" movement and its political and aesthetic radicalisms.[75]

This conceptual and methodological intervention helps to clarify and restore in critical discourse a political, ideological, and geographical complexity that was always there in practice. If we return to *Kicks & Co.*, for instance, we realize that within the ranks of Brown's college protesters are students who occupy diverse class positionalities; students who debate the racial politics of "natural" hair; students who both endorse nonviolence and criticize the "sit-in nonsense"; and students who caution their colleagues not to "wait for heaven," warning that "if there is a heaven, let it wait."[76] With its satirical tapestry of complex dialogues about race, class, sex, respectability politics, and protest, *Kicks & Co.* was hardly constrained by a dominant narrative of civil rights activism.

Despite tendencies to regard histories of the short movement as "commonplace," "tired clichés," examining black theatre in this era urges us to rethink any critical approach that threatens to trivialize what was, in reality, a far more nuanced set of social, political, and cultural conditions.[77] In lieu of sidelining the movement's classical phase, we should work toward building more multidimensional histories of this period through a willingness to expand the archival and conceptual schemas that have heretofore shaped traditional histories of the movement. Building on the work of scholars who have analyzed the value of photography and television to the movement, this book moves in this direction by considering how black theatre, like the camera, was a valuable technology of civil rights activism. This marginalized genre of embodied political action is a key site to which we can turn to "make civil rights harder."

Doing Time Otherwise, Feeling Otherwise

In navigating the profundity of violence that shapes the racial project of black patience, black people have vigorously resisted its enclosures. Unsettling the temporal and affective regulations that serve as the pillars of this project, they have devised strategies of doing time otherwise and of feeling otherwise. The otherwise is about the creation and existence of worlds that move in relation to, but in excess of, the norm. It is an assemblage of "infinite alternatives" that contain the capacity to shape ontology and to disrupt prevailing structures of power.[78] To be sure, neither the otherwise nor any genre of alternative possibility can lay claim to a position that is fully outside of power. But the otherwise does lay bare how power is never absolute in its performance of domination or infinite in its capacity to control every terrain, every fiber of existence, within its reach. In the face of the gratuitous violence of black patience, black artists, activists, and everyday people have developed techniques of doing time otherwise and of feeling otherwise. These counter-normative engagements with time and affect have created pathways to decolonial modes of thinking and doing time, of thinking and doing feeling. Below I offer the terms *Afro-presentism* and *fugitive affect* as conceptual interventions that help us to understand these otherwise strategies of relating to the violent times and affects that structure the racial project of black patience.

Violent Afro-Futures and the Politics of Afro-Presentism

Perhaps the most salient phrase in the movement's political lexicon, the civil rights mantra "freedom now" not only inflected the political and aesthetic sensibilities of this era but also challenged the authority of black patience by flouting its racialized logics of deferral and by situating the movement's strategies of social transformation within the revolutionary time of the "now." Mining this time-centered expression for its conceptual, political, and aesthetic utility, I argue for the singular importance of the "now" for analyzing the Civil Rights Movement, but more than this for reexamining some of the most pressing critical concerns animating the fields of black studies and performance studies in particular. Taking seriously the conceptual and theoretical importance of "freedom now" allows us to approach perennial questions surrounding the ontology of black life and the ontology of black performance with fresh insights.

Black people's performative call for "freedom now" was a world-making refusal to accede to the temporal demands of black patience. It belongs to a radical structure of racial time that I call *Afro-presentism*. By this I mean a black political and ontological orientation toward demanding and enjoying "the good life" in the here and now. By "the good life," I do not mean to impute to black experience a semantics or political conception of the good life that has historically been reserved for the prized subjects of liberal democracy, or more precisely for him who is not black. But I do have in mind a hybrid and flexible paradigm of the good life; one that is sometimes political, sometimes social, other times cultural; one that reminds us that in the midst of black people's (often failed) strivings toward the good life of liberal democracy, blackness itself is good. As the performances in this book demonstrate, rather than capitulating to the temporal impositions of black patience, black people have routinely engineered a range of creative strategies to enjoy the affordances of the good life by tapping into the latent possibilities of the here and now. Unlocking the radical potential of the now, these engagements with Afro-presentism have both critiqued and refused the West's wily attempts to quarantine black people's access to the good life to an always arriving, and often unarrivable, black future.

To better understand the prevalence and political impact of Afro-presentism on the black political imagination in this period, we can turn

to Dr. Martin Luther King's Jr.'s now-fabled "I Have a Dream" speech, delivered at the March on Washington in August 1963.[79] Though rhetorically framed by the future-oriented metaphor of a dream, King's speech persuasively advocates for what he calls the "fierce urgency of the now."[80] He warns the crowd of almost a quarter million:

> There is no time to engage in the luxury of cooling off or to take the tranquilizing drug of gradualism. *Now is the time* to make real the promises of democracy. *Now is the time* to rise from the dark and desolate valley of segregation to the sunlit path of racial justice. *Now is the time* to lift our nation from the quicksands of racial injustice to the solid rock of brotherhood. *Now is the time* to make justice a reality for all of God's children. It would be fatal for the nation to overlook the *urgency of the moment.*[81]

King's repetition of "Now is the time" indexes the value of the "now" to postwar black political culture. In a speech most commonly remembered for its stated focus on black freedom dreams and black political futures, King proffers now-time as the foremost temporality of black political culture.[82] By the time King delivered his iconic rumination on blackness, time, and freedom, John Lewis—who at only twenty-three years old was chairman of SNCC and the youngest person to speak at the March—had already called out the violent cultures of black patience. "To those who have said, 'Be patient and wait,'" Lewis declared, "we have long said that we cannot be patient. We do not want our freedom gradually, but we want to be free now! We are tired. We are tired of being beaten by policemen. We are tired of seeing our people locked up in jail over and over again. And then you holler, 'Be patient.' How long can we be patient?"[83]

Lewis's and King's speeches at the March on Washington signal the importance of Afro-presentism to black political culture, and to black people's attempts to resist black patience. Afro-presentism is a mode of doing time otherwise because its insistence on the "now" disrupts black patience and challenges its gross manipulations of black futures. Seen this way, Afro-futurism is less an attempt to "speculate on black possibilities in the future" and more a violent form of delay, or racialized experiment in duration.[84] In other words, within the context of black patience, Afro-futurism is not about "the future and liberation."[85] Instead, it is a practice and ideology that transforms the time of the "not-yet-here" into

an arena of anti-black oppression.[86] My aim here is not to downplay the radical and brilliant paradigms of Afro-futurism that have transformed the field of black studies, but to trace a parallel Afro-futurist project that claims the future as a wheelhouse for manufacturing the global operations of black patience.

Recognizing the precarity of black futures, Afro-presentism imagines, crafts, and accounts for the aesthetic, experiential, and political strategies that black people use to embrace the possibilities of the present while continuing to engage in the necessary practice of black freedom dreaming; of spying the horizon; of pursuing the not-yet-here. In this way, Afro-presentism challenges a violent relation to the future that literary theorist Lauren Berlant has called cruel optimism. According to Berlant, a part of what renders our hopes for improved futures so cruel is that the objects of our optimistic attachments—whether political rights or economic security—constantly elude our reach but succeed at continuing to nurture our optimistic attachments. What motivates Berlant's conclusion, in part, is an astute recognition of how the historical present, especially under the conditions of neoliberal governance, strategically obscures the routinized nature of crisis. In the face of these conditions, the shock of the traumatic scenario, and its rendering as an exceptional event, conceals the ubiquitous, ongoing crisis that plagues the historical present, a condition that Berlant calls "crisis ordinariness."[87]

Building on Berlant's *Cruel Optimism*, in *Black Patience* I am interested in the temporal and affective dimensions of black political life, and in how the obligations of black patience constrain possibilities for accessing and enjoying the good life. For black subjects, the ordinariness of crisis, and the structures of cruel optimism that generate and sustain desires for the good life, are hardly a product of post-1980s neoliberalism. Instead, these relations of cruel optimism have been constitutive of black life since the onset of chattel slavery. From the moment Africans were captured, enslaved, and converted into objects of property, the crisis was set in motion and the seeds of its enduring effects planted. If we consider further the illusory promises of improved black futures that continue to circulate in the wake of transatlantic slavery, we realize the critical role of black patience in orchestrating the "ordinariness of crisis" for black people in particular. Seen this way, cruel optimism is exceptionally specious in its manipulation of black futures and in weap-

onizing black freedom dreaming as a means of shoring up white power. It seeks to orchestrate strong attachments to the illusory promises of black patience and to a future that is likely never to come. This racialized performance of patient waiting threatens to wear the black subject out.

Even so, what are we to make of those moments when the subject's quest for the object of optimistic attachment succeeds, however brief the encounter? How do such acts of "fugitive movement" invite a conceptual adjustment to the scale of analysis and the temporal frames of inquiry?[88] Whereas Berlant focuses on the historical or "stretched-out" present, Afro-presentism prioritizes a more narrow scale of the present, one that emphasizes "the instant,"[89] or more precisely "the fleeting instant of the present."[90] This scalar distinction between the "stretched-out" present and the "instant" within that present affords a productive theoretical frame to more carefully consider those moments in which the subject manages to grasp the object of the optimistic attachment. Clawing against the object's structured and structural slipperiness, this moment of embrace, however fleeting, troubles the presumed unembraceability of that ever-elusive object. In this instance, it is harder to approach questions of freedom, subjectivity, and society through critical frameworks that revolve around the teleological chasing of an object of impossible capture. Perhaps ephemeral but no less real and instructive, this unthinkable scene of encounter invites a more sustained attention to the archive of instants in which black people have managed to grasp and inhabit dimensions of the good life. Put another way, this parsing of the stretched-out present yields a series of instants that cannot be explained away through critical perspectives calibrated toward the inevitability of failure. To the degree that black people occasionally experience— and capture, as it were—happiness, freedom, and other objects of the good life, we need alongside Berlant's astute theory of cruel optimism something along the lines of what Lefebvre has called a "theory of moments."[91] Afro-presentism is offered in this vein. It is my contention that these moments stage a challenge to the violent enclosures of black patience while, at the same time, fueling the necessary work of black freedom dreaming.

At stake here, in the final analysis, is a case for more thoroughly embracing the now as a theoretical and conceptual priority in the broad field of black studies, a field whose temporal preoccupations tend be

oriented toward the past and the future and less attuned to the analytical possibilities of the now or the present. Whereas scholarship on Afro-futurism and blackness and memory are burgeoning and abundant, far less work takes the present as a critical framework for analyzing the nature of black life.[92] This lack of critical attention to the now accords with a broader, cross-disciplinary tendency to eschew presentism as a viable method of philosophical and historical engagement.[93] To be sure, the past and future are vital temporalities for black people and are equally meaningful for understanding the essence of black performance. At the same time, my aim in this book is to elaborate the under-recognized value of the present for the fields of black and performance studies. Because black patience routinely plunders black futures and produces traumatic black pasts, the moment or the instant of black freedom and vitality assumes radical meaning insofar as it strains against and reconstitutes the normative enclosures of racial time that habitually defer black freedom and black citizenship to the time of the future.

Black Performance: The Racial Politics of Ephemerality and Disappearance

Like the ontology of black life, the ontology of (black) performance is intimately linked to the question of time. From rehearsals to the repetition of rituals to the duration of live theatrical productions, performance can "bend and remake" time.[94] This performative capacity to reshape time is a vital dimension of the plays and the live performances that I examine in this book, all of which work to "bend and remake" the time of black patience. Further, like black life, (black) performance occupies a precarious relationship to the future. On this front, one of the most salient dimensions of performance studies scholarship is an acknowledgment of how disappearance and ephemerality are constitutive of performance's ontology. Because live performances cannot be saved, recorded, or documented, performance "becomes itself through disappearance."[95] Performance therefore exists in a fraught relationship to the future. For black theatre and performance in particular, the threat of disappearance and ephemerality is an especially prominent and paradigmatic quality. If theatre is a "temporal medium" that exists "in the crease or fold of its own condition," I am interested in those conditions of blackness—which

is also to say of anti-blackness—that permeate the "crease or fold" of the environments in which black theatre and performance are staged.[96] Whether bombed in Mississippi, shuttered on Broadway for their searing portrayals of whiteness, or closed by police department vice squads in Los Angeles and Detroit for their risqué depictions of queer sex, the performances in the chapters that follow demonstrate how the singular conditions of ephemerality that haunt black being likewise haunt the ontology of black theatre and performance. They demonstrate how the lives of black theatre and performance, like the lives of black people, are precarious entities whose futures are routinely jeopardized by an assemblage of violent world systems that range from white supremacy to racial capitalism to heteropatriarchy.

As black theatre and performance negotiate the existential threats posed by this violent relationship to the future, the moment of the "here and now," the present, obtains particular value. We might consider, on this front, a well-known claim from performance theorist Peggy Phelan, who has argued that "rarely is the 'now' to which performance addresses its deepest questions valued."[97] Troubled by what she perceives as a lack of critical attention to the "now" in performance studies scholarship, Phelan stresses the centrality of the present for understanding the essence of performance. These observations serve as the premise for Phelan's widely cited claim that "performance's only life is in the present."[98] I join performance theorists like Fred Moten and Phillip Auslander who have grappled with the prescriptive nature of this presentist orientation toward the ontology of performance.[99] Nonetheless, I find Phelan's emphasis on the present particularly instructive, namely for how it forces a critical attention to the present and how, in doing so, offers a useful analytical framework for making sense of black performance and black life staged against the historical backdrop of black patience.

In observing that performance "is always bound to the present" and thus "marks the perpetual disappearance of its own enactment," Phelan identifies disappearance as a formal quality of performance.[100] For black performance, the ontological quality of disappearance is not solely a function of form. It is as much a product of a structural threat of disappearance and ephemerality that hovers over black lives, to be sure, but also over the lives of the theatrical objects and environments that black people curate and invent. From transatlantic slavery's inaugural

capture and disappearing of African people to the thousands of black people who have been lynched, killed by police, disproportionately incarcerated, or slain by the hand of medical injustice, black subjectivity maintains a close affinity to disappearance and a structural relationship to ephemerality. When viewed from this angle, ephemerality and disappearance are not only formal conventions of theatre and performance writ large; they exist in a singular relation to black people and to black theatre and performance in particular. Disappearance and ephemerality, in other words, are socially produced and vital to modernity's procedures of racial formation and their impact on black aesthetic and black performance futures. This racial specificity is crucial to any conception of ephemerality and disappearance within the interdisciplinary field of performance studies as well as to understanding the relationship between performance and American culture.

Under these racialized conditions of precarious futures, Afropresentism is as critical to black art and black life as it was to the clarion call for "freedom now" during the Civil Rights Movement. On this front, we might recall the widespread consensus that Oscar Brown Jr.'s *Kicks & Co.* was a "surefire contender for Broadway."[101] But this "Broadway bound musical" closed on the fourth night of its Chicago previews, effectively marking the death of the play—a death due in no small part to its forthright engagements with race.[102] These types of premature deaths and near-deaths of the black theatrical object are common occurrences. In his foundational 1967 history of black theatre, black playwright and theatre historian Loften Mitchell calls attention to the precarity of black theatrical futures. He prefaces the concluding section with a poem entitled "TOMORROW":

> Tomorrow is a fleeting, still-born moment,
> The sum total of our yesterdays and todays,
> Elusive,
> Evasive,
> Unless negativism is torn from our calendar,
> And truth made the symbol of our eternity.[103]

Seeming to function as a referendum on the comprehensive history of black theatre that Mitchell has emplotted throughout the text,

"TOMORROW" captures the "Elusive, / Evasive" nature of the future for black theatre. This recognition of the precarity of black theatrical futures foregrounds the significance of the present, and more specifically of Afro-presentism, for the black theatrical object: its ontology, its live performance. The playwrights and performers that I consider throughout *Black Patience* used theatre and performance to fashion a political aesthetics of now-time that advanced the goals of the Civil Rights Movement while disassembling the racial project of black patience and its violent Afro-futurisms. Ultimately, their embodied experiments in Afro-presentism revised the temporal conventions of black citizenship and altered the time of black life.

Fugitive Affect

As much as these theatre workers were challenging the temporal conventions of black patience through their creative deployments of the now, they were also resisting the affective orthodoxies that organize the racial project of black patience. Whereas Afro-presentism marks a political response to the cruel temporalities of black patience, fugitive affect highlights black people's political response to its affective coercions. By *fugitive affect* I mean a dissident practice of straining against the affective protocols of black patience in particular and white supremacy more generally. Fugitive affect is a counter-normative performance of affect that stages a "transgression of the proper" rules of black affective expression that subtend black patience and the logics of anti-blackness in which it is grounded.[104] Thus, even as black patience exploits and manages black affect as a way to discipline black subjects, black theatre and performance open up channels of affectivity—whether through anger, laughter, or sexual pleasure—that disrupt the affective enclosures of black patience.

Such performances of fugitive affect are evident throughout black theatre in the Civil Rights Movement. In civil rights plays like William Branch's *A Medal for Willie* (1951) and Alice Childress's *Trouble in Mind* (1955), audiences met black protagonists who, by the end of each play, have run low on (black) patience. In Branch's fiery one-act, a southern town decides to celebrate a fallen black soldier named Willie. When summoned to accept her son's posthumously awarded medal, Willie's

mother abandons the patient disposition she'd shown throughout the play, ultimately irrupting into an impassioned critique of the town's embrace of anti-blackness. Rather than perform deference, gratitude, or long-suffering, she argues that Willie should have "come down here with his machine gun and shot up some white folks," a wish that anticipates an emerging black nationalist openness to violence that would fester across the next two decades.[105] Like Willie's mother, in Alice Childress's 1956 Obie Award–winning play, *Trouble in Mind*, Wiletta Mayer—the protagonist of an interior lynching drama within the play—spurns the affective protocols of black patience and stages performances of fugitive affect. Joining members of the cast, Wiletta grows impatient with the number of flowers and jewels—Gardenias, Magnolias, Petunias, Crystals, Opals, and Pearls—that black actresses are limited to playing. She is miffed by how these stock roles demand manufactured smiles and fidelity to a broader repertoire of black affective performances that exploit "affect's function as a vector of racialization."[106] Refusing to remain silent about her qualms with the script, especially that it requires her to surrender her son to a lynch mob, the otherwise patient Wiletta lashes out at the white director, seething: "The writer wants the damn white man to be the hero—and I'm the villain." "The story goes a certain way," the director retorts. Hardly content with his rebuttal, the actress fires back: "It oughta go another way."[107] Examining civil rights plays like *A Medal for Willie* and *Trouble in Mind* illuminates the "affective power of black cultural production."[108] A specific dimension of black theatre's affective power during the Civil Rights Movement was its ability to combat the use of racial affect as a tool of anti-blackness and white supremacy, and more specifically of black patience.

It is important to note, however, that even the earliest works in the tradition of African American theatre depict a profound refusal of black patience, namely by chronicling fugitive escapes from slavery. Works like William Wells Brown's *The Escape: or, A Leap for Freedom* (1858)—widely regarded as the first play published by an African American writer—and Pauline Hopkins's *Peculiar Sam, or The Underground Railroad* (1879) portray enslaved black subjects who refused to wait for freedom, whose fugitive escapes were nothing less than embodied demands for freedom now. In considering how black theatre disrupted modernity's possessive investment in black patience, this book not only

charts a new cultural and political history of the Civil Rights Movement, but also maps a racial history of time, and unfurls an affective history of blackness, by analyzing the lasting impact of black patience on the making of modernity and the production of the modern racial order.

Overview

In chapter 1, "One Hundred Years Later: The Unfinished Project of Emancipation," I examine the 1963 Emancipation Proclamation Centennial, a commemoration of one hundred years of freedom from US chattel slavery. Unfolding in the thick of the Civil Rights Movement—a movement commonly called the "Second Emancipation"—the Centennial occasioned an opportunity for black people to weigh how the legacies of transatlantic slavery continued to defer black freedom, or to demand black patience, in post-emancipation America. I begin by looking at centennial events in Indiana, specifically a production of Lorraine Hansberry's 1959 play, *A Raisin in the Sun*. Guided by Langston Hughes's prescient question—"What happens to a dream deferred?"—the play invited centennial audiences to ponder the operations of black patience a century after emancipation. I then offer the first detailed scholarly account of the Century of Negro Progress Exposition in Chicago. Duke Ellington's 1963 musical drama, *My People*, was the highlight of this Exposition. Though hardly considered a radical, and often referred to as "Uncle Tom" and "Stepin Fetchit," Ellington's play invites a consideration of the *scales of black radicalism*. Drawing participants from as far as Madagascar, and flanked by meetings about civil rights, labor, and gender, the Exposition revealed the enduring violences of black patience but refrained from collapsing the time of slavery and the time of freedom.

In chapter 2, "Black Time, Black Geography: The Free Southern Theater," I shift my attention to Mississippi, the US nation-state's most iconic geography of black patience. I consider how, even in this bastion of racial terror, the Free Southern Theater used theatrical performance to contest black patience, namely by performing and repurposing plays like Samuel Beckett's *Waiting for Godot* (1952) and Ossie Davis's award-winning musical, *Purlie Victorious* (1961). The theatre's founders believed that theatre, born from the fervor of Mississippi's local Civil Rights Movement, would "open a new area of protest [and] add a necessary dimension to

the current civil rights movement."[109] In choosing a repertoire that was keenly attuned to the global history of black patience, the theatre's temporal politics and aesthetics energized and reinforced the movement's radical demand for "freedom now." Further, in using the back porches of shacks, cotton fields, and former plantations as theatrical stages, their performances altered the racial and temporal meanings of Mississippi's "plantation geographies," much like those who were marching, sitting-in, and transforming southern space in other ways.[110]

Histories of the Civil Rights Movement routinely decouple black sexual and black political desires, and have made even less room for desires that are black and queer. This has amounted to what Audre Lorde calls "a suppression of the erotic" within civil rights discourse.[111] In chapter 3, "Black Queer Time and the Erotics of the Civil Rights Body," I examine the centrality of queer desire to the Civil Rights Movement, and show how homophobia and heteropatriarchy inform the temporal and affective violences that anchor racial project of black patience. To examine these issues, I turn to the work of Amiri Baraka. Whereas most scholars engage Baraka as an architect of the Black Arts Movement, he was a key figure in the Civil Rights Movement as well. Reading what I refer to as Baraka's black queer trilogy—*The Eighth Ditch* (1961), *The Toilet* (1964), and *The Baptism* (1964)—I contend that this understudied collection of one-act civil rights plays illuminates how queer pasts and futures are routinely disavowed and foreclosed by the pressures of normative racial and sexual ideologies. Under these conditions of queer shame and sexual regulation, the *queer present* emerges as a key temporality for black queer subjectivity and erotic expression. Seen this way, the clarion call for "freedom now" that animates the book's previous chapters accords with a temporal imperative that profoundly shaped black queer aesthetics and sexual practices during the movement. I end this chapter by turning briefly to Paul Carter Harrison's practically unknown one-act civil rights play, *The Experimental Leader* (1965), which also focuses on the politics of queer time. Having produced this play while living as a black expatriate in Amsterdam, Harrison demonstrates the transnational reach of black theatre and performance during the movement.

The first three chapters of this book theorize black people's historical experiences of black patience. In chapter 4, I turn to a cadre of black playwrights who used theatre to position *white impatience* at the cen-

ter of the movement's visual field. "Picturing White Impatience: The-
atre and Visual Culture" argues that during the Civil Rights Movement,
theatre was a key visual technology. Examining James Baldwin's *Blues
for Mister Charlie* (1964), Douglas Turner Ward's *Day of Absence* (1965),
Alice Childress's *Trouble in Mind* (1955), and Lorraine Hansberry's *Les
Blancs* (1970), I argue that these playwrights used theatre to paint radical
portraits of white people that reframed the problem of race as a prob-
lem of whiteness. In doing so, they recalibrated the visual economy of
the Civil Rights Movement, specifically by challenging a paradigmatic
gaze (one nurtured by television and photography) that desired and fe-
tishized images of damaged black people—from the maimed body of
Emmett Till to the battered "hearts and minds" of the black children at
the center of *Brown v. Board of Education*. By shifting their audiences'
gazes from injured black bodies to white people, the artists considered
here uncovered a historical lack of white patience, especially in matters
of racial relations.

The final chapter shifts gears to think about the transformative po-
tential of black patience, or how black people have used patience as a
tool of black political world-making. "Lunch Counters, Prisons, and the
Radical Potential of Black Patience" turns to performances of sit-ins and
jail-ins to consider how activists reinvested patience with radical po-
tential. Reading C. Bernard Jackson and James V. Hatch's Obie Award–
winning musical, *Fly Blackbird* (1962), alongside Oscar Brown Jr.'s *Kicks
& Co.* (1961) and archival ephemera like nonviolence training manu-
als, prison writings, and curricula for nonviolence workshops, I argue
that the sit-in and the jail-in were not passive forms of political protest,
but rather creative performances of patience that helped to energize the
Civil Rights Movement and to alter the landscape of US democracy. Em-
bodied expressions of "freedom now," these acts of "urgent patience"
repurposed and redeployed black patience and its oppressive uses of ra-
cial time and racial affect.[112] Whereas the racial project of black patience
coerces calm, uncomplaining endurance and long-suffering, in the case
of the jail-in and the sit-in, activists put the temporal and affective pro-
tocols of patience in the service of black freedom. Whether waiting at
lunch counters and in prisons or remaining calm while enduring as-
saults from movement antagonists, they attacked the violent cultures of
black patience via black patience.

Coda

Black people's challenge to the racial project of black patience is as old as the racial project of black patience itself. As Dr. King put it in another of his poignant meditations on racial time—one suggestively entitled *Why We Can't Wait*—the "Negro ha[s] never really been patient in the pure sense of the word."[113] The Civil Rights Movement, he explains, did not ignite a "sudden loss of patience within the Negro."[114] While the Civil Rights Movement marked a spectacular and unprecedented affront to black patience, this revolutionary encounter was not without precedent. We can turn, on this front, to a telling memory from former slave, activist, and educational guru, Booker T. Washington. Washington was known widely as a staunch proponent of black patience whose strategies for racial uplift King described as "having too little freedom in its present and too little promise in its future."[115] In the pages of his 1901 narrative *Up from Slavery*, however, Washington recalls a personal encounter with a clock that is instructive for understanding the historical relationship between blackness and time and the counter-normative strategies that black people have long employed to revamp their relationship to the violences of racial time. Here Washington recounts that he adjusted the hands of a clock that regulated the labor time of a group of formerly enslaved workers. By changing the clock, and thus altering time, Washington succeeded in bringing his labors to an early close. In doing so, he ultimately achieved his goal to "reach that schoolhouse in time."[116] Upon discovering this covert challenge to the norms of white time, which is also to say to the enduring labor time of slavery and racial capitalism, Washington's "boss" promptly "locked the clock in a case."[117]

Like Washington, black people have been adjusting the hands of the clock for centuries. But the Civil Rights Movement was a singular moment in these efforts to challenge the gratuitous violences of racial time. Though inundated by a symphony of calls to go slow, the artists and activists in this book knew that the disciplinary protocols of black patience, of blackness as patience, would continue to vitalize anti-blackness and white supremacy. Armed with this knowledge, they used the theatrical stage to wrest black people from the violent enclosures of black patience.

1

One Hundred Years Later

The Unfinished Project of Emancipation

In 1963, as black people staged the Civil Rights Movement, they were also observing the Emancipation Proclamation Centennial, or one hundred years of freedom from US chattel slavery. A vital moment in a movement commonly called "the Second Emancipation," the Centennial spawned a vast and vibrant culture of commemoration, from the founding of local centennial groups to the planning of major international exhibitions. Like the Civil Rights Movement, it spotlighted how, a century after emancipation, black people were still waiting for freedom, or being forced to perform black patience. Living amid the ruins of slavery's afterlives, Centennial organizers and participants exposed and forcefully critiqued the "unfinished project of emancipation" and its persisting deferrals of black freedom.[1] In a 1963 special issue of *Ebony* magazine dedicated to observing the Centennial, noted black publisher and editor John H. Johnson warns,

> this is not an occasion for hosannas and hurrahs. The freedom proclaimed by Abraham Lincoln is not yet a reality . . . On the 100th anniversary of the Emancipation Proclamation, America is again at the turning of the fork. Again, as in 1863, Americans are grappling with the "dragon seed" of slavery. . . . The Emancipation Centennial, therefore, is not a time for celebration. It is a pause for spiritual refreshment: it is a time for rededication to the unfinished business of eradicating segregation and discrimination from every facet of American life.[2]

Arguing for a "time" and a sentiment of reflection over revel, of "pause" and "rededication" over "hosannas and hurrahs," Johnson calls attention to the fact that, a century after emancipation, black people were yet wrestling with "the 'dragon seed' of slavery." They were still being forced to performance black patience.

The Emancipation Proclamation Centennial was a critical moment in the history of civil rights activism and is important to understanding the long black freedom struggle. Layered against and reinforcing the movement's demands for "freedom now," it called attention to the enduring deferral of black freedom in the wake of US chattel slavery. It is therefore a key site for theorizing the racial project of black patience and the making of black political ontology in post-emancipation America. Despite attracting international attention, however, the Centennial is curiously overlooked in civil rights historiography and cultural criticism, and within the field of black studies more generally. In addition to advancing the movement, this opportunity to ponder one hundred years of relative freedom allowed black citizens to reflect upon and to theorize the state of black politics and the nature of black political ontology. In the course of attending to their fraught relationships to freedom, and wrestling with the animate proximities of slavery, they produced nuanced conceptions of blackness and black political conditions that recognized the Proclamation's world-altering achievements but that also evidenced a critical consciousness of its startling limitations. This profound sense of being suspended "betwixt and between slavery and freedom" renders the Emancipation Proclamation Centennial one of the most valuable historical instances for theorizing the complexities of blackness and black political ontology in the wake of transatlantic slavery.[3] The Centennial thus warrants a greater priority of place within the fields of black and American Studies.

Black theatre and performance were vital to black citizens' efforts to grapple with the "unfinished business" of emancipation as well as the racial project of black patience.[4] We can turn, for instance, to the 1963 Century of Negro Progress Exposition in Chicago, Illinois—the largest of the Centennial observances. There we find black composer, bandleader, and pianist Duke Ellington using theatre to pose a question that is useful for understanding the longue durée of emancipation and the violent cultures of black patience. "What color," Ellington asked, "is virtue?"[5] This somewhat odd query is the title of the song that concludes Ellington's 1963 musical drama, My People, a work that Ellington composed for the Exposition. Featuring jazz vocalist Joya Sherrill and the Irving Burton Singers, the song opens with a coy, playfully poetic assertion from Sherrill: "Roses are red / Violets are blue / Tulips are for

kissing / and here [the sound of a kiss] is one for you."[6] But Sherrill's coquettish and playful tone gives way to a loud expression of "But." This abrupt transition stages a pivot to the song's grounding question and refrain: "What color is virtue?"[7] The song goes on to ask, "What has color got to do with behavior / Or when under fire how brave you are?"[8] Though Ellington's questions were posed as rhetorical queries that garner no reply from the cast, those who attended *My People* at the Century of Negro Progress Exposition likely had a good sense that the answer was that color, and more specifically race, had everything to do with virtue and behavior. They likely understood that black patience—a racialized virtue—was used as a weapon of anti-black violence and civic exclusion. They knew for sure that, one hundred years later, black people were still waiting for freedom.

Running twice daily at Chicago's dazzling, 5,000-seat Arie Crown Theater (housed in Chicago's newly built McCormick Place), Ellington's *My People* was the highlight of the Century of Negro Progress Exposition. That Ellington's musical figured so prominently in this international observance of the Centennial begins to illuminate the significance of black theatre to the postwar era of civil rights activism. *My People* was but one act within a much wider economy of theatre and performance events at the Century of Negro Progress Exposition. In addition to being entertained by black performance juggernaut Larry Steele, audiences also attended fashion revues, pageants, dances, and even a documentary play entitled *Dred Scott to the Present*. Performed by a cast of black lawyers and judges, the play was, according to one reviewer, a "living documentary of civil rights issues in the courts."[9]

Works of theatre like *My People* and *Dred Scott to the Present* are vital to this book's effort to map a new cultural and political history of the Civil Rights Movement by elaborating the under-recognized importance of theatre to civil rights activism. Paying attention to black theatre in this period furnishes a deeper understanding of the nuanced textures of black political culture and black cultural politics that animated the movement, namely its "short" or "classical" phase (circa 1954–1968). Scholars of what is now called the Long Civil Rights Movement have rightly begun to unsettle narratives that are routinely prioritized in civil rights studies. These narratives, they suggest, tend to sideline radicalism, to downplay labor rights, and to confine the movement geographically

to the US South and temporally to its short or classical phase. The result, they find, is often an obscuring of earlier and supposedly more radical periods of civil rights activism. Examining works of theatre like Duke Ellington's *My People*, and understudied events like the Century of Negro Progress Exposition, unearths a "short" movement whose transnational geography was just as nuanced and expansive as its political goals and ideologies. On this front, if we zoom out to take a closer look at the Century of Negro Progress Exposition, we get a clearer sense of the radical and transformative nature of its cultural and political priorities.

Alongside commemorating the Centennial, the Exposition was also an important locus of civil rights activity. Organized by the American Negro Emancipation Centennial Authority (ANECA)—a national centennial group with regional chapters spanning from its headquarters in Chicago to New York (a division chaired by baseball legend and vocal opponent of black patience Jackie Robinson) and Indiana—this international observance reflected the political ethos of "freedom now" that galvanized the Civil Rights Movement. By the time that ANECA staged the Century of Negro Progress Exposition, its embrace of the "here and now" of black freedom was not only apparent throughout the Exposition but across its local and regional divisions. Its radical use of Afropresentism as a bold affront to black patience was on full display at a gathering of the Cleveland, Ohio, branch on November 30, 1961. The group recognized that a century of legal freedom was certainly a historic milestone. But the guest speaker for this event, Jeff Donaldson, maintained that one hundred years after the abolition of slavery, black people were still waiting for freedom. Addressing the newly formed branch of ANECA, Donaldson declared that a "fast moving world is in no mood to wait for those who cling to 'horse and buggy mentality.'"[10] Set against the backdrop of a century of waiting for full emancipation, Donaldson frames time ("fast moving world") as a constituent element of black being, of black political desire, and of the making of modernity. Juxtaposing a "fast moving world" with the "horse and buggy mentality" that obstructs black people's strivings for full citizenship, he highlights a structural asynchrony between the quick time of modernity and the slow time of black social and political change. The Emancipation Proclamation Centennial exposed how these relations of asynchrony, or deployments of racial time, were critical to the production of a post-

slavery world that would remain rooted in the repeating violences of transatlantic slavery. Joining thousands of civil rights activists who were likewise demanding "freedom now," Donaldson identified time as a key axis in modernity's globalized systems of racial power.

Further, in using "mood" ("no mood to wait") as the grounds of a radical refusal to pursue black freedom at the speed of a "horse and buggy," Donaldson highlights the importance of affect to the making, and the unmaking, of a post-slavery world haunted by black patience. The cruel deployment of black patience as a means to regulate and discipline black affective expression is critical to the calculations of anti-blackness and white supremacy. This racialized management of black affect reinforces the racialized management of black subjects. At the same time, though, Donaldson's impatience illuminates how black people have mobilized affect to strain against modernity's violent cultures of waiting. To be in "no mood" to wait for black freedom is to stage a performance of fugitive affect. It is to feel against the affective norms and regulations of anti-blackness and white supremacy. It is to challenge the coerced performances of black patience that, by this point, had been used for over a century to defer black people's access to racial and civic equality—in effect, to black freedom.

While observances of the Emancipation Proclamation Centennial occurred in several states, in this chapter I look at Centennial events in Indiana and Illinois. What motivates my decision, in large part, are the rich archival traces of Centennial events that were left behind in these states. This archival abundance certainly has to do with the fact that Abraham Lincoln—the so-called "Great Emancipator" who issued the Proclamation—spent the majority of his childhood in Indiana before making Illinois his home. Drawing on play scripts, sound recordings, newspapers, and archival ephemera from ANECA and the state governments of Indiana and Illinois, I argue that the Emancipation Proclamation Centennial was an important moment in the history of civil rights activism, and a key site for theorizing black patience and the making of black political ontology in the wake of US chattel slavery. Theatre was key to these efforts.

In the sections that follow, I turn first to a 1963 production of Lorraine Hansberry's award-winning 1959 play, *A Raisin in the Sun*. Staged by the Indianapolis, Indiana, branch of ANECA, this production highlights the

importance of theatre to the Centennial and to ANECA's effort to disassemble the racial project of black patience, to map the complex realities of blackness and black politics, and to reinforce the movement's political ethos of "freedom now." As the Younger family in *A Raisin in the Sun* learn through their various encounters with deferred dreams, patience has been a site of racial power, a place to nurture the gross ambitions of white supremacy and anti-blackness. Following a brief look at Indiana's 1963 Century of Negro Progress Exposition, I then pivot to the Century of Negro Progress Exposition in Chicago, Illinois. Returning to Duke Ellington's *My People*, I read this musical drama within the context of the broader cultural and political landscapes of the Exposition and the Civil Rights Movement more generally. Whether staging *My People* in Chicago or *A Raisin in the Sun* in Indianapolis, Centennial organizers and participants used theatre to unsettle the violent operations of black patience, and to grapple with the knotty constitution of blackness and black political ontology in post-emancipation America. Congealing to form a transnational network of black cultural and political activity, these works and their live performances help us to better understand the movement and the world-making mechanics of black patience. In doing so, they allow us to approach an answer to Ellington's momentous question: "What color is virtue?"

A Raisin in the Sun: The Deferral of Black Freedom Dreams

One hundred years after Abraham Lincoln issued the Emancipation Proclamation, Indiana Governor Matthew E. Welsh issued his own executive order, declaring January 1, 1963, "Emancipation Centennial Day." In his order, Welsh touts Lincoln's Proclamation for "legally ending slavery" and for marking the "beginning of the Negro's march to full freedom and equal opportunity."[11] Emancipation, he proclaims, had "brought [the United States'] practices closer to the American dream of freedom for all," and had allowed black citizens to make "significant progress toward full freedom and equal opportunity."[12] Ultimately, he directs the citizens of Indiana to commit themselves to the "task of eliminating the last vestiges of discrimination in Indiana."[13] Welsh's remarks are expressly laudatory and spin a narrative of liberal democratic progress. However, his reliance on a grammar of proximity and qualification

(e.g., "closer to" and "significant progress toward") to articulate black people's relationship to freedom signals how emancipation was yet unfinished and how the "march to full freedom" continued.

Issued in the same year that found black people routinely assaulted by racist sheriffs, bitten by police dogs, shocked with cattle prods, denied admission to segregated schools, murdered in acts of domestic terrorism, and generally treated as second-class citizens—both in Indiana and across the nation—Welsh's Executive Order overestimates the scale of racial progress that had been achieved in the century following emancipation. As one newspaper columnist put it in an article fittingly entitled "Unfinished Business: After 100 Years," "the task . . . is yet unfinished. . . . After a hundred years our [black people's] civil rights are honored *more* in the breach than in the observance."[14] The contention that black citizens' rights were recognized more in their "breach" than in their "observance" is at odds with Governor Welsh's more celebratory account of racial progress and mid-twentieth-century racial relations. Further, because the Centennial unfolded in the thick of the Civil Rights Movement, black citizens were afforded a unique context for assessing the degree to which freedom and citizenship had materialized, or not, in the wake of US chattel slavery. What they learned from the movement, and from the everyday realities of black being, is that Indiana—and the nation, for that matter—remained a far cry from the "last vestiges of discrimination."

This reality was all too apparent to the local branch of ANECA in Governor Welsh's home state. Organized to "promote locally a program of activities commemorating" the Centennial, the Indiana chapter of ANECA aimed to "observe" this watershed event by "exploring and bringing to public attention the history, heritage, achievement, and significance of the Negro."[15] Rather than merely recognize the one hundredth anniversary of the Emancipation Proclamation, the chapter's creative and politically attuned observance framed emancipation as an ongoing process whose still-unfolding status was engendered by the still-unfolding violences of anti-blackness and white supremacy. Calling attention to the lingering presence and effects of anti-black oppression, ANECA showed that black subjects in post-emancipation America were compelled to inhabit an interstitial space—one somewhere between slavery and full freedom, but fundamentally irreducible to either.

As ANECA went about the business of commemorating the Centennial, theatre was vital to its purpose and its core ambitions. In addition to producing written texts and exhibits, and to operating a "historymobile" that crisscrossed the state of Indiana exhibiting repressed histories of black people, ANECA turned to theatre to critique the racial project of black patience and to frame black people as important architects of the US nation-state, from its inception forward. In a prospectus outlining its aims and purpose, the group identifies theatre as a critical resource for observing the Centennial and for meeting its social and political aspirations. Staging "dramatic presentations" for "the general community" was one of the chief objectives outlined in its founding vision.[16] ANECA's work both within and beyond the theatre exposed the limits of Governor Welsh's imaginative allusion to the "last vestiges of discrimination," helping to clarify the fraught legacies of emancipation and their lingering impact on black life, black politics, and black art in post-emancipation America.

These complexities were on full display when ANECA presented a production of Lorraine Hansberry's 1959 Broadway hit, *A Raisin in the Sun*. Staged in the auditorium of Cathedral High School in Indianapolis, ANECA's production of *Raisin* ran for two performances, opening on March 10 and closing the following day. The local dynamics of this production accorded with ANECA's goal of translating the history of emancipation, and the history of black people, into forms of knowledge that would be legible and accessible to local communities across the nation. In keeping with this spirit of the local, the furniture for the play's set—itself a salient character in Hansberry's play—was donated by a furniture store located on the same street as Cathedral. Further, the cast for this production was drawn from the Laderson Players, a theatre troupe that was based in Indiana. On many levels, the Laderson Players were ideal collaborators for the Indianapolis division of ANECA. The troupe's primary "purpose" was "to entertain and inform," a goal that resonated with ANECA's own hopes of using theatre to educate and entertain Centennial audiences.[17] More still, not only did their founder, Mose Laderson, graduate from colleges in Indianapolis, but he also studied drama under Dr. Alfred Edyvean, who, as Director of the Repertory Theatre at Christian Theological Seminary, used theatre to engage US racial relations. In other words, Laderson had local roots in Indiana and was also well versed in mobilizing theatre to address social and political issues.[18]

When considering the runaway success of Lorraine Hansberry's *A Raisin in the Sun*, it makes sense that ANECA would find the playwright and her play useful for their goal of portraying black achievement. Hansberry, the playbill notes, was "one of the most talented and promising young Negro playwrights that America had produced . . . *A Raisin in the Sun* was an instant hit on Broadway."[19] It goes on to note that Hansberry had "appeared on television with many top stars as a result of the awards won by her play."[20] What the playbill was surely referencing here is Hansberry's historic reception of the 1959 New York Drama Critics Circle Award for "Best Play." At twenty-nine years old, Hansberry was the first African American, the fifth woman, and the youngest playwright to receive the award. It is no surprise that ANECA found this cocktail of black achievement alluring in the Centennial year.

But in addition to the play's and playwright's successes, and their status as evidence of black achievement, *A Raisin in the Sun*'s content was profoundly relevant to the discourse about deferred freedom that saturated Centennial observances and the Civil Rights Movement. In this regard, the play's title, *A Raisin in the Sun*, evokes how black patience routinely consigns black freedom to a future that is likely never to come—at least in any complete sense of an arrival. Taken from the poem "Harlem" by black poet Langston Hughes, Hansberry's title conjures the prescient question that anchors the opening line of Hughes's poem: "What happens to a dream deferred?" The poem's speaker goes on to ask:

> Does it dry up
> like a raisin in the sun?
> Or fester like a sore—
> And then run?
> Does it stink like rotten meat?
> Or crust and sugar over—
> like a syrupy sweet?
>
> Maybe it just sags
> like a heavy load.
>
> *Or does it explode?*[21]

One hundred years after the Emancipation Proclamation, black freedom dreams were still postponed, and black life was still a "Montage of a Dream Deferred," to invoke the title of the collection in which Hughes's poem appeared.

But even as black patience engineered conditions to ensure the drying up, the festering, the stinking, the crusting and sugaring over, the sagging of black people's dreams, this era of civil rights activism was as much a moment in which these freedom dreams "explode[d]"—at the lunch counter, in the courtroom, in the street, in the prison, and (as this book demonstrates) on the theatrical stage. In the course of reflecting on *A Raisin in the Sun*, black poet and playwright Amiri Baraka captures the explosive capacities of civil rights drama. Drawing a connection between these works and other genres of embodied political performance, he argues that *A Raisin in the Sun*—which he refers to as "the quintessential civil rights drama"—was a form of "political agitation."[22] *Raisin*, he argues, confronts "the very same issues of democratic rights and equality that were being aired in the street."[23] As the Civil Rights Movement was waged, artists like Lorraine Hansberry and Amiri Baraka used the imaginative affordances of theatre to make radical demands for "freedom now." In these moments of mobilizing page and stage, of tapping into the political and aesthetic possibilities of body and script, they invented creative ways to contest the racial project of black patience—or to explode, much like the activists "in the street." They demanded, as one critic puts it in his review of *Raisin*, that "whites not impede the fulfillment of those dreams for one more second."[24]

Lorraine Hansberry's Racial Time

Perhaps the most salient theme in *A Raisin in the Sun* is time. Before audiences meet any of the play's characters, before the plot moves toward its unfolding, the sound of an alarm clock—which is also to say the sound of time—penetrates the audience's ears, setting in motion the plot and the soundscape of this American classic. What follows is a common ritual: a mother, responding to the sound of an alarm clock, attempts to rouse her son from his sleep, while stressing the time and the fact that others must use the bathroom.

RUTH: Come on now, boy, it's seven thirty! (*Her son sits up at last, in a stupor of sleepiness*) I say hurry up, Travis! You ain't the only person in the world got to use a bathroom![25]

The ritual of a mother awaking her son may seem benign enough. But as this opening sequence takes shape, the relationship between this black family and time is anything but benign. Time, in fact, comes to function as a disciplinary tool that orders the structural and experiential conditions of black life. Having successfully goaded Travis from the bed, Ruth then turns her attention to Walter Lee, her husband: "Walter Lee! . . . It's after seven thirty. . . . it's time for you to GET UP!" "Is he [Travis] out yet?" Walter retorts. "What you mean *out*?" Ruth replies. "He ain't hardly got in there good yet."[26]

There is nothing especially distinctive about such ritual performances of loathing the act of waking up, or struggling to step into the start of a new day. But what imbues this scenario with a kind of defining singularity is the constellation of structural forces and environmental conditions that inflect the operation and experience of time in this instance. As the audience discovers soon, Ruth, Walter, and Travis share their cramped, overpriced, roach-infested apartment with Walter's mother (Lena) and younger sister (Beneatha), and are forced to share a community bathroom with other families in the building. These overcrowded conditions foster an environment that ultimately prompts Ruth and Lena to dub the Youngers' apartment a "rat trap," and that lead Beneatha to declare that the family is plagued by "acute ghetto-itus."[27]

Scholars have written prolifically about the spatial dynamics of kitchenette living in Chicago, and they have considered how works of art like *A Raisin in the Sun*, Richard Wright's best-selling novel *Native Son* (1939), and Gwendolyn Brooks's 1953 novel *Maud Martha* weave these racialized spatialities into their imaginative geographies.[28] Writing about *Raisin* in particular, black geographer Rashad Shabazz observes that the Youngers experience "many of the frustrations of living in a crowded dwelling, such as the friction and tension that emerged from too many people living in too little space."[29] But as important as the trope of "too little space" is to understanding *A Raisin in the Sun*, the trope of "too little time" is equally imperative. Read within the context of

racial capitalism, housing discrimination, and racial segregation, Ruth's urgent commands to "get up" and to "hurry" are not solely products of racial-spatial inequality. They are also the living manifestation of a racial order that regulates black people's experiences of time as a way to execute and reinforce its structures and procedures of anti-blackness. Within this context, time assumes a disciplinary function that is imperative to racial formation.

These confrontations with racial time serve as *A Raisin in the Sun*'s inaugural plot point. Their prominence in the play's opening sequence foreshadows Hansberry's abiding concern with the theme of racial time. If we take Travis as an example of this thematic preoccupation, we recognize that in addition to rising early to compete for the bathroom, the young boy must also delay falling asleep, because his bed doubles as the sofa for the family's living room. When Walter groans that Travis spends "all this time" in the bathroom, and proposes that the boy "start getting up earlier," Ruth fires back: "It ain't his fault that he can't get to bed no earlier nights 'cause he got a bunch of crazy good-for-nothing clowns sitting up running their mouths in what is supposed to be his bedroom after ten o'clock at night."[30] Underneath Ruth's biting defense of Travis is a startling reality: living in an urban, cramped, racially segregated environment shapes Travis's experiences of time, from the moment the boy awakes to the instant he falls asleep.

At every turn, *A Raisin in the Sun* offers windows into understanding the assorted structures and scales of racial time that shape, discipline, and ultimately pose a lethal threat to black life—and to black people's hopes of enjoying the good life. From the premature death of Big Walter (the family's patriarch) to Ruth's and Walter Lee's unmet desires for leisure time, *Raisin* demonstrates how time labors to grind black life into synchronic matter that must step and move to the nearly automated rhythms of anti-blackness, white supremacy, and racial capitalism. It exposes how time is used to orchestrate a network of socio-temporal conditions that configure blackness as automatonic matter whose movements are choreographed by, and to the violent tempos of, a metronomic force known otherwise as anti-blackness.

This paradigm of using time to regulate black life and to constrain black freedom manifests most vividly in *Raisin* through the structure of the dream. One of the play's most salient themes, Hansberry uses the

dream, and specifically the deferral of black people's dreams, to map the elusive character of black freedom. As the Indianapolis branch of ANECA worked to salvage the unfinished project of emancipation, they were concerned deeply with the long history of black people's deferred dreams. Throughout this production of Hansberry's play, and at Centennial events across the nation, the undercurrents of Langston Hughes's "Harlem"—and its prescient opening question ("What happens to a dream deferred?")—were palpable. *A Raisin in the Sun* is, in effect, a dramatized meditation on Hughes's poetic query. The play orbits around an abundance of black dreams: from Ruth's and Lena's dreams of buying a new house to Walter's dream of becoming a business owner to Beneatha's dream of attending medical school. And yet, the play captures the frequency with which black people's dreams are deferred, while showing how these deferrals are structural and systemic.

Hansberry's characters are viscerally aware of the violent cultures of black patience that aim to manage, defer, and annihilate their futures. In a telling moment, Mama laments to Ruth, "Seem like God didn't see fit to give the black man nothing but dreams."[31] Speaking more directly of her dreams of owning a decent home, she declares, "Lord, child, you should know all the dreams I had 'bout buying that house and fixing it up and making me a little garden in the back—(*She waits and stops smiling*) And didn't none of it happen."[32] Despite this ominous deferral of Mama's and Walter's dreams and foreclosure of their futures, they muster up enough hope to believe that their dreams will one day be realized, or at least made worth their patience, by their children. Citing her deceased husband, Lena notes, "He [God] did give us children to make them dreams seem worthwhile."[33] Lena and Walter conceive of their offspring as the beneficiaries of their deferred dreams, or the justification for their performances of black patience. They concede their dreams to a time and a place—to a future—that are yet to come.

As literary critic Lee Edelman has explained, within civil society the "figural child" often assumes the status of "ideal" citizen, "entitled to claim full rights to its future share in the nation's good."[34] Edelman warns, however, that this discursive construction of the child actually limits the rights of citizens like Mama and Big Walter who come to value a "notional freedom" for the child more than "the actuality of freedom itself."[35] When we consider the racial project of black patience, we come

to understand how this system works by conditioning black people to surrender their dreams to its violent procedures of deferral. Despite its promises of improved black futures, black patience is a cyclical system that works across time and space to cultivate generations and genealogies of anti-black violence and sociopolitical exclusion. Therefore, even as black children are imagined as symbols of hope who embody potential for the belated fulfillment of their parents' and ancestors' dreams, black patience works to concretize the belatedness of these dreams and to conscript black children's own dreams into its violent machineries of deferral.

Hansberry's innovative aesthetics of parallelism and repetition are important in this regard. Specifically, they enable the playwright to chart the transgenerational deferral of black people's dreams. We see can this in the startling relationalities that Hansberry maps between Ruth and Walter Lee and the more senior Youngers. While Big Walter and Lena imagine their son as a vector for realizing their own deferred dreams, the son's dreams are ultimately deferred by the same cultures of black patience that had dealt a forceful blow to his parents' dreams. In a moment of vulnerability, Walter explains to Mama, "Sometimes it's like I can see the future stretched out in front of me—just plain as day. The future, Mama. Hanging over there at the edge of my days. Just waiting for me—a big, looming black space—full of *nothing*. Just waiting for *me*. But it don't have to be."[36] For Walter, the future constantly eludes his grasp. It hangs at the "edge" of (black) life. It awaits him, but is ultimately "full of nothing." In narrating his relationship to the future, Walter sounds uncannily similar to his father, Big Walter, whom Lena remembers as a man who "just couldn't never catch up with his dreams."[37]

By the time *A Raisin in the Sun* nears its resolution, the entire Younger family is engaged in a similar dream-centered quest, one in which the dream seems always to elude the black dreamer. As literary and cultural theorist Imani Perry observes, the family's dreams are plagued by the "harrowing prospect of deferral."[38] These dynamics of advancing toward, but never being able to obtain, one's dreams conjure up and solidify a network of relations that I call the *holding pattern of blackness*. Most commonly associated with aviation, holding patterns mark a relation of constraint between time and space, movement and matter. Serving as tools of delay, holding patterns aim to defer the arrival of matter (e.g., an

airplane) that is already in motion, especially where that matter is near-ing its destination. Holding patterns function as scripts that constrain possibilities for movement through time and space. When considered within the context of black patience, these instances of holding—the operations of the hold as noun and verb, as a space of and a doing in black suffering—aim to define black people's lived experiences of time and space; to structure their political and ontological relationships to the world; and to thwart their access to the full possibilities of emancipation. In this vein, the Younger family's dream of a decent, affordable home is instructive. By the play's end, it appears that the family is well on its way to homeownership and will finally "catch up" with their dreams. But when they purchase a home in the segregated Clybourne Park neighbor-hood, threats of white supremacist violence render their decades-in-the-making movement toward improved black futures an encounter with deferred dreams.

As the Youngers ready themselves to inhabit a better home and to enter an ostensibly improved black future, they receive a visit from Karl Lindner, a future neighbor and representative of the Clybourne Park Improvement Association, a group "set up to look after . . . things like block upkeep and special projects." In particular, Lindner was there on behalf of the "New Neighbors Orientation Committee."[39] Pressed by the always skeptical Beneatha to describe the purpose of this committee, Lindner, the committee's chair, explains that they "go around and see the new people who move into the neighborhood and sort of give them the lowdown on the way we do things out in Clybourne Park."[40] He adds that another association committee handles what he terms "special com-munity problems."[41] Before long, Lindner makes clear that the Youngers' move into the neighborhood would certainly be classified as a "special community problem," something at odds with "the way [they] do things" in Clybourne Park. Spinning his wheels to moralize and justify his and his neighbors' investment in racial segregation, Lindner opines that Cly-bourne Park residents are hardworking, honest people who "don't really have much but those little homes and a dream of the kind of community they want to raise their children in."[42] Despite his tone-deaf assertion that "race prejudice simply doesn't enter into it," he proceeds to mount a more bold defense of racial-spatial segregation,[43] positing that each Cly-bourne Park resident has "the right to want to have the neighborhood

he lives in a certain kind of way."[44] "For the happiness of all concerned," he adds, "our Negro families are happier when they live in their *own* communities."[45] Fed up with Lindner's racist antics, Walter orders him to leave their home.

Lindner's visit to the Youngers' apartment ignites a war of dreams, a battle between competing racial futures. On the one hand, Clybourne Park's white residents imagine a future that would further entrench white supremacy and anti-blackness, while tightening their grip on Chicago's racial geographies. On the other hand, the Youngers dream of a future in which race would not be the basis for securing decent and affordable living. Lindner eventually issues a striking threat to the Youngers: "I am sure you people must be aware of some of the incidents which have happened in various parts of the city when colored people have moved into certain areas."[46] Lindner is gesturing here toward the routine bombing of black citizens who integrated all-white neighborhoods. Within this war of dreams, white citizens marshalled these acts of domestic terrorism to punish black subjects who defied the protocols of black patience.

The opening of *A Raisin in the Sun* calls attention to the regularity of such bombings and their threat to black futures. Minutes into the action, Ruth asks Walter Lee how he wants his eggs prepared. To this he offers a curt reply: "Not scrambled."[47] When Ruth gestures toward a copy of a newspaper on the table, Walter reads the front page aloud: "Set off another bomb yesterday."[48] With "maximum indifference," Ruth responds, "Did they?"—a seemingly apathetic reply that renders the bombing of black citizens as commonplace and ritualized as the scrambling of an egg in the morning.[49] As the Youngers prepare to move to Clybourne Park, the terror of these bombings reenters the plot through a visit from the family's tastefully jealous neighbor, Mrs. Johnson. Despite performing happiness for the Youngers, Mrs. Johnson is envious, and begrudges the family's move. "Yessir! Lookathere! I'm telling you the Youngers is really getting ready to 'move on up a little higher!'—Bless God."[50] Mrs. Johnson's ecstatic performance of celebration is soon undercut by her devious reminder that black families, like the Youngers, were being bombed for integrating all-white neighborhoods, like Clybourne Park. "I guess y'all see the news what's all over the colored paper this week," she says. Mama admits that they

haven't. Raising her head and "blinking with the spirit of catastrophe," Mrs. Johnson apprises them of the bombings. "You mean you ain't read 'bout them colored people that was bombed out their place out there? . . . Ain't it something how bad these here white folks is getting here in Chicago! Lord, getting so you think you right down in Mississippi!"[51] Attempting to further ignite feelings of fear, Mrs. Johnson adds, "Lord—I bet this time next month y'all's names will have been in the papers plenty—(*Holding up her hands to mark off each word of the headline she can see in front of her*) 'NEGROES INVADE CLYBOURNE PARK—BOMBED!'"[52]

Whatever the depth of Mrs. Johnson's resentment, her and Lindner's gestures toward the bombing of black families who purchased homes in all-white neighborhoods reveal a biting truth: as the Youngers prepare to "move on up," to finally realize their deferred dreams, this move/movement is a fraught and contested process, whose outcome can easily be black death. Under these structural conditions of compromised black futures, the time of the here and now, or the Afro-present, is a vital temporality for people of African descent. Rather than lean into the possibilities of the Afro-present, Lindner would have the Youngers continue deferring their dreams, performing black patience. So grave is this racialized war of dreams that segregationists like Lindner are willing to commit murder as a way to safeguard their own dreams of building a racist utopia in the heart of the American Midwest.

When the curtain closes on *A Raisin in the Sun*, audiences find the Younger family preparing for a series of futures—racial, domestic, democratic, and otherwise—that never come to fruition within the dramatic present of the play. Even the FBI special agent assigned to surveil Hansberry understood that *Raisin* "deals essentially with negro aspirations" but demonstrates the "problems inherent in their efforts to advance themselves."[53] Sitting in their cramped, overpriced apartment, awaiting the arrival of their movers, the Youngers stand on the "edge" of these futures, as Walter might put it. But they never actually inhabit them before the play concludes. Although audiences witness the Younger family packing and preparing to transition into a new home, into an integrated neighborhood and in many ways an integrated nation, the materialization of these dreams is left hanging in the balance, looming in the time of the "not-yet-here."

Black Political Ontology and the (Non)Event of Emancipation

The routinized nature of the Youngers' deferred dreams exposes a structural antagonism toward black life and black futures. It is therefore tempting to read this constellation of failed dreams as a sign for the impossibility of black futures, or, for some, as evidence of black people's ontological status as slaves. These positions become all the more alluring when considering the overwhelming pattern of deferred dreams that plagues *Raisin*'s black characters. While the Younger family has multiple openings to realize their dreams—Walter Lee almost becomes a business owner; Beneatha almost goes to medical school; and the family almost moves into a decent home—it is telling that every one of these dreams remains unrealized by the play's conclusion. On the other side of this extreme pessimism, it is shocking that some reviewers walked away from the play believing that it "celebrates with slow impressiveness a triumph of racial pride."[54] By the time *A Raisin in the Sun* reaches its denouement, it has hardly spun a narrative of triumph. But neither has it woven a story of total failure; of wholly foreclosed black futures; of ontological slavery. Rather, as the Youngers sit in their apartment, caught in but straining against the holding pattern of blackness, they occupy a space that is "betwixt and between," a symbolic space irreducible to any extremity, and in that striking irreducibility says something about the nature of blackness and the essence of black political ontology.

This image of standing on the brinks of black freedom dreams would certainly have resonated with black audience members who attended ANECA's production of *Raisin* in Indianapolis. One hundred years after emancipation, they, too, were trapped in the holding pattern of blackness, facing a symphony of violent demands for black patience. A recognition of this dynamic is likely why many centennial organizers routinely used a grammar of "observation" and "commemoration" rather than an optimistic language of celebration. But even as Centennial organizers and participants forcefully critiqued the unfinished project of emancipation, they recognized that this century of legal freedom was not the "time of slavery," nor were black people "slaves."[55] In highlighting the continuing devastation of slavery, they, like Hansberry, refused to peddle overly optimistic ideologies and visions of racial progress. Though acknowledging the troubling symmetries between slavery and freedom,

they consistently honored the critical distinctions between them. Their nuanced outlooks on the modern racial order, and their layered analyses of black people's political conditions, produced visions of racial progress that were decidedly hopeful but necessarily tempered.

In the course of reflecting on this state of existing "betwixt and between slavery and freedom" in the wake of emancipation, literary critic Saidiya Hartman maintains that the "perpetuation of the plantation system and the refiguration of subjection . . . insinuated" what she refers to as the "nonevent of emancipation."[56] I do not take Hartman here to be positing emancipation as nonevent; rather, she is acknowledging how the legacies of transatlantic slavery labor to "insinuate," or to maneuver, emancipation into the position of nonevent. For Hartman, then, emancipation is not a "nonevent" in the strict sense of a fixed, existential reality. It is instead a phenomenon routinely besieged by an army of structural forces and historical continuities that strive to transmute this event into nonevent. If we read Hartman carefully, we recognize that she employs a series of rhetorical gestures that capture emancipation's hovering between event and nonevent, indexing its foundational nuance while marking its histories of irreducibility. In addition to deploying "event" and "nonevent" interchangeably, Hartman relies on verbs like "insinuate" and modifiers like "as it were" to index and preserve emancipation's varied manifestations and its plastic meanings. These rhetorical choices conjure a connotative force that emphasizes motion, proximity, and irresolution over certainty and fixity. In the final analysis, Hartman's grammar of "in a sense" and her rhetorical gestures of intimation open a conceptual space that admits the kind of nuance and slipperiness of meaning and experience that are necessary for the fullest and most robust accounting of the long emancipation and relatedly of black political ontology.

It was at this intersection of the "event" and "nonevent" of emancipation that Centennial organizers observed the centennial and critiqued the tragically slow/non-arrival of emancipation. At the same time as they enjoyed some semblance of black presents that were relieved of slavery's procedures of anti-black violence and political exclusion, they recognized that their access to these freedoms was provisional at best. This fraught but distinct political location must necessarily figure into any calculus that seeks to give an accounting of blackness and black po-

litical ontology in the wake of transatlantic slavery. This complex recognition of the entanglements of black freedom and unfreedom models for scholars of black studies a paradigm for practicing modes of black study that keep these tensions—between slavery and freedom, optimism and pessimism, social life and social death—alive as constituent elements of black being and black political ontology. The Emancipation Proclamation Centennial spotlights the limitations of forcing all black subjects into any sweeping ontological singularity, particularly one called "the slave," which is the case within a recent school of black critical thought called "Afro-pessimism."

As film critic Frank B. Wilderson explains, "Afro-pessimists are theorists of black positionality" who believe that the "structure of the entire world's semantic field . . . is sutured by anti-Black solidarity."[57] Afro-pessimism's critical examination of the proximities that bind slave pasts to provisionally emancipated black presents has usefully expanded our critical consciousness of the structural—or paradigmatic—character of anti-blackness and white supremacy. Both I and an overwhelming number of Centennial organizers and participants share Afro-pessimists' profound sense of how anti-blackness and white supremacy continue to shape and inflect the modern world. However, I want to put pressure on an assumptive logic in Afro-pessimist thought that views anti-blackness as so all-encompassing in its paradigmatic effect that it successfully hijacks the totality of black political ontology. Paying attention to Centennial discourses, and their nuanced framings of blackness and black political conditions, exposes the sheer sophistication and the singular insight that centennial organizers brought to theorizing their own ontology. What they constantly found is that the afterlives of slavery continued to cordon off their access to full emancipation. But they concluded, nonetheless, that black subjects were not slaves; they were citizens. And I believe that we should take their conclusions seriously, and embrace the valuable lessons that they teach us about the importance of history and memory, time and place, structure and experience for the critical enterprise of analyzing the shape of blackness and the nature of black political ontology.

The Hidden Transcripts of Civil Rights Activism

As the Indianapolis division of ANECA staged *A Raisin in the Sun*, they were working simultaneously to achieve another of their founding objectives: to sponsor a state exposition that would "vividly portray the history and contributions of the Negro in Indiana."[58] Though missing the April 1963 projected date, the Century of Negro Progress Exposition ran from Friday, October 25, to Sunday, October 27, at the State Fairgrounds in Indianapolis. There, audiences found six carefully conceived displays that highlighted black people's contributions to areas like education, sports, art, and government. In the same way that ANECA had used its production of *Raisin* to tout and honor Lorraine Hansberry's success, they were eager to regale Exposition participants with deep histories of black achievement. But just as Hansberry's success in the theatre industry was contextualized by *A Raisin in the Sun*'s engagement with black patience, Indiana's Century of Negro Progress Exposition acknowledged that, alongside this extensive ledger of black achievement, black people's freedom and full citizenship were yet forestalled.

The local media was attuned to these relational tensions between freedom and unfreedom in their coverage of the event. *The Indianapolis Star*, for example, noted that the Exposition had "an uplifting, positive emphasis on the advancements Negroes have made in the hundred years since slavery."[59] The paper added, nonetheless, that "there is also a strong note of eagerness for further and more rapid advancement."[60] In a similar register, the *Indianapolis News* noted on October 22, 1963, that while the "emphasis unquestionably will rest largely with the theme of progress," the "speakers and displays will underline the fact that 100 years after the Civil War, the Negro remains a second class citizen." As the local media sensed, Indiana's Century of Negro Progress Exposition was as much a lament as a celebration.

In modeling how blackness and black political ontology existed "betwixt and between" slavery and freedom, the Century of Negro Progress Exposition in Indiana revealed the persisting need for black social movements, and was itself a vital locus of civil rights activity. It is thus surprising that the *Indianapolis News* continued that the Exposition was "unconnected with any 'movement' groups such as the National Association for the Advancement of Colored People (NAACP)." While the

paper might have been correct in acknowledging the absence of any formal affiliations between ANECA and civil rights groups (like the NAACP), it downplays the movement's towering presence throughout the Exposition, and its significance to ANECA more generally.

To bring this importance into sharper focus, I want to turn briefly to the Exposition's souvenir booklet. In addition to housing the program for this three-day affair, the booklet also carried welcome letters, advertisements, a draft of the Emancipation Proclamation, maps of Underground Railroad stops in Indiana, and profiles of notable black people from Indiana and across the nation. These disparate sections of the program are linked by a shared recognition of how vital civil rights were to the stakes and configuration of this Centennial observance. In the opening pages of the booklet, Indiana's Lieutenant Governor, Richard O. Ristine, writes, "Today civil rights is on the tongue of every American from every corner of the country. No longer can it be shunted aside and forgotten about either by public officials or the citizens they represent."[61] Also included in the booklet is a copy of the "Resolution on Civil Rights By the 1962 Convention of the Indiana State AFL-CIO." Here, the Indiana branch of the AFL-CIO—the largest US federation of labor groups—contends that "America must move forward in the area of Civil Rights by making our constitution a living document in guaranteeing equal opportunity for all the present developments as evidenced by the freedom riders and student movements throughout America. . . . THEREFORE BE IT RESOLVED," it concludes, "that we wholeheartedly support the Indiana Civil Rights Commission and their proposals to strengthen state legislation in the area of civil rights."[62]

These materials—one from an agent of the state and the other from a radical labor union—were not alone in focalizing the intimate connection between civil rights and the Emancipation Proclamation Centennial. They were flanked in the booklet by a range of documents and images that likewise illuminate the importance of civil rights. There is, for instance, a half-page spread (entitled "The Stand at Little Rock") on the iconic 1957 "Little Rock Crisis."[63] On the next page, readers find a one-page story on the "March on Washington," which, as the article explains, involved "more than 200,000 people . . . gather[ing] in Washington, D.C. . . . and well[ing] their energies and voices together in a loud demand for 'freedom now.' The peaceful demonstration reverberated

throughout the world and added impetus to the movement."[64] Notably, this ad is dominated by a towering photograph of the march that depicts a symbolic interplay among "marchers," the Washington Monument, and the reflecting pond that sits at the foot of the Lincoln Memorial—a national homage to the "great emancipator" who was, in many ways, responsible for the Century of Negro Progress Exposition. The reflecting pond in this photograph serves as an instructive metaphor for black people's political conditions in post-emancipation America. Nestled deep in the material geographies of the nation's capital, the pond invites and forces the act of reflection. On the surface of its dark waters rests the vertical and even darker shadow of the Washington Monument—a memorial dedicated to George Washington, the nation's first president, but more than this to the founding ideals of liberty and equality that allegedly anchor the foundational experiment in democracy that Washington helped to sire. If this monument stood as a national tribute to these ideals, for the nation's black citizens its dark, slightly off-center shadow was a far more accurate depiction of their own prohibitive relationships to these ideals. Like the reflecting pond, the March on Washington—hosted just two months prior to the Exposition—reflected the dark, off-kilter state of US democracy for the nation's black subjects.

Even beyond the Exposition, the Civil Rights Movement was pivotal to ANECA's Centennial events. On the opening day of Centennial year, the group collaborated with two ministerial alliances to host an "Emancipation Day Celebration" at St. John Baptist Church in Indianapolis. Not only did the printed program include a section called "Notes on Civil Rights in Indiana," but it also contained a note to ministers that emphasized the connection between the Centennial and the Civil Rights Movement: "This year's assembly marks the beginning of the centennial observance of the emancipation proclamation. The *movement of the times*," it contends, "demands that all people in America and around the world become more aware of the significance of the annual Emancipation Day celebration program."[65] A few months later, the group hosted an "Emancipation Centennial Church Day." Featuring speakers like Virginia "Virgie" Davis, President of the local NAACP, the event was filled with speakers from organizations that were vital to staging "the movement of the times," and to achieving the program's theme: "From Emancipation to Participation."[66] ANECA also worked closely with the

State of Indiana to put civil rights on the state's agenda. These efforts helped to spur the creation of programs like the Governor's Conference on Civil Rights, hosted in September of 1962. These varied engagements with civil rights index how ANECA'S observance of the Emancipation Proclamation Centennial was linked intimately to the Civil Rights Movement, itself a daring and spectacular response to the incomplete project of emancipation, the ongoing legacies of US chattel slavery, and the violent cultures of black patience.

In the section that follows, I turn to the Century of Negro Progress Exposition in Chicago. The largest of the Centennial observances, it was a "lilting chronicle of the Negro's first 100 years of citizenship." Theatre and civil rights were central to the Exposition and to ANECA's political goals.[67] When the Chicago branch of ANECA hosted a luncheon on January 31, 1962, to unveil plans for a Century of Negro Progress Exposition, its president was Dr. J. H. Jackson, pastor of Chicago's Olivet Baptist Church and president of the National Baptist Convention (NBC). Unabashedly opposed to the sit-ins, freedom rides, and other strategies of nonviolent direct action, Jackson had survived a failed but telling challenge to his leadership of the NBC just four months prior to this luncheon. His antagonistic view of nonviolent direct action motivated a coterie of young ministers—including Dr. Martin Luther King Jr.—to coordinate this attempted coup.[68]

Though Jackson triumphantly weathered rebellion within the ranks of the NBC, on the eve of the Century of Negro Progress Exposition, he resigned as President of ANECA, under a cloud of controversy and rumors that his resignation was forced—though, according to him, it was due to "increased commitments."[69] Earl B. Dickerson, a "militant" attorney, assumed the mantle of leadership.[70] Having been brought in to "give positive direction and leadership," Dickerson emphasized that he "was not part of any move to oust the minister," but added that he "would not want to be associated with any old, status quo leadership."[71] This thinly veiled jab at Reverend Jackson was a sentiment with which the ousted minister was, by then, familiar. Less than a month prior to his resignation as president of ANECA, he had been booed at an outdoor rally hosted by the NAACP. Whereas Jackson's reproach of nonviolent direct action was at odds with the Civil Rights Movement and its political logic of "freedom now," Dickerson was unequivocal in his commitment to the

movement and its revolutionary spirit of Afro-presentism. This commitment to social transformation through civil rights activism was evident in the resolution that ANECA released on the heels of Dickerson's appointment. ANECA, the resolution announced, supported "unconditionally . . . all legal and time-honored methods of individual and group protests," marking a sweeping departure from Jackson's more conservative political position. The "militant" tenor of Dickerson's leadership informed his outlook on the Century of Negro Progress Exposition. As he saw it, the event "must not merely be a recognition of the achievement of the Negro for the past 100 years, but a symbol of the unfaltering, uncompromising and increasing demand for complete equality."[72] Focusing on this major but understudied exhibition and the repertoire of theatrical performances it generated further underscores how a century after Lincoln's Proclamation, black people were still waiting for emancipation to materialize in its fullest capacity. Like the Youngers, they were caught in the holding pattern of blackness, and still being forced to perform black patience.

On Black Progress

So how did the Century of Negro Progress Exposition come to fruition? Despite its "militant" leaders and radical cultural and political platforms, the event was essentially funded by the state. After ongoing conversations between state legislatures and ANECA, on June 30, 1961, the 72nd General Assembly of Illinois passed House Bill 1409 (HB-1409), establishing the American Negro Emancipation Centennial Commission. According to the bill, the Commission would "develop and plan an exhibit . . . in Chicago in the summer of 1963 under the auspices of the Authority [ANECA] to commemorat[e] the 100th anniversary of the emancipation of the American Negro." The exhibit, the bill notes, would be "developed in such a manner as to show the history and progress of the American Negro from slavery to citizenship."[73] Composed of state legislatures, citizens appointed by the governor, and the state archivist and historian, the nondenominational, nonpartisan, interracial Commission held its first meeting in Chicago on February 14, 1962. It was at this meeting that Representative Corneal A. Davis—the chief sponsor of HB-1409—was elected chairman of the Commission. Known

throughout Illinois as the "Jim Crow Buster," Davis routinely used the power of his office to sponsor key civil rights legislation and to fight discrimination more generally. He therefore brought to his leadership of the Commission a thick consciousness of social injustice and a set of political commitments that were particularly attuned to race and labor.

As Davis was "busting" Jim Crow in Illinois, he understood that anti-blackness and white supremacy were global phenomena, and that his own activism was linked to a much broader theatre of civil rights activism. A native Mississippian, Davis was especially enthralled by the movement's southern front. "Thank God for the Negroes of the South," he exclaimed, "who are withstanding boycotts and mob violence to bring full freedom to themselves and their children. These southern Negro leaders are uncompromising."[74] But even as Davis recognized the potent operations of anti-black violence in the US South—a topic at the center of this book's next chapter—he unsettled the popular myth that racial inequality was a distinctively southern problem. In an April 1957 address to the Regional Council of Negro Leadership (RCNL) in Greenville, Mississippi, the Chairman observed, "Sure you [Mississippi] have problems but so do we [in Illinois]. . . . The problem of hate is a worldwide problem. . . . The problem of people trying to make a living is a worldwide problem. The problem of housing is a serious problem in all our large metropolitan cities of the North. Don't expect to find a utopia if you come North."[75] Delivered in one of the most financially impoverished regions of the nation, these remarks illuminate how, for activists like State Representative Corneal A. Davis, the Civil Rights Movement—and the problems of anti-blackness and white supremacy—transcended the boundaries of the US South; they were "worldwide" issues. Further, that Davis positions "making a living" and "housing" alongside "hate" on his index of social ills signals how issues like labor and housing were key to the movement's political goals and ideologies.[76]

During the 1950s and '60s, in fact, Davis led an unrelenting campaign to pass labor rights legislation in Illinois. Having obtained a copy of a labor bill that had passed in New York, he observed on one occasion that "naturally [Illinois] wanted to outdo them fellows in New York. Looks like they were getting ahead of us, the blacks over there, because they had a fair employment practice bill." Considering his fierce dedication to labor rights, it is no surprise that the Labor and Industry Committee

of the Peoria, Illinois, branch of the NAACP routinely invited Davis to serve as a guest speaker and praised his "very fine record" on labor.[77] Following years of failures, record-setting filibusters, bipartisan collaborations, and some concessions, Illinois's Fair Employment Practices Commission was finally signed into law in July 1961. Davis, the "Jim Crow Buster," had helped to secure a seismic victory for labor rights.

My point is that upon electing Corneal A. Davis as its chairman, the Illinois Centennial Commission chose a passionate activist who helped to shape the Civil Rights Movement; who knew that injustices like labor and housing discrimination were just as important as voting rights; who knew that the fight against oppression was local, national, and global in scale. With this complex outlook on the movement, Davis assumed his tenure as Chairman, and the Commission began its work of planning the Century of Negro Progress Exposition. In doing so, they found that the choreography of Negro progress was one of both movement and stasis, or one caught in the holding pattern of blackness. They understood that the Centennial was not a moment of blithe celebration, but rather, as they put it, a "time of challenge and assessment," a time of reckoning with "the social and historic distance over which we have come . . . and the distance yet to go."[78]

The complexity and depth of this nuanced conception of Negro progress was evident at the Commission's inaugural program, hosted at Chicago City Hall on September 21, 1962. On this front, we might consider a speech by Judge Edith S. Sampson—a black woman who was secretary of the Commission, a member of ANECA, and the "Negro speaker" for this event.[79] In remarks that were biting and measured, sobering and optimistic, Sampson offered a straitlaced appraisal of the Emancipation Proclamation. "Of all the keystone documents in our American tradition, none is so forbiddingly stiff or legalistically narrow as the Emancipation Proclamation." This "limited writ" was written in a "formal, official language remote from the stirring cadences of [Lincoln's] Gettysburg address" and "did not even run to all the states of the embattled Union."[80] Surrounded in the Rotunda of City Hall by photographs of Abraham Lincoln, abolition ephemera, slave sale and reward posters, routes of the underground railroad, copies of the Emancipation Proclamation and the Thirteenth Amendment, Sampson admitted that black citizens had "come a tremendously long way in the hundred years since

emancipation was proclaimed."[81] But she contended that "we still have a tremendously long way to go toward complete fulfillment of the ideal of true liberty that animated the proclamation. It is good that we should recall, on this occasion, the great progress that has been made. It will be even better if we also rededicate ourselves to the formidable task of further progress. The eyes of the whole world are upon us."[82] Sampson understood that to be free was not solely to be loosed from the "bondage" of chattel slavery, but it was also to be, as she put it, "free from all shackles, physical, social, political, economic."[83] But she also understood that black people in 1963 America were not slaves, legally or ontologically.

As the nation observed the Centennial within the context of global anti-colonial struggle and civil rights activism—what Sampson referred to as "the accelerating revolution"—such intricate visions of blackness and black political ontology became a hallmark of black cultural production and black political culture. Even as they grappled with the "eclipsed possibility" of emancipation, black people recognized that the black slave of 1862 was not the black citizen (however partial) of 1963.[84] It is within this frame of thought that Centennial organizers and participants envisioned and articulated conceptions of black progress. In doing so, they were able to both map the afterlives of slavery and index the vital distinctions that inhere between the black slave and the black citizen. These nuanced conceptual strategies enabled them to hold in balance the living residue of slavery, on the one hand, and the dawning of the (limitedly) righted black citizen, on the other. This posture of being "betwixt and between" slavery and freedom was evident throughout the Century of Negro Progress Exposition, which opened to much acclaim on August 16, 1963 at Chicago's McCormick Place.

Century of Negro Progress Exposition

The Century of Negro Progress Exposition was a towering site of black cultural, political, and intellectual significance, one that illuminates the diversely radical and transnational character of the Civil Rights Movement—specifically its "short" or "classical" phase. Running for eighteen days (August 16 to September 2, 1963), the Exposition featured twenty-one exhibits, or "theme centers," that portrayed black people's contributions to making of the modern world. If McCormick Place was

"the finest structure of its kind in the world," this feat of architectural genius was matched by the extraordinary histories of black achievement and innovation archived in its halls during the Exposition.[85] With nods to inventions like the traffic light, the air brake and lubrication cup system, the method to preserve and transport human blood, and the first successful open-heart surgery, black people's contributions to art, technology, medicine, sports, and government, for example, were on full display.

From everyday citizens to state legislatures, from local high school teachers to school-age children, from Seattle and Mexico to the continent of Africa, the planning and execution of this event fostered the formation of an international, diasporic network that communed around the common goal of observing the Emancipation Proclamation Centennial. In July 1962, for instance, Chairman Davis received a letter of interest from Albert N. Logan, Faculty Coordinator at George Washington Carver High School in Chicago, inquiring about "the role our school can play in the Emancipation Centennial being planned by the Legislative Committee of which you are chairman."[86] Donald I. Foster, Director of Exhibits and Concessions for the Seattle World's Fair, asked if their "exhibits on Africa" might find a home at the Exposition.[87] In a less formal letter, handwritten on legal paper in all caps, James W. Fitzpatrick wondered if some of the tablecloths he had made might be "GOOD ENOUGH TO EXHIBIT AT THE EMANCIPATION PROCLAMATION CENTENNIAL."[88] The letters from Logan, Fitzpatrick, and Foster are emblematic of black citizens' diverse interests in the Exposition. By the summer of 1962, twenty-seven nations had indicated their intention to participate.By the time the Exposition opened, the number of "foreign governments" who actually participated would be closer to six—a still significant showing of international and diasporic affiliation motivated by the Centennial.[89]

Exposition organizers took the international dynamics of its audiences and participants seriously, even hiring translators to "serve as Spanish interpreters and hostesses to visiting Latins."[90] Whereas Mexico and Madagascar contributed "displays showing outstanding contributions of their Negro citizens," other international guests participated on panels and delivered talks.[91] During the Exposition's "International Day," there was a panel on "Africa and Her New World Descendants"

that included representatives from Uganda, Mauritania, Morocco, and the United Arab Republic alongside representatives from the United States like prominent sociologist Dr. St. Clair Drake.[92]

As these examples begin to reveal, the Century of Negro Progress Exposition was expansive in its political goals and ideologies, international in scope and participation, and capacious in the objects and forms of knowledge it showcased to its audiences. Capturing the wonder and scale of this Exposition, *Jet* magazine had this to say: "One-hundred years of progress is crammed into nearly 300,000 square feet of space at cavernous McCormick Place. Every foot broadcasts the hardships, the loyalties, the pains, the glories, the contributions, the culture of black men, telling what it was, and is, like being a Negro in America." It concludes that the Exposition was a "magnificent, first-time showcase for the beauty that has been the Negro ascent from slavery to *near equality.*"[93] Alongside its glowing affirmation of the Exposition, this article is equally important for what its allows us to glean about how ANECA chose to narrate "the history and progress of the American Negro from slavery to citizenship."[94] What is especially striking in this regard is the author's conclusion that the Exposition traced the Negro's journey not from "slavery to citizenship"—as the official, state-sanctioned bill had ordered—but rather from slavery to a position of "near equality." This physics of nearness, which is at the same time a physics of distance, has historically structured black people's relationships to emancipation. On this front, the staging of the Emancipation Proclamation at the Exposition offers an instructive analogy.

Hours prior to the Exposition's opening, the only surviving copy of this historic document was delivered to McCormick Place. Having been conveyed in an armored vehicle from a vault at First National Bank of Chicago, the document was encased in seventy-five pounds of clear plastic, enclosed in bulletproof glass, and placed under the constant surveillance of a guard. Those who attended the Exposition—most of whom were black—were prohibited from coming within eight feet of a document that was, in many ways, the provenance of modern black freedom and citizenship in the United States. The transport and staging of this document, and the rules that governed participants' interactions with it, can be read as a symbol of the fraught relations of distance and proximity that have come to characterize black citizens' historical relationships to the materiality of freedom. These acts of enclosing the

Proclamation within the protective armor of trucks, plastic, and bullet-proof glass accord with the lived reality of how, in the wake of slavery, emancipation has continued to be guarded and sheltered from black people. Reading the figurative dimensions of these material dynamics illuminates the relations of distance and proximity, of desire and limited fulfillment, that are symbolic of a social order that works to seal the full possibilities of emancipation within a network of enclosures that are subjected to constant surveillance. These enclosures—and their racial-ized geometries—strive to keep black people adjacent to, or "near," full emancipation, or to suspend blackness and black political ontology "be-twixt and between" slavery and freedom. Like those Exposition partici-pants who were forced to wait, eager to steal a glimpse of emancipation from a distance, black people in 1963 America were forced to be patient, and to exist in a proximal relationship to the materiality of freedom.

In his welcome letter for the Century of Negro Progress Exposition, President John F. Kennedy notes that the Exposition would "hasten the coming time of equal opportunity for all citizens of these United States."[95] If the Civil Rights Movement was anything, it was a coordi-nated attempt to shift the time of black freedom from the illusory future tense of the "coming" to the radical present tense of "freedom now." It was a radical cultural and political adventure in Afro-presentism, in en-joying the affordances of black freedom in the here and now. By the time Kennedy penned his letter for the Exposition, civil rights activists were already staging a historic challenge to black patience and its specious uses of the future. The president's own brother, US Attorney General Robert Kennedy, was among those whose violent deployment of black patience was met with the radical force of civil rights activism. Seeking to suppress the freedom rides—a series of integrated bus rides designed to challenge racial segregation—the attorney general urged these activ-ists, or "Freedom Riders," to enter what he called a "cooling off period." This yearning for a period of "cooling off" stemmed from a desire to defer the arrival of black freedom and full citizenship. By stalling the freedom rides, the attorney general sought to control black political dis-sent through a state effort to control black time. Further, to cool off was not only to consent to this violent deferral of black freedom, but it was also to accede to the state's attempt to manage and control black affect as a means of regulating black political protest. More than a violent maneu-

ver in racial time, the call to cool off demanded an affective performance of calmness and restraint that would undermine the movement's radical insistence on "freedom now." In this way, Kennedy's demand for a period of cooling off sought to conscript black subjects into the temporal and affective holds of black patience, and to thereby further delay their access to the fraught event of emancipation.

Black activists like James Farmer (who had helped to organize the freedom rides) knew that such calls for "cooling off" were intended to delay black people's access to freedom. With a deep consciousness of the duplicities that have historically animated demands for black people to be cool, or to perform black patience, Farmer and other activists staged performances of fugitive affect that refused the racial mandate to be cool. Echoing a sentiment that resounded throughout the movement, Farmer explained to the attorney general, "we have been cooling off for 350 years. If we cool off any more, we will be in a deep freeze."[96] His retort signals black people's awareness of how black patience used racial time and racial affect to solidify white racial authority, to manage and discipline black subjectivity, and to suspend full emancipation in the "coming time."

This recognition of, and resistance to, the "deep freeze" of black patience animates the welcome letters that ANECA'S leaders wrote to Exposition participants. In his letter, President Earl B. Dickerson observes that the Negro has "moved forward with his contributions—in spite of well calculated and cleverly designed obstructions set in motion by vicious men in many circles."[97] A bold affront to these "obstructions," the Exposition "brings the Negro people to the point of demand for freedom, liberty, equal justice under the law, NOW!"[98] For Dickerson, the Century of Negro Progress Exposition was intimately linked to the Civil Rights Movement and grounded in its political logic of Afro-presentism. The Exposition's concern for civil rights was certainly attractive to activists like Dr. Martin Luther King Jr. and Reverend Fred L. Shuttlesworth, both of whom attended the Exposition (and who had also collaborated to found SCLC, one of the most influential civil rights organizations to emerge from the movement). During the Exposition's "Civil Rights Night," Reverend Shuttlesworth delivered a timely talk entitled "Why We March."[99] King was scheduled to visit on Wednesday, August 20, but made an early surprise appearance on Sunday, August 18, and held a brief press conference while there.[100]

This was not King's only surprise visit in Chicago. He also made a pit stop to meet black musical genius and Century of Negro Progress Exposition headliner Duke Ellington at the Blackstone Hotel. Upon learning that King (whom Ellington referred to as his "main man") was waiting downstairs to meet him, Ellington began to fret over what to wear for this fortuitous moment. Ultimately, he decided on an eclectic ensemble that included a bathrobe, a stocking cap, and a hat. Upon meeting, the two men "embraced, like old friends." With his arms still around the civil rights leader, Ellington stood adorned in his stocking cap, his bathrobe "fluttering in the breeze," as a police officer "chased his beat-up old porkpie hat down the street."[101] Soon after, Ellington invited King to McCormick Place to attend a rehearsal of "King Fit the Battle of Alabam," a pulsating song in *My People* in which King appears as the eponymous and heroic protagonist. His participation in "Project C," a major civil rights campaign in Birmingham, Alabama, takes center stage. Having experienced Ellington's theatrical rendering of this iconic crusade, King "was very moved."[102]

Duke Ellington and the Civil Rights Movement

When considering the archive of civil rights activism, Duke Ellington is likely not the first person who comes to mind. After all, in 1951, when questioned about his views on integration, he reportedly declared, "We [black people] ain't ready."[103] Ellington's alleged call for black patience was fiercely rebuked by the black media and by black people more broadly. Five years later, when the NAACP announced that Ellington would receive its Spingarn Medal, its highest award, this decision was met with waves of criticism and public dissent. According to one newspaper, the Spingarn should be reserved for those "who have been active in civil rights, to the exclusion of all other claimants," while another paper made clear that this award honored Ellington's "musical accomplishments"—not his political activism.[104] Charging Ellington with political apathy at best and political antagonism at worst, this mounting tide of criticism continued to balloon in the wake of Ellington's reported endorsement of black patience.

As the Civil Rights Movement transitioned into the 1960s, Ellington's reputation on civil rights waxed and waned, as did his own positions on

the movement. Even as Ellington played benefit shows for civil rights groups like the NAACP, CORE, and SNCC; even as he incorporated anti-discrimination clauses into his contracts, and generally refused to play segregated venues; and even as he played a small role in challenging racial segregation at a diner in Baltimore, he harbored mixed, often critical feelings about key civil rights initiatives like the 1963 March on Washington, which he dismissed as "the biggest parade in the world."[105] "The only people who did good out of the goddam parade," Ellington fumed, "was the people who owned businesses in Washington, the hotels and all that, they had a fucking ball, put all the fucking money in their pockets."[106] Ellington's biting appraisal of this crowning civil rights event was not lost upon the public, and treaded dangerously close to his "we aint' ready" faux pas from a decade earlier. Given his complex and capricious relationship to the movement, it is not surprising that Ellington was both hailed by the NAACP as the person who had made "the highest and noblest achievement by an American Negro" and roundly dismissed as a "Stepnfetchit and Mr. Bojangles" "straight out of the 1930s" by others.[107] This tension surrounding Ellington's position on civil rights certainly contributes to why *My People* is rarely considered as an important component of the movement's cultural and political fronts, despite featuring "top Negro entertainers" like the Alvin Ailey Dance Theatre and the Tally Beatty Dancers.[108]

Duke Ellington was deeply invested in *My People*, so much so that he not only composed its score and script, and directed its live production, but also painted the set and assembled its lighting. Still, Ellington is largely to blame for how this and other works of his were de-politicized during the movement. For example, in describing *My People*, he proclaimed that the work is "definitely not political," but instead "has social significance," an evacuation of politics from his art that was all too familiar to his audiences and observers.[109] Whatever Ellington's conception of the political, though—or the terms of the distinction he intends between something being political versus having social significance—he uses works like "King Fit the Battle of Alabam" to perform important political work and to build a bridge between theatre and civil rights activism.

Specifically, the lyrics of the songs in *My People* move within a cultural and political economy that literary critic GerShun Avilez has called

"aesthetic radicalism." By this, Avilez means "the artistic inhabiting and reconfiguring of political radicalism," a mode of "disruptive inhabiting" that entails both "the purposeful adoption of political ideology" and "the active attempt to unhinge the components of the ideology that threaten to constrain expressions of identity."[110] Although Ellington was notorious for sidestepping overt political action, a careful examination of the songs in *My People* illuminates the powerful, though subtle, modes of "disruptive inhabiting" that imbue this revue with lyrical and political force. To begin excavating the political dimensions of Ellington's supposedly apolitical musical drama, let's return to "King Fit the Battle of Alabam."

Performed by the Irving Burton Singers, "King Fit the Battle of Alabam" opens with a warlike soundscape. Its jarring blasts of "Bam!" evoke the sounds of bombs, guns, and other weapons of white supremacist violence that were used to quell the Civil Rights Movement and to attack the bodies of civil rights activists:

> Martin. Luther. King fit the battle of
> Bam! Bam! Bam!
> King fit the battle of
> Bam!
> And the bull jumped nasty, ghastly, nasty
> King fit the battle of Alabam, Birmingham, Ala-ma-bam
> And the bull jumped nasty, ghastly, nasty
>
> Bull turned the hoses on the church people . . .
> And the water came splashing, dashing crashing
>
> Freedom rider, ride
> Freedom rider, go to town
> Y'all and us gonna get on the bus
> Y'all aboard?
> Sit down. Sit tight. Sit down
> Sit-downs, babies
> Sit down. Sit tight
> Go to that school, don't be no fool,
> Sit down, be cool

Little babies fit the battle of police dogs, police dogs
Little babies fit the battle of police dogs
And the dogs came growling, howling, growling

The dog looked the baby right square in the eye
And said bye! Scram!
The baby looked the dog right back in the eye and didn't cry, didn't
　　lam
Now when the dog saw the baby wasn't afraid
He pulled his uncle bull's coat and said
That baby acts like he doesn't give a damn
Are you sure we still in Alabam?[111]

Ellington found inspiration for "King Fit the Battle of Alabam" from Project C, known otherwise as Project Confrontation: a watershed civil rights campaign that Dr. Martin Luther King Jr. helped to organize in Birmingham, Alabama, in the spring of Centennial year. Using sit-ins, boycotts, and marches to protest Birmingham's cultures of racial segregation, Project C activists drew the ire of Bull Connor, the city's notoriously violent and brutally racist Sheriff. Connor's unabashed use of dogs, firehoses, cattle prods, and billy clubs to attack activists remains one of the most affecting scenes of the movement's visual iconography.

Ellington models "King Fit the Battle of Alabam" on the popular African American spiritual "Joshua Fit the Battle of Jericho." In his reimagining, Ellington retains the song's warlike narrative frame as a way to call attention to black people's war against white supremacy and anti-blackness. And yet, he disrupts the logic of progress that supplies the spiritual and the biblical story on which it is based—i.e., the Battle of Jericho—their narrative thrust. In both the biblical account and the spiritual, the children of Israel, led by Joshua, marched around the walls of Jericho once every day for six days, and then again for seven times on the seventh day. Having finished the final lap, the priests blew the trumpet, the Israelites adhered to Joshua's command to shout, and the walls of Jericho came tumbling down. Led by a charismatic male leader, and ending in victory for a formerly enslaved people, it makes sense that this spiritual became a hallmark of black musical and religious traditions.

But Ellington's radical refashioning of this triumphalist narrative of progress entails a series of aesthetic refigurations that render this work far more political than the artist admits. In Ellington's version, the triumphant fall of the wall that anchors the original composition ("And the wall come tumbling down") is replaced with repeated allusions to the gratuitous violences of Bull Connor (e.g., "the bull jumped nasty, ghastly, nasty") and his implements of racial warfare. By the song's conclusion, the fight is never won; the walls of anti-blackness and white supremacy remain firmly intact. Ellington thus frames the Civil Rights Movement, and black people's struggles for full citizenship, as battles that remain in process, rather than struggles that have been completed and won. And although the new song retains its epic praise of a heroic, charismatic male leader, it ultimately destabilizes the overriding paradigm of heroic male leadership that saturates the lyrics of the original song. Rather than simply praising King, Ellington revises the song's lyrics to foreground the wider army of activists—from babies to unnamed Freedom Riders—who fought the "battle of Alabam." In doing so, he unsettles conventional stories of civil rights activism, whose attachments to patriarchal structures of leadership "constrain expressions of identity," like those of the lesser known "babies" and "Freedom Riders" who helped to fuel the Civil Rights Movement. In "restaging the charismatic scenario," Ellington neither downplays King's and Joshua's roles as leaders nor marginalizes the broad cast of everyday actors that was central to waging these battles of the oppressed.[112] This approach to narrating the political struggles of the subaltern recognizes the contributions of leaders, while refusing to paper over the sacrifices and accomplishments of a broader network of minoritarian political actors. Through these subtle gestures of aesthetic radicalism, Ellington keeps in view the diverse labors and laborers who contributed to the making of the movement and to the arc of the long black freedom struggle.

By recovering and critically analyzing theatrical works like Duke Ellington's "King Fit the Battle of Alabam," or organizations like ANECA and the Illinois Centennial Commission, we are better positioned to engage in the intellectual project of "making civil rights harder." Paying attention to these dimensions of the Civil Rights Movement demonstrates that we need not downplay the movement's classical phase in order to do so. Nor do we need to prioritize leftist political activism to

approach an understanding of black radicalism in this era. One benefit of reimagining the archive of civil rights activism is uncovering sites of political and aesthetic radicalism that potentially escape the radars of critical approaches that are primed to soften the radical tenor of the movement's short or classical phase. "King Fit the Battle of Alabam" is Ellington's most explicit engagement with the Civil Rights Movement in *My People*. He was certainly referring to this song when he declared "I've only got about one minute of social protest written into the script [of *My People*]."[113] So salient is this minute of social protest that *Jazz* magazine suggested that it "should be recorded and played in Congress at regular intervals during the civil rights debates."[114]

The political imperative at the core of "King Fit the Battle of Alabam" is undeniable. Other songs in Ellington's revue are less explicitly political, but are nonetheless also radical. Perhaps the most prominent dimension of *My People*'s radicalism is Ellington's innovative engagements with black history, an effort that courses throughout his work and is the most consistent strain of his hushed political sensibility. Responding to accusations that he was not sufficiently political, Ellington offers an illuminating rejoinder that is just as much a lament as it is a revelation of his own conception of history's importance to his work: "They've not been listening to our music," he complains. "For a long time, social protest and pride in black culture and history have been the most significant themes in what we've done."[115] I want to linger for a moment on Ellington's self-proclaimed investment in history, and consider how this particular dimension of his work is not only political, but consistent with the radical historical work that ANECA and the Illinois Centennial Commission shouldered as they observed the Centennial.

"Duke Was a Historian": Ellington's Archival Impulse

Several of the songs in *My People* appeared first in a three-movement jazz suite entitled *Black, Brown and Beige*, a work that Ellington introduced at his Carnegie Hall debut in 1943. Tracing the history of black people from slavery to the present, this work, as Ellington saw it, was "a parallel to the history of the American Negro."[116] Uncovering and chronicling the history of black people in the United States was a priority for Ellington, and is precisely what ANECA and the Illinois Centennial

Commission hoped to achieve. In addition to organizing the Century of Negro Progress Exposition, these groups' most seismic feat was to collect, document, and preserve the histories of black people. In a June 14, 1962, letter to the State Library, Chairman Davis writes that the Commission is "engaged in the process of gathering materials and historical data concerning the history of Negroes in the state of Illinois from the earliest days. This material," he asserts, "will be woven into the pattern of the exhibits for the forthcoming centennial in 1963." Davis wondered if the State Library could "help . . . by compiling a bibliography on the History of the Negro."[117] Nearly two weeks later, he received a reply informing him that the Reference Department would "start compiling this bibliography at once."[118] The librarian adds, "but [we] will ask for your patience because of the necessary bibliographic research that will be entailed *and the dearth of material on the subject*."[119] I have italicized, in the foregoing quote, a handwritten clause that the state librarian added to an otherwise typed letter. This addendum to a seemingly standard appeal for patience is instructive, because it demands from Davis an extended performance of patience, due to the "dearth of material on the subject." In other words, the paucity of information on the "subject"—whether subject refers here to black history or the black human subject—will require of Davis more patience than normal. Nearly a month later, the chairman finally received the requested bibliography.[120]

Clearly disappointed in what the state librarian had compiled, two days later Davis wrote to the chief librarian of the Chicago Public Library.[121] Noting that he had already contacted the State Library for assistance, he explains that their report "indicates a scarcity of materials on the history of the Negro in Illinois."[122] Hoping that the local library might provide a more substantive bibliography, the chairman emphasizes that as important as the Century of Negro Progress Exposition was, it was only "one facet of the total program of the Commission. The research and publishing will constitute another."[123] Three days later, the chief librarian wrote that she would be "very pleased" to help.[124]

By the time ANECA and the Commission mounted the Century of Negro Progress Exposition in August 1963, they had amassed an expansive, multi-generic archive of black history that narrated the "long story" of black people's presence in Illinois and across the nation—a story about black people's contributions to the nation as well as the na-

tion's contributions to black people's experiences of racial violence. This archive included, for instance, a journal special issue, a "quickie" pamphlet, student essays, a "dramatic production" (or documentary film), as well as a "historymobile," a mobile museum of sorts that would tour the state.[125] Through these diverse archival and intellectual interventions, ANECA and the Commission were able to excavate and transfer repressed knowledges. They engaged in radical knowledge-making acts that literary critic Christina Sharpe might call "black annotation" and "black redaction." By this she means acts that facilitate "new modes of writing, new modes of making sensible," that foster ways of "seeing and reading otherwise."[126]

Considering his similarly throbbing archival and historical impulse, it is no surprise that ANECA and the Commission chose Duke Ellington as the main act for the Century of Negro Progress Exposition. Whereas these parties often turned to written modes of producing, archiving, and circulating black histories, Ellington's preferred method was music. Attending to what we might understand as Ellington's sonic archivalism helps to clarify the depth of the artist's routine amalgamation of race, music, and history, and how this strategic triangulation is an example of the "vital acts of transfer" that performance theorist Diana Taylor sees as a defining element of performance. According to Taylor, these acts of transfer facilitate transmissions of "social knowledge, memory, and a sense of identity."[127] For Ellington, musical performance was the conduit, or the mode of transference, through which he conveyed memories and knowledges of black people's experiences to his audiences, while hoping that these acts of transference would foster the production of a new black consciousness. In this sense, performance is both that which disappears (as commonly noted in performance studies scholarship) and that which persists into the future as black knowledge and consciousness, as black critical memory, in the wake of the live performance.

The radical effects of these acts of transfer are evident in "King Fit the Battle of Alabam." More than using music to document a key civil rights event, and to transfer knowledge of its importance to his audiences, Ellington versions an account of this event that foregrounds the wide range of historical actors who deserve credit for its success. In this way, Centennial audiences left the Arie Crown Theater with a democratic vision of black political participation, rather than a history weighed down

by an overinvestment in history from the top. This use of music to archive and transfer knowledge and memories of black pasts, and to curate a black historical sensibility, is likely why jazz musician and composer Dizzy Gillespie exclaimed that "Duke was a historian."[128]

If, for Ellington, *Black, Brown and Beige* was "the history of the Negro with no cringing and no bitterness," this ethos continued to shape his reanimation of this work in *My People* at the Century of Negro Progress Exposition.[129] Opening with a stirring monologue from Ellington, the title song of this revue suggests that the history of the United States is always already a history of black people. Without ever uttering the words *slavery*, *sharecropping*, or *chain gang*, the song is insistent in rendering the history of black labor exploitation, and in showing how this theft of body and work are critical to any account of U.S. nation formation. "My people. MYYYY PEOPLE! Singing, dancing, praying, thinking. Talking about freedom. Working (oh, hard, too). Building America into the most powerful nation in the world. Cotton, sugar, indigo, iron, coal, peanuts, steel, railroad, you name it. The foundation of the United States rests on the sweat of my people."[130] In typical fashion, Ellington downplays the histories of violence and coercion that compelled much of this labor, perhaps in an attempt to eliminate "bitterness" from his telling. He relies on a seemingly tortured strategy of implication, of muted candor, as his primary mode of historical narration. This narrative technique requires of audiences a prerequisite knowledge about the racial histories of these commodities, specifically the exploitation of black people required for their production and circulation within the global economy. Fortunately, the Century of Negro Progress Exposition provided these audiences an appendix to the black pasts that Ellington engages without always offering a robust historical accounting. But even as Ellington evacuates direct acknowledgments of racial terror from these histories, he produces theatrical counter-histories of a nation that cannot ignore or disentangle itself from the specter of the laboring black subject who both haunts and is haunted by this history.

War is another site to which Duke Ellington turns to engage in the work of sonic archivalism. "In addition to working, and sweating," Ellington exclaims, "don't ever forget that my people fought and died in every war. Every enemy of the USA has had to face my people on the front line."[131] As performance studies scholar Koritha Mitchell has

shown, black communities have sometimes perceived participation in the military as a viable path to full citizenship.[132] This tricky logic is certainly at work for Ellington, who is eager to frame black subjects as agents of empire whose courageous contributions to the nation's wars are, in many ways, the nation's condition of possibility. Even so, in 1963, when bibliographies of books by and about black people were "scant"— when there existed "a dearth of material on the subject"—Ellington's performed histories are transformative, because these acts of transfer move against the grain of those "proper" histories that have historically erased, invisibilized, and contorted black people's histories within the dominant scrolls of the nation's past. Characterized by call-and-response, repetition, and a vocal sonority reminiscent of civil rights speeches in this era, Ellington's political aesthetics imbue his sonic counter-histories with an air of gravitas and political righteousness that demand the audience's attention.

Ellington's histories are far from revolutionary. And his silences about racial violence in this particular song (which is not the case in "King Fit the Battle of Alabam") are glaring. Thus, the radical dimensions of this and other songs throughout Ellington's musical drama might not be apparent, especially when considered alongside the more conspicuously radical aesthetics of jazz artists such as Max Roach, Abbey Lincoln, Charles Mingus, and Sonny Rollins in the same period. But drilling deeper into the content of these works uncovers Ellington's powerful (if subtle) methods of transferring repressed knowledges and memories, of redacting and annotating dominant archives, as a way to ignite a transformation of black racial being. The difficulty of hearing Ellington's political movements against the grain of the proper emerges in an unsigned editorial that appeared in the *Los Angeles Tribune*. "Lord knows, we love his music," the editorial contends. "But its sexy growls and moans have never moved us to go out and register to vote, or bowl over a bastion of prejudice."[133] But historian Robin D. G. Kelley has argued that the "most radical art is not protest art," but rather "works that take us to another place, envision a different way of seeing, perhaps a different way of feeling."[134] This is precisely what Ellington achieves in works like "King Fit the Battle of Alabam" and *My People*. Set against modernity's structures of anti-blackness, Ellington's "growls and moans" furnish "different" epistemologies, frames, and affects that invite us to consider

black radicalism in all of its necessary capaciousness. They occasion an opportunity to examine what I call the *scales of black radicalism*.

The Scales of Black Radicalism

As much as Centennial events like the Century of Negro Progress Exposition were crowning achievements of black culture and politics, many were funded by the state. This collaboration produces a fraught encounter between state power and black political culture that illuminates the nuanced textures of the black freedom struggle and the complex geographies of black radicalism. ANECA's Centennial activities in Indiana were made possible when the Indiana General Assembly voted in 1963 to appropriate $20,000 to form and fund the Indiana Centennial Commission. And, as we have already seen, the Illinois Centennial Commission was established through nearly identical modes of state appropriation. Because ANECA relied on state funding for its Centennial events, they were forced to negotiate the weight and oversight of state power. In Illinois, for instance, the Commission forced ANECA to tailor its bylaws and Constitution to the state's satisfaction. In a letter to ANECA, the Commission expressed its hopes of establishing a "very close and meaningful collaboration," but goes on to stress that it "operates within the framework of the State statutes," and that its "relationship to the Authority is conditioned by this fact."[135] The Commission's commitment to operating within "the framework of [their] statutory responsibility" became a constant refrain in its correspondence with ANECA.[136] The Authority sometimes pushed back on the Commission's demands, once writing that "we see no reason why the Constitution should be amended."[137] The Commission's response was a hard-edged ultimatum: "there can be no collaboration or cooperation with ANECA until issues raised concerning program and structure are satisfactorily resolved for all parties concerned."[138] Ultimately, the constitution was amended. And on the heels of state audits and probing reviews by the attorney general, the Commission and ANECA agreed to work collectively on the Emancipation Proclamation Centennial.

Rather than reading these collaborations as a death knell for the Commission's and ANECA's radical efforts, I use these entanglements to highlight the *scales of black radicalism*. In calling attention to the scale of

black radical activity, my aim is to offer a conceptual paradigm to better identify and analyze the various and varied forms of black radicalism: those big and small acts that co-constitute the production of black radical activity. Seen this way, our rubrics for assessing black radicalism are less burdened by a standard that prioritizes political purity or an explicitly leftist orientation. Thinking black radicalism through an analytics of scale enables an analysis of the black radical tradition that acknowledges how—out of the necessities of anti-black oppression—black radicalism has often unfolded in relation to, and even in collaboration with, agents of power, like the state, that constrain and threaten the vitality of black political life as well as the vitality of black life more generally. As messy and perhaps disappointing as these fraught entanglements are, any journey toward interpretive and historical integrity must account for these burdened intersections of black radical activity. We must do so in a way that neither obscures nor minimizes their significance, but instead contextualizes these acts along a scale of black radical activity and in relation to a violently anti-black modern world. ANECA's collaboration with the states of Illinois and Indiana is illuminating in this regard.

To be sure, the problematics of state sponsorship are numerous. At the most general level, the creation and funding of Centennial Commissions provided a route to state oversight and thus a path to state surveillance of Centennial events. On this front, the configuration of the commissions' executive leadership is illuminating. In Indiana, the Commission's "honorary" chairman and vice chairman were Governor Welsh and Lieutenant Governor Richard O. Ristine, respectively—both white men and members of the state political elite. Further, with the exception of four people, the organization's leadership was all male. Of the four women, two filled the roles of secretary and assistant secretary, while another was state chairman of the women's auxiliary. These gender dynamics were also present in the makeup of the Illinois Centennial Commission. Of the seventeen-member Commission, Judge Edith S. Sampson was the only woman. Two other women worked on the staff as executive secretary and secretary. Further, even within its radical acts of annotating and redacting dominant archives and histories, ANECA tended to focus almost exclusively on the "life of great men."[139] Rather than downplay these dynamics of racial and gender power, attending to the scales of black radicalism allows us to figure the particularities of

time, place, and resources into conceptions of black radical activity and strategies of black freedom dreaming. It reveals how black radicalism is a situated practice whose performance and constitution vary according to time and location, to context and local realities.

ANECA's collaborations with the state demonstrate how black radical activity often entails entanglements with adversaries and adversarial dynamics that compromise the operations of black radicalism itself. That ANECA's and the Commissions' observations of the Centennial were both radical and rooted in patriarchy and state power—relations that are hardly an aberration within the history of black radical activity—unfurls the complex and messy architecture of radical projects. Without question, it is necessary to critique the complicities, failures, and limits of these projects. But we cannot diminish the radical nature of their attempts to strain against dominant structures of power. This approach to conceptualizing the black radical tradition allows us to consider the scales of black radicalism and thus attunes us to look for and locate traces of the radical where they might not, at first glance, seem present. Such a reorientation to the black radical fosters new possibilities for approaching and imagining the archive of black radical activity. As a result, we can better understand events like the Century of Negro Progress Exposition and works like *My People*. While their radicalism might not be immediately apparent, their engagements with civil rights and history, their transnational and diasporic visions, and their concerns with economic equality confronted some of the most pressing issues at the heart of the Civil Rights Movement as well as the long black freedom struggle.

Postscript

As I sat in the archive conducting research for this book, I stumbled upon a surprising but welcomed link between the Illinois Centennial Commission and the black southern theatre at the heart of the next chapter. On June 13, 1962, as the Commission was busy planning the Exposition, Chairman Corneal A. Davis wrote to Mr. John O'Neal, a recent graduate of Southern Illinois University in Carbondale, Illinois, thanking him for his "encouraging" presence at a Commission-sponsored meeting hosted at O'Neal's alma mater on March 30, 1962.[140] In addition to soliciting his participation in Centennial events, Davis explains that it is

the Commission's "firm conviction that the celebration of 100 years of the signing of the Emancipation Proclamation, and the knowledge and information which will be gathered in the process of the preparation for this event, will have lasting value."[141] As this chapter has shown, a key strand of the "knowledge" and "information" that would be unlocked by the end of Centennial year was the stark reality that, one hundred years after emancipation, "Negro" progress was evident, but was relative, regulated, and incomplete. The incompleteness of emancipation emerged from a global effort to reinvigorate the violent cultures of chattel slavery in post-emancipation America. These efforts to engineer the afterlives of slavery entailed a meticulous campaign to convince black people that a radical transformation of their condition loomed on the horizon. This recurrent positioning of black freedom in the future, or the time of not-yet-here, is designed to encourage the performance of black patience and is thus a threat to black freedom. The planning and execution of the Century of Negro Progress Exposition exposed the deceptive impulses that undergird these cruel deployments of racial time and racial affect. O'Neal would discover soon that the violent cultures of black patience were nowhere more conspicuous than in the US Deep South, and specifically in the state of Mississippi.

In the same year that O'Neal attended a meeting of the Illinois Centennial Commission, he journeyed to Mississippi to join scores of college students and recent graduates who were on the front lines of the Civil Rights Movement. As O'Neal settled into the Jim Crow South, he developed a thicker consciousness of how the operations of anti-blackness and white supremacy relied on black patience. Motivated by his training as an actor and playwright, he believed—like ANECA—that theatre could help to unsettle this violent world-system. Fortunately, O'Neal encountered two equally committed activists who also believed in theatre's capacity to expose and unsettle the racial project of black patience, and to forward the goals of the movement. These shared interests ultimately crystallized into the birth of a radical black southern theatre that would eventually become the Free Southern Theater.

Interestingly and uncannily, the theatre was born on the grounds of Tougaloo College, the historically black institution where Corneal A. Davis had been educated. In an oral interview, Davis recalls his time at Tougaloo fondly. In addition to hearing talks by George Washington

Carver and Booker T. Washington, he also served as quarterback for the football team. But what is most striking in Davis's interview is his description of the school's material geographies, which were once the grounds of a cotton plantation. Tougaloo, he recalls, "was a 500-acre farm. . . . the old mansion where the slave-owner used to stand out and watch them farm—he could stand up top in his mansion on the—a veranda. His veranda is still—it's still there. The old mansion is still there. Watch—see slaves farm there. Well that's what it was."[142] The lingering presence of the Bodie Plantation house—which, at this writing, continues to sit at the heart of Tougaloo's campus—was a stark reminder of slavery's afterlives, and what literary critic Jarvis McInnis has called the "afterlives of the plantation."[143] Recalling how he and other students used a mule to plow the grounds of this former plantation, Davis maps a telling relation between post-emancipation black subjects and their enslaved ancestors who had plowed those same grounds. Still, whatever the lingering residue of slavery, or the structural repetition of its violences, Davis and his classmates were not slaves—not in the sense of their legal condition nor in the context of their ontological realities. As Tougaloo students worked the grounds of this former cotton plantation, they did so as citizens who used their bodies and their labors to transmute the school's plantation geographies into spaces of black possibility. Whatever the historical affiliations that connect black subjects on both sides of the emancipation divide, there is no conceptual or theoretical calculus that can justly construct Corneal A. Davis, the college student–cum–Congressman and Centennial Commission Chairman, as a slave.

Like the Century of Negro Progress Exposition, the Free Southern Theater used theatre and performance, within local geographies, to expose, critique, and disassemble the violent cultures of black patience. In this, they mobilized performance to highlight the importance of "freedom now" for black subjects who, one hundred years after emancipation, were still waiting for freedom.

2

Black Time, Black Geography

The Free Southern Theater

In a 1956 letter to *Life* magazine, Nobel Prize–winning author William Faulkner urged black southerners to wait, or to defer their pursuits of the rights, privileges, and protections of full US citizenship.[1] Writing on the heels of the US Supreme Court's decision to abolish legal segregation with "all deliberate speed," Faulkner answered the Court's imperative with an injunction of his own, one that was equally steeped in a grammar of time and space: "Wait, wait now, stop and consider first . . . I would say to the NAACP and all the organizations who would compel immediate and unconditional integration: Go slow now. Stop now for a time, a moment."[2] In this widely circulated missive, the world-renowned writer condemns the speed with which black people were fracturing the barriers of racial segregation in the US South. That Faulkner is especially critical of what he calls "immediate" integration illuminates the centrality of time ("immediate") and space ("integration") to the racial order of the Jim Crow South. What motivated Faulkner's appeal for back people to "wait," to "go slow," and to "stop" was a wariness of the new racial order that the Civil Rights Movement was beginning to establish. So riddled with fear and anxiety was the writer that he turned to the pages of *Life* to decry the speed at which black people were pursuing their freedom dreams. By meeting the movement's demands for "freedom now" with deceptive appeals for black people to wait, to go slow, and to stop, Faulkner tapped into and reinvigorated the racial project of black patience.

Faulkner's plot to stall the wheels of civil rights activism was hardly a new phenomenon. It marked a new effort in a long and deep history of regulating the movements of black people through the time-space of global modernity. Whether waiting in the dungeon of the slave castle or in the hold of the slave ship, whether waiting on the auction block

or lingering on the edge of emancipation, black patience was as pivotal to transatlantic slavery and colonialism as it remains to procuring their afterlives in the wake of emancipation. And yet, as if these centuries of waiting were not enough, here was Faulkner engineering yet another strategy to divest the black body of motion, and to subject the movements of black people to the laws of a violent physics of stillness.

But Faulkner's crafty plea for black patience drew pointed criticisms from black artists and civil rights activists. In a searing reply aptly entitled "How Long is a Moment, Mr. Faulkner?" the writer John Oliver Killens observes that black people are "the most patient . . . folks in America, maybe in the world."[3] But "after three hundred and forty years, patience wears thin, very thin. We've waited too long now. Good Lord! What patience my people have! A moment may be another hundred years or two."[4] Just ten years later, Killens would reelaborate these sentiments in an epic 1967 novel entitled 'Sippi, in which Faulkner makes a veiled but conspicuous appearance. In the novel's prologue, audiences meet Jesse Chaney, a late-fifties black sharecropper who is engaged in a curious performance of running. This act puzzles Jesse's longtime "friend," plantation owner, and white employer, Charles Wakefield. "That black bastard is hauling," Wakefield exclaims.[5] "What in the hell was anybody doing running like that in all this God-forsaken heat. . . . Especially a poor-ass Negro? . . . Must be the devil chasing him."[6] Jesse was hardly retreating from the "devil." Rather, his performance of running was sparked by the US Supreme Court's 1954 decision that segregation in public schools was unconstitutional and its mandate for states to comply with "all deliberate speed." Emboldened by the court's decision, Jesse used the black body in performance to translate the court's time-space imperative into a radical act of civil rights protest. Abandoning his work "in the cotton field of . . . Wakefield's plantation," the sharecropper "didn't stop running till he reached the Big House more than a mile and a half away."[7] Choosing to snub the racial protocol of entering through the back door, Jesse infiltrates the segregated space of the Wakefields' front porch, staging a courageous performance of protest that flouts the doctrines and decrees of racial-spatial segregation while troubling the violent structures of racial time that have historically shaped Mississippi's "plantation geographies."[8] In other words, by untethering his body from the exploitative labor time of sharecropping, and then utilizing that

body to mount a performative enactment of "all deliberate speed," Jesse stakes an embodied claim to a different time-space horizon: one that is both a saying and a doing of "freedom now," staged on the very grounds of a Mississippi plantation.

Wakefield attributes Jesse's odd behavior to the addling effects of the weather, surmising that the heat must have "got the best of [him]."[9] But the sharecropper offers an imperious if comical retort that counteracts this attempt to render black political protest unthinkable and void of volition. "The Supreme Court done spoke," Jesse declares! "Ain't going around to the back door no more. Coming right up to the front door from now on. . . . And another thing—ain't no more calling you Mister Charlie. You just Charles from here on in."[10] Growing increasingly perturbed at what he now perceives as blatant impudence, or a bold affront to the affective protocols of black patience, Wakefield responds in a decidedly different register: "Nigger, don't you know you're in Mississippi?" "That's another thing," Jesse retorts. "Ain' no more Mississippi. It's jes' 'Sippi from now on!"[11]

I bring up Faulkner's letter and Killen's replies here to begin a deeper discussion of black patience in the US South. Like Jesse Chaney, black artists and activists in this era used embodied performance to expose and rework the racially restrictive time of the Jim Crow South. Focusing on these attempts to decolonize time, this chapter examines the Free Southern Theater: a vibrant grassroots theatre that emerged from the soils of Faulkner's Mississippi. Founded in 1963, the Free Southern Theater was crucial to the cultural and political fronts of the Civil Rights Movement. As the theatre's more well-known and celebrated counterparts were marching, sitting-in, and deploying other modes of embodied political performance, the Free Southern Theater was also harnessing the power of the body in performance to likewise contest the regimes of racial power fueling demands for black patience in Mississippi and across the Jim Crow South.

Their courageous and innovative efforts unfolded in two primary ways. First, the theatre assembled a repertoire of time-conscious plays, and used the temporal aesthetics of these works to expose and critique the violent cultures of black patience. Secondly, they conducted novel experiments in theatrical setting that revamped the violent histories of black time stored in the cotton fields, plantations, porches, and other

symbolic spatialities that served as the company's theatres and stages. Through these innovative experiments, the Free Southern Theater joined thousands of civil rights activists who were claiming time as a province of black political action and as a tool for altering the material geographies of a state and a region firmly wedded to preserving the violent cultures of black patience.

When Charles Wakefield asks Jesse Chaney, "Nigger, don't you know you're in Mississippi," his question is less a genuine query than an interrogative proclamation that declares and reinforces the racial meanings of Mississippi's social and material geographies. Further, his statement illuminates the obligations of racial comportment that structure the affective protocols of black patience. A performative utterance, it seeks to announce and calcify the ontology of the land as well as the ontology of blackness. Wakefield knows that Jesse no more forgot that he was in Mississippi than the heat was to blame for his running or his defiant performance of standing-in. But Wakefield strains to downplay the political intentionality that undergirds the sharecropper's bid to ascribe new meaning to a porch, a cotton field, a plantation, a state, a region, and importantly a "black-south body" that had all come to epitomize anti-black violence and to operate as important geographies of black patience.[12] As his spiraling anger makes clear, such efforts to dismantle racial-spatial segregation, and the speed with which these efforts were apace, posed a serious threat to the established racial order of the Jim Crow South. Viewing the Civil Rights Movement as an existential threat to the prevailing time-space of the region, Faulkner, Wakefield, and scores of others found in the grammar of black patience an auspicious antidote to the movement's radical demands for "freedom now." That Wakefield had "emptied many a bottle of Scotch and bourbon" with the fictional "Willie Faulkner"—another "famous Mississippi plantation owner"—comes as little surprise.[13]

Faulkner's letter was an artful but no less violent incursion into the radical grammar of the present that was fast becoming the tense of black freedom dreams. It was a sly petition for black stillness over black motion, for black patience over freedom now. In an era characterized by speed and the swift movement of matter through space—from modernized news cycles to spaceships to the accelerated turnover time of capital—Faulkner labored to extricate black political progress from the

global currents of modern innovation. He hoped to quarantine black politics and black being to a decidedly different economy of time, one governed by black patience rather than the radical politics and possibilities of Afro-presentism.

But if black people are the "most patient people . . . in the world," as John Oliver Killens suggests, they have "never been simply waiting," a point that black writer Ralph Ellison makes in a letter to longtime friend and fellow black writer Albert Murray in which he denounces Faulkner's demands for black patience.[14] Ellison was joined in his rebuke of Faulkner's call for black patience by black artists and activists like James Baldwin ("Faulkner and Desegregation") and little-known playwright Lola Jones Amis ("The New Nigger, or Who's Afraid of William Faulkner").[15] But he was joined, too, by everyday black southerners who staged a bold, region-specific challenge to the violent cultures of black patience.

We get a sense of this radical campaign in a now-forgotten volume of essays on the Civil Rights Movement, entitled *The Angry Black South: Southern Negroes Tell Their Own Story* (1962). The "dark history of oppression and degradation in the South," the editors write, "is now being challenged and overcome by the relentless efforts of its own Negro citizens."[16] They argue that only by increasing the speed at which black southerners were moving toward full citizenship, they contend, can a "new South" emerge—an argument that they develop across the essays in the collection. The lead essay, appropriately entitled "The Long Struggle," contends that black people were discontent with the "snail-like pace" of social and political change, and were no longer "satisfied with the age-old warning" that "you should not push things too fast."[17] Another essay on nonviolence contends that "Negroes have been told to 'wait a little longer' or 'let's not go too fast' for so long that it is ludicrous. What white men mean when they say this is 'don't push me at *all*.' To say that the time is not right for equality for all Americans is to deny all that America stands for."[18] Like this little-known collection of black southern intellectual thought, black people in the US South were pointed in critiquing the racial logics of deferral that motivate and sustain black patience. Further, like these writings, they not only contested the temporal imperatives of black patience but also rubbed up against the affective protocols of this project through the performance of an "angry" Black South.

Emerging in the year following the publication of *The Angry Black South*, the Free Southern Theater was a creative flashpoint within a vast matrix of black art, activism, and political discourse that challenged the South's violent cultures of black patience. By the time the theatre cast its lot in Mississippi, it was joining a social movement that was well-versed in the radical uses of time and affect, in the political possibilities of embodied performance, and in the brave creation of new materialisms. It was within this vibrant assemblage of performance and politics that the Free Southern Theater found in theatrical performance a radical instrument of black political action and a powerful vector of black cultural expression. The theatre added yet another node to a global culture of performance that found Afro-diasporic peoples from Selma to Johannesburg, from Mississippi to Chicago, singing, marching, preaching, shouting, and gesturing the radical refrain "freedom now," doing so over and against the world's clarion calls for black patience.

In what follows, I begin by tracing the emergence of the Free Southern Theater in the context of the 1960s local Civil Rights Movement in Mississippi. I then examine how the theatre performed and repurposed plays like Samuel Beckett's *Waiting for Godot* (1952), Ossie Davis's award-winning comedy *Purlie Victorious* (1961), and Martin Duberman's *In White America* (1964), an award-winning documentary drama. Forming the core of the Free Southern Theater's founding 1964 repertoire, the theatre's performances of these plays exposed and critiqued the racial project of black patience. Further, I explore how the theatre's use of theatrical setting—including back porches, cotton fields, and even former plantations—likewise intervened into the structures of racial time that were archived in Mississippi's plantation geographies.

As committed to aesthetic innovation as it was to using performance to reinforce the Civil Rights Movement's insistence on "freedom now," the Free Southern Theater worked to expand the political and artistic consciousness of its black southern audiences while dismantling the cruel temporalities that fueled the economies and ecologies of slavery and its afterlives. Their stages were often improvisational. Their set designs were as skimpy as their budgets. They were chased, bombed, terrorized, and—as one might expect—deemed communist. But even in the face of these remarkable circumstances, the Free Southern Theater transformed theatrical performance into a powerful genre of civil rights

activism. Like Jesse Chaney, they used the black body in performance to alter the tempo of black political action and to endow Mississippi's material geographies with new meanings, more radical potentialities, and different—even revolutionary—structures of racial time. Writing in the waning days of the Civil Rights Movement, noted black journalist Lerone Bennett, Jr. observed that it is "hard to tell time by revolutionary clocks. Everything, including time, changes in a revolutionary time, and the clocks inherited from the old regime are usually too slow or too fast." A "real revolution," he continues, "introduces a new time and a new space and a new relation to both time and space."[19] Seen this way, we can say that the Free Southern Theater was staging a revolution in the land of Dixie.

"They'll Take Drama into the South"[20]

When Doris Derby, Gilbert Moses, and John O'Neal established the Free Southern Theater, they added a new weapon to the arsenal of civil rights activism in Mississippi: black theatre. Like scores of college students and recent graduates, they embarked on a risky journey into the belly of the Jim Crow South, lending their time and bodies to the Civil Rights Movement. While Derby and O'Neal worked as field secretaries for SNCC, Moses—who had already appeared off-Broadway—was a writer for the *Mississippi Free Press* (*MFP*), a weekly civil rights newspaper. It was during an assignment for *MFP* that Moses would first cross paths with fellow activist and theatre connoisseur John O'Neal. Having already heard about Moses's interest in theatre, O'Neal encountered Moses on the campus of Tougaloo College, a historically black institution in central Mississippi, often hailed as the cradle of the local Civil Rights Movement in that state.

As if an omen for the future, the duo first met on the road to the theatre. I don't offer the road as a metaphor here, but am instead referencing a quite literal meeting on a road leading to the Tougaloo College Theatre. On assignment for *MFP*, Moses was slated to photograph students as they rehearsed for a campus production of Jerome Lawrence and Robert E. Lee's 1955 play, *Inherit the Wind*. Centering on the social and legal drama surrounding early-twentieth-century debates over creationism and evolution, the play's focus on the suppression of evo-

lutionist thought surely resonated on a campus whose activism constantly rendered its students, faculty, staff, visitors, and the institution itself vulnerable to the paranoid gaze of McCarthyism and its efforts to suppress any vestige of communism, real or imagined. On the heels of this providential encounter, Moses and O'Neal wasted little time before launching into spirited debates about theatre and aesthetics, namely the merits of comedy and tragedy. To O'Neal's mind, the tragic drama was the "highest and most noble of all art forms," a claim that Moses found utterly "absurd."[21] "Anyone who believes that must be presumptuous and ignorant," Moses retorted, before explaining that comedy was "the most perfect form."[22] Though riddled with passion, this animated exchange did not stop the two theatre lovers and civil rights activists from becoming roommates days later.

But if this friendly kerfuffle marks "the beginning of the dialogue that led to the birth of the Free Southern Theater," it was Doris Derby who supplied the "magic chord."[23] "If theatre means anything anywhere," she declared, "it certainly ought to mean something here!"[24] Derby's comment conveys a powerful faith in the place specific meanings of theatre. She names theatre's capacity to operate differently according to location and audience, "to mean something" distinct at a given site of performance. For Derby, this was especially true for Mississippi. Motivated by a shared commitment to the movement and a mutual passion for theatre, Derby, Moses, and O'Neal planted the seeds for a radical black southern theatre that would use the body in performance as a tool of civil rights activism and a mode of black artistic expression. With scarce financial resources and theatre accoutrements, the founders transformed these hopes into a fledgling but ambitious grassroots theatre that would eventually become the Free Southern Theater.

Excited about the possibility of introducing black southerners to live theatrical performance, the founders crafted a "General Prospectus for the Establishment of a Free Southern Theater."[25] This founding document frames the organization's emergence as a pivotal addition to the cultural and political arms of the movement. The theatre would "open a new area of protest [and] add a necessary dimension to the current civil rights movement through its unique value as a means of education."[26] In a "Special Report on the Free Southern Theater," the Council of Federated Organizations (COFO)—a coalition of major civil rights groups

that provided office space for the theatre—also emphasized the Free Southern Theater's connection to the movement. It concluded, in fact, that the theater was as much a "product of 'the movement' as voter registration, community centers, or the Mississippi Freedom Democratic Party."[27] As these observations and the company's prospectus suggest, a major component of the theatre's mission was to integrate theatrical performance into the already robust cultural and political landscapes of civil rights activism in the US South.[28] Like the lunch counter, the bus, the voting booth, and the street, the theatrical stage was a key site of embodied civil rights activism.

These views, however, hardly index a widespread consensus on the theatre's significance to the movement. According to Free Southern Theater actress Denise Nicholas, despite supplying housing, food, contacts, and performance venues, even SNCC harbored "mixed feelings" about the theatre's role in the movement.[29] She recalls that "some people felt theater and the arts, basically, were frivolous in the face of what needed to be done in terms of voter registration. They couldn't see how it would help or how it could be anything but a nuisance to have us running around all over the place with our sets, props, and costumes."[30] Far from a "frivolous" "nuisance," the Free Southern Theater was a vital dimension of the movement. Not only were its participants involved in movement initiatives like voter registration, but, according to Richard Schechner—a white Tulane University drama professor who served as chairman of the theatre's board of directors, and who went on to become a key architect of the field of performance studies—the movement gave the Free Southern Theater "a way of choosing [its] repertory."[31]

Curiously, the small body of scholarship that examines the Free Southern Theater is marked by a predilection to downplay the importance of the Civil Rights Movement to the theatre's political and aesthetic formation. This critical tendency is likely motivated by the theatre's decision in 1964 to transfer its headquarters from Jackson, Mississippi, to New Orleans, Louisiana, and to reground its vision, politics, and aesthetics in the rising influence of the Black Arts and Black Power Movements. This dramatic shift was accompanied by an equally dramatic call for the theatre's white participants to leave. With these changes likely in mind, one critic contends that the Free Southern Theater only "came to artistic fruition when it rejected the integrationist platform in favor

of the multiplicity of the black experience espoused by the Black Arts Movement."[32] The civil rights movement, she continues, "gave the Free Southern Theater its purpose, but not its aesthetic, because there was no aesthetic of integration."[33] This type of periodizing maneuver is emblematic of a penchant in African American literary historiography to overlook the Civil Rights Movement as a key period of black literary achievement, and a recent trend in civil rights historiography to de-center the movement's "short" or "classical" phase. To the extent that the Free Southern Theater began as a troupe with three black and five white participants, that it emerged from an integrated social movement, and that it crafted a corresponding set of "integrated" political and aesthetic practices (from its troupe and repertoire to its audiences), one is hard pressed to trivialize the importance of integration and the Civil Rights Movement to the theater's political and artistic practices. In order to reemphasize the significance of the Civil Rights Movement to the Free Southern Theater's aesthetics and politics, I will focus on its inaugural year of operation: 1963–1964. While this predates the theatre's embrace of Black Power, this phase was no less radical.

Having outlined the theatre's mission, the founders began to host workshops in the playhouse of Tougaloo College. Tougaloo was certainly an auspicious place for the theatre to launch its operations. In addition to a vibrant theatre program and a rich legacy of civil rights activism, the college was also a private institution, which allowed it to exist—as one Free Southern Theater playbill put it—"outside the jurisdiction of the state legislature."[34] But although Tougaloo was private, it was not wholly immune to state attempts to quell its participation in the movement. In February 1964, for instance, Mississippi's Lieutenant Governor demanded an investigation of the college. Two days later, the Mississippi state legislature introduced a bill to revoke the college's charter. Still, unlike its public peers, Tougaloo was not funded by the state government, so it was less vulnerable to the legislature's habit of using its purse to suppress activism on college campuses.[35]

In the spring of 1964, the Free Southern Theater began to solicit participation for its "Summer Stock Repertory Theater," announcing calls for actors, dancers, singers, directors, technicians, designers, and "angels" (people with money).[36] On this front, one of the theatre's brochures notes, "Checks should be made payable to Theater Project, Tougaloo

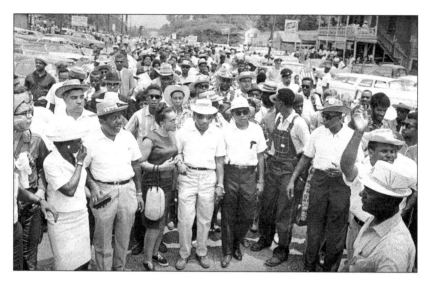

Figure 2.1. A group of prominent civil rights activists assembled in front of the gate of Tougaloo College. In the front row, left to right, are Juanita Abernathy, Rev. Ralph Abernathy, Mrs. Coretta Scott King, Dr. Martin Luther King Jr., James Meredith, Stokely Carmichael (looking back), and Floyd B. McKissick. Photo by Charles Kelly, Associated Press, 1966.

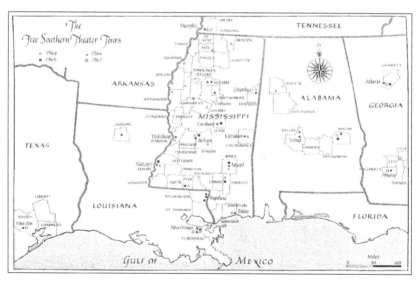

Figure 2.2. Map of Free Southern Theater Tours in the US South, 1964–1967. In Thomas Dent, Gilbert Moses, and Richard Schechner, eds., *The Free Southern Theater by the Free Southern Theater* (New York: Bobbs-Merrill, 1969), xvi.

College. We still need $15,000."[37] As the Free Southern Theater negotiated its own fiscal uncertainties, it recognized that black Mississippians' financial resources were often as scarce as their own. Thus, they decided as a general practice to forgo fees for admission. The theatre knew, too, that these financial realities would impact the nature of their stages as well as their sites of performance. A far cry from the lush theatre houses of Broadway, their stages would be the "community centers, schools, churches, and fields of rural Mississippi and of the South."[38] Though influenced by economic constraints, these performance spaces reflected and embraced the spatial realities of black southern life, while putting the South's material geographies in the service of radical performance. The theatre's considered and inventive approach to setting was as seminal to challenging the South's violent cultures of black patience as the radical aesthetics of time at the heart of plays like *Waiting for Godot* in the theatre's repertoire. Examining these relations of theatrical production alongside the Free Southern Theater's temporal aesthetics provides a clearer sense of the histories of racial time (e.g., the time of black patience, the labor time of slavery and its afterlives) contained in the shacks, cotton fields, plantations, and other spatialities that composed Mississippi's material geographies. Transmuting these spaces of anti-black violence into staging grounds for radical expressions of "freedom now," the Free Southern Theater used embodied performance to reinvest the histories of racial time archived in Mississippi's plantation geographies.

The theatre's ten-week pilot program ran from May 30 to August 22, and traveled to various cities and towns primarily in Mississippi. But the summer of 1964 was not just an ordinary summer in Mississippi. It was a time when activists staged the Mississippi Summer Project, known otherwise as Freedom Summer. This massive and daring voter registration drive combined the resources of major civil rights groups to dramatically increase the number of black voters in Mississippi. Like many of the more than 1,000 Freedom Summer volunteers, the majority of the Free Southern Theater's participants were not native southerners, but had journeyed to the US South to advance the southern arm of the movement. And their journeys took them into some of the most rural, impoverished, and unabashedly racist corners of Mississippi.

As one might imagine, the mission of organizing a radical black southern theatre in Mississippi was a brave and perilous undertaking. Only three weeks after initiating their pilot project, the theatre received a stark reminder of this reality when James Chaney, Andrew Goodman, and Michael Schwerner—an interracial coterie of civil rights activists— were arrested, kidnapped, and murdered in Neshoba County, Mississippi. When the county's deputy sheriff, Cecil Price, stopped the trio, he arrested James Chaney, the only black member of the group, on what was likely a trumped-up charge of speeding. The real crime, however, was Chaney's defiant refusal to accede to Mississippi's codes of black patience, and his radical choice to pursue the full entitlements of US citizenship "with all deliberate speed." Neither activist was seen again until their bodies were exhumed from an earthen dam in Neshoba County. As an integrated theatre expressly committed to the movement, the Free Southern Theater was rattled by these ruthless murders, a case the FBI labeled "Mississippi Burning."[39]

Even so, the theatre refused to backpedal or to ground its practices in ideologies of theatre for theatre's sake. Though the theatre was unequivocally committed to aesthetic innovation and performance technique, race and politics were integral to its platform and performance practices. Acknowledging the potentially fatal conditions awaiting prospective participants, the founders were frank about the imminent dangers of joining an integrated theatre in the heart of "Dixie." In addition to requesting applicants' name, mailing address, and present occupation, and asking if they hoped to pursue a career in theatre, the application also requested the "name, address and phone number of person(s) to contact in the event of your arrest."[40] The follow-up to this question was even more suggestive: "Would they be able to send you as much as $500 for bail bonds and fines on short notice if necessary?"[41]

Because the Free Southern Theater often performed under racial terror, these questions were certainly justified. In a September 1964 letter, for instance, actor Albert Murray writes, "The bombings in McComb yesterday fill me with rage and I wish we were ready to play now. McComb I think will be our first stop."[42] Actress Denise Nicholas recalls that in McComb someone threw a bomb at the stage, and that the troupe had to sleep under armed watch that evening.[43] The group was shocked at an Indianola, Mississippi, performance by the surprise visit of forty-

two white-helmeted police. The officers escorted a group of twenty-five white men—most likely members of the White Citizens' Council—into a Free Southern Theater production of *In White America*. While refraining from physical acts of violence, members of the group concluded that the Free Southern Theater was influenced by the Communist Party—a familiar refrain among those committed to preserving the violent cultures of black patience.[44]

In Beulah, Mississippi, an interracial group of Free Southern Theater actors was not so fortunate. After a performance, a pair of black police officers, with a rifle and revolvers drawn, stopped the unsuspecting actors. When several white officers arrived on the scene, the actors were forced to the police station, where they were not interrogated about a crime but asked questions like "What are you doing down here, Pretty Boy?" "How is that black pussy?" and "How does it feel to screw a white woman?" Finally releasing the trio at approximately 2 a.m., the police alerted the Ku Klux Klan that "two nigger lovers and a nigger were loose—'so pick them up for us.'"[45] For three hours, the actors endured "abject terror."[46] Crawling along country roads, hiding in weeds, and dodging the beams of the Ku Klux Klan's flashlights, they clawed against meeting the fate of Chaney, Goodman, and Schwerner. By some grace of fate, the actors managed to elude physical harm, though not without a visceral reminder of the dangers haunting the material geographies that the Free Southern Theater had chosen as a site of performance and a radical stage of civil rights activism. Like hundreds of other activists who put their bodies on the line for the movement, the Free Southern Theater endured violence, terror, and imprisonment for performing in the theatre of civil rights activism. Their stages and performances, however, are practically invisible in conventional histories of the movement.

Waiting in White America

The Free Southern Theater kicked off its pilot project by touring Martin Duberman's *In White America* (1964). A documentary drama, Duberman's play allowed the theatre to tap into the "power of documentation" that was changing the tide of civil rights activism in the middle of the twentieth century.[47] As the Civil Rights Movement gained international appeal in the 1950s, documentary technologies helped to capture

and circulate evidence of anti-black violence to local, national, and international audiences. In this age of rising mass consumerism and technological advancement, sensationalist images of civil rights activism were stimulating fodder for the camera, for media outlets, and for the global markets they hoped to reach. As scholars have shown, television and photography were critical to these efforts. But the Free Southern Theater's staging of *In White America* occasions an opportunity to consider other modes of documentary practice that helped to shape the movement.[48]

Further, even as activists transformed televisions and newspapers into tools of sociopolitical change, these technologies were often marshaled to solidify structures of racial power. In its founding prospectus, the Free Southern Theater addressed the impact of racial power on the production of mass media in Mississippi in particular:

> The newspapers in Mississippi are not a source of information concerning the activities of the community or of the state. The distortions of these newspapers are twofold: (1) What is not printed—any valid information about Mississippi's economics and politics; (2) what is printed—highly distorted and biased articles supporting the Mississippi "way of life." The two Negro weeklies, excluding the *Mississippi Free Press*—financed, and in one case controlled, by the same association which owns the white newspapers, fail to convey true information to the Negro community and are virtually useless and retrogressive in purpose.[49]

The founders go on to suggest that in Mississippi television is "controlled and almost never admits controversial topics."[50] Conscious of the racial and political economies of Mississippi's media culture, the founders imagined and developed a theatre that would expose black southern audiences to histories and contemporary issues that were routinely suppressed in the state's tightly controlled media. According to Denise Nicholas, furthermore, many black Mississippians "had not seen television."[51] And rampant illiteracy among this population likewise constrained their access to information in newspapers. While the world was busy consuming images of the movement through televisions and newspapers, then, many of the individuals and communities captured in these scenes lacked access to the very technologies that documented

these performances of black political action. Aware of these racial and technological constraints, the Free Southern Theater found in theatrical performance an engaging and politically expedient cultural form that could speak across varying degrees of literacy and economic conditions. Much like the living newspapers of the 1930s radical theatre movement, Duberman's documentary play exposed the limits of US democracy. And it allowed the Free Southern Theater to use the "power of documentation" to challenge the violent cultures of black patience in Mississippi and across the Jim Crow South.

Likely realizing the irony of inaugurating a black southern theatre with a play by a white northern man, the Free Southern Theater found *In White America* a "funny" choice.[52] But staging the play within black southern communities expanded, rearticulated, and linked the symbolic meanings of this work to the social contexts of black life in the Jim Crow South. Having seen a Free Southern Theater production of *In White America*, radical black civil rights activist Stokely Carmichael said it was "a play that people listened to, cried and laughed with, a play which is truly theirs."[53] The theatre's decision to begin its pilot with *In White America* was based to some degree on the play's thoughtful engagement with black patience. According to actress Denise Nicholas, the play enabled audiences to "see today's struggle as an *old* fight," and to recognize "that people had been fighting much the same way, all over the country, for a long time: for *all the time*."[54] *In White America* enabled the Free Southern Theater to stage a regionally specific challenge to black patience, a global phenomenon that, in Nicholas's words, had left black people "suffer[ing] for recognition for three hundred years."[55]

Moving from the transatlantic slave trade to the Civil Rights Movement, the historical scope of *In White America*'s plot is vast. Along these lines, its characters range from slaves to sharecroppers, from US Presidents to iconic black freedom fighters like Frederick Douglass, Sojourner Truth, Booker T. Washington, W. E. B. Du Bois, and Marcus Garvey. This broad historical setting is an especially instructive aesthetic choice, because it allows audiences to track the long history of black patience. As is common for the genre of documentary theatre, Duberman incorporates a seemingly omniscient narrator, who drives the dramatic action forward, and who brings these disparate historical moments into a clarifying relation. What remains constant across this wide histori-

cal and geographical expanse is the primacy of anti-black violence and white supremacy—whether in the form of a slave master or the Ku Klux Klan, a chain gang or a mob that works to suppress the Civil Rights Movement. As *In White America* unfolds, this vast temporal setting accrues epistemological importance insofar as it produces knowledge about slavery and its afterlives, and about the limits of waiting in a world where the repetition of anti-black violence constantly subtends the flow of historical time. The play's temporal setting therefore exemplifies the transhistorical character of black patience, or the long history of black people waiting in white America.

On this front, the opening scene is telling. Set on January 12, 1964, the dramatic action begins when one of two characters named "White Man" retrieves a newspaper from a table. Reading the date aloud, he proclaims, "If God had intended the races to mix, he would have mixed them himself."[56] In the wake of this provocative but all-too-familiar claim, other characters begin to chime in. A vital dimension of the dialogue that ensues pivots around the violent cultures of black patience. According to a second character named "White Man," "Negro impatience can be readily understood."[57] Just moments later, "Negro Man" adds to this: "After 400 years of barbaric treatment, the American Negro is fed up with the unmitigated hypocrisy of the white man."[58] When the curtain opens on *In White America*, audiences are faced head-on with the dilemma of black patience and its origins in transatlantic slavery.

In this vein, the play leaps from 1964 to the transatlantic slave trade. Duberman culls this early segment of the script from the notes of a doctor who worked aboard a slave ship in the 1700s. Describing the interval prior to leaving the coast of Guinea to start "the middle passage," the doctor explains,

> The slave ships lie a mile below the town, in Bonny River, off the coast of Guinea. . . . Scarce a day passes without some negroes being purchased and carried on board. . . . The wretched negroes are immediately fastened together, two and two, by handcuffs on their wrists and by irons riveted on their legs. They are then sent down between the decks and placed in a space partitioned off for that purpose. They are frequently stowed so close as to admit of no other position than lying on their sides. Nor will the height between decks allow them to stand.[59]

The doctor's observations highlight the centrality of time and space to the making of transatlantic slavery. They also underscore the significance of the slave trade to the racialized production of time and space. During this inceptive phase of global modernity, the transatlantic slave trade persisted as a horrific venture in organizing black people's relationships to time and space, and in rooting that association in the time-space logics of black patience. The hold of the slave ship was critical to establishing and codifying these relations. With hands and legs fettered, the newly enslaved Africans were being primed to wait and to suffer the restrictive spatialities that would come to characterize black people's spatial experiences in the New World, whether in slave cabins or in legally segregated schools. The doctor's use of "scarce a day passes" to relate these conditions underscores the everyday nature of the slave trade's extravagant violence, while gesturing toward a movement of natural time counterpoised to the slave's compulsion to remain still in the hold of the ship. The "relentless rhythm of the slave ships" stood in contradistinction to the slave's compulsory stasis.[60] These time-space dynamics—that is, the forced stillness of black bodies within environments of rapid motion—inaugurated a paradigmatic relationship between black bodies, time, and space within the context of global modernity.

While *In White America* opens with images of black bodies waiting in the hold of the slave ship, it goes on to chronicle black people's centuries-long wait for emancipation and full citizenship. In the play's final moments, audiences encounter a young black girl being taunted by a white mob: "No nigger bitch is going to get in our school. Drag her over to this tree! Let's take care of the nigger."[61] The girl's offense: like Jesse Chaney, the Free Southern Theater, and scores of civil rights activists, she dared to take seriously the US Supreme Court's (prima facie) directive to alter the prevailing racial order of the US nation-state, and to do so with "all deliberate speed."

As *In White America* reveals, one dimension of black patience entails the historical use of "the wait" as a strategy for deferring and ultimately denying black freedom. But such oppressive manipulations of time are accompanied by a powerful set of affective protocols that also aim to regulate possibilities for black being. Black patience is, then, not only about the wait, or deferral, or time. It is also grounded in a violent code of affect that strives to discipline black people by disciplining

black affective expression. The mob's tempestuous outrage for the black girl stems not only from her refusal to wait, but also from the mob's perception of this refusal as a sign of black impudence and therefore as an affront to the affective protocols of black patience. Through such depictions of "negro impatience," *In White America* shows how during the Civil Rights Movement black people were becoming increasingly averse to black patience. Armed with centuries of evidence that black patience fuels anti-blackness and white supremacy, Negro Man and Negro Woman close the play with a vision of black life unencumbered by the strictures of black patience:

> NEGRO WOMAN: We can't wait any longer.
> NEGRO MAN: *Now* is the time.[62]

The play therefore resolves itself with a vigorous rejection of black patience and a spirited embrace of Afro-presentism. It leaves audiences with a portrait of black people who insist upon enjoying the good life "now" rather than deferring that enjoyment to the time of the "not-yet-here."

Blackness, Time, Geography

In choosing Mississippi as its primary site of performance, the Free Southern Theater chose a space haunted by legacies of slowness and anti-blackness, one that exists as the US nation-state's iconic geography of black patience. When Denise Nicholas arrived in Mississippi "alone and scared," she felt that she had "landed on another planet or stepped back in time."[63] Mississippi was, for Nicholas, an unearthly geography, ensnared in a primitive sense of time. The state certainly registered in this way for black singer and civil rights activist Nina Simone. In her now classic civil rights anthem "Mississippi Goddam," Simone meditates on the storied geographies of black suffering that make up the US Deep South. Draping her sharp condemnation of racial violence in the garb of a "show tune," she sings, "Alabama's gotten me so upset / Tennessee made me lose my rest / And everybody knows about Mississippi goddam."[64] In Simone's "civil rights song," Mississippi emerges as the exceptional site of anti-black violence, what we might call the ur-scene

of subjection.[65] Whereas Alabama and Tennessee are rendered unruly southern states, or villainous geographies that leave Simone restless and "upset," it is finally Mississippi that occupies the role of accursed titular character in Simone's Deep South drama of anti-blackness and white supremacy. These designations lend meaning to the song's title and refrain: "Mississippi Goddam."

By the time Simone released "Mississippi Goddam" in 1964, there was no shortage of anti-black violence in Mississippi, Alabama, or Tennessee. In fact, if the assassination of prominent Mississippi civil rights leader Medgar Evers compelled Simone to finish sheet music for this anthem in under an hour, the other force driving the artist to complete "Mississippi Goddam" with such startling urgency was the highly publicized murders of Addie Mae Collins, Denise McNair, Carole Robertson, and Cynthia Wesley: four black girls who were murdered when a bomb exploded at the Sixteenth Street Baptist Church in Birmingham, Alabama, a local bastion of civil rights activism.[66] Such attacks were frequent in Alabama and Tennessee and were backed by a violent assemblage of laws, customs, and behaviors that aimed to suppress the movement and to breathe new life into the South's violent cultures of black patience. And yet, in Simone's "civil rights song," Mississippi alone emerges as the exceptional site of anti-black violence.[67]

This paradigmatic rendering of Mississippi as the essence of racial violence has pervaded the global imagination. As the Civil Rights Movement developed, the state became a vital element of political discourse and a touchstone in the global geopolitical imagination. Consider, for instance, Malcolm X's claim that the United States should "get Mississippi straightened out before we worry about the Congo."[68] On yet another occasion, the leader argued that Mississippi is "anywhere south of the Canadian border."[69] In these striking geographical claims, X captures the national character of anti-blackness and white supremacy. He posits racialized oppression as a national phenomenon unbound by state or region. In doing so, however, he configures Mississippi as *the* exceptional geography of racial violence, and ultimately conscripts the state into shouldering the weight of a nation historically complicit in anti-blackness and white supremacy.

As Simone's "Mississippi Goddam" and Malcolm X's speeches suggest, during the Civil Rights Movement, Mississippi was a well-used emblem

for the scale of anti-black violence plaguing the Jim Crow South and the US nation-state more broadly. In framing Mississippi as ground zero of anti-black violence, Simone and X gesture toward a wider structure of feeling that developed and thrived in the social and semiotic processes of producing Mississippi as geographic fact. Rooted in a deep history of racial violence and a powerful set of ideological assumptions, this geography-based feeling has wrought Mississippi into a knowable and a commonly known geographic being. To quote Simone: "everybody knows about Mississippi Goddam." But what is it that they know? How did they come to know it? And how does everybody know about Mississippi, but not Tennessee and Alabama—or for that matter the total experiment known otherwise as the United States of America? These questions are not an effort to downplay the gratuitous forms of anti-black violence that have structured Mississippi's racial order and sustained its uneven distribution of rights and resources. They are intended instead to highlight the convergence of geography and semiotics, of power and epistemology, of repetition and the performative production of geographic being. What I am calling attention to are the historical and discursive processes that infuse material geographies with ontological meaning; to how Mississippi, in particular, has come to be hailed as the US nation-state's most iconic geography of black patience. In this way, we might rearticulate Frantz Fanon's now classic "Look, a Negro" as "Look, Mississippi."[70] Whereas black flesh has historically been perceived as excess, or racialized matter that exceeds the norm, Mississippi likewise exists in the social imaginary as the epitome of geographic excess. If the visual command "Look, a Negro" ushers the "Negro" into being as such, which is to say as racial Other, in this alternative scene of hailing, fantasies of geographic otherness, and the regimes of imaginative geography[71] that breed them, form a compelling analogue for understanding how power and discourse collaborate to produce difference and, in this instance, to curate Mississippi as an unusually "abjected regional other."[72]

But alongside these discursive machinations, Mississippi has also come into being through a knotty assemblage of social, political, legal, and economic systems—whether slavery, Jim Crowism, or the gross theatrics of lynching—that have not only spawned the imposition of an aberrant geographic singularity, but have effectively organized relation-

ships between black people and Mississippi's plantation geographies. As Charles Wakefield said to Jesse Chaney, "Nigger, don't you know you're in Mississippi?" There is a long catalogue of racially segregated spaces (e.g., lunch counters, buses, parks, pools, schools, neighborhoods, churches, and courtrooms) that have defined and reinforced the precarious and often prohibitive relationships between black people and Mississippi's material geographies. Mississippi therefore exists as a geographical instantiation of what performance theorist Robin Bernstein has called a "scriptive thing." According to Bernstein, material objects often contain a set of culturally specific "invitations" that affect—or script—how individuals relate to a given object. Under the historical conditions of slavery and its afterlives, Mississippi's physical landscapes exist as a scriptive thing. Conditioned by the state's racialized modes of governmentality and the pillars of anti-blackness that support them, Mississippi's material geographies have historically bent to the contours of racial-spatial inequality, and have therefore proscribed relations between themselves and those who desire and pursue an encounter with the (geographical) object.

Such relational dynamics between race and space, blackness and geography were certainly alive when the Free Southern Theater pitched its tent in Mississippi during the Civil Rights Movement. In making the back porches of shacks, cotton fields, and former plantations some of its primary sites of performance, the Free Southern Theater chose performance spaces that were teeming with histories of anti-black violence. They adopted stages chock-full of ontological meaning. They planted roots in grounds that had long scripted the ways that black people could inhabit their racially restrictive spatialities. And yet, even as scriptive things inflect user interaction, they remain "open to resistance, interpretation, and improvisation," to "live variations that may not be individually predictable."[73] Despite the "scripts" of anti-blackness and the conditions of black patience that have historically defined Mississippi's material geographies, the Free Southern Theater used embodied performance to unsettle the authority of these scripts, and to encourage black southerners to forge new and more radical relationships to Mississippi's plantation geographies. This radical practice of rescripting racially exclusive spaces was a hallmark of black political culture in the Civil Rights Movement. Just as the Free Southern Theater shunned the

"invitations" of Mississippi's racially situated geographies, other activists likewise refused the invitations of segregation signs, for instance, that sought to regulate how black people could relate to and inhabit southern space. What links the Free Southern Theater to these more widely remembered and celebrated forms of protest (like the sit-in) is that they all mobilized embodied performance to forge new relationships to their material environments, to alter the ontology of southern space, and ultimately to rewrite the scripts of race, time, and black embodiment that were etched into the grounds of Mississippi and into the geographies of the Jim Crow South.

Because the Free Southern Theater so often used outdoor settings, I am especially interested in the racialized histories of southern land and the modes of geographic being—both human and nonhuman— they engendered. I wish to consider how these geographic histories and modes of being interfaced with the novel political and aesthetic experiments that the Free Southern Theater piloted on these very grounds, the same grounds that Nina Simone would find troubling enough to damn. In effect, I will approach Mississippi's material geographies as forms of nonhuman matter that are as open to the currents of racialization and performativity as the production of human identity. If southern geographies can be said to possess being, this being has been forged in the crucible of slavery, and preserved by the repetitions of racial exclusion that its afterlives continue to enact. Even still, Mississippi's fraught geographies afforded the Free Southern Theater a fertile ground for staging new possibilities for being both black and southern, for building radical black political futures, and for crafting "new geographic stories."[74]

What holds my attention in this regard is the role of time in the interrelation between southern geographies and black performance, between black political aesthetics and the global signifier "Mississippi." To be sure, the historical intersection of race, time, and geography finds its roots in slavery and colonialism, and survives in the contemporary structures of anti-blackness and racial capitalism that they have helped to sire. More precisely, the historical extraction of black labor to fuel modernity's uneven accumulations of capital—whether through slavery, sharecropping, or the chain gang—has worked to produce and racially order southern land, and to imbue these regional geographies with racial and ontological meaning. Time is critical to the social production of

southern geographies and to the racial order that it labors to protect and reproduce. In the interface between time and geography, we discover an important truss in the infrastructure of anti-black oppression as well as the historical enterprise of black patience.

As scholars working in the interdisciplinary field of time-geography have acknowledged, the experience of time and space is crucial to the making of society and informs possibilities for being human. At the intersections of time and geography, we can glean the importance of time to defining western conceptions of the human—and to orchestrating transatlantic slavery and its afterlives. More specifically, the confluence of time and space that motivates critical concerns in this field is especially useful for analyzing the time-space configurations that structure racial experience in the Jim Crow South.[75] Zooming in on the temporal dimensions of physical environments, the time-geographic framework foregrounds "the conditions which space, time and environment impose on what the individual can do."[76] For geographer Torsten Hagerstrand, widely credited as the architect of the time-geographic approach, the "life-paths" that objects and humans take as they move from one point in space to another influence the experience of social life. But these paths or movements between "stations" are affected by "constraints," which not only impede travel through space but also control and limit one's ability to access stations. On this front, Hagerstrand outlines three categories of constraints: capability, coupling, and authority. Whereas capability constraints emphasize the limits that biology might pose (e.g., one needs sleep), coupling constraints acknowledge "where, when, and for how long, the individual has to join other individuals, tools, and materials in order to produce, consume, and transact."[77] Finally, authority constraints account for those "domains" or "control areas" in which movement through time-space is regulated, for example, by law and social custom.

When considered through the valence of black life, however, each of these restrictions on movement through time-space is always already encumbered by the weight of an authority that finds its muscle in the production and preservation of racial difference and in the social transformation of that difference into uneven distributions of power and capital. As scholars like Thadious M. Davis, Clyde Woods, Katherine McKittrick, and Rashad Shabazz have shown through their scholarship

in the field of black geographies, race is foundational to the production and experience of space, and space is likewise fundamental to the production and experience of race. As McKittrick puts it, "black matters are spatial matters."[78] I would add to McKittrick's illuminating claim that black matters are *temporal* matters as well.

With this interconnection of race, time, and space in mind, we recognize that, when distilled to their most basic social operations, for black people Hagerstrand's categories of constraint are inextricably linked to the proscriptions of racial authority. Taking the constraining capabilities of biology as an example, more than a lack of sleep, for instance, the possession of black flesh is the most limiting biological constraint one encounters while navigating the social fiction of race and the "stations" this biologized fiction creates. Now, to disregard the deprivation of sleep that pressures and strains black life under modernity's extractive regimes of labor domination would be a grave oversight. But it bears emphasizing that for the victims of world systems like slavery and its afterlives, even sleep deprivation, a "capability constraint," is at the same time also an authority constraint—one inseparable from, and attributable to, the fact of blackness and the structures of racial authority that ground that fact in the material geographies of black flesh. We can say then that within the racial order of global modernity, and in the Jim Crow South more specifically, black flesh is rendered a dynamic constraint that impinges upon the time-space experiences and the life-paths of black people, a reality made clear in the Free Southern Theater's production of *In White America*.

Rescripting Mississippi's Plantation Geographies

As black southern audiences sat in cotton fields, around porches, and on the grounds of former plantations to experience plays like *In White America*, they forged a different relationship with the storied geographies of Mississippi and the Jim Crow South. Mounting exhilarating, sometimes confusing, but always community-centered performances, the Free Southern Theater furnished a cultural and political conduit for black southerners to challenge the "hierarchies of power inherent in physical spaces," and especially in Mississippi's plantation geographies.[79] Its novel experiments in and with the "black outdoors" enabled its audiences to stage a local challenge to the global phenomenon of

black patience by reelaborating the racial histories of time archived in Mississippi's social and material geographies, particularly their histories of anti-black violence and labor exploitation.[80] In doing so, the theatre not only revamped the temporal and affective character of a state and a region, but helped to alter the ontology of southern time, of southern space, and of black southern identity itself.

In a 1964 article that appeared in *The Nation*, journalist Elizabeth Sutherland provides an account of how black southerners received the Free Southern Theater's production of *In White America*. She recalls that "much of the irony and humor eluded them," and that they occasionally laughed when they were not supposed to, or vice versa. Sutherland observes further that they clapped equally for Booker T. Washington delivering his conservative "five fingers speech" and for Black Nationalist Marcus Garvey. "Members of the audience who started to join in singing with the cast," she notes, "would sometimes be hushed by others more decorous."[81] These kinds of visceral and improvisational irruptions are precisely what the Free Southern Theater's founders had in mind when envisioning the distinctive functions and characteristics of a radical black southern theatre. In fact, the theatre's audiences were invited to partake directly in the dramatic action. "You are the actors," John O'Neal exclaimed. At a Greenville, Mississippi, performance, one audience member decided to test O'Neal's proclamation. In a bold act of improvisation, he interrupted the production and took a spot on the stage. But language eluded this ambitious audience-member-cum-actor, as he stood there perhaps excited but ultimately speechless. Elsewhere, audience members shouted: "That's right!" "Amen!" "You tell it!"[82] Sutherland writes of Ruleville, Mississippi, resident and civil rights activist Fannie Lou Hamer, "There was no need to tell her 'you are the actors,'"—Hamer needed no encouragement to add her voice to the theatre's performances.[83]

The walls between audience and performer were productively blurred during the Free Southern Theater's live performances. This intentional maneuver allowed the theatre to curate a thick sense of *communitas*, and to forge intimate relationships with its black southern audiences, whom they described as "articulate" and "active."[84] "No one who has seen a FST performance," they assert, "can fail to recognize that the audience is the most important and expressive element in it. If the FST can ever

match the beauty and virility of its audience it will be a great theater."[85] That audiences' responses often moved against conventional protocols of audience behavior should not have warranted Sutherland's barely muted condescension. These nonstandard modes of audience reception are better regarded as performance practices that resonate with the call-and-response and the testimonial aesthetics of black religious practices; they are the dissonance and riffs of jazz performance; they are the blues and the cathartic releases made possible in and through this musical art form that, like the Free Southern Theater, was forged within the oppressive geographies of rural Mississippi.

While the founders of the Free Southern Theater worked to build performance environments that were rooted in black southern culture, their settings were equally grounded in Mississippi's physical geographies and built environments and thus in the configurations of racial power that these spatialities signified and reinforced. This was certainly true for the company's 1964 performances of *In White America*. Throughout this opening season, productions were generally "simple—with a few lights and one platform."[86] And because the theatre often used outdoor, afternoon settings, even these lights were sometimes unnecessary. This was the case at a performance in Holmes County, Mississippi, where audience members had traveled "from the farms" to attend a production of the show but wanted to "get back home by dark."[87]

Such vibrant synergies between performance and geography, theatre and environment, were also apparent at a lively production of *In White America* in Ruleville, Mississippi. The stage for this performance was the back porch of a shack, a space that certainly resonated with the theatre's largely poor black southern audiences. Conjuring up memories of the slave cabin and signifying the stark economic inequalities that black southerners have faced historically, the porch of a shack might seem an unlikely and even undesirable site of performance. But by reinvesting this historical spatiality, the Free Southern Theater creatively wove the architecture of black southern life into the setting of their live performance. In the US South, porches have historically functioned as a valuable arena for black cultural production and communal formation. In addition to serving as "stages for interactive storytelling" or a "gallery seat" for watching the goings-on of a town, porches have also been critical to developing an "alert political community," an outcome

that was pivotal to the Free Southern Theater's founding vision.[88] Seen from this vantage point, the back porch of a shack is something more than a makeshift stage. It exceeds the results of any calculus that would limit its being to a material sign for black deprivation. In transforming the back porch of a shack into a radical site of performance—of black political participation and community engagement—the Free Southern Theater converted this historical site of inequality into a generative space of "radical openness."[89] Thus, even as the porch continued to conjure up specters of plantation slavery, and to embody capitalism's uneven and racialized distributions of wealth, the social meanings and the ontology of the porch were transformed in the moment of live performance, affording the porch, the shack, and black southern audiences another way of being in the world and of relating to Mississippi's traumatic geographies.

If the stage for this performance was unconventional, the seating was as improvisational and attuned to the material geographies of the US South. Audience members not only sat on cots, benches, and folding chairs, but some even watched the production while sitting on the ground. Here I want to linger for a moment on this seemingly trivial but supremely evocative performance of *sitting on the ground*. To sit on the ground in this instance—whether sitting on a bench, a cot, or directly on the land—is to stage a haptic encounter between black southern bodies and southern land—to gather the signs and histories of these material geographies into an important relational proximity that disturbs the historically violent relationship between black-south bodies and Mississippi's plantation geographies.[90]

Scholars working in the field of New Materialism have persuasively argued that "history is no longer simply the history of people" but also the "history of natural things."[91] Along these lines, I am interested in the histories of anti-black violence and the violent histories of racial time enfolded in Mississippi's material geographies. Here I want to zoom in on a key dimension of this particular history of the natural thing, one that exposes the role of race and time in that historicity: that is, the laboring black body within the South's plantation economy. Under the brutal conditions of slavery, sharecropping, the chain gang, and other racialized systems of labor domination, the black-south body has consistently been forced to work quickly, or to move to the crushing labor time of racial capitalism. Theorizing what he calls "clock-regulated slave

labor," historian Mark M. Smith explains that the clock became "the planters' weapon of choice in their on-going battle with their chattel."[92] Clock time therefore operated as a modern "weapon" of anti-blackness that hardened the master/slave binary while fortifying the structures of racial power that define this relation. When considered from this vantage point, "all deliberate speed" is better regarded as a guiding principle of black labor exploitation than a juridical, liberal democratic intervention into the US nation-state's racialized politics of time and space.

This tension between the quick time of black labor and the slow time of black rights is a hallmark of global modernity. It is one dimension of an abiding paradox that has aided western modernity in establishing a violent and paradigmatic relationship between blackness and time, namely as a way to produce black suffering and to maximize the acquisition of profit and racial power. This aporia in the racial timescapes of the modern world has been an especially salient feature of the Jim Crow South and of Mississippi in particular. Black artists like Nina Simone and Langston Hughes have consciously turned to black expressive culture to capture this historically fraught triangulation of race, labor, and time in Mississippi and across the Jim Crow South. In "Mississippi Goddam," Simone sings an especially illuminating verse:

> Don't tell me
> I tell you
> Me and my people just about due
> I've been there so I know
> They keep on saying "Go slow!"
>
> But that's just the trouble
> "too slow"
> Washing the windows
> "too slow"
> Picking the cotton
> "too slow"
> We're just plain rotten
> "too slow"
> We're too damn lazy
> "too slow"

The thinking's crazy
"too slow"
Where am I going
What am I doing
I don't know
I don't know[93]

Here, the black body's primary relationship to the spatial environment pivots on the violent extraction of its labor. Time and space converge to choreograph the movements of the laboring black body, and to adjust its rhythms and spatial experiences to the tempos and desires of racial capitalism. As Simone references forms of black labor—picking cotton and washing windows—the background vocalists respond to each of these references with "too slow." In this call-and-response, Simone and her background singers unfurl a historical affiliation between blackness and time, or more precisely between time and modernity's exploitation of black labor. Under these conditions, black workers are routinely disciplined for working "too slow," and accused of being "rotten" and "too damn lazy." Simone's blistering lyrics reveal how regimes of anti-black oppression not only "spatialize blackness," but *temporalize blackness* as well.[94]

As Simone demonstrates, these demands for the quick time of black labor stand in contradiction to global demands for the slow time of black rights and revolution. Whereas racial capitalism perceives slow black work as a threat to the maximization of profit and racial power, it likewise perceives the quick time of black freedom as a danger to white power and capital accumulation:

You keep on saying "Go slow!"
"Go slow!"

But that's just the trouble
"too slow"
Desegregation
"too slow"
Mass participation
"too slow"

Reunification
"too slow"
Do thing gradually
"too slow"
But bring more tragedy
"too slow"

Black people are ordered to "pick cotton" and to "wash windows" rapidly, but they are instructed to "go slow" in their fights for "desegregation," their attempts at "mass participation," and their overall campaign to construct societies that honor and protect black people's access to full citizenship.

Langston Hughes—who gave the Free Southern Theater its first monetary contribution—also weighed in on these tensions between the time of black labor and the time of black freedom. In one of his wildly popular "simple stories" (which appeared as weekly columns in the *Chicago Defender* from 1943 to 1965) entitled "Wigs. For. Freedom," Minnie—a cousin of Hughes's famed protagonist, Jesse B. Semple—observes, "When I was down South picking cotton, didn't a soul tell me to go slow and cool it. 'Pick more! Pick more! Can't you pick a bale a day? What's wrong with you?' That's what they said," she exclaims. "Did not a soul say, 'Wait, don't over-pick yourself.' Nobody said slow down in cotton-picking days. So what is this here now? When Negroes are trying to get something for themselves, I must wait, *don't demonstrate*? I'll tell them big shots, 'How you sound?'"[95] Simone and Hughes highlight how time ("wait") and affect ("cool it") converge to produce race and to shape racial relations by regulating black people and their relationships to their material environments. In the context of plantation slavery and its afterlives, then, the history of people is always already a history of natural things; and the history of natural things is always already a history of people. In this way, the South's material geographies function as key repositories for the racialized histories of time and the lived experiences of black-south bodies that have been forced to work and to move to the extractive rhythms of racial capitalism—to the tempos of slavery and its afterlives.

And yet, whether aestheticizing time in art or using time as a philosophical and rhetorical building block of black political discourse, black

artists, activists, and everyday citizens have used time to unsettle the violent enclosures of black patience. In the final moments of Simone's civil rights song, for example, Simone imbues the line "too slow" with new meaning. Rather than issue from the stewards of racial capitalism managing the tempos of black labor, in this instance "too slow" belongs to and emerges from the lexicon of black political dissent. Inverting and radically reengineering modernity's exploitative grammars of slowness, Simone uses the temporal logic of delay to formulate a profound critique of black patience. Her radical refusal of black patience is as evident in the exigencies of the song's production as it is in the textures of its sonic aesthetics. In this regard, Simone writes,

> I had it in my mind to go out and kill someone, I didn't know who, but someone I could identify as being in the way of my people getting some justice for the first time in three hundred years. In this vein, I sat down at the piano. An hour later I came out of my apartment with the sheet music for 'Mississippi Goddam' in my hand. It was my first civil rights song, and it erupted out of me quicker than I could write it down.[96]

Infuriated by the cultures of black patience that had robbed her "people" of justice for "three hundred years," Simone created "Mississippi Goddam" with a profound sense of impatience and urgency. The song marks a sonic straining against the temporal and affective protocols of black patience. This searing ambience of speed and anger redoubles in the hurried, staccato cadences of the song's instrumentals and its rapid tempo. It is as if the song itself is performing impatience and demanding "freedom now."

Similar to Simone's creation of "Mississippi Goddam," the act of sitting on the ground at Free Southern Theater performances was a meaningful engagement with time. In a labor economy that overrepresented black Mississippians in jobs that required long hours and physically exhausting work (like sharecropping), time was a valuable resource. Thus, attending a Free Southern Theater performance meant that laundry was deferred. Cooking had to wait. Managing the garden was delayed. Black southerners' attendances at these performances were, then, willful uses of time that challenged a historical aversion to black people's temporal autonomy. Like the performance of sitting-in, the act of sitting on the

ground was an agential exercise in waiting, one that creatively repurposed the wait by putting it in the service of black leisure and radical black political aesthetics. In this suggestive convergence of dark matter—of dark southern soil and black southern flesh—the subject who sits on the ground rubs up against and revamps the racial histories of time archived in Mississippi's plantation geographies. In this moment of live performance, the audience suspends labor, body, and reality to tarry in the theatre's imaginative flights. Considered alongside histories of slavery and colonialism and their substantive constraints on possibilities for black leisure, the willful act of sitting on the ground to experience a play is a meaningful and politically significant performance and experience of time that troubles and recasts black people's historical relationships to the South's social and material geographies.[97] In this way, Free Southern Theater audiences staged an embodied intervention into the time-space of the South's plantation geographies, the clock time of racial capitalism, and the repeating temporalities of slavery and its afterlives. Forging a different relationship to these traumatic geographies and to modernity's structures of racial time, this embrace of black leisure constitutes an act of "stolen time or time stolen (back)."[98]

The performance of black leisure does not wholly disassemble the violent infrastructure of racial time. We might recall, for instance, the Holmes County, Mississippi, performance at which the audience wanted to "get back home by dark."[99] The wish to return home before "dark" was, for many of them, likely rooted in having to begin the work of sharecropping early the next morning, or, even worse, in their consciousness of how the threat of racial violence increased as time passed and as darkness neared. Because the Free Southern Theater's repertoire so boldly bucked the violent cultures of black patience, this threat was exacerbated on the heels of attending the theatre's performance. In the hours following *In White America*, the grounds of black leisure would soon become a theatre of black labor exploitation and quite possibly a stage for murder. Acknowledging this interconnection of white racial violence, black death, and Mississippi's plantation geographies, Fannie Lou Hamer dubbed Sunflower County—the site of many Free Southern Theater performances—"the land of the tree and the home of the grave."[100] As the theatre would come to learn, Hamer's adage was as true for other regions in Mississippi as it was for Sunflower County. They

gained a clearer sense of this stark reality when James Chaney, Andrew Goodman, and Michael Schwerner were murdered and found buried in the grounds of a Mississippi dam. Not only did the theatre cancel its August 7, 1964, performance to observe the slain activists, but they added a section to their production of *In White America* that wove these murders into the plot, exploiting theatre's formal capacity to respond to the moment of the now.

In taking time to sit on the ground, the Free Southern Theater's black southern audiences managed to eke out from the ephemeral moment of live performance a moment in the Afro-present that was both entertaining and politically generative. Whatever the dimness of their pasts or the uncertain promises of their futures, the transient moment of live performance enabled them to forge a different relationship to Mississippi's plantation geographies by tapping into the radical potential of the black outdoors. This act of sitting on the ground was, for many of the theatre's audiences, a vector to black joy, laughter, community, and political possibility. Using the wait to imagine and to create the South otherwise, it fostered a performance environment that challenged the violent protocols of black patience.

Staging "Divine Impatience" in the Cotton Field

When the Free Southern Theater staged *In White America* in Milestone, Mississippi, the community center hosting the production was missing its walls, and the stage stretched into a cotton field. Like the porch, southern fields were a staple site of performance for the theatre. This was especially the case for its production of Ossie Davis's 1961 satiric comedy, *Purlie Victorious*. Similar to *In White America*, *Purlie*'s temporal and spatial settings are key to understanding the transhistorical workings of black patience and the racialized time-space of Mississippi's plantation geographies. The script notes that the place is the "cotton plantation country of the *Old South*," while the time is "the *recent past*."[101] Most of the action takes place within "an *antiquated*, run-down farmhouse."[102] Stage props like "an old dresser" similarly conjure a setting in which the past lingers as animate present.[103] As the plot develops, the temporal setting "recent past" comes to highlight the visceral proximities between slavery and its afterlives.

The first actor the audience meets is the eponymous protagonist, Purlie Judson, who later renames himself Purlie Victorious. "Tall, *restless*, and commanding," Purlie is "consumed with . . . *divine impatience*," a radical affect that recalls the "Negro impatience" at the center of *In White America*.[104] Purlie's palpable aversion to waiting signals his staunch resistance to the violent enclosures of black patience. Set in fictional Cotchipee county in the "cotton plantation country" of Georgia, *Purlie* bears a striking resemblance to John Oliver Killens's *'Sippi*. In both works, the plantation form continues to structure society in the wake of plantation slavery. And they both frame sharecropping as an especially brutal genre of slavery's afterlives. Whereas Charles Wakefield was the boss of Wakefield County in *'Sippi*, in Davis's play Ol' Cap'n Cotchipee is the master of Cotchipee County. "You see that big white house, perched on top that hill with them two windows looking right down at us like two eyeballs?" Purlie asks. "That's where Ol' Cap'n lives. . . . And that ain't all," he continues: "hill and dale, field and farm, truck and tractor, horse and mule, bird and bee and bush and tree—and cotton!—cotton by bole and by bale—every bit o' cotton you see in this county!—Everything and everybody he owns!"[105] That nearly the entirety of Cotchipee county's material geographies is owned and controlled by one man is striking. Even more shocking is Purlie's claim that Cotchipee owns "everybody." During a post-slavery moment in which trafficking in human bodies was outlawed, such a statement might seem hyperbolic. But one cannot ignore the ruses of power and the tricky calculus that kept scores of black sharecroppers indebted to landlords, and thus confined to peonage, well into the middle of the twentieth century. As Purlie so aptly puts it, "the longer you work . . . the more you owe at the commissary; and if you don't pay up, you can't leave."[106] These conditions of entrapment worry any neat division between slavery and freedom. And they illuminate how such violent suspensions of black bodies in time and space ("the longer you work" / "you can't leave") endure in the wake of slavery.

While these conditions had prompted Purlie to migrate from Georgia twenty years prior, the native son's desire to reclaim Big Bethel—a historical black church that was pilfered by Ol' Cap'n Cotchipee—inspired his return. When Purlie fails to recover Big Bethel, Charlie, Ol' Cap'n Cotchipee's liberal-leaning son and civil rights sympathizer, registers the deed to Big Bethel in the name "Purlie Victorious Judson." Charlie's act

of betrayal deals a lethal blow to his father. On the one hand, Cotchipee's death could signal a vanishing of the South's plantation geographies, or a dismantling of the "big white house" and the plantation society that it represented and struggled to preserve. On the other hand, according to Purlie's brother Gitlow, Ol' Cap'n Cotchipee was "the first man [he] ever seen in all this world to drop dead standing up."[107] That Cotchipee dies while standing hints at the possibility of a resurrection, of a renewal that would breathe new life into the South's plantation geographies and its violent cultures of black patience.

With its fusion of political awareness, black sermonic aesthetics, slapstick comedy, gospel music, and a setting that was intimately familiar to black southerners, *Purlie Victorious* was a hit among Free Southern Theater audiences. In the words of Gilbert Moses, *Purlie* "laid the audience in the aisles with laughter."[108] As was often the case, the Free Southern Theater performed *Purlie Victorious* in outdoor, makeshift theatres. This decision was sometimes not by choice, but made out of necessity because the original site of performance had been sabotaged by violent acts of white terror, acts that were nothing less than savage demands for black patience. In a 1964 letter to its New York Fundraising Committee, the Free Southern Theater writes of one such instance:

> Last month in Indianola we gave an outside performance of PURLIE VICTORIOUS. We set up our playing area on a field next to the Indianola Freedom School which had recently been condemned by city officials due to a fire which had 'mysteriously' broken out in the building. COFO workers say that firemen watched the building burn, and that after finally deciding to put the fire out, they destroyed a lot of equipment in the building with water hoses and axes.[109]

The mysterious destruction and subsequent condemning of the Freedom School-cum-theatrical site of performance was a material injunction for black people to adhere to the violent protocols of black patience.

Still, the Free Southern Theater transformed this scene of racial terror into a site of empowering, comedic performance. They argued that the outdoor setting was "especially appropriate for the character Gitlow who . . . literally ran on stage from the cotton field spewing cotton from his pockets."[110] Recalling this particular performance, Denise Nicholas

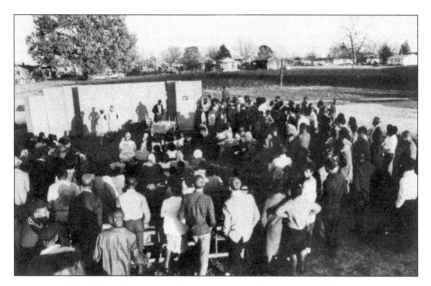

Figure 2.3. The FST performing *Purlie Victorious* outdoors in a small Mississippi town, 1965. Photo by Matt Herron, *The Drama Review* 12, no. 4 (1968): 74.

writes, "In one town we performed the play right next to a cotton field. There's a scene where a character comes running through the rows of cotton pitching cotton bolls into the air. It was real cotton." She adds that *Purlie* "allowed for another way of venting—through comedy—and people loved it. They laughed and laughed."[111] Not only does this performance revamp the meaning of the cotton field by challenging the "exchange-value/use-value binary,"[112] but the access to laughter and political awareness afforded in the act of sitting on the ground rubbed up against the exploitative histories of black time that were etched into the cotton fields and cotton bolls that served as stage and prop for the theatre's radical performances. The audience's laughter in the moment of live performance was an act of joy; a transitory reprieve; a performance of fugitive affect. It was an inhabiting of the Afro-present that strained against the temporal and affective protocols of black patience.[113] This was the making of revolution. It was a sitting, a laughing, a performing, and a practicing of *communitas* that moved over and against modernity's historical regulation of black time and black affect.

Waiting for Godot in Mississippi

I want to pivot now to what was perhaps the Free Southern Theater's most explicit engagement with black patience: its production of Samuel Beckett's 1952 classic, *Waiting for Godot*. While Beckett's high modernist play might seem a curious choice to stage in black southern communities that were habitually deprived of substantive formal education, it was, in many ways, the perfect play. Whether being staged in Sarajevo to protest the cruelty of Serbian Soldiers, in Haifa to critique the Israeli State, in Japan to resist the enclosures of patriarchy, or in post–Hurricane Katrina New Orleans to spotlight the racialized negligence of the US government in the wake of a natural disaster, Beckett's play has long been a rallying cry for the oppressed. Further still, the Free Southern Theater's production of *Godot* came in the wake of at least three productions with all-black casts in Boston, South Africa, and even on Broadway. But the production that inspired the Free Southern Theater to stage *Waiting for Godot* was presented at the infamous Alcatraz prison in San Francisco, California. It was this production that convinced the theatre that the play "would be readily understood and welcomed in that larger prison, Mississippi."[114]

The Free Southern Theater placed *Waiting for Godot* on a double bill with *Purlie Victorious* in its fall 1964 season. Like *Purlie*, the setting of Beckett's play bears a striking resemblance to the material geographies of the US South. The details that Beckett gives in this regard are sparse but telling: the play is set on a "country road," the time is evening, and there is a tree.[115] The country road not only resembles the southern geographies upon which the Free Southern Theater performed, but also symbolizes possibilities for movement through time and space. Such movements, the play reveals, can be both forward and backward, not to mention the possibility of stasis. Indeed, the play ends where it begins. This uncertain mixture of possible paths captures how, for black people in particular, bouts of progress have routinely been followed by large-scale regressions, even as time marches along.

The time-conscious dynamics of Beckett's plot accorded with and underscored the game of waiting for full citizenship that black southerners had been playing for over a century. The central conceit of *Waiting for Godot* is that Vladimir (played by Gilbert Moses) and Estragon (played

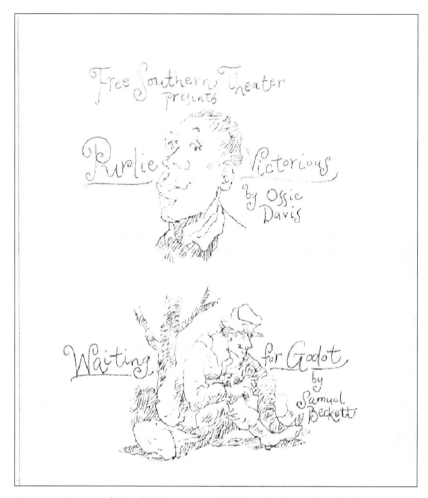

Figure 2.4. Program for *Purlie Victorious* and *Waiting for Godot*, Free Southern Theater, 1965. Free Southern Theater Papers, 1960–1978, Amistad Research Center, Tulane University, New Orleans.

by white actor Murray Levy), Beckett's two campy protagonists, are trapped in a cycle of waiting for the arrival of one Mr. Godot:

> ESTRAGON: He should be here.
> VLADIMIR: He didn't say for sure he'd come.
> ESTRAGON: We'll come back tomorrow.
> VLADIMIR: And then the day after tomorrow.

ESTRAGON: Possibly.

VLADIMIR: And so on.[116]

Interestingly, the duo is anticipating the arrival of a person who has made no promises to come. But even in the face of their uncertainties about his impending arrival, they agree to return "tomorrow. . . . And then the day after tomorrow. . . . And so on," entering a seemingly incessant cycle of waiting and patience that holds no guarantees for Godot's anticipated arrival. In the course of their dialogue, Vladimir asks Estragon where he had spent the previous night, and learns that Estragon had slept in a ditch. He queries further: "And they didn't beat you?" "Beat me?" Estragon replies. "Certainly they beat me."[117] Even with *Waiting for Godot*'s dizzying, disjointed, and sometimes-hard-to follow modernist plot, Free Southern Theater audiences experienced a live theatrical performance that mirrored so much of their own realities of everyday violence, whether inhabiting deplorable spaces or performing patience while enduring waxing and waning hopes for social and political change in the US Deep South.

The Free Southern Theater's production of *Waiting for Godot* baffled and even failed to entertain some Free Southern Theater audiences. Penny Hartzell, a Free Southern Theater actress, noted in her journal that *Godot* "mystified, amused, bored, [and] shocked" many of those who experienced the play. In fact, some audience members even registered their disappointment by walking out before the play had ended, as many other audience members had done at productions around the globe.[118] At a performance in Greenville, Mississippi, a group of children threw spitballs at the stage.[119] These disapproving acts of audience reception illuminate how the practice of reinvesting black patience through sitting on the ground was not void of nuance and complexity; audiences sometimes grew impatient with the Free Southern Theater's critiques of black patience. The decision to use one's time as one wishes, or to perform boredom, is as much an affective and temporal claim of authority over the (black) self as the act of sitting on the ground to enjoy the time of black leisure.

For many members of the theatre's black southern audiences, however, Beckett's play resonated with their own histories and experiences of violence and forced performances of waiting. Of particular note was

the audiences' reactions to Lucky (played by John O'Neal) and Pozzo (played by white actor James Cromwell), two characters who play a master/slave duo. Bound by a rope throughout the play, Lucky, the slave, is doltish and subservient, and caters to the demands and caprices of his master, Pozzo. Weighing in on this relationship, one "Negro lady" in the audience exclaimed that "the reason why we keep talking about slavery is the rope; it has great significance."[120] Another black woman in the audience noted that Lucky and Pozzo "made me think of slavery. . . . I took the rope off my neck by thinking for myself."[121] For many audience members, Vladimir and Estragon's fruitless patience indexed how the US nation-state routinely manipulates time as a way to defer black people's acquisition of freedom and full citizenship. As one youth put it, "If the Negro never moved it'd be like these people Waiting For Godot."[122] This point was certainly not lost on Fannie Lou Hamer. Here we can recall Hamer's remarks at a 1964 performance of *Godot* in Ruleville, Mississippi: "You can't sit around waiting," she declared.[123] "Ain't nobody going to bring you nothing. You got to get up and fight for what you want. Some people are sitting around waiting for somebody to bring in freedom just like these men [Vladimir and Estragon] are sitting here. Waiting for Godot."[124] Later, Hamer cautioned the audience to "pay strict attention to the play because it's due to waiting that the Negro is as far behind as he is."[125] "We could have kissed her," Penny Hartzell wrote in her journal. "We needed her confidence in the play as much as the audience did."[126]

As Vladimir and Estragon ponder whether or not Godot actually intends to come, Vladimir begins to "look wildly about him, as though the date was inscribed in the landscape."[127] In this gesture of searching for a date in the land, Vladimir looks for traces of time that are archived in a material geography. Considered alongside the histories of black time and black geography that I have engaged in this chapter, such an act of looking for time in the material geographies of the US South would unearth histories of blackness and time that are rooted in plantation slavery, racial capitalism, and their afterlives. It would illuminate black southern futures that are as precarious and uncertain as the futures of Beckett's protagonists. It would highlight how the racial project of black patience has forced black people—whether slaves, sharecroppers, or members of the chain gang—to work with "all deliberate speed," while

They Are Waiting for Godot in Mississippi, Too

By W. F. MINOR

HATTIESBURG, MISS. "BEFUDDLEMENT," declared John O'Neal, stroking white shoe polish through his wiry dark hair and smearing white grease paint on his Negro face.

"Yes, the adjective is befuddlement. That's the way they respond to 'Godot,'" he declared as he sat on a wooden stool applying his makeup in the tiny anteroom of Mt. Zion Baptist Church, deep in the Negro neighborhood of this south Mississippi city.

Outside, waiting in the pews and in the little raised section for the church choir, an eager audience of 150 Negroes, tots, oldsters and a handful of whites, mostly students active in civil rights, sat waiting. They were waiting for "Waiting for Godot," which would be presented, free of charge by the Free

rod across the top of the gabled ceiling, caught two players of "Godot" in their glare. Some Negro elders and their wives still trooped in.

O'Neal, 24 years old, an English and philosophy major from Southern Illinois, put on the finishing touches in the improvised dressing room. "The reaction to 'Purlie Victorious' is enthusiastic. The audience relates early and quickly," he said. "But 'Godot,' ask James." James, a tall blond, crew-cut beaknosed young man, was also busy applying grease paint. He identified himself as James Cromwell, 25, of New York City, a graduate in theater from Carnegie Tech. He directed "Godot." "It is not a popular play and is not supposed to have the same reaction," he said. "There are those, however, who want to look at the play and see something beyond Mississippi."

A Mississippi audience watches a performance by the Free Southern Theater. The bi-racial group, which has been bringing theater to Southern audiences, gives fund-raising performances here Friday and on Feb. 14.

Figure 2.5. A Mississippi audience watches a performance by the Free Southern Theater. Photo by Norris McNamara, *New York Times*, January 31, 1965.

ordering them to go slow in their fights for freedom and full citizenship. This temporal paradox between the quick time of black labor and the slow time of black freedom was a driving force of slavery, and continues to shape the racial order of the modern world. The Free Southern Theater's critique of black patience and its radical engagement with the histories of racial time stored in Mississippi's material geographies were pivotal to the Civil Rights Movement's campaign to curate new materialisms, to engender new political possibilities, and to cultivate new modes of sociality that were grounded in the movement's revolutionary demand for "freedom now."

Postscript: The Death of the Black (Theatre)

In November 1985, the Free Southern Theater was given a traditional New Orleans jazz funeral, only twenty-two years after its birth. In attendance at this funeral were former Free Southern Theater participants, local residents, and theatre companies from as far away as San Francisco. In his interview with Tom Dent (a native black southerner

who became the theatre's director in 1966), literary critic Jerry Ward argues that although the theatre's funeral wasn't held until November 1985, "the institution seems to have died in the middle of the 1970s."[128] Dent replies, "It did. It died at the same time so many black community theatres did. I see the death of the Free Southern Theater as part of the national backlash against black cultural activity that took a separatist, Black Pride direction and identified strongly with black political and economic gains."[129] Dent goes on to explain that the Free Southern Theater had inspired the founding of black theatres across the US South. Between 1970 and 1974, he observes, "almost every substantial black community in the South had a theatre crop up."[130] By the time of Dent's 1987 interview with Ward, "almost all of these [had] died."[131]

Ward's interview with Dent captures the threat of death that hovers over black theatres, especially those that embrace black nationalism, or radical politics, aesthetics, and ideologies more generally. As I argue throughout this book, the clouds of death and precarity that loom over the futures of black theatres illuminate a historical affinity between black people and death. At the same time, these dynamics highlight how black people's structural proximity to death adds special value to those moments of joy, of leisure, of practicing freedom and citizenship in the here and now, in the present—doing so over and against the traumas of black pasts, the precarities of black futures, and the paradigmatic realities of premature black death. As black people continue to live in the wake of slavery and to navigate its lingering structures of black fungibility, the Afro-present is, and will remain, key to the time of blackness and to the practice of black politics, black performance, and black being.

Far from a cure-all for the violences of black patience, or of anti-blackness more generally, Afro-presentism is instead about seizing and enjoying the good life in the here and now, knowing that in the context of anti-blackness the future is always a zone of precarity. And yet, access to a different way of being in the world—however fleeting—puts pressure on prescriptions for black racial being that take teleology's force of finality, or white supremacy's violence, as their chief grounds of critical imagination. In the physical act of sitting on the ground, the relational tensions among black pasts, black presents, and black futures is dramatized in and through the black body's communion with the land and the differential histories of time—the time of slavery and racial capitalism, of

black leisure and black aesthetics, the time of black political discourse—
this communing assembles and allows. In other words, when black
southern audiences sat on the ground to experience the Free Southern
Theater's performances, the exploitative quick time of black labor stored
in the South's plantation geographies converged with the time of black
patience, the time of black leisure, and the play's radical temporal aes-
thetics. This fraught palimpsest of black time exposes how any line of
flight made possible in the Afro-present always unfolds in relation to
the racial traumas of the past and to the precarities of black futures. Far
from a flight from history, or a pessimistic rejection of the future, or a
naïve celebration of the present, Afro-presentism is a heightened attun-
ement to black possibility in the here and now, knowing that in the face
of anti-blackness the enjoyment of these possibilities will likely be as
fleeting and ephemeral as the Free Southern Theater's live performances,
or as the too-short life of the Free Southern Theater itself.[132]

As the sounds of the iconic spiritual "Just a Closer Walk" emerged
from the horns of a band in New Orleans' historic Armstrong Park, the
Free Southern Theater's funeral was set in motion. Led by a funeral mar-
shal adorned with a red satin sash, and carrying a sequined white um-
brella, the integrated crowd of nearly one hundred assembled around a
rust-colored coffin to celebrate the life and to mark the death of the Free
Southern Theater.[133] Within this ritual environment thick with the cul-
tural traditions of New Orleans and the broader circum-Caribbean, the
audience approached the coffin and left offerings that ranged from pho-
tos and money to Free Southern Theater memorabilia and a South Af-
rican passbook. On the heels of these offerings, the crowd followed the
marshal in a lively procession through the streets of New Orleans. As the
sounds of civil rights anthems like "We Shall Overcome" transitioned
into the pulsating tunes of "Good Golly Miss Molly" and "Li'l Liza Jane,"
onlookers watched and waved from stoops, cars, and barbershops, and
some even joined the processional, keeping with the ritual of communal
participation at the heart of second-line funerals.

But even in the cultural glory of this ritual celebration, and even as
theatres whose own founding had been inspired by the Free Southern
Theater stood as evidence of black theatrical futures, there was not
enough dancing and drinking to obscure the reality that the Free South-
ern Theater was dead at only twenty-two, and, by all accounts, had died

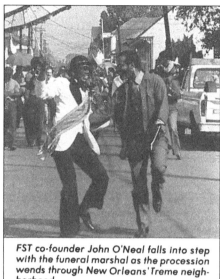

FST co-founder John O'Neal falls into step with the funeral marshal as the procession wends through New Orleans' Treme neighborhood.

Figure 2.6. Free Southern Theater co-founder John O'Neal with funeral marshal as procession travels through New Orleans's Treme neighborhood. Photo by Jim O'Quinn, *American Theatre*, March 1986, 27.

Mementos from early days of Free Southern Theatre are placed in a symbolic empty coffin (foreground) during a traditional jazz funeral for the near-legendary company.

Figure 2.7. The funeral marshal begins the ceremony. Photo by Jim O'Quinn, *American Theatre*, March 1986, 26.

many years prior to its funeral.[134] As Tom Dent observed, moreover, many more black theatres would die before the close of the century. Still, under these routinized conditions of imminent black death, such turns in the Afro-present—as we see in the Free Southern Theater's second-line funeral, as we see in the theatre's performances during the Civil Rights Movement—are vital to the essence of living black life and of producing black art in the face of black death. These moments or instants within the Afro-present contain possibilities for accessing the good life, even if the goodness of this life is as fleeting and ephemeral as the ontology of live performance, as the ontology of blackness.

In the next chapter, I consider how the looming deaths of black theatres and black subjects are exacerbated in the face of queer sexual desire. If the futures of black people, black social movements, and black performance are routinely compromised and confronted with premature death, black queer futures are rendered even more precarious because of the particular violences meted out to those who cruise and inhabit the intersections of blackness and queerness. Under these conditions of compromised black futures, the time of what I term the *black queer present* is an especially important genre of "freedom now."

3

Black Queer Time and the Erotics of the Civil Rights Body

To analyze the Civil Rights Movement is to grapple with the triumphs and failures of desiring black bodies. Black political desire was the engine of civil rights activism, and the body was a crucial instrument for bringing these desires to fruition. Whether marching in the streets, sitting-in at lunch counters, or refusing to yield their seats on buses, activists harnessed the power of the body as a way to telegraph black people's desires for full citizenship and to build more just and inclusive societies. But embodied performances of desire in the Civil Rights Movement were not limited to formal politics. They were also sexual, erotic, and—as quiet as it has been kept—queer. Taking this claim as my point of departure, in this chapter I examine relations of queer desire in the Civil Rights Movement, and consider their connections to the racial project of black patience.

In this sense, I critically engage the civil rights body not only as a site of formal political activity but also as a locus of sexual action. I am interested in writing a history of black flesh in the Civil Rights Movement that accounts for the queerness of that flesh as well as its multiple modes of desire. The civil rights body was more than a target for police dogs, bombs, fire hoses, or the range of other weapons deployed to quell the movement; its history encompasses, but remains unbound by, the well-known record of embodied terror that dominated international media in this period—and that continues to dominate the field of civil rights studies.

To consider these issues, I examine an understudied trilogy of one-act civil rights plays—*The Eighth Ditch*, *The Toilet*, and *The Baptism*—written by influential black playwright, poet, and essayist Amiri Baraka, known also as LeRoi Jones.[1] I conclude the chapter by turning to a virtually forgotten one-act civil rights play, *The Experimental Leader*, written by Baraka's expatriate contemporary Paul Carter Harrison. Hailed as the "spiritual and philosophical father of black theatre," Harrison wrote pro-

lifically about the Civil Rights Movement during his stint in Europe, and even led a "March on Washington" to the US Embassy in Amsterdam.[2] Importantly, for both of these playwrights, it is the figure of the queer black male leader—whether a soldier, the head of an adolescent clique, a duplicitous preacher, or an embattled civil rights leader—who occupies the center of these dramas. None of Jones's one-act plays directly portrays the Civil Rights Movement, especially in the explicit way that Harrison does in *The Experimental Leader*. But, if we consider the iconic roles that children, preachers, and soldiers played in the movement or Jones's decision to set these plays in a church, a school, and an army camp—all important sites of civil rights activism—we recognize that although these works are not always conspicuous in their connections to the movement, the historically situated symbolism of their characters and settings illuminates why I am calling them civil rights plays.

Examining this transnational assemblage of queer one-acts, this chapter reconsiders the libidinal economy of the Civil Rights Movement. In the previous chapter, I examined how a black southern theatre transformed the civil rights mantra "freedom now" into a radical style of embodied political performance to resist the violent cultures of black patience in the Jim Crow South. In this chapter, I extend my analysis of black patience onto the territory of erotic desire. This conceptual move stems from a recognition that black patience not only engenders anti-blackness but also (re)produces the cultural and political logic of heteropatriarchy. The pathologization of same-sex desire has rendered black queer subjects even more vulnerable to the gratuitous violences of black patience. Joining scholars in queer theory who explore the profound intimacy between time and sexual desire, I am interested in the erotic dimensions of black patience, or in how white supremacy and anti-blackness use the erotic as a staging ground for their biopolitical management of black time and black affect—their deferral of freedom.

In analyzing these understudied queer civil rights plays alongside newspapers, court cases, interviews, and other ephemera, I chart a more erotic, queer, and therefore radical history of the Civil Rights Movement. These archival and conceptual interventions contribute to recent scholarship in civil rights historiography that aims to make civil rights "harder" by emplotting more radical histories of the movement. Most scholars have taken up this task by returning to earlier periods of civil

rights activism and by prioritizing leftist political ideology. Like these scholars, I am also interested in mapping a more radical movement. My method for doing so, however, neither requires nor advocates for a pivot away from the movement's "short" or "classical" phase. Rather than cast the "short" period aside for its alleged want of radicalism, we should more carefully consider—for instance—the radical nature of the queer visions of erotic desire that emerge in Amiri Baraka's and Paul Carter Harrison's one-act civil rights plays, all of which were written and produced in the movement's "short" or "classical" phase.

Paying attention to these plays and performances allows us to probe more deeply into an obscured node of the movement's otherwise well-known cultures of embodied performance, and thus furnishes a different aperture for theorizing the civil rights body and for attending to the queer dimensions of its flesh. Mining that reservoir of "deep" knowledge that black lesbian feminist Audre Lorde finds in the erotic, this chapter reorients the field of civil rights studies away from its tendency to suppress the erotic in general and the black queer erotic in particular.[3] In doing so, it clears the way to highlight the historical connection between black patience and the normative protocols of sexual desire, specifically the precarity of black queer futures under the violent regime of black patience.

The compromised queer futures highlighted in these works underscore the singular value of what I call the *black queer present*. By this I mean the matrix of queer possibility afforded by—and stolen from within—the time of the here and now in fugitive moments of intimate sociality and sexual consummation. A queer genre of Afro-presentism, the black queer present is an erotic orientation to the "now." Like black lives and black political futures, black queer futures are caught in a structural web of precarity. Much like the political ethos "freedom now," then, the black queer present poses a threat to the structural deferral and suppression of black freedom. When black queer intimacies manage to escape (however briefly) the constraints of racialized homophobia and its perpetual mechanisms of delay, they provide the black subject a conduit to a radical mode of black sociality that literary critic Fred Moten has called "stolen life," or black people's "fugitive movement in and out of the frame . . . or enclosure."[4] Viewed this way, black fugitivity emerges as an erotic affront to the sweeping enclosures of black patience.

In this chapter, I raise these stolen moments of the black queer present to the level of political and theoretical priority. To do so, I begin with an examination of how queer sexual desire is routinely surveilled and suppressed, engendering fears and feelings of queer shame that often constrain and overdetermine performances of black masculinity and civil rights leadership. I then turn to Baraka's and Harrison's civil rights plays to show how such deployments of queer shame, or negative affect, inflect possibilities for queer eroticism while impacting the nature of queer time. Under the regulatory force of homophobic surveillance and suppression—which were present not only in the plots of these works, but in their production histories as well—black queer futures are rendered especially uncertain. Along these lines, Baraka's and Harrison's plays teach us that any joy and pleasure that the black queer present affords must be fingered, held, and nurtured, because the futures of black queer lives are as precarious as the futures of those ephemeral moments of black queer intimacy that have managed to steal enough time and space to exist, if only for a moment.

Suppressing the Black Queer Erotic

On Wednesday, October 18, 1961, as LeRoi Jones slept in his apartment on Manhattan's Lower East Side, he likely had little suspicion that before sunrise he would be arrested and imprisoned for trumped-up charges of perverse and obscene language—and that, like his own future, the future of his queer one-act play, *The Eighth Ditch*, would be endangered by a state attempt to suppress the erotic. As Jones recalls, around 3 a.m., he awoke to a clan of FBI agents, treasury agents, and police "standing over [his] head."[5] Having barged into Jones's East 14th Street apartment, these officials arrested the artist for violating Title 18 of US Code 1461: a federal statute that prohibits the distribution of obscene matter through the mail. At the heart of these allegations was the ninth issue of *The Floating Bear*, a modest literary newsletter that Jones coedited with the poet, activist, and his one-time lover, Diane di Prima, who was also arrested and imprisoned by federal authorities on the same charges. Though this issue of *The Floating Bear* was only circulating to three hundred subscribers, the trouble was that it included *The Eighth Ditch* as well as a scathing parody of presidential corruption by American writer William

Burroughs. Both taken from longer works of narrative fiction, these racy excerpts drew the eyes and ire of federal authorities when a copy that had been mailed to an inmate at New Jersey's Rahway State Prison was intercepted. According to Jones's FBI file, this issue of the *The Floating Bear* was put on the FBI's radar after a New York Postal Inspector informed a special agent that it "contained references to several types of sexual perversion and obscene language."[6]

As Jones sat in prison for his allegedly "obscene" one-act play, a work that chronicles a sexual relationship between two black male soldiers, time weighed heavily on his mind. In a piece published in the *New York Post* just one day after his arrest—one fittingly entitled "A Poet Laments Time Lost in a Courthouse"—Jones opines that he "would have liked something to do while sitting around in jail," noting that he "could have spent the time writing something."[7] Jones's arrest and imprisonment illuminate how his engagements with same-sex desire—here in the form of a play—ignited a state campaign to regulate and effectively steal his time. This spectacular seizure of the artist's time vis-à-vis imprisonment aimed to suppress the circulation of the black queer erotic.

During the Civil Rights Movement, state-sponsored suppressions of queer sexual desire were rampant, and were key to quelling the force of civil rights activism. Like Jones, prominent Mississippi civil rights leader Aaron Henry would learn this lesson all too well. On March 3, 1962, Henry was arrested at his home in Clarksdale, Mississippi, as his wife and daughter looked on. This was certainly not the leader's first run-in with police. A vocal and revered "race man," he was also a thriving pharmacist and the owner of Clarksdale's popular Fourth Street Drug Store, a hub of black political organizing. That Henry's success as a pharmacist and civil rights leader rattled the foundations of Mississippi's Jim Crow establishment is hardly surprising. Even less shocking in this era of rampant anti–civil rights retaliation is the leader's extensive record of arrest prior to this encounter.

This time, however, the circumstances were different. According to police, the famed civil rights leader had both sexually assaulted and solicited sex from an unsuspecting teenager. The rub, of course, was that Henry's alleged victim was not only white, but also male. As Henry recalls it, police had accused him of

picking up a young white male hitchhiker near Mound Bayou [Mississippi] and asking him to find me a white woman. When the boy said he couldn't do that, the conversation had allegedly moved to other forms of sex. I was supposed to have told the boy that he would have to play the role of substitute if he couldn't find a white woman for me.[8]

Curiously, there is no mention of a white woman in the trial transcript. In other words, Henry's (alleged) queer sex act had effectively trumped the very serious threat of heterosexual miscegenation—which, under Mississippi's duplicitous codes of retribution, could have easily carried a penalty of death. But in this instance, the state had deemed queer sex the more criminal and perverse articulation of sexual desire. By the trial's conclusion, the court found that Henry had "reached over and touched" the "privates" of teenager Sterling Lee Eilert.[9] For this alleged offense, he was sentenced to sixty days in jail and a fine of $250.

Nearly a decade prior to Henry's arrest, black civil rights leader Bayard Rustin had already discovered that black queer erotics were not only vilified and policed, but were viciously criminalized and prosecuted. In 1953, having delivered a lecture to the Pasadena Athletic Club, Rustin was arrested in Pasadena, California, for allegedly having sex with two men in a car. When Rustin appeared in court the following day, a judge found him guilty of performing a lewd and lascivious act. For his transgression, he was ordered to serve two months in a Los Angeles County prison.

Jones's, Rustin's, and Henry's arrests for their engagements with queer sexual desire signal the significance of queer erotics to the Civil Rights Movement and thus to the field of civil rights studies. Histories of the Civil Rights Movement routinely decouple black sexual and political desires, and have made even less room for desires that were black and queer. Such an abstraction of the movement's libidinal economy has generated a "suppression of the erotic" within civil rights discourse.[10] According to Lorde, the erotic is a vital "source" of "power and information," a "nurturer and nursemaid of all our deepest knowledge."[11] If the erotic is, as Lorde argues, a fountain of knowledge and information, then downplaying histories of the erotic in the Civil Rights Movement limits our abilities to know insofar as this gesture sidelines a vital source of

knowledge and information crucial to our understandings of the movement. The erotic is critical to our efforts to rethink conventional paradigms of civil rights historiography and to reimagine the orthodoxies of civil rights leadership.[12]

For Jones, Henry, and Rustin—all civil rights leaders—their alleged expressions of queer desire and engagements in queer sex acts resulted in sizable prison sentences, or months of "doing time," that ultimately nourished and reinforced the violent cultures of black patience. The state's criminalization of these acts transformed the leaders' black queer intimacies into erotic illegalities. By conscripting these leaders into the hold of its structures of carceral domination, the state cultivated and shored up the conditions of deferred freedom that have historically buttressed the racial project of black patience. Whereas in the previous chapter William Faulkner turned to the pages of *Life* magazine to counsel black southerners on the virtues of exercising black patience in their fight for full citizenship, here the writer's native Mississippi joined New York and California in marshaling the machineries of anti-blackness, incarceration, and homophobia to version yet another scenario of black patience, this time as a punitive measure for black civil rights leaders who had allegedly trafficked in the black queer erotic. Crossing regional divides, these encounters with the law illuminate "the strange relation between libidinality and temporality," or the interrelation of time, violence, and sexual desire.[13] That these leaders lost days and months of their lives to the hold of the prison for allegedly engaging in queer sex acts underscores the racial and sexual politics of time that subtend experiments in the black queer erotic.

Further, this violent relation between same-sex desire and time would likely exceed the time frame of imprisonment insofar as the state's carceral response would continue to impact, if not wholly delimit, future possibilities for the flow and consummation of black queer erotics. On this front, Rustin arrived at a telling conclusion. Writing in a letter from a California jail, he opines, "I know now that for me sex must be sublimated if I am to live with myself in this world longer."[14] Rustin's anxieties about queer sex, and his alleged pivot to sublimation, index the precarity of black queer futures in the face of homophobia, heteropatriarchy, white supremacy, and state power. Highlighting the intimate proximities between black sexual and political desire, Jones's, Rustin's, and Henry's

arrests reveal the foundational role of race to a brand of biopolitical maneuver that literary theorist Dana Luciano has called chronobiopolitics, or "the sexual arrangement of the time of life."[15]

Queer Shame, Masculinity, and the Demands of Black Leadership

In addition to functioning as enactments of temporal violence, these arrests were also intended to produce black queer shame, and to therefore weaponize affect as a tool of racial and sexual violence. Through the sexual regulation of civil rights leaders, such deployments of negative affect aimed to regulate blackness and queerness as well as to stifle black political possibility. Oppressive uses of the sexual have been prized possessions in the toolbox of anti-blackness and white supremacy. Whether considering the savage rapes that were hallmarks of chattel slavery, bigoted miscegenation laws, or abiding efforts to pathologize black sexualities as a way of rendering black people unfit for citizenship, black sexuality has been crucial to delaying and denying the eventuality of black freedom.[16] The nineteenth century in particular was a singular moment in the development of racial and sexual ideologies that would come to define modern epistemologies of race and sexuality. With the rise of academic disciplines in this era, intellectual discourses played an increasingly formative role in the production of social knowledge. Science and medicine in particular were central to engineering knowledges, and modes of knowledge formation, that concretized social taxonomies of race and sexuality. Under the auspices of academic disciplines like psychiatry, sexology, and phrenology, hierarchies of human difference were institutionalized in new ways and began to circulate in public discourse with the legitimizing authority of scientific fact. Igniting a vibrant stream of (pseudo)intellectual discourses, these efforts were translated into social-scientific epistemologies that served as a basis for codifying hierarchies of racial and sexual difference. Through a strategic grammar of perversion, these efforts cast nonnormative racial (read black) and sexual (read queer) beings as morally and biologically inferior outlaws and social outsiders.[17]

Thus, at the same time that black people were attempting to salvage the potential of US Reconstruction—battling designs to abrogate their

newly acquired rights in the wake of slavery—the social and scientific production of race and sexuality swayed public conceptions of normalcy by furnishing scientific "proof" that certain racial and sexual subjects were biologically "other," and thus warranted more careful scrutiny and inferior treatment. There was not, in this way, a vast ideological gap between this "higher," intellectualized order of bodily violence and the ritual of race-based lynching that likewise targeted and pulverized the black sexual body on the heels of US emancipation. Both modes of violence were committed to achieving a similar outcome: the disciplining and subjugation of the black sexual body.

A key biopolitical technology, lynching was vital to producing and policing black masculinities, and to shaping cultural conceptions of black men's sexuality. It is within this historical context that the myth of the black male rapist took root and began to circulate in the US cultural imagination as a powerful fiction of race, gender, and sexuality. In a period commonly seen as the "nadir of U.S. race relations," racial and sexual ideologies of black male bestiality and "phallic primitivity" were alive in the ritual act of lynching black male bodies.[18] The routine, forced nudity and physical emasculation of black male lynching victims marked a deep entanglement of repulsion and desire that sheds light on a lasting relationship between the nation and black men, or, more precisely, between the nation and the black male penis. Straining to preserve the vanishing arrangements of racial slavery, the nation found in the project of managing black masculinity a means of justifying the torrent of legal and extralegal violences that sought to dismantle black men's newly acquired access to the entitlements of US citizenship.

Such campaigns to "script" the black masculine have been central to the lifeblood of white supremacy—from the social inventions of "Uncle Tom," the "buck," and the "criminal" to the sneers routinely hurled at the United States' forty-forth commander-in-chief, Barack Hussein Obama: an allegedly foreign, birth-certificateless, Muslim-affiliated outsider who managed to squat in the nation's most illustrious seat of power. Against this historical backdrop, it is hardly surprising that black men have attempted to position themselves beyond sexual and racial typologies, and to evade their performative force. Whether turning to respectability politics, rugged individualism, or Christian propriety, black men have deployed a range of performative strategies to "struggl[e] against

the terms of their stigmatization," or to avoid the experience of shame these signs of black pathology conjure up.[19] That white men have historically stood in as metonyms for the proper citizen in the West, and that straight white masculinity has been configured as the human ideal, has certainly not been lost upon black men. Their struggles to transform black men's appositional relation to the white masculine has inculcated not so much a desire to mimic or inhabit white masculinity, but more a powerful yearning to approximate a mode of gender performance capable of securing the entitlements of full citizenship and preventing a fall into the subterranean territory of shame. It is important to note, however, that these approximations have motivated styles of gender performance routinely constrained by the racial and sexual norms of heteropatriarchy. This was certainly true in the Civil Rights Movement—an era shaped by the gravitas, and often the patriarchy, of charismatic black male leaders.[20]

In light of these fraught histories of black masculinities, and the shame attached to nonnormative modes of masculine performance, we can understand how one might be lured by the "violences of charisma" and the possibilities afforded in and through their intimate entanglement with heteropatriarchy.[21] Among these violences is a glaring proclivity to narrowing the modes of gender performance, and the types of sexual desire, available to those who seek and assume the mantle of black leadership. This process not only negates the complexity of black masculinities but also creates a system of value that renders alternative performances of black masculinity unthinkable and shameful.

In their civil rights plays, Amiri Baraka and Paul Carter Harrison grappled with and pressured narrow conceptions of black leadership and limited paradigms of black masculinity. Their decisions to stage queer black male leaders in the Civil Rights Movement challenged the conventions of black masculine performance. In a period that placed a premium on charismatic authority and the heteronormative conventions of black masculinity it solidified, Harrison's and Jones's theatrical experiments in black queer erotics were radical choices. But like Rustin, Henry, and Jones himself, the leaders in these plays recognize that certain expressions of sexual desire would jeopardize their roles as leaders and hang an albatross of queer shame around their necks. Importantly, several scholars have shown how shame, a negative affect, can sometimes

perform a liberatory function.[22] My focus here is not on the queer potential of shame, but rather on its disciplinary outcomes, or how shame is used to limit possibilities for black and queer subjects and by extension for black and queer futures. The plays in this chapter show how the looming threat of queer shame informs how queer sexual desire—its pasts, presents, and futures—can be claimed, remembered, and consummated. Conscious of the punitive measures that police same-sex desire, the characters in these plays often suppress and disavow queer pasts while foreclosing possibilities for queer futures. Considering the precarity of black sexual futures alongside the enduring foreclosure of black political futures sheds light on the singular importance of the here and now, of the black queer present, for black sexual and black political possibility. It reveals the significance of the Afro-present to the ontology of blackness as well as to the ontology of black performance.

Queer Archivalism and Black Flesh

In the archive of civil rights activism, there is no shortage of black flesh. From marches and sit-ins to maimings and murders, the movement would have been almost impossible in its absence. Less visible in critical examinations of this archive, however, are the erotics of black flesh and of black queer flesh in particular. According to literary critic Elizabeth Freeman, "we are still in the process of creating . . . a historiographic method that would admit the flesh, that would avow that history is written on and felt with the body, and that would let eroticism into the notion of historical thought itself."[23] Studies of the Civil Rights Movement have rigorously established the black body's importance to the choreographies of civil rights protest. But this scholarship generally stops short of centering eroticism as a historiographical and theoretical priority.[24]

In this chapter, my aim is to employ a methodology that not only admits the flesh (as civil rights scholars have done), but one that also emphasizes queer flesh and the eroticism of that flesh in the making of historical consciousness as well as in the production of civil rights historiography and cultural criticism. Given the politics of respectability that routinely structured black political engagement during the Civil Rights Movement, this methodological pursuit is certainly not without significant challenges. Because activists knew that the movement's "success"

hinged, in large part, on their capacities to revamp the social meanings of blackness, or to revise the derogatory signs conjured up at the sighting of black flesh, the geography of the civil rights body—its adornment, it gestures, its desires—was indispensable to mounting the movement. These dynamics fostered an economy of embodied restraint in which any trace of erotic desire, especially of a queer variety, threatened to jeopardize and possibly derail the Civil Rights Movement.

According to Aaron Henry, the practice of "queer baiting"[25] was quickly becoming a powerful weapon of white supremacy and a popular technology of state power. By launching accusations of homosexuality, adversaries of the movement worked to compromise the moral authority of movement activists, especially its leaders. Exploiting the social stigmas tethered to queerness, these antagonists hoped to similarly stigmatize the movement while solidifying the social norms of race, gender, and sexuality. "No longer," Henry avowed, "were bigoted officials satisfied with trying to brand us as communist. That charge, along with the claim that our goal was to put a Negro in every white woman's bed, had lost its punch. Standard charges were getting old. . . . So they picked up a new charge—one detested equally by whites and Negroes—homosexuality."[26] Whatever the verity of the court's findings, or of Henry's denials, this legal drama underscores the racial and sexual politics of comporting the civil rights body in this era of social transformation. And it signals how anxieties surrounding black queerness had grave implications for the strategies activists employed to stage the movement—from the choreography of their embodied protests to their carefully curated sartorial performances. Seen from this vantage point, it stands to reason that performances of civil rights activism were often characterized by a suppression of the erotic, and of black queer erotics in particular. That scenes of civil rights activism were routinely bursting at the seams with photographers and cameramen eager to enframe black bodies in protest, and to export these images to international audiences, often generated among black activists a heightened attunement to the signifying properties of embodied performance.

If suppressing the erotic was a mainstay of civil rights activism, then this dynamic raises important questions about what methodologies might allow us to locate and to critically analyze eroticism in the archive of the Civil Rights Movement, and in the long black freedom struggle

more broadly. What critical approaches can help us to uncover and more thoroughly examine the intimate relationalities between history and the flesh, civil rights activism and the erotics of the civil rights body? The study of black theatre is one answer to this question. Black theatre is critical to thinking the (queer) erotics of civil rights history, and is a valuable, if undervalued, object in the archive of the Civil Rights Movement.

On this front, let's return for a moment to Bayard Rustin's letter from a California jail, and consider once more the leader's decision to sublimate queer sex. According to Sigmund Freud, sublimation is a process by which individuals channel less acceptable forms of behavior, desire, and satisfaction into modes of creative production, such as art.[27] Whatever Rustin's own understanding of sublimation, what is evident is the leader's decision to suppress his sexual adventures. Equally apparent is how this resolution would essentially reroute and conceal Rustin's engagement in queer sex. This gesture has serious implications for the practice of historical thought. If the black queer erotic is occasionally sublimated, then our methods for locating and critically examining the erotics of history must necessarily peer beyond those conventional precincts typically privileged in the archives and repertoires of modern civil rights activism. What I am pointing to is an archival analogue to Rustin's claim of sublimation, or to how his decision to suppress queer sex generates archival outcomes that require a different attunement to the repositories of the past, and perhaps a journeying beyond (and beneath) mainstream archives in hopes of locating and critically analyzing traces of the black queer erotic.

Black theatre is one such overlooked but profoundly instructive zone of archival knowledge. Theatre is central to the archive and repertoire of the Civil Rights Movement and to the radical enterprise of "queer archivalism." Although television and photography have become our primary frames for examining the cultural politics of the movement, artists like Amiri Baraka repeatedly stressed the significance of theatre and live performance to this mid-century era of technological modernity. "Theater is a good medium," Jones proclaimed, "because it enables us to cut through that electronic curtain they've got up, you see, by actually being on the scene."[28] A vector of sentient presence, *communitas*, and critical imagination, theatre was a valued mode of black political and expressive culture and a key site of black communal formation during the move-

ment. It is to this record of the past—a record that is both written and embodied, preserved and ephemeral—that I turn to analyze the erotic life of the civil rights body during the movement, and to consider its relationship to the violent cultures of black patience.

LeRoi Jones's/Amiri Baraka's Civil Rights Period

In the late 1950s, LeRoi Jones was fast becoming more interested in the relationship between art and politics, and in how black artists might engage this relation. Observing the tide of political change resounding throughout global communities, he grew increasingly confident in the political utility of art. In a 1964 interview with journalist and film critic Judy Stone, Jones had this to say: "You have to be involved, whether you say you are or not. I'm black. I have to be involved. When I walk down the street, a man doesn't say, 'There goes a cultured nigger.' He says, 'There's just another nigger.'" When Stone probes Jones about what motivated his shift toward a more pronounced political aesthetics, he attributes this change to "the whole Civil Rights thing."[29] While scholars generally emphasize Jones's foundational role in the Black Arts Movement, the Civil Rights Movement had a major influence on his political visions and aesthetic practices. During interviews in each of the next two decades, Jones reiterated the movement's decisive impact. In 1979, for instance, he credited these political and aesthetic transformations to "the whole Civil Rights Movement."[30] And just one year later, in an interview with literary critic William J. Harris, he asserted, "a lot of what had moved me to make political statements were things in the real world . . . obviously the civil rights movement upsurge, the whole struggle in the South, Doctor King, SNCC, and the Cuban revolution—all those things had a great deal of influence on me in the late fifties and early sixties."[31]

Although Baraka would eventually break with the "traditional" phase of the Civil Rights Movement, he constantly acknowledges the movement's profound significance in shaping his political positions and aesthetic strategies. Given Baraka's recurring recognition of the movement's influence, it is curious that scholars routinely label the post-Beat, pre-Black Arts phase of Baraka's development (circa 1963–1965) as simply the "Transitional Period." That critics situate other phases of Baraka's life and art in relation to his political attachments—whether Black Nationalism,

Pan-Africanism, or Third World Marxism—further renders the vague periodizing grammar of "transition" all the more surprising. Motivated by Jones's own regard for the importance of the Civil Rights Movement to his artistic craft and political activity, here I want to suggest that we reassess our current periodizing schemas that frame 1963–1965 as merely "transitional" in the arc of his political and aesthetic development. More than transition, or mere interlude between the "Beat Period" and the "Black Nationalist Period," 1963–1965 is more aptly regarded as the *Civil Rights Period* in Baraka's literary and political formation. By unhinging this period from the vague nomenclature of "transition," we can return to his earliest work in the theatre with historical and analytical frameworks that are more carefully attuned to the political and aesthetic exigencies of this watershed historical moment, and reflective of Baraka's self-avowed connections to the Civil Rights Movement.

If 1964 was a defining year in the history of civil rights activism— from the historic voter registration drive known as "Freedom Summer" to the passage of the 1964 Civil Rights Act to Dr. Martin Luther King Jr.'s Nobel Peace Prize—it was also a signal year for LeRoi Jones and for black theatre more broadly. With Adrienne Kennedy's *Funnyhouse of a Negro* opening in January, Baraka's *Dutchman* (which won the Obie Award), *The Eighth Ditch*, and *The Baptism* in March, James Baldwin's *Blues for Mister Charlie* in April, and Lorraine Hansberry's *The Sign in Sidney Brustein's Window* in October, 1964 was buzzing with productions of important plays by now-canonical black playwrights. So momentous was 1964 for Jones in particular that *New York Post* drama critic Jerry Tallmer declared the week of March 22 "LeRoi Jones week in the theater."[32] In a similar register, famed black poet Langston Hughes dubbed 1964 in its entirety "The Jones Year."[33] If we take a closer look at the content of the works that Jones produced during his monumental year in the American theatre, we recognize that Tallmer could have very well designated the week of March 22 the week of LeRoi Jones and the black queer erotic. That two of the plays in Jones's March triptych—*The Eighth Ditch* and *The Baptism*—foreground queer sexual desire among black men, specifically black male leaders, is telling. This dynamic is even more notable when considering that Jones closed 1964 with the opening of yet another one-act play, *The Toilet*, that foregrounds race, time, black male leadership, and queer erotics. Hughes, too, then, could

have very well proffered a different designation—perhaps something like The Year of Jones and the Black Queer Erotic.[34]

Analyzing *The Eighth Ditch, The Baptism,* and *The Toilet* together uncovers intertextual relations so blatantly grounded in shared formal and thematic concerns that they urge a reading of these works as a black queer trilogy. At the most general level, they are all one-act plays; each of them features a queer black male leader; they were all written and performed during the Civil Rights Movement; and each play's dramatic conflict stems from a queer sexual encounter that shapes the plot. There is also a remarkable interconnection among the titles of these works. What links a ditch to a toilet and a site of baptism is the shared task of housing potentially hazardous and excessive matter—from floodwater and urine to feces and sin—whose escape could threaten the health of the human, ecological, or religious body. But like the flooding of a ditch, a toilet, or a site of baptism, the contained substance sometimes escapes, staging a return of the very thing these sites were designed to manage, contain, and route away. Keeping in mind each play's preoccupation with disavowing and suppressing queer sexual desire, we might say that one outcome of such returns of queer desire, of contained queer matter, is a doubling down on those acts of suppression and disavowal staged by those who orchestrated the containment of the queer excess in the first instance. Because these negations jeopardize possibilities for queer futures, the moment of initial encounter, or the time of what I call the *black queer present,* assumes a special value.

We will return to this trilogy and to the black queer present in a moment. But first, it is important to acknowledge that much of Baraka's 1960s art is rife with homophobia. Consider, in this regard, "Civil Rights Poem," in which Baraka writes,

> Roywilkins is an eternal faggot His
> spirit is a faggot
> his projection and image, this is to say,
> that if i ever see roywilkins on the
> sidewalks
> imonna
> stick half my sandal up his
> ass.

The poem's speaker pegs Roy Wilkins—the Executive Director of the NAACP during Jones's standout year—as an "eternal faggot." The speaker's use of "eternal" conjures a semantics of scale that conveys the ostensibly infinite reach of Wilkins's faggotry. Even in the afterlife, the leader will continue to be a faggot. By situating Wilkins under the historically fraught sign of the faggot, Baraka's speaker signals a broader antipathy toward black queer subjects that pervaded this historical moment, one marked by an expanding orientation toward black nationalist thought. The homophobic animus of Baraka's poem found company in the works of Black Arts Movement artists and activists like Eldridge Cleaver, Jayne Cortez, and Haki Madhubuti (Don L. Lee), leading the Black Arts Movement to become a "cultural backdrop for the establishment of blackness as anti-gay."[35] Baraka was, by this point, deeply entangled in literary and artistic communities that were laden with homophobia.

If we set our sights on an earlier Baraka, however—or more precisely on LeRoi Jones—we encounter an artist who used theatre to imagine far more nuanced and dynamic conceptions of black queer erotic relations. And perhaps it is this earlier Baraka (LeRoi Jones) lurking in the lines of "Civil Rights Poem." Maybe it is him, after all, who gives us the poem's impassioned speaker, yearning to "stick" half his sandal "up [the eternal faggot's] ass." To be sure, this queer poetics of anal penetration, the threat of sexual violence, and the centering of a black male leader harken back to Baraka's earliest works in the theatre, including his inaugural play, *The Eighth Ditch*—a titillating one-act about a fraught sexual encounter between two black male soldiers.

Queer Aesthetics and the (Black) Queer Present

Initially published in the June 1961 issue of *The Floating Bear*, *The Eighth Ditch* was one of the most risqué depictions of black queer erotics in the then-extant history of black theatre. In this lyrical drama, the narrator offers a graphic account of a sexual encounter between two black male protagonists, identified as 46 and 64. Set in the sleeping quarters of an army tent, the play opens by highlighting the vast sea of differences that separates 46, a "young, smoothed-faced" middle-class bibliophile, and 64, a slightly older bluesman type who imagines himself the wiser of the

two—and in many ways the leader.[36] As the plot unfolds, the duo engage in a dialogue that is thick with images, symbols, and references whose meanings are often difficult to crack. Jones's style is consistent with the aesthetic sensibilities of the Beat era, especially its preoccupations with abstraction. But even within these layers of coded meaning, the play's investment in the temporality of queerness and queer desire is striking.

On this front, the play's opening dialogue is instructive. We find 46 lamenting the destruction of the natural environment to accommodate the construction of a military facility. "Puzzled" and "looking up," he exclaims:

> Things are joys even cut off from our lives. This was a field. A rough wood, they cut off. For loot mostly, impersonal. Buses of young sinister shadows herded into summer. So much of this will get lost. These pictures, of what sadness?
>
> Who are you really?[37]

Jones's images of ecological destruction and vulnerability inaugurate the play's extended meditation on time, queerness, and desire. Focalizing the consumptive practices of military expansion, 46 uses this destruction of the natural environment to establish an important relationship between time and matter. What once was a "field," "a rough wood," had been plundered to manufacture ecologies of war. 46 links this calamitous disappearance and destruction of the land to a looming disappearance and destruction of soldiers (the "young sinister shadows herded into summer"). If the military had demolished nature in one fell swoop, 46 sensed that its new ecologies of war—soldiers and their experiences among them—could just as easily disappear, like the rough wood and the field they'd replaced. "So much of this," he laments, "will get lost." 46's history of the environment shows that what is vibrant matter in the present can quickly become ephemeral trace in the future. This attentiveness to the future's uncertainty provokes in 46 a fear of disappearance, an anxiety about the future that returns in the domain of the black queer erotic.

As the soldiers move closer to a sexual encounter, 64 appears to detect the young soldier's angst about the future. Asked by 46, "who are you really," 64 replies to the boy's question with a telling rejoinder:

The Street! Things around you. Even noises at night, or smells you are afraid of. I am a maelstrom of definitions. I can even fly. But as you must know, whatever, poorer than yrself. (64 *rises slowly, taking out cigarette, unbuttoning his shirt*).[38]

In answering the metaphysical query, "who are you," 64 defines his being as a presence that occupies 46's everyday environment. Intimating that his presence will linger beyond the present, 64 insinuates a near-certain possibility for a queer future. Despite his anxieties about the future, 46 seems persuaded by 64's answer. That these moments unfold as 64 unbuttons his shirt seems to signify an optimistic outlook on the sexual encounter, and the queer future, that loom on the play's horizon.

But 46 continues to worry over 64's existence in his future. "I don't recognize you [64] as anything," he groans. "Just dust, as it must be thrown into the air. You'll disappear so fast. (*Sadly*) . . . What is it I shd talk about now? What shd I be thinking up? My uniform is pressed and ready."[39] For 46, his older comrade and soon-to-be sex partner is analogous to dust, likely to be whisked away by the wind to some other time and place. According to the stage directions, 46 expresses these thoughts "sadly." This melancholic mood emerges from his torturing concerns about 64's imminent disappearance from his life and the likely disappearance of this burgeoning scene of queer sexual intimacy. Closing these lines with a nod to his "pressed and ready" uniform, 46 further betrays his firm attachment to the future. Like the pressed and readied uniform, the young soldier awaits a time that is yet to come. His eyes are fixed on the horizon.

Within recent scholarship in queer theory, the concept of queer futures has been central to discourses surrounding queer time. So robust is this strand of critical thought that queer theorist Alexis Lothian contends that the "history of queer scholarship is a history of queer futures."[40] In his groundbreaking study *Cruising Utopia: The Then and There of Queer Futurity*, the late José Esteban Muñoz critiques a strand of queer thought that, to his mind, derogates the value of queer futures. Muñoz points in particular to Lee Edelman's *No Future: Queer Theory and the Death Drive*. In this incisive study, Edelman details how conceptions of the future are routinely grounded in heteronormative logics of reproduction that strategically render the figure of the child the face of

the future. Elaborating how these ideologies of reproductive futurism both marginalize and exclude queer subjects, Edelman proffers the present as the most viable order of queer time. For Muñoz, Edelman's pivot away from the future is troubling because it configures the future as "the province of the child and therefore not for the queers."[41] Fueled by a fervent commitment to hope and critical idealism, and a firm critique of the queer pragmatics that lull Edelman into the present, Muñoz urges an embrace of the promises and possibilities of queer futures. These futures, he concedes, are "not-yet-here," but are, nonetheless, "in the horizon."[42] In this vein, he writes,

> Queerness is a structuring and educated mode of desiring that allows us to see and feel beyond the *quagmire of the present*. The *here and now is a prison house*. We must strive, in the face of the here and now's totalizing rendering of reality, to think and feel a then and there. . . . Queerness is essentially about the rejection of a here and now and an insistence on potentiality or concrete possibility for another world.[43]

Muñoz frames the present as a "quagmire" and a "prison house." For him, it is a temporality that constrains possibilities for practicing and envisioning queerness otherwise. In arguing that "queerness is primarily about futurity and hope," he concludes that "if queerness is to have any value whatsoever, it must be viewed as being visible only in the horizon."[44] At stake in this argument is a critique of the "ontological certitude" that Muñoz understands to be partnered with the "politics of presentist and pragmatic contemporary gay identity. This mode of ontological certitude," he posits, "is often represented through a narration of disappearance and negativity that boils down to another game of fort-da."[45]

I share Muñoz's critique of anti-relational theories that discard the future in favor of pragmatic models of queer being that are rooted in the "ontological certitude" of the present. At the same time, when we consider the historical singularity of anti-black violence and the perpetual threat of black death, we recognize that for black queer subjects the present has hardly afforded any semblance of ontological certitude. There is, then, some tension between Muñoz's negative framing of the present and this book's claims about the historical salience of the "here

and now" for black being, black performance, and black politics. Rather than urge a "rejection" of the present, my ambition is to map a theory and a racial history of the present that recognize the here and now as a critical temporality for black people and a vital structure of queer time. Under the historical conditions of black patience, the present accrues significance that risks being obscured when we regard the present as the "uninspiring here and now."[46]

Black patience has taught black subjects something about the nature of horizons; about how they appear so close but always seem to elude one's grasp; about how they are often tools of white supremacy deployed to delay, defer, and abrogate black people's access to full citizenship and to the pleasures of everyday life. It is imperative that black queer subjects continue to scout and pursue multiple horizons, that they continue to engage in the radical project of black freedom dreaming—as they have always done. And yet, our critical investment in queer futures must unfold alongside a sobering acknowledgment of the singular violence that drives the racial project of black patience and the existential threat that this project poses to black futures. When viewed against the backdrop of black patience and black people's radical uses of the here and now, not only does the present warrant a fuller, more contextualized hearing, but to cast the present aside is to refuse a historical structure of time that has been germane to black being, black politics, and black aesthetics. As we rightly resist surrendering the future to the social arrangements of straight time, we must also refuse to cede the present to the powers of heteronormative ideology, while more carefully weighing the racial implications of enjoining queer subjects to disavow the present. We must forge a relationship to the time of the here and now that is as radical and unruly as civil rights activists' insurgent demands for "freedom now."

My point here is not that the past and the future are inadequate; nor is it that the present exists as a utopian structure of time or as an escape hatch from modernity's violences. As Amiri Baraka's, Aaron Henry's, and Bayard Rustin's arrests illuminate, within societies structured in dominance, namely of a racist and homophobic sort, black queer subjects—and black queer art—encounter modes of social regulation that routinely produce disavowals of queer pasts (allegedly Henry's denial), foreclosures of queer futures (Rustin's sublimation of queer sex), and the making of queer presents that are literally (as all of these cases

reveal) transformed into prison houses. No time or temporal location is inoculated against the gratuitous violence of heteropatriarchy, anti-blackness, and white supremacy. Those willful acts of queer intimacy consummated in stolen moments of fugitive eroticism must, then, be embraced and valued for managing to exist over and against the paradigmatic fungibility that haunts blackness and black sexual temporalities. The sexual encounter at the center of *The Eighth Ditch* helps to ground this claim.

When 64 removes his shirt and sits on the edge of 46's cot, they engage in a game of foreplay and sexual banter. While reading his book, 46 "turns on his stomach," and gives 64 a better glimpse of his "ass."[47] As 46 reads, 64 looks over the boy's shoulder and reads along, placing his face "very close to the reader's."[48] 64 eventually "sprawls his legs across the bunk" before sliding down to lie "parallel to 46, hands still around his shoulders."[49] At one point, the older soldier offers a sensual joke, encouraging 46 to relax: "Just sit tight. (*Laughs*) Or no, you better not!"[50] 64 eventually "moves his body onto the prone 46 . . . moving his hips from side to side."[51] He then loosens the young soldier's belt, before slipping the boy's trousers "half-way down."[52] In the midst of these sexual interactions, the duo's abstract dialogue persists—that is, until 46 finds 64's excessive, self-absorbed chattiness unbearable: "Oh, shudup, shudup, willya, for Christ's sakes keep your fat mouth quiet."[53] On the heels of this eruption, 46 attempts to leave. But 64 restrains him, "pull[s] his pants down past his buttocks," and "sinks down."[54] Responding with a "short sharp moan," 46 "begins to move with the other, who is on top of him, pushing up and down as fast as he can," until 64 orgasms. "Oh, yeh, I came. I came in you," he brags, before removing his penis and showing it to 46.[55] The consensual nature of the soldiers' sexual relationship devolves abruptly into a scene of sexual terror. This is likely not the future, sexual or otherwise, that 46 had envisioned. Ultimately, 64 was right to declare that he would have a lingering presence in 46's future. But his presence, his existence in memory, will likely return 46 to the experience of rape, leading him—time and again—to relive this scene of sexual assault. This future, a queer future to be certain, will likely be pouring over with traumatic memories of rape.

At the same time, this encounter is also a reminder that even the present can engender violent experiences. What begins as a consensual mo-

ment of black queer intimacy turns suddenly into an act of rape, with hardly a moment's notice. Keeping these kinds of gross violations in mind, my investment in the "here and now" is grounded in a deep awareness of how the time of modernity writ large—the present included—is always already a time of violence. 64 reminds us of this in recalling a prior experience of delivering newspapers. Addressing 46, he exclaims, "I cd walk out of yr life as simply as I tossed newspapers down the sewer."[56] The newspaper is a key metaphor for the fraught nature of black and queer time in a virulently racist and homophobic social world. Generally bearing the current date, newspapers both belong to the present and are chronicles of past events. In the act of tossing the paper down the sewer, 64 poses a material threat to the newspaper as past and present, while also limiting possibilities for its future. These circumstances of being relegated to the sewer might certainly foster opportunities for creating fugitive futures—for constructing an undercommons in the dark and subterranean space of the sewer, just as black and queer subjects have always done, and just as 46 might manage to do in the wake of his rape. Still, in light of the racialized specters of death and ephemerality that hover over black and queer people and black and queer time, we must embrace, cherish, and theorize the value of the Afro-present. We must raise to the level of theoretical priority those moments and instants of black queer freedom and joy, of consensual pleasure, beauty, and vitality that emerge in the here and now, however fleeting. These moments— the sprawled legs, the close faces, the arms around shoulders, the lying next to—are especially important for black and queer subjects, whose bodies—like 46's—are violated with hardly a moment's notice, and whose futures are tossed down the sewer as easily as 64's newspaper.

Queer Pasts, Queer Futures

On December 16, 1964, LeRoi Jones's *The Toilet* (Jones's favorite play from this period) opened at St. Mark's Playhouse in New York City, where it played for over a hundred performances.[57] Directed by Leo Garen, the play was presented on a double bill with another of Jones's fiery one-acts, *The Slave*—a play that considered "what might happen if the patience of the neglected and scorned gave out."[58] Like *The Eighth Ditch*, *The Toilet* explores the interconnection of time and queer erotics, but it is even

more explicit in its focus on how they intersect with black male leadership. When *The Toilet* opens, audiences meet a group of black high school boys in the throes of a search for James Karolis, the white male student who had penned a love letter to Ray Foots, the group's leader. Referring to Foots as "beautiful" and expressing desires to "blow him," the boy's letter incites the young clique to violence. Seeking to avenge their leader, they hatch a plot to kidnap and attack Karolis in a school restroom.[59]

Once Karolis is detained, the group physically and verbally assault him as they await the arrival of their leader. In the interim, Ora—known otherwise as "Big Shot" because of his bad boy persona—expresses desires for sex with Karolis.

> ORA (*bending over as if to talk in KAROLIS' ear*): Hey, baby, why don't you get up? I gotta nice fat sausage here for you.
> GEORGE: Goddam, Big Shot . . . You really a wrong sonofabitch!
> ORA: Look man. (*Now kneeling over the slumped figure.*) If you want to get in on this you line up behind me. I don't give a shit what you got to say.
> LOVE: Man, George, leave the cat alone. You know that's his stick. That's what he does (*laughing*) for his kicks . . . rub up against half-dead white boys.
> *All laugh.*
> ORA (*looking over his shoulder . . . grudgingly having to smile too*): I'd rub up against your momma too. (*Leaning back to KAROLIS.*) Come on, baby . . . I got this fat ass sa-zeech for you!
> *All laugh.*
> ORA (*turns again, this time less amused*): Fuck you, you bony head sonofabitch. As long as I can rub against your momma . . . or your fatha' (*laughs at his invention*) I'm doin' alright.[60]

Considering the occasion for the group's assembly in the restroom, this sexualized exchange is thick with irony. When the group takes "Big Shot" to task for his sexual overtures, almost instinctively he begins a fight to repair his bruised straight credibility. Directing his reprisal at Love, "Big Shot" fires back by expressing desires to "rub against" Love's "momma." And yet, this attempt to disavow his sexual yearnings for Karolis falls flat when he communicates desires to rub against Love's "fatha" as well.

Ora's fluid expression of sexual desire for men and women is separated in the script by an ellipsis that was likely heard as a pause in the moment of live performance. Marking a twinned relation of distance and proximity, of connection and separation, the ellipsis and the pause reflect the plastic forms of sexual desire that course throughout Jones's black queer trilogy. As Ora's reaction indicates, nonetheless, these desires are often suppressed or engaged through acts of homophobic violence. In this way, the futures of these desires are rendered precarious in the face of heteronormative power and standardization.

Before Ora is able to explore sharing his "sausage" with Karolis, Ray Foots, the gang's aggrieved leader, joins them in the restroom. Upon discovering Karolis in the corner, the leader's reaction is far from the venomous response audiences might anticipate from a boy whose straight masculinity has been so dramatically impugned. With no visible appetite for revenge, Foots saunters over to the badly beaten Karolis and kneels beside him, "threatening to stay too long."[61] Having gathered that "Big Shot" is responsible for Karolis's injuries, Foots "looks at Ora quickly with disgust but softens it immediately."[62] In a perhaps surprising gesture, the leader warns the group that Karolis is in no condition to fight. To this, Big Shot replies, "No, but he might be able to suck you off," making a rapid return to his queer sexual attachments.[63] The group continues to pressure Foots into fighting. Karolis stands and insists upon the fight. Visibly startled, Foots's eyes "widen momentarily, but he suppresses it," as Karolis declares:

> KAROLIS: I'll fight you, Foots! (*Spits the name.*) I'll fight you. Right here in this same place where you said your name was Ray. (*Screaming. He launches at* FOOTS *and manages to grab him in a choke hold.*) Ray, you said your name was. You said Ray. Right here in this filthy toilet. You said Ray. (*He is choking* FOOTS *and screaming.* FOOTS *struggles and is punching Karolis in the back and stomach, but he cannot get out of the hold.*) You put your hand on me and said Ray![64]

Recognizing that the boy is getting the best of their leader, the group come to Foots's rescue and proceed to pummel Karolis, who salvages enough breath to exclaim, "No, no, his name is Ray, not Foots. You stupid bastards. I love somebody you don't even know."[65]

From *The Toilet*

Figure 3.1. Foots cradles Karolis's head in the
restroom. Photo by Hoyt Fuller, *Black World/Negro
Digest*, July 1965, 49.

The constant distinction that Karolis draws between Ray and Foots
is instructive. Within this swirl of split identity, it becomes clear that
for Foots—a straight-identified black boy—embracing queer pasts and
futures would violate the protocols of heteronormative masculinity and
the sexual conventions of black male leadership.[66] Navigating the field
of queer shame, Ray chooses to suppress and disavow his sexual ex-
periences in the restroom with Karolis, restricting them to the time of
a now-vanished present. This incites Karolis to rage. Having described
Foots as "possessor of a threatened empire" in the character list, by this
point in the play it is clear that the "empire" Baraka has in mind is het-
eronormative masculinity, and that the threat is James Karolis, who lies
on the bathroom floor as a fleshly reminder of a queer past that cannot,
in this instance, be granted a queer future.[67]

Having avenged the attack on their leader's masculinity, the boys exit the restroom and leave Karolis on the floor. But Foots doubles back to the scene of violence. Once there, he "stares at Karolis's body for a second, looks quickly over his shoulder, then runs and kneels before the body, weeping and cradling the head in his arms."[68] Here we find Foots and Karolis stealing a moment of erotic relationality. The gravity of this stolen gesture of queer intimacy—this fugitive act of lingering in the break of same-sex desire—becomes all the more pronounced when read alongside the necessarily hurried gestures that structure relations between the boys moments prior. For instance, when Foots enters the restroom initially, and kneels beside Karolis, he "threaten[ed] to stay *too long*."[69] When Foots discovers that Ora has attacked Karolis, he "looks at Ora quickly with disgust but softens it *immediately*."[70] And when Karolis insists on fighting, Foots's eyes "widen momentarily, but he *suppresses it*." Finally, when the leader returns to cradle Karolis, he "looks *quickly* over his shoulder" before embracing the boy's head. [71] In this evocative assemblage of hurried and suppressed queer gestures, Jones reflects the danger of lingering "too long" in the moment of queer desire. To linger is to risk the threat of exposure; to invite censure and the violences of queer shame.

As Foots cradles Karolis's head in his arms, Jones's ending seems to index the possibility of a future, queer or otherwise. At the same time, it underscores the singular importance of the here and now, and specifically of the black queer present.[72] Who knows if the gang will return? Or if "Foots" will continue to suppress and disavow "Ray"? Or if the gang's violence will lead to Karolis's death? What Jones allows us to hold on to for sure is this specific moment of queer intimacy, staged in and as the play's denouement.

But even this affectionate scene of queer intimacy was subjected to the machineries of suppression and disidentification. In Baraka's account of crafting the play's resolution, he repeatedly places a wedge between himself and the play's ending, disavowing the queer futures and the visions of racial reconciliation that animate the play's final moments.[73] As he tells it, the original draft of *The Toilet* "ended with everybody leaving." "I tacked the other ending on," he claims, noting that "the kind of social milieu that [he] was in dictated that kind of rapprochement. It actually did not evolve from the pure spirit of the play."[74] In the process of re-

calling the act of constructing the queer future that resolves *The Toilet*, Jones scrambles to disavow that artistic past and its vision of a queer future. For both Jones and Foots, then, *The Toilet*/the toilet stands as the trace of a queer past that can neither be embraced nor granted a queer future. Under these pressures of queer shame, and their threat to queer futures, the present obtains a special value.

The call to embrace the black queer present is not is an apologia or safe harbor for those who engage in strategic performances of queer disavowal or other modes of queer injury. That Foots waits until it is safe to return to Karolis is an act of violence steeped in privilege and power. It is self-centered and harmful, and ultimately helps to fuel queer antagonism and homophobic violence. Further, such strategies of disidentification are rarely total, and often shot through with slippages, contradictions, and nuances that paint a fuller portrait of queer relationality. In the same interview in which Jones disavows *The Toilet*'s queer denouement, he adds that he refrained from changing the play's ending because doing so would have only been "cute."[75] "I think you should admit where you were even if it's painful," he explains. "That was ground that I walked on and covered. I can't deny it now."[76] In the time-span of a single interview, Jones both disavows and embraces a queer past. In the time-span of a short one-act play, Foots both embraces and disavows a queer past. These slippages between embrace and disavowal underscore the precarity of queer futures as well as the singular importance of the here and now, and specifically of the black queer present. Even as we hope for and strive toward the possibility of queer futures, we must also embrace the queer present, recognizing that in the face of modernity's foreclosure of black and queer futures, the present is a vital structure of (black) queer time. This was nowhere more apparent than in live productions of *The Toilet*, which were routinely shut down as the play was staged across the nation. The struggle for queer futures at the level of plot mirrors a struggle for the queer future of *The Toilet* itself.

The Social Life of *The Toilet*

As *The Toilet* was produced in major cities like Detroit and Los Angeles, it encountered an avalanche of attempts to surveil and censor it. In part, these campaigns were intended to quell the play's depictions of queer

eroticism. Critics began early on to level charges of obscenity. During its run at St. Mark's Playhouse, many theatre critics deemed it Jones's most obscene play. In an otherwise positive review, black intellectual Hoyt Fuller described the play as "a little much" and explained that it deals with "unorthodox matter."[77] Some audience members were so rattled by Jones's "unorthodox matter" that they "elected to leave the close quarters of the St. Mark's Theatre" in the middle of *The Toilet*, which was the first of two one-acts on a double bill.[78] Such a spectacular display of impatience for *The Toilet* was not reserved for the play's content. Audiences also found its material set—a boys' restroom—obscene. According to theatre critic Raoul Abdu, it was "shocking to walk into the theatre to be confronted with a perfect replica of 'the john' in a boys high school. . . . Then, to see the first character enter and use these facilities right before our very eyes!" Abdu went on to ask, "Why has [Jones] chosen such distasteful material?"[79] That the play is named for and set within an environment dominated by the toilet—an object that hails the exposure of penises and asses, and that invites the accumulation of waste and excess—was far too risqué and outright "distasteful" for many of the play's audiences.

During the 1960s, the toilet circulated within a symbolic economy of queer objects and spatialities that were central to the Civil Rights Movement and the sexual revolution alike. In this era, public toilets and restrooms were known sites for queer sex. Especially popular in these spaces were anonymous acts of oral and anal sex typically performed through small openings, or "glory holes," that had been carved into partitions between toilets. The place where Ray first "put [his] hand" on Karolis, the toilet is a site of queer possibility. But it is also a fraught provenance of a queer past that struggles against a mountain of odds to realize a queer future. For some St. Mark's Playhouse audience members, the overwhelming presence of the toilet likely trod too close to St. Mark's Baths, a popular bathhouse and site of queer sex just down the street from the theatre.

As *The Toilet* was staged in cities like Los Angeles, charges of obscenity transcended the province of theatre review and began to pose a material threat to the future of the play. Like the eventual closure of New York City's queer bath houses, like Rustin's, Henry's, and Jones's arrests, like Foots's disavowal of Karolis, like Jones's subdual of the play's queer denouement, live productions of *The Toilet* called attention to the

Figure 3.2. LeRoi Jones the day his play *The Toilet* debuted at St.
Mark's Playhouse (Second Ave. and Eighth St.), December 13,
1964. Photo by Fred W. McDarrah/Getty Images.

precarity of queer futures. On March 4, 1964, the *Los Angeles Times* an-
nounced that *The Toilet* would open on a double bill with *Dutchman* at
Las Palmas Theater in Hollywood on March 24. Before *The Toilet* could
reach opening night, however, it was roundly evicted from Las Palmas
and was, in a matter of weeks, booted from the *Los Angeles Times* as well.
Having already begun to omit letters from the play's title in its ads, the
Times joined organs like the *Hollywood Citizens-News* in censoring *The
Toilet*. According to the play's producers, copies of the script were being
circulated with the "dirty words" circled.[80] The play's producers would
go on to sue the owner of Las Palmas, who had balked at the play's "lan-
guage and subject matter" and parted ways just one week prior to open-
ing. In a desperate attempt to salvage the life of *The Toilet*, they moved
the Los Angeles production to the Warner Playhouse.

But *The Toilet*'s troubles began to compound. On Thursday, March
25, only one day after its opening at Warner, eleven members of the Los
Angeles Police Department (LAPD) Vice Squad "raided the theatre."[81]
As the curtain closed on the performance, a gaggle of undercover of-
ficers revealed themselves and announced that they had taken tape
recordings of both plays that "proved they were obscene."[82] Upon con-
ducting further investigation, police discovered that the theatre's owner,

Myron M. Warner, was running the theatre under a previous operator's license, which officers deemed non-transferrable—a development that prohibited Warner from collecting fees for admission. Fortunately, performances of *The Toilet* and *Dutchman* proceeded, as audiences offered donations instead.

There is no question that in the muck of the Vice Squad's shake-down was one primary aim: the suppression of Jones's "obscene" content, namely the scenes of queer eroticism at the heart of *The Toilet*. In no uncertain terms, the LAPD warned Myron Warner to "banish the present tenant" if he hoped to be issued a permanent license.[83] Some semblance of reprieve surfaced when the City Police Commission granted Warner Playhouse a sixty-day permit that allowed paid performances of *The Toilet* to resume. The Commission made clear, however, that their investigation would continue throughout the life of the permit. Upon applying for a permanent license, the play's producers were forced into a period of waiting, one that cannot be disentangled from the racial and sexual histories of black patience, nor from the precarity of black and queer futures that such disciplinary maneuvers have engendered.

In August of the following year, these conditions of state censorship, surveillance, and policing continued to vex a production of *The Toilet* at Detroit's historic Concept East Theatre. Founded and directed by prominent actor, playwright, and director Woodie King—frequently dubbed the "Renaissance Man of Black Theatre"—Concept East (like the Free Southern Theater) began as an explicitly integrated theatre before adopting a more explicitly black nationalist stance. Opening on a double bill with *The Slave*, Concept East's production of *The Toilet* received affirming nods from critics. Even as the seventy-five-seat theatre-in-the-round layout positioned audiences in close proximity to the play's embattled setting and its contentious action, Detroit reviewers seemed less worried by the play's alleged obscenity. Writing for the *Detroit News*, Jay Carr found Jones's racy aesthetics a product more of "artistic fidelity" than of "sensation-seeking." Without this content, he argued, "'The Toilet' would be unable to project the crude power it undeniably has."[84] In a similar tenor, Louis Cook observed in the *Detroit Free Press* that while Jones's scripts are "more shockingly realistic in language and action than sophisticated people would be comfortable about," they reflect "what people think, if not what they say."[85]

But this affable reception deviated drastically from the reaction of another segment of Jones's audience: the Detroit Police Department Vice Squad. On Friday, August 13—perhaps itself an omen—the Squad issued citations to the Concept East production of Jones's plays, on the basis of "obscene, indecent and immoral language in a stage play."[86] Scheduled to appear in Court on August 19, the theatre hoped to salvage the life of *The Toilet* and, more than this, to salvage the life of the Concept East Theatre. By the end of the day, however, Concept East was ordered closed for a period of four months, accused by the Detroit City Marshall of "Distributing Obscenity." The machinery of censorship and suppression had struck once again, foreclosing the life and the future of *The Toilet*—and this time the life and the future of a radical black theatre. This turn of events highlights the precarity of black and queer futures and how, in the face of these structural conditions of ephemerality, the here and now assumes singular importance for black and queer subjects and also for black and queer art, performance, and institutions.

In a May 1963 article introducing Concept East, *Negro Digest* contributor William Barrow argues that the life of the "little" theatre is, at its core, a life of precarity. On this front, he explains, "The birth of a new theatre is an event usually as sad as it is hopeful. Sad because—in most cases—it is pre-doomed to a brief lifetime. Outside of New York City, professional or semi-professional 'little' theatre has seldom survived more than a few seasons in this country."[87] Performance studies scholarship takes as a central concern questions of ephemerality in critically analyzing the ontology of live performance. But Barrow's observations about the precarious life of the "little" theatre urge a closer examination of how the ontological precarity of performance transcends the live performance event. It also haunts the ontology, and impacts the futures, of the material spaces and institutions in which these performances are staged. If a structural threat of ephemerality and disappearance plagues the ontology of performance and the life of the "little" theatre, this threat is heightened by the presence of black and queer bodies and black and queer aesthetics. If we recall the bombing of a Free Southern Theater performance venue from the previous chapter, as well as the Free Southern Theater's own premature death, we might ask: What is the history of black theatre but a history of "little" theatres and therefore a history of precarious theatre and performance futures?

The Free Southern Theater's bombing and, later, death, the closure of Concept East, and the censorship, closure, and eviction of *The Toilet* signal how race, sexuality, and other categories of social difference compound the carefully studied operations of ephemerality and disappearance that have become cornerstones of performance studies scholarship. As tracing the social life of *The Toilet* makes clear, the historical practice of foreclosing minoritarian futures—and therefore of regulating minoritarian time—renders black/queer being and performance perpetual zones of precarity and paradigmatic sites of uncertain futures. This reality helps to clarify why, for black artists and activists working in the civil rights period, the here and now was imperative to the black artistic and political imaginations. Like Ray's performances of disavowal and Jones's disidentification with the play's queer resolution, the censorship and closure of *The Toilet* not only inhibited possibilities for black and queer futures, but also underscored the critical importance of the here and now for the social life of minority subjects as well as the social life of minoritarian performance. These symmetrical relations of compromised futures highlight the conceptual value of the present for analyzing the ontologies of black and queer life as well as the ontologies of black and queer performance.

The Queer Time of Apocalypse

In his satirical one-act play *The Baptism*, Baraka further highlights the insecurity of black and queer futures by situating the play within the time frame of an impending apocalypse. By the time the curtain closes on this satirical tragedy—set in a Baptist church—the minister and all of his parishioners are dead, with one notable exception: a character named Homosexual. Working to "extricate[] himself" from a "pile of bodies," Homosexual stands in the midst of calamity, the living in a sea of dead.[88] He has managed, it seems, to survive the catastrophe. Observing that the time is 1:30, and aiming to flee before someone "asks [him] to help clean the place up," he scurries off to cruise Bickford's, a local 42nd Street gay bar that would be closing in an hour.[89] With ballet steps, he exits the scene of destruction, adventuring toward what appears to be a promising queer future, an auspicious horizon fashioned from the remainder of catastrophe.

Having been unconscious, however, Homosexual is wholly unaware that a God-like divinity "will be destroying the whole works tonight. With a grenade."[90] Although Homosexual is oblivious to this impending catastrophe, the audience has been forewarned by a character named Messenger and is therefore aware of the insecurity that surrounds the queer future that Homosexual is anticipating. Glancing at his watch, Messenger observes, "It's twelve now . . . The man's going to start the fireworks as soon as the bars let out. Only three more hours."[91] As the apocalypse brews, the clock ticks. It is thus a matter of time before the queer future that Homosexual is imagining will likely be foreclosed and relegated to the dustbins of history. In the face of this impending apocalypse, the black queer present—that single hour that stands between Homosexual's traumatic past (near death) and his queer future (a looming apocalypse)—is a valuable moment, especially when considered in relation to violent histories of black patience and its existential threat to the possibilities of black and queer futures.

Opening on March 23, 1964, at New York City's Writers' Stage Theatre, *The Baptism*—like the other two plays in Jones's black queer trilogy—highlights the paradigmatic importance of the black queer present. Like these plays, too, it calls attention to the erotic life of black flesh during the Civil Rights Movement, while portraying the complex dynamics of black leadership in this period. With all of this in mind, I want to turn now to the events that precede and instigate the play's apocalyptic resolution. By briefly plotting the course of the play's catastrophe, we get a clearer sense of the complex visions of queer time, the erotic life of black flesh, and the nuances of black leadership that Jones envisions in the play.

Set in an "almost well-to-do arrogant" Baptist church that is plagued by opportunism and an unabashed use of the sacred for personal gain, *The Baptism* is especially concerned with religious hypocrisy, or what Jones refers to as "priest-craft." Priest-craft, according to Jones, is the process by which "religious ideals" are "twisted by the people who are supposedly keeping those ideals alive."[92] A key cog in the machine that fuels quests for power and domination within structures of institutionalized religion, priest-craft operates in *The Baptism* as a sexualized technology of social control. In other words, the institutional rituals and protocols of religion function as tools of sexual regulation that enable

the church to manage erotic engagements with the flesh and to discipline illicit sexual behavior. Ironically, throughout the play, it is the practitioners of "priest-craft" who most actively traffic in the very economies of erotic flesh that their craft is designed to interdict. Minister, the church's leader, is a telling example.

Like Ray Foots in *The Toilet*, the leader struggles with, suppresses, and disavows his desires for same-sex intimacy. In a telling prayer that opens the play, he offers audiences a glimpse into his complex desires while offering a compelling, though coded, confession about the furtive nature of his "priest-craft":

> Break the chain of ignorance. Lord, in his high place. What returns to us, images, the tone of death. Our cloak of color, our love for ourselves and our hymns. (*Moves to center of the stage bowing, with folded hands at his chin.*) Not love. (*Moans.*) Not love. The betrayed music. Stealth. We rise to the tops of our buildings and they name them after us. We take off our hoods (*Removes red hood*) and show our eyes. I am holy father of silence. (*Kneels.*)[93]

These opening lines of *The Baptism* gesture toward Minister's dissident practices of black leadership, carried out in the name of religion. The "holy father's" sounds and images enter a symbolic feedback loop in which they return as "images" and "tones" of death, and are motivated by a love that is "not love," but a love of self that amounts to narcissism. "Stealth. We rise to the tops of our buildings," he contends, "and they name them after us." Here stealth and the imagery of rising that it evokes signal the problematics of black leadership grounded in hagiography and obsessed with egotistic ambition. But "stealth" not only serves as a critique of avarice or selfishly aspirational styles of black leadership, but conjures images of secrecy, inconspicuousness, and difficulty to detect. These particular meanings of the term gain currency in Minister's opening supplication. In the act of removing his hood, the leader hints at concealed elements of himself that do not accord with the regulations—sexual or otherwise—to which he subjects his parishioners. Among these cloaked dimensions is Minister's attachment to same-sex desire, a revelation that sheds light on his self-proclaimed status as the "holy father of silence."[94]

On the heels of this prayer, Minister engages in an illuminating but contentious dialogue with Homosexual. Referring to the leader as "Tarzan of the apes of religion," "Lothar in the world," "Weakling and nonswimmer," and "Manager of the Philadelphia Phillies," Homosexual casts the leader as savage, cartoonish, weak, and a member of the managerial class. Notably, he concludes his string of insults by claiming that Minister is "not a good person to sleep with," adding that he "gags on all flesh. The flesh hung in our soft sleep. That thin Jewish cowboy."[95] Despite Homosexual's long menu of insults, Minister focuses his rejoinder on the sexual claims. Addressing Homosexual as "my kindly queen," he asserts, "I fuck no one who does not claim to love me. You are less selective."[96] Running in place, he continues, "When you are strapped in sin, I pray for you, dear queen. I stare with X-ray eyes into your dark room and suffer with you. I smell your lovers, and pray that you be redeemed. I bathe them in my holy water, and they are as baptized as children."[97] Scrambling to take the moral high ground, Minister juxtaposes his own sex acts with Homosexual's. But rather than marking a clear distinction, his comparisons instead expose a glaring proximity between his behaviors and the queer sex acts he derides. The leader's recollections of smelling Homosexual's lovers, of bathing them in his holy water, and of staring into Homosexual's dark room index a queer web of erotic relations that are consummated in the domain of sensory perception. From the taste of "hung" flesh in his mouth to acts of touching, smelling, and gazing at Homosexual and his "lovers," the leader's performance of disidentification is ultimately unraveled by his own acknowledgment of these embodied, sensory attachments to same-sex desire.

In the course of Minister's row with Homosexual, a "handsome, almost girlish" fifteen-year-old named Boy enters the church.[98] Having come to be baptized, he weeps and sprawls on the floor. While Minister kneels down to comfort Boy, Homosexual removes his pants, exposing a pair of red leotards. Noticing that something has attracted the young man's attention, Minister sees Boy "looking over [his] shoulder at HOMOSEXUAL."[99] Troubled by Boy's interest in Homosexual, in a fit of jealous rage Minister "rushes" Homosexual, and they begin to "scuffle."[100] "You are becoming unpleasant Miss Cocksucker," the leader grumbles, "and I don't like it."[101] Bearing in mind his history of relating to Homosexual and his lovers through prayer, of bathing them in holy

water, and of "baptiz[ing] them as children," it is hardly shocking to discover Minister hankering to pray for and baptize Boy. Seen this way, his command to Boy to "fall on me, my son . . . fall on me praying" registers less as a genuine gesture of religious leadership and more as an oblique sexual advance refracted through the practice of religion and the deceptive grammars of priest-craft.[102]

Minister's desire for Boy's body indexes the fundamental role of same-sex desire and erotic flesh in *The Baptism*, of course, but also their broader presence in this era of modern civil rights activism. Jones's depictions of erotic flesh proliferate as the play develops. While Minister seeks to pray for and baptize Boy, Homosexual, in a much more explicit register, propositions Boy for a dance and entreats him to "fuck everything and everyone."[103] This burgeoning field of sexual desire—one set at the altar of a church, a key staging ground of the Civil Rights Movement—expands when a character named Old Woman enters the church, claiming to have witnessed Boy sinning, and more specifically masturbating, while she was standing in her window. Like Homosexual and Minister, she, too, is sexually attracted to Boy, and petitions him to join her in a "slow off-time seductive dance" that she performs while removing her clothing.[104] Caught in a web of dynamic desires for his body, Boy confesses to these sins. In a quick turn of events, Minister, Old Woman, and a coterie of women who have joined them in the church—claiming that Boy is the father of their children—resolve to murder Boy, allegedly for masquerading as the Son of Christ. Homosexual alone refuses to participate in the murder. And though he attempts to intervene on Boy's behalf, the mob of worshipers assault him, and resume the path toward crucifixion. But before they can murder him, Boy reveals that he is indeed the Son of Christ. Removing a silver sword from his bag, he kills all of the parishioners, with the exception of Homosexual.[105] Having survived the tragedy, and hoping to cruise a bar before last call, Homosexual journeys to 42nd Street. Strutting off into the night, he seems to stride toward the possibility of a queer future—one that will perhaps include Boy, who has at least a modicum of interest in Homosexual, who has confessed that "thinking about God always gives [him] a hard on," and who concludes ultimately that "nothing will make me forsake this flesh."[106]

The Baptism's scenes of erotic flesh acts and queer desire signal the importance of bringing an analytics of flesh to the study of black social

movements that is attuned to both the political and the sexual economies of that flesh. As I show throughout this book, the civil rights body was a key instrument for demonstrating how white supremacy has historically terrorized black bodies. Working from a faith in the metonymic capacities of injured black flesh to serve as evidence of anti-black violence, activists transformed the black body into a staple of civil rights activism. Still, as black theatre in this period demonstrates, the political utility of black flesh took root in relation to a thriving archive and repertoire of erotic flesh acts as well. But because activists recognized and strained against modernity's habit of tethering black subjects to the arena of the body within its Cartesian mind/body split—effectively rendering the idea of black reason, and thus of black humanity, unthinkable—these erotic acts were often suppressed and disavowed. Through an adherence to Victorian styles and ideologies of dress and restraint, activists hoped that their embodied performances of human standardization would revamp this intentioned schism between black bodies and black minds, and would, by extension, aid black people in securing a more even access to the entitlements of full citizenship. The histories of these embodied struggles against problematic constructions of black flesh remain important dimensions of civil rights scholarship. At the same time, plays like those in Jones's black queer trilogy are equally valuable because they furnish a different way of conceptualizing flesh and body in this era of civil rights activism. More than matter open to the workings of spirit and religion, or trained to perform the choreographies of civil rights protest, black flesh moved within a charged sexual economy that is just as meaningful as the religious and political economies prioritized in conventional analyses of embodiment in this period.

Throughout *The Baptism*, Minister and his parishioners constantly grapple with this tension between mind and body, flesh and thought. Along these lines, Minister posits that the "place of the soul is its virtue. It is man's music. His move from flesh."[107] Elsewhere, he bemoans the "evil pleasures of the flesh," the "sins of the flesh," in addition to the "evil the body is."[108] This rendering of soul as superior to flesh, of flesh as a pathological agent that warrants management and suppression, is a theme that pervades *The Baptism*. In fact, it is ultimately Boy's obsession with flesh—the flesh of his own penis, the erotic flesh of God, the flesh of the coterie of women he'd allegedly impregnated—that provides

the justificatory logic for his crucifixion. But even as Minister and his mob label Boy a "demon of hot flesh," the irony is that each of them is nearly obsessed with his flesh.[109] Minister brushes Boy's hair "softly and tenderly," strokes his head, and kisses his feet; Old Woman calls him "Holy cock of creation"; the chorus of women dubs him the "big stroker of the universe."[110] Despite, and likely because of, this swelling tide of erotic desire for Boy's body, the congregation's failure to take ownership of their desires leads them down a path of murder. Negotiating the competing pressures of erotic desire and the subterfugal logics of priestcraft, they project their repressed and disavowed expressions of carnal desire onto the body of the young boy, making him a sacrifice for their own repressed sexual desires and pleasures.

Like his fellow parishioners, Homosexual is also attracted to Boy. In a bluesy and seductive tune, he pines, "Drill me baby. Drill me so I don't need to be drilled no more."[111] But what distinguishes Homosexual's erotic attachments to queer flesh from the other congregants' is his unabashed embrace of these desires. Dubbing himself "the Willie Mays of the queers," rather than police or disavow the erotics of black flesh, Homosexual contends that "flesh must make its move." "I am the sinister lover of love. The mysterious villain of thought," he exclaims. "I love my mind, my asshole too."[112] Homosexual's parallel love of his mind and "asshole too" enacts a duality of love that troubles modernity's overrepresentation of blackness as body and whiteness as mind. He finds wholly unnecessary the denial of body and flesh as a reasonable means of indexing and verifying the worth of black people's humanity.

Such a dynamic love of "mind" and "asshole" was certainly not breaking news in the Civil Rights Movement. Nor was it on the front page of newspapers. And yet, paying attention to the erotic life of black flesh in this era furnishes a different vantage point for more fully grasping the complex socialities and the multiple modes of desire that shaped the lived experiences of the civil rights body. For the black queer subjects in Baraka's trilogy, the violent Afro-futurism that animates the racial project of black patience forecloses possibilities for black queer pleasure as well as for black queer futures. In the face of this routinized disappearance and ephemerality, we can better appreciate how those consensual relations of intimacy consummated in the black queer present provide paths to structures of queer relationality that, however temporary, can afford a turn in

the good life—probably not the good life of liberal democracy, but the goodness of black queer life that comes in and through an embrace of the shoulder, a holding of the head, a stroll to cruise the local gay bar. There is power in the now. There is possibility in the present.

And yet, because the pressures of respectability and sexual propriety worked to conceal erotic desire in the Civil Rights Movement—especially where those desires were of a queer sort—these yearnings have often been corralled into the chambers of obscurity and therefore can be, for the contemporary researcher, elusive at best. Still, if we are to take seriously the radical project of "making civil rights harder," we must probe the depths of the movement's archive and repertoire in search of those wayward desires, those rogue transactions in the flesh, that might have been suppressed but are there nonetheless waiting for their moment of articulation. It is here in the depths of the movement's archive and repertoire that we find LeRoi Jones's black queer trilogy. And it is here, too, where we discover Paul Carter Harrison's *The Experimental Leader*, written on the other side of the Atlantic.

Paul Carter Harrison: Civil Rights and Transnationalism

In concentrating on Amiri Baraka's queer trilogy, my analysis has been situated within the geographical borders of the US nation-state. But the work of theatre and performance to explore the temporal dimensions of black political and erotic desire was not confined to these boundaries, nor was the Civil Rights Movement itself. Like the movement, the theatrical project of engaging the erotic life of the civil rights body was a transnational undertaking—one central to the political and artistic imaginations of black expatriate playwright, director, and scholar Paul Carter Harrison. Often regarded as "the spiritual and philosophical father of black theater," Harrison is key to understanding the importance of theatre to the Civil Rights Movement and the critical role of black patience in racial formation.[113] As racial tensions continued to fester in the 1960s, Harrison relocated to Europe, where he would live for seven years. Based primarily in Amsterdam, he continued to produce plays, essays, and other works that engaged and critiqued the structures of anti-blackness that the Civil Rights Movement was working to disassemble.

In August 1963, as Harrison was hard at work on "Impressions of American Negro Poetry," a screenplay starring black poets from the United States, he was accosted by a group of "Left Wing radical scholars" with an unexpected request: would he lead a sympathy March on Washington to the US embassy in Amsterdam? Harrison did not, at the time, imagine himself an activist. But after much persuasion from the group, paired with the surprise that James Baldwin and black visual artist Harvey Cropper would lead similar marches in Paris and Sweden, he agreed to headline Amsterdam's march. Harrison was no stranger to exploring racial issues in his work, but the march marked his first experiment in formal political protest. Led by two policemen on horseback and flanked by a modest throng of nearly thirty protesters, on August 23, 1968, Harrison began the "March on Washington" to the US Embassy in Amsterdam.[114] As the three-mile journey proceeded alongside canals, past museums and breweries, the number of protesters began to swell. Upon arriving to the Embassy, the group had grown to almost three thousand, making it, according to Harrison, the biggest support march in Europe.

Believing that his job was done, once at the embassy Harrison was blindsided with yet another request from the radical group: would he deliver to the door of the embassy a signed petition to "Let My People Go"? Though reluctant, he accepted what seemed a Herculean task. To his surprise, when the door opened, he encountered a sea of cameras and an eager cache of journalists. The consummate student of theatre, the disinclined leader perked up and responded "spontaneously to [the] lights," staging "a bombastic, uncharacteristically animated performance condemning the United States for tolerating the abuses to black folks since slavery."[115] On the heels of this improvised "60-second tirade," Harrison delivered the petition and exited the embassy to the roars of a cheering crowd.

In the years following this march, Harrison's interest in the Civil Rights Movement expanded. Although nearly four thousand miles away from home, he and other members of Amsterdam's black expatriate community remained intimately aware of and connected to the movement. "We were not just living there and not being aware of what was going on [in the US]," Harrison explains.[116] Comprising about eight "club members"—including visual artist Sam Middleton; avant-garde

dancer and choreographer Eleo Pomare; poet, painter, and musician Ted Joans; Donald Jones, the "Sammy Davis, Jr. of the Netherlands"; dancers Billy Wilson and Sylvester Campbell; naturalistic writer Big Phil; and later abstract artist Bill Hutson—this collective of black expatriate artists gathered nearly every evening for a drink around 5 p.m., usually at Hoopman's on the Leidseplein (Leiden Square). Because icons like Dr. Martin Luther King Jr. and Nina Simone were not uncommon visitors to Amsterdam in the 1960s, this "collection of worldly black ex-pats" was often joined by other notable artists, activists, and intellectuals including James Baldwin, James Earl Jones, and John A. Williams, whose 1967 novel, *The Man Who Cried I Am*, is partly set in Amsterdam.

Harrison's stint in Amsterdam included regular return visits to the United States. These trips were motivated, in large part, by his desire to escape the bruising cold of Amsterdam. But they were as inspired by the brutal climate of racial antagonism conjured up by the city's annual ritual of using blackface to represent Zwarte Piet (Black Pete), St. Nicholas's black helper. Once tucked among New York City's relatively more modern heating systems, Harrison plugged into the city's buzzing theatre scene. In addition to having staged readings and productions of several of his own plays—including *The Post Clerks* in New York City and *Pavane for a Deadpan Minstrel* in Buffalo—the itinerant artist was also invited to join the Playwright/Directors Unit at The Actors Studio. In 1964, that signal year for black theatre and for LeRoi Jones, Harrison caught a production of Adrienne Kennedy's *Funnyhouse of a Negro*, which he found "stunning."[117] Soon after, he received a complimentary ticket to another black-authored play that was opening at the Cherry Lane Theatre off-Broadway: LeRoi Jones's *Dutchman*, which, according to Harrison, drove the primarily white audience to their feet "with thunderous applause."[118] Harrison "could not believe that a play so dramaturgically flawed would receive such consensual validation."[119] The next day, in fact, he traveled to Jones's Lower East Side loft to air his grievances with the playwright. But his presence was dwarfed by a gaggle of reporters and photographers and the sounds of phone calls that had begun to crescendo in response to *Dutchman*'s success. Harrison left Jones's loft unnoticed.

Nearly forty-seven years later, Harrison's troubles with Baraka's formal choices were revivified when, at the behest of black theatre guru

Woodie King, he was invited to direct Baraka's final play, *The Most Dangerous Man in the World*, an elegiac homage to black intellectual and activist W. E. B. Du Bois. Concluding that Baraka "did not adhere to any formal structure" and that "the script's merely a grid to serve his words," Harrison suggested a major revision. In particular, he recommended the form of the choreo-poem. Situated at the crossroads of theatre and poetry, this hybrid genre was popularized nearly four decades prior with the production of Ntozake Shange's *For Colored Girls Who Have Considered Suicide / When the Rainbow Is Enuf*. As Harrison saw it, the choreo-poem would allow Baraka to capitalize on his greatest strength: poetry. Baraka's outright rejection of these proposed revisions reactivated Harrison's decades-old qualms with Baraka's theatrical aesthetics. Recalling his departure from Jones's loft almost forty years earlier, Harrison abandoned his work on Baraka's play, which opened to mixed reviews in June 2015—one year after Baraka's death. Despite these tensions between Baraka's and Harrison's formal inclinations, during the Civil Rights Movement, they shared an interest in exploring the figure of the queer black male leader and the relationship between time and queer erotics. Though they are not usually considered together, the thematic and formal synergies between Baraka's black queer trilogy and Harrison's one-act play, *The Experimental Leader*, warrants their consideration together here.

Experimental Leaders and Queer Methods

Amsterdam was, in many ways, the perfect location for Harrison to write *The Experimental Leader* and to cultivate the queer and erotic content of its plot: a city, in his words, of "unrepressed libidinal desire," where the nights were filled with "carnal adventures."[120] Harrison was, by this point, already familiar with the beauty and possibilities of queer sociality. For instance, on the heels of completing his first year of graduate studies at The New School, he joined his friends Herb and Josh for a trip to Provincetown, Massachusetts, a "popular East Coast summer-hang for theatre artists and the LGBT community." "Though not lovers," Herb and Josh made the trek to Provincetown together and invited Harrison to join them for a month. In Provincetown, Harrison interacted with "many gay men and women," several of whom were actors with

interests in "what a Negro playwright was writing in those times." Once in Amsterdam, Harrison could count among his closest friends gay artists like Eleo Pomare, a dancer and fellow expatriate Harlemite. And throughout his travels in Europe, he often frequented bars that catered to, or were owned by, gay-identified individuals. Harrison's movements across these queer geographies likely proved valuable in imagining the figure of the queer civil rights leader and the erotic life of the civil rights body.

Where *The Experimental Leader* has not been met with critical silence, it has often been received with less-than-favorable reviews or, worse still, cavalier dismissal. According to literary critic Steven R. Carter, *The Experimental Leader* is a "minor" play that contains "some silly dialogue and sophomoric humor" but is ultimately "muddled and poorly developed."[121] Carter is among a handful of scholars who have made any reference—usually in passing—to Harrison's one-act. However, *The Experimental Leader* offers one of the most nuanced and intriguing engagements with black queer erotics, time, and civil rights leadership to emerge from the movement, and it illuminates the transnational itineraries of civil rights activism and black theatre in this period.

In *The Experimental Leader*, we find a perhaps surprising—or, we might say, experimental—portrait of black civil rights leadership and sexual desire. When the curtains open, the audience meets a character named Leader, the de facto head of the revolution that festers throughout the play—one whom Harrison refers to as a "James Baldwin figure."[122] The audience learns in the opening sequence that Leader is not only black but also queer. With "effeminate gestures and voice," he stands adorned in only his underwear, striking a series of "suggestive" poses.[123] This presentation of a civil rights leader engaged in spectacular performances of queer gesture, voice, and flesh unsettles the conventional iconography of civil rights leadership and the heteronormative logics of black masculinity in which they are grounded. Recalling the conventions of Greek tragedy, Harrison incorporates a young character named Messenger, who relays messages between Leader and the revolutionary masses (whose increasingly impatient voices are heard from offstage). Messenger warns Leader that if he fails to pacify the masses, the outcome will be tragic—a warning that recalls LeRoi Jones's *The Baptism* and its visions of apocalyptic black and queer futures.

Invested in quelling the ballooning impatience of the masses, T.S. and Samantha—a black man and white woman who serve as representatives of the Society for Humane Integration Techniques, or "S.H.I.T."—meet with Leader, claiming to have developed a "program to relieve the whole stinking mess."[124] When the "two S.H.I.T.s" enter, they find Leader "elegantly attired, his face generously powdered and eyes penciled."[125] Leader's keen interest in T.S., and obvious disdain for Samantha, are gestured toward in the amiable greeting he extends to T.S. and the cold shoulder he turns to Samantha. This contrasting response is as much a product of Leader's sexual interest in T.S. as of his misogynistic, homopatriarchal dismissal of Samantha's place in the movement. "I am always surprised to find a woman in the struggle," he proclaims. "I should think that Sam would have more urgent feminine functions to discharge."[126] Samantha fires back by suggesting that Leader himself is a woman: "As you much know, sir, when you get used to it, there's nothing to it, really."[127]

On the heels of this testy introduction, Samantha and T.S. proceed to unveil the program they'd engineered to contain the impatience of the masses. With aplomb, T.S. declares, "It's time for action, sir." But Leader has another kind of action in mind. Turning to Samantha, he offers an interesting suggestion: "Tell you what, baby, why don't you go out and pacify them while he and I get down to serious business." Hardly ruffled by this misogynistic and erotic sleight of tongue, Samantha retorts, "Any business concerning you and him, most certainly is my business."[128] With the clock ticking, Samantha unveils the details of the S.H.I.T.s' experiment. In order to suppress the masses' political unrest, they propose rerouting their "energies" into more productive channels:[129]

> SAMANTHA: As exhibits A and B we manifest body tension at no less and no greater than the 0 plus or minus tension threshold. Isn't that grand??? This means that our energy has been equally displaced through a fixed channel of the body. Thus, no wastage and our energy is restored. The Conservation-Recouperation quotient is then maintained constant at 99.9%. It's that extra 1/10% that does the trick.[130]

According to the S.H.I.T.s' results, the key to regulating the masses' swelling impatience was (hetero)sexual intercourse. Offering themselves

as evidence of the experiment's "positive results," T.S. implores Leader, "Look at me, sir, I can even walk a straight line." "He walks a beautifully straight line," Samantha chimes in. The metaphor of the "straight line," which recurs throughout the play, ostensibly corroborates the success of the S.H.I.T.s' experiment. But Leader is not so certain that T.S. walks as "straight" a line as he and Samantha are claiming. When his incredulity becomes clear, Samantha accuses Leader of impugning the duo's integrity. "It's not your integrity I want to expose," Leader replies, "only your methods."[131]

When Leader casts doubt on both the experiment and Samantha's relevance to it, T.S. suggests that they are all "grouped in an essential threesome." "Listen, baby," Leader replies. "I'm not aware of any essentials beyond the merits of two . . . no resolution can be held by three. Too chanc-ie . . . (places arm around T.S.'s shoulder)."[132] Leader learns that the first variable in the experiment is "energy," which is housed "in the body." "So body and energy," he ponders, "make up one independent variable since energy is housed in the body. The body is a kind of generator, right"?[133] "That's about right," T.S. replies. After this confirmation, Leader instructs T.S. to remove his jacket and begins a test of the S.H.I.Ts' results; this visibly frustrates Samantha. "I don't see what any of this has got to do with organizing those wretchedly confused people out there." Casting yearning glances at T.S.'s body, Leader warns Samantha that she has "no interest to the movement," and invites her, once again, to "evacuate the premises."[134] Beginning to massage T.S.'s neck and shoulders "very gently," and moving his hands to the young activist's chest, Leader begins "testing" their positive results. "Now is this the body you speak of?" he asks. "And inside this Body is the immutable, independent variable?" T.S. confirms these parts of the experiment and begins to speak "phlegmatically," his body "relaxing" and "appearing drowsy."[135]

Shocked to learn that the only dependent variables in the experiment were "man" and "woman," Leader inquires, "Is that all?" "Man and Woman . . . and you call this a controlled experiment? Take off your pants."[136] Unsettled, Samantha stands between T.S. and Leader. Attempting to disrupt the exchange of energy unfolding in Leader's own experiment, she sticks out her chest, grabs Leader's hands, forces him to rub her breasts, and eventually lifts her skirt in a desperate effort

to conscript Leader into a heteronormative economy of sexual desire. This absurd performance is put in the service of interrupting the queer desires that Leader's revised experiment has elicited from T.S. and his straight-walking body. This outcome threatens to upend the validity of the S.H.I.T.s' "positive results." Informing Samantha that her particular "part of the experiment doesn't interest" him, Leader resumes his efforts to test the results. When he requests again that T.S. remove his pants, Samantha "senses a loss of control over T.S." In a last-ditch effort to reclaim power over T.S.—his body and his sexual desires—she rips off his shirt and tie, leaving him adorned only in his underwear, socks, and shoes, and thus resembling the image of Leader the audience discovers in the play's opening scene.[137] In this brilliant moment of parallelism, the embodied commonalities between the two civil rights leaders are striking.

When Leader asks T.S. again if there were any variables beyond "Man and Woman," T.S. answers, "No." Leader resumes his intimate exploration of the young activist's body, ordering him to strike a series of gestures that mimic the queer gestures Leader had performed in the play's opening. "Arms out to side at shoulder length . . . Arms forward . . . Hands on waist, one half turn right . . . Hands-on-Wrist-Bend-Forward."[138] Zooming in on T.S.'s thighs and buttocks, Leader finally concludes that the S.H.I.T.s' original "variables are rigid" and that there was still "one variable untested."[139]

> LEADER: I'm for any program that thoroughly liberates tension. You
> must know that, T.S. (he continues to rub T.S.'s chest) . . . I'm for your
> program, but only when it is fully tested and approved.
> SAMANTHA: The program is already proven. Now your only concern is
> to give it to the people.
> LEADER: (T.S. breathes harder)
> Now baby, are we going to get ourselves together so we can initiate a
> real program?
> (T.S. nods affirmatively)
> The folks are counting on us, right?
> SAMANTHA: T.S. honey, remember what we've been through. Be care-
> ful, now.
> LEADER: I think we understand each other, don't we? (T.S. nods).[140]

Hoping that T.S. will admit the limitations of the S.H.I.T.s' research design, specifically its "rigid" variables, Leader invites him to have "a man-to-man talk." "You've got this Man-Woman variable," he asserts. T.S. nods. "[W]ell, what's missing?" "Nothing," Samantha interjects, commanding T.S. "not to say another word." But Leader persists in pressing T.S. to admit that other variables are needed: "C'mon, Man-Woman . . . Woman . . . Man . . . let's have it, what's left . . . say it for me . . . C'mon it's on the tip of your tongue. On the edge of your mind. Let's hear it! I'll help you . . . Man-Woman . . . and now, Man . . . yes . . . Man . . ." "Man-Tan," Samantha blurts out. "We forgot about Man-Tan."[141] Annoyed, Leader offers a curt reply: "As long as she is holding the reins to your zipper, I'll be damned if I'm going to endorse such a program for the folks."[142]

At this point in the play, Leader's experiment has already revealed the limitations of the S.H.I.T.s' research design and results. To test the S.H.I.T.s' original findings, Leader inserts a queer variable. His turn to queer methods uncovers queer outcomes unthinkable within the (heteronormative) parameters of the S.H.I.T.s' original experiment—in the same way that methods like queer archivalism can help to unearth obscured and radical dimensions of the Civil Rights Movement and thus to make civil rights harder. Recognizing that both Leader and Samantha are invested in his body for their own selfish reasons, T.S. becomes enraged, staging a diatribe that is interrupted by an illuminating Freudian slip: "We gotta move forward together . . . the journey is not far to the threshold of . . . *erection* . . . er, I mean, resurrection."[143] With a heightened sense of assurance following this gaffe, Leader retrieves a gun and entreats T.S. to shoot Samantha. As if T.S.'s slip had supplied the missing variable, Leader grabs the hand holding the gun and "a bullet flies into Samantha's side," thus bringing this experiment and this triangle of mixed sexual desires to an instructive if tragic end.[144]

With Samantha dead, Leader attempts to retrieve the gun. But refusing to "give up [his] power," and bearing the weight of queer shame for having taken a turn in the black queer present, T.S. accuses Leader of being "full of . . . SHIT" and concludes that "I'll never bend my ass over a stool again."[145] When T.S. storms out of the room, the leader retaliates by phoning the police, informing them that a "mad Negro has just slayed a White lady . . . I think it was a passion killing."[146] This constellation

of events paints a striking portrait of black leadership, time, and queer intimacy. Here, T.S., "a mad Negro" who allegedly shoots "a White lady," signals the imminent rise of a more militant black male leader as black nationalist thought and the Black Power Movement began to gain more popular appeal. Further, in expressing his break with Leader and the S.H.I.T.s' program, T.S. not only registers a political shift, but in doing so makes a firm commitment to never "bend [his] ass over a stool again." This remarkable declaration is a performative utterance that seeks to keep queerness at bay in his own future and the looming futures of black leadership and black social movements. But as much as T.S.'s machismo is intended to stage a political and erotic departure, and to allay his feeling of queer shame, this performative utterance marks and preserves evidence of a queer past that places him in closer proximity to Leader than he cares to admit. In the final analysis, the rising Black Power–like leader with the gun—much like the civil rights leader he labors to depose—admits a queer past, but is hellbent on preventing this past from becoming a queer future. Harrison's fraught resolution captures the threat of ephemerality that routinely enshrouds black queer futures while underscoring the value of the black queer present. Examining plays like Amiri Baraka's black queer trilogy and Paul Carter Harrison's *The Experimental Leader* provides a new epistemological basis for understanding the Civil Rights Movement as a body-on-the-line-revolution. Attending to the queer erotics of the civil rights body provide a clear sense of the sundry and radical workings of body and flesh in this period as black people strained against the violent enclosures of black patience.

4

Picturing White Impatience

Theatre and Visual Culture

This book has been arguing that theatre is a vital yet under-recognized technology of civil rights activism, one that exposes the violent workings of black patience. I build on that argument in this chapter by showing how the routine occlusion of theatre from civil rights historiography and cultural criticism limits our understandings of visual culture in this period. If theatre is nothing else, it is an art form that summons and makes demands on the eyes of its audiences. It is a genre that facilitates acts of looking. While television and photography were the chief instruments for circulating images of the movement to local, national, and international audiences, I will show that theatre was likewise an important visual technology that afforded international audiences a unique vantage point for seeing the movement and for understanding the violent cultures of black patience.

Central to the visual grammars of civil rights activism was a pervasive desire for black spectacle. Spectacular images of black bodies that had been injured by white supremacist violence were hallmarks of photographic and televisual practices in this era. The visual horrors of black people being drenched by fire hoses, attacked by dogs, and assailed by police officers were thought by activists to offer a viable strategy for eliciting sympathy from viewing audiences across international communities. They hoped and believed that these portraits of black injury would function in the vein of what cultural theorist Roland Barthes has called the *punctum*; that is, the element of the image that "stings," "pricks," and "arouses great sympathy" among its viewers.[1] As civil rights activists fought to garner cross-racial, international support for the movement, these images were key to exposing the scope and scale of black suffering at the hands of white supremacist violence. Such spectacles of black injury, they believed, would facilitate modes of intersubjective relation

between spectacle and viewer that might usher into being a viewing subject that was more empathetic to black people's struggles for "freedom now." But as Barthes points out, the punctum "has no preference for morality or good taste" and can therefore be "ill-bred."[2] As activists marshaled images of spectacular violence to expand public support for the movement, these visual products were often monetized and transformed into prized fodder for cameramen and the media-industrial complex for which they worked. Clambering to increase its numbers of viewers and subscribers, and therefore to maximize its profits, this arm of capitalist modernity understood that these horrific spectacles of injured black bodies pleased the visual palate of the mid-twentieth-century cultural imagination: they satisfied both a craving for horror and a taste for profit.

And yet, during the Civil Rights Movement, black playwrights like James Baldwin, Alice Childress, Douglas Turner Ward, and Lorraine Hansberry used theatre and performance to practice visuality otherwise. Rather than fix the gaze of the international community on damaged black people in hopes of establishing intersubjective pathways of sympathy, these dramatists set out to improve racial relations by focalizing whiteness and by shifting the public gaze to white people. For them, spotlighting whiteness and white people would foster a wider consciousness of how the "Negro problem," as it were, was in reality a problem of whiteness. Using theatre as a visual technology, these playwrights crafted techniques of "countervisuality" through which they made a radical claim to "the right to look" at whiteness.[3] In doing so, they creatively unsettled a deep-seated fetish for black injury that shaped the visual conventions of mid-twentieth-century media culture.

In using the theatrical stage to visualize whiteness and white people, this coterie of black playwrights uncovered how, despite white supremacy's ancient demands for black patience, white people have demonstrated a historical penchant for impatience—in terms of a habitual refusal to wait as well as a tendency to engage in violent performances of affect grounded in the racial entitlements that whiteness affords. This racialized refusal to wait, or to engage in long-suffering, moves within a dual economy of time (i.e., refusing to wait) and affect (e.g., anger and eagerness) that is germane to white power's conditions of possibility. Motivated by and reinforcing the supposed superiority of whiteness and

white people, this historical refusal to be patient emerges from and rei-
fies a historical network of affective performances and dispositions that
constitute what I call *white impatience*, a performative convergence of
time, affect, and racial power that is critical to the making of whiteness
and the construction of the modern racial order.

In the sections that follow, I argue that black playwrights like Alice
Childress, James Baldwin, Lorraine Hansberry, and Douglas Turner
Ward used theatre and performance to paint countervisual portraits of
whiteness and white people. In doing so they disrupted the racial con-
ventions of visual modernity and generated temporalities of aesthetic,
affective, and performance experience—from the length of a play to
racial content that angered white audience members—that exposed the
violent cultures of black patience while revealing the constitutive role
of white impatience in modernity's procedures of racial formation. To
get a clearer sense of how these countervisual portraits of whiteness
ignited white impatience, we can consider a review of James Baldwin's
1964 play, *Blues for Mister Charlie*. According to this reviewer, *Blues*
was "a hard play for a white man to take . . . and enough of them have
stayed away from the ANTA Theater to put *Mister Charlie* [*sic*] in im-
minent danger of folding."[4] In the United States, black people have
often been forbidden in law and social custom from looking at white
people. We can consider, for instance, the existence of "reckless eye-
balling" laws that disciplined black subjects for looking at white people
in ways that were deemed improper.[5] When considering this racialized
regulation of black vision, it comes as little surprise that Baldwin's sub-
jection of whiteness and white people to visual scrutiny—his attempt
to "force [his] brothers to see themselves as they are"—outraged audi-
ences and critics alike, putting *Blues for Mister Charlie* in "imminent
danger of folding"—or, we might say, of dying.[6] These racialized modes
of reception signal the centrality of affect—in this case, white rage and
anger—to the performative production of race. And they clarify how
the lives and futures of black theatrical objects are as precarious as the
lives and futures of black people. In the face of this structural threat
of death, ephemerality, and disappearance, the moment of live perfor-
mance, the here and now, holds a special value for the black theatrical
object, just as it has for the black people and the black performances
that I have considered throughout this book.

I begin this chapter by examining the relationship between theatre and visual culture in the Civil Rights Movement, and by making a case for more firmly situating theatre as a key part of this critical relation. I then consider how the historical practice of circulating visual depictions of injured black bodies as a means of rallying support for black social movements has engendered a visual icon that I call the *telescopic black body*. By this I mean a racialized technology of seeing that transmutes injured black bodies into frames through which one can see and better understand the racial problem. In the final sections of this chapter, however, I turn to a group of black playwrights whose innovative aesthetics of countervisuality unsettled problematic uses of the telescopic black body while mapping the startling unruliness of white impatience. Working within mid-twentieth-century visual and cultural economies that thrived on spectacular images of injured black people, these playwrights tapped into the possibilities of black opacity, staging what black performance theorist Daphne Brooks has called "Afro-alienation acts"—that is, acts that call attention to the "hypervisibility and cultural constructions of blackness," that "render racial and gender categories 'strange,'" and that "'disturb' cultural perceptions of identity formation."[7] Whether using whiteface to conceal black actors' racial identities (Ward), or disappearing black characters from the plot (Ward), or removing a murdered black person from the stage and therefore from audiences' lines of vision (Baldwin), this process of rendering black bodies strange, alien, and opaque cleared the way for these playwrights to zoom in on whiteness. Turning to theatre reviews, newspapers, and other archival ephemera to track white audiences' reception of these spectacularizing gestures, I demonstrate how these theatrical portraits of whiteness called attention to the gratuitous violence of white impatience while spotlighting its foundational role in sustaining the racial project of black patience.

Theatre and Visual Culture

In the last fifteen years, scholars have done significant work to excavate and critically analyze the complex terrains of visual culture in the Civil Rights Movement. As this work has shown, there was an intimate, complex, and often generative connection between black visual and political cultures in this era. For example, in his excellent study *For All the World*

to See: Visual Culture and the Struggle for Civil Rights, visual theorist Martin Berger explores an expansive archive of visual products—from photography and films to television and hand fans—that circulated within and helped to constitute the visual economy of the Civil Rights Movement. Similarly, in *Signs of the Times: The Visual Politics of Jim Crow,* literary critic Elizabeth Abel offers an incisive analysis of how segregation signs shaped the material and social geographies of the Jim Crow South. These signs, Abel shows, used the power of vision to generate a set of visual cues that carefully scripted the production of race and space in this region. As scholars like Abel and Berger demonstrate, visual culture and visuality were crucial to the Civil Rights Movement and to accomplishing "the visual construction of the social field."[8] Less apparent in this important body of scholarship, however, is the role of theatre in shaping the movement's visual field and in combating white supremacy's historical weaponization of vision and transformation of visuality into tools of anti-blackness. In this chapter, I will expand and build upon this scholarship by incorporating black theatre into discourses surrounding visual culture and civil rights activism and by positioning this genre more firmly within conversations surrounding race and visuality more broadly.

If "the visibility of civil rights spectacle" has been a "central theoretical problem for contemporary African American history and social movements," theatre is a cultural form that creatively addresses, and often reconfigures, the normative design of civil rights spectacle.[9] As a visual technology, theatre bridges the distance that normally separates newspaper and television audiences from the spectacles enframed in these media. Bringing the material bodies of spectator and object of the gaze into close spatial proximity, live theatrical performance engenders opportunities for more multidirectional and multifaceted acts of looking. Scholars of visual culture have examined how subjects within the visual frame can stage countervisual acts that trouble the gaze of the photographer or cameraman. What makes live theatrical performance distinctive in this regard is not only that it affords a line of vision to those subjects positioned within its frames, but unlike photography and television, it allows its audiences to experience these subjects as material, animate, and sentient beings. It therefore fosters the emergence of a visual subject who is not solely an object of the audience's gaze but

also an "agent of sight," or one who looks back.[10] My argument here is not that black sentience, animacy, and materiality are uncontested zones for disrupting the racial practices of visual modernity or extinguishing cultural desires for images of black damage. Rather, it is that the liveness of theatre and theatrical performance engenders conditions of presence and publicness, if not always *communitas*, that allow for an animation of the spectacle that, while not guaranteeing a recognition of the spectacle's full humanity—or assuring a more ethical relationship between viewer and spectacle—invites a recognition that a human, whatever genre of that social invention the viewer admits, is standing before you, and, like each member of the audience, possesses the capacity to see. More than a hard faith in materiality, or in the moral conviction of materialist presence, this position is offered as a way to gesture toward the disruptive possibilities that emerge in the cut between "to-be-looked-at-ness" and "looking-at-being-looked-at-ness"—or, in other words, looking at one's self "through the eyes of others."[11]

By expanding the archive that has been at the heart of theorizing visual culture in the Civil Rights Movement, in this chapter I offer new ways of engaging the "visibility of civil rights spectacle."[12] Positioning black theatre at the center of these discourses, I am interested in how "theater invites ways of looking and mediates in a particular relation between the one seeing and what is seen."[13] Interested in the visual dimensions of live theatrical performance, I argue that black dramatists used theatre to reconfigure the visual economy of the Civil Rights Movement and to craft innovative "ways of looking" that renegotiated the normative terms of which racialized bodies are conceived of as "the seeing" and which racialized bodies are habitually framed as "the seen." For these artists, the theatrical stage functioned as an optic onto the social. It offered a different lens through which they and their audiences could look at race and then better understand its critical function in the constitution of society. In this way, black theatrical performance pressured and redefined the racial logics at the heart of visual practice in the Civil Rights Movement while challenging the fetish for damaged blackness that structures visual modernity.

The Telescopic Black Body

Within the history of relations between damaged black spectacles and visual modernity, the murder of fourteen-year-old Emmett Till during the Civil Rights Movement stands as an instructive example. In August 1955, Till journeyed from Chicago, Illinois, to the Jim Crow South to visit relatives in Money, Mississippi. In just a few days, Till would be reminded of the harsh racial realities of the US South after being accused of "wolf-whistling" at Carolyn Bryant, the white woman proprietor of a small community store at which his transgression allegedly occurred. Accompanied by a half-brother, Bryant's husband kidnapped Till, carried him to a barn, tortured and shot him, tied a cotton gin fan around his neck, and dumped his body into the depths of Mississippi's Tallahatchie River. When she had recovered her son's maimed body, Mamie Till-Mobley was determined to have an open casket funeral. "Let the people see what they did to my boy," she exclaimed, offering Emmett's damaged black body as a frame for the world to witness the unbridled workings of white violence.[14]

Jet magazine published a shocking photograph of Till's corpse in its September 15, 1955, issue. The photograph revealed punctures and lacerations in the boy's flesh that quite literally exposed his bodily interiors to viewing audiences. On this exposure of Till's black interiors, literary critic Fred Moten reflects,

> [His face] was turned inside out, ruptured, exploded, but deeper than that it was opened. As if his face were the truth's condition of possibility, it was opened and revealed. As if revealing his face would open up the revelation of a fundamental truth, his casket was opened, as if revealing the destroyed face would in turn reveal, and therefore cut, the active deferral or ongoing death or unapproachable futurity of justice.[15]

As Moten notes, this act of "revealing" Till's damaged black body was staged in hopes that this gesture would likewise reveal the unrestrained brutality of white violence and, in doing so, aid black people in moving closer to a "futurity of justice." Till-Mobley's desire for "all the world" to see her son's opened body was an effective political strategy. The barely recognizable geography of the boy's face gave rise to an international

outcry of protest against this gratuitous act of anti-black violence, one that produced an iconic instance of black activists "plumbing and expanding the political power of the photograph."[16]

Such strategies of exposing injured black interiors to the global field of vision became a cornerstone of modern civil rights activism. In the landmark *Brown v. Board of Education* US Supreme Court case, for instance, the legal team for the NAACP also held up the damaged interiors of black children "for all the world to see." Using the research findings of black psychologists Mamie and Kenneth Clark, they dramatized the negative effects of racial segregation on the psychic interiors of black youths. In their now-famous "doll study," the Clarks presented black youths with a choice between two dolls, one visibly "white" and the other visibly "black." The majority of those studied preferred the former. For the Clarks, and subsequently the Court, this partiality for whiteness signified a damaged black psyche, one engendered by the everyday violences of white supremacy. Believing that segregation produced psychic damage that "was unlikely ever to be undone," the Court reversed its previous endorsement of racial segregation in its 1896 *Plessy v. Ferguson* ruling.[17] Like Till's corpse, the "damaged" black interiors of the Clarkes' young subjects were transformed into frames through which international audiences could see and thereby know the tyranny and the terror of white supremacy. What links Till to the subjects of the Clarkes' study is that they were all conscripted into performing the labor of a historical mode of visual iconicity that I call the *telescopic black body*.

In developing a theory of the telescopic black body, my aim is to account for how, during black social movements, injured black bodies are routinely accorded a certain optical instrumentality and epistemic function. Much like the telescope, this body functions as a visual technology that brings distant objects closer and in so doing creates conditions to know more about them. Telescopic black bodies like Emmett Till's and the subjects' in the Clarkes' study often serve as a lens through which global communities can "see" and "know" anti-black racial terror and better understand the terms of its production. Such acts of telescoping black suffering through the lens of injured black bodies have been crucial to rallying global support for black social movements from the nineteenth century forward. Whether the injured bodies of formerly enslaved Africans in the Abolitionist Movement or the lynched bodies

of black people whose deaths became hallmarks of anti-lynching campaigns, the telescopic black body has been used historically to curate a path of "empathetic access" between white audiences and oppressed black subjects. Its abiding presence across time and space has wrought this historical body into an icon.[18] Further, there has been a historical expectation that this particular icon will "do something to alter a history and system of racial inequality that is in part constituted through visual discourse."[19]

But what are the limitations of transfiguring injured black bodies into surrogates that are conscripted into shouldering the weight of portraying white violence? How do such conscriptive practices obscure as much as they reveal while reinvigorating the very structures of power they seek to disassemble? These questions become especially salient when we consider that many of those who produced these images were often invested more in drawing a portrait of black victimhood than in capturing the perpetration of white and state violence. As scholars have shown, relations of empathy toward black subjects often rely on and reinscribe orthodox relations of racial power.[20] In training their gazes on the "spectacular character of black suffering," cameramen and photographers in the Civil Rights Movement routinely tapped black people and injured black bodies to translate white violence into visual epistemologies that would satiate the tastes and curiosities of modern media publics in particular.[21] Within this network of relations between vision and racial epistemology, white bodies were often allowed to inhabit a privileged position of opacity—one that limited possibilities to see and contemplate what black dramatist and poet Langston Hughes referred to as "the ways of white folks."[22]

Widespread enchantment with the telescopic black body in the Civil Rights Movement was a central concern for black dramatists. In this vein, we can consider works like Lorraine Hansberry's *Les Blancs* (*The Whites*) and Alice Childress's 1955 comedy-drama, *Trouble in Mind*. Ailing from a long battle with cancer, Hansberry spent the last days of her life writing *Les Blancs* as a response to a 1959 play by white French playwright Jean Genet entitled *Les Nègres* (*The Blacks*), which went on to become the longest-running off-Broadway show of the 1960s. Despite the commercial success of *Les Nègres*, its pointed critiques of colonialism and whiteness, and a star-studded cast that included the likes of Maya

Angelou, James Earl Jones, Cicely Tyson, and Roscoe Lee Browne, Hansberry took serious issue with the play's reliance on spectacular images of black people that render them "exotic" and "unique," and that ultimately perform a telescopic functionality.[23]

We get a sense of these dynamics in a dialogue between two of the main characters in *Les Blancs*: Charlie, an overzealous white liberal US journalist, and Tshembe, a native son of Zatembe—the fictional African country in which the play is set. Like so many white journalists who traveled to sites of black protest during the Civil Rights Movement, Charlie journeys to Zatembe to write a story. Tshembe consistently refuses to grant Charlie access to his interiority, especially in the way that the world was granted access to the interiors of black subjects like Emmett Till and the children at the center of *Brown v. Board of Education*. Refusing to be conscripted into the operations of the telescopic black body, Tshembe critiques Charlie's troubling desires to probe his black interiors:

> I have had—(*Mimicking lightly but cruelly*)—too many long, lo-o-ong "talks" wherein the white intellectual begins by suggesting not only fellowship but the universal damnation of imperialism. But that, you see, is always the beginning. Then the real game is begun. (*With mock grandiloquence*) The game of plumbing *my* depths! Of trying to dig out *my* "frustrations"! And of finding deep in my "primeval soul" what *you* think is the secret quintessential—"root" of my nationalism: "SHAME"!"[24]

According to Tshembe, Charlie is trapped in ways of conceiving race that reduce blackness and black people to a "tide, a flood, a monolith: The *Bla-a-acks*."[25] Aware that Charlie is attempting to "plumb" his "depths," Tshembe seethes, "Now go, sir, write your book! The whole damned world is waiting!"[26] As Hansberry saw it, this searing critique of Charlie's attachment to the telescopic black body was as true and relevant for Genet. In *Les Blancs*, she turns a "third eye" to Charlie, Genet, and *Les Nègres*. That is, she uses theatre to call out "the process of being visualized as an object," but also "returns the glance," taking a careful look at the whites.[27]

Using a play-within-a-play structure, Alice Childress's *Trouble in Mind* similarly critiques white liberal attachments to the telescopic black body. The play's interior drama, *Chaos in Belleville*, announces itself as

an anti-lynching civil rights play. Written by fictional white playwright Ted Bronson, *Chaos* incorporates a lynching narrative that ostensibly decries white violence against black people. And yet, Wiletta Mayer—an accommodationist-turned-revolutionary black woman protagonist in both works—poses a probing series of questions about Bronson's use of the telescopic black body. In *Chaos*, Wiletta plays a conciliatory black sharecropper (Ruby) at odds with the decision of her son (Job) to become a registered voter, fearing the retaliation that would likely follow. As Ruby suspects, when white citizens get wind of Job's transgression, they form a mob, orchestrate a search, and prepare to perform the ritual act of lynching. Ultimately, Ruby persuades Job to surrender to police, trusting that her employer, Mr. Renard—a relatively liberal white judge—will protect him.

In *Chaos in Bellville*, Ted Bronson uses theatre to expose and critique the murderous act of lynching. Still, for Wiletta Mayer the script is deeply troubling. The glaring dichotomy between a liberal white man who shoulders the burden of protecting a fugitive black subject and a black mother who essentially places her son in the hands of a lynch mob fuels Wiletta's anger. Shunning the affective protocols of black patience, Wiletta shares her concerns with Al Manners, the play's white director, who is unmoved by the actress's qualms with the script. Breaking the fourth wall, Manners turns to the audience and mounts an impassioned defense of the script, justifying its use of the telescopic black body: "Do you think I can stick my neck out by telling the truth about you? There are billons of things that *can't be said* . . . do you follow me, billons! Where the hell do you think I can raise a hundred thousand dollars to tell the unvarnished truth."[28] Giving credence to James Baldwin's claim that "American Theatre" is a series of "commercial speculations," Manners exposes how capitalism inflects racial performance in the US theatre industry and therefore shapes how blackness can appear in the visual field of the American theatre.[29] Manners's explanation does little to allay Wiletta's concerns. Arguing that Bronson's script is "a damn lie," her unrelenting protest sends Manners into a frenzy, or a fit of white impatience. Waving the script angrily above his head, he seethes,

> So maybe it's a lie . . . but it's one of the finest lies you'll come across for a damned long time! Here's bitter news, since you're livin' off truth. . . . The

American public is not ready to see you the way you want to be seen be-
cause, one, they don't believe it, two, they don't want to believe it, and . . .
they're convinced they're superior. . . . Get it? Now you wise up and aim for
the soft spot in that American heart, let 'em pity you, make 'em weep buck-
ets, be helpless, make 'em feel so damned sorry for you that they'll lend a
hand in easing up the pressure. You've got a free ride. Coast, baby, coast.[30]

Still not persuaded, Wiletta refuses to "coast." Staging a one-woman boy-
cott, she eschews the temporal and affective protocols of black patience
and refuses to perform until the script of *Chaos in Bellville* is revised.
"I'm playing a leadin' part," she exclaims, "and I want this script changed
or else."[31]

As several scholars have pointed out, *Trouble in Mind* critiques the
structural inequalities that black actors face in the US theatre industry.[32]
I would add that the play is also concerned with the fraught practices
of surrogation that animate deployments of the telescopic black body.
Performance theorist Joseph Roach has argued that surrogation is criti-
cal to how "culture reproduces and re-creates itself."[33] Surrogation is one
of the most critical mechanisms by which white supremacy reproduces
and re-creates itself. In the case of the telescopic black body, the injured
black surrogate comes to stand in as an alternative for the white people
who actually perpetrate anti-black violence but who routinely occupy
a privileged position of opacity. As Bronson and Manners would have
it, the figure of the lynched black body is the most effective surrogate
for cultivating "empathetic access" among audiences and translating
these affective outcomes into social and political progress and, as im-
portantly, into money. During her lengthy career, Alice Childress took
issue with such proclivities to "single out" black people "as source mate-
rial for a derogatory humor and/or condescending clinical, social analy-
sis," especially among mass media.[34] It is precisely this iconic structure
of blackness that Ted Bronson places at the center of *Chaos* in offering
Job's lynched black body as a visual frame, or a site of "social analysis,"
through which theatre publics could see and understand white suprem-
acy and the workings of white supremacist violence.

The practice of framing white violence through the telescopic black
body has enjoyed a long shelf life in the archive of black social and po-
litical protest. But Alice Childress and Lorraine Hansberry belonged to

a larger coterie of black artists and intellectuals who, during the Civil Rights Movement, began to challenge this extensive trafficking in the telescopic black body and to call into question its rampant use as a political, intellectual, and aesthetic resource, as a surrogate for white supremacist violence, as a site of "clinical, social analysis." In August 1965, the Johnson Publishing Company—a black-owned publishing house founded in 1947—released a special issue of *Ebony* magazine entitled *The White Problem in America*. John H. Johnson, the company's founder and CEO, imagined that this issue would constitute a substantial shift in the discursive field of the Civil Rights Movement:

> For more than a decade through books magazines, newspapers, TV and radio, the white man has been trying to solve the race problem through studying the Negro. We feel that the answer lies in a more thorough study of the man who created the problem. . . . We, as Negroes, look at the white man today with the hope that our effort will tempt him to look at himself more thoroughly. With a better understanding of himself, we trust that he may then understand us better—and this nation's most vital problem can then be solved.[35]

In this special issue, the editor and contributors position whiteness and white people as objects of social concern and spectacles of the black gaze. As Johnson's remarks suggest, this countervisual strategy moves against the grain of the popular practice of using telescopic black bodies to bring whiteness into the field of vision as well as the field of knowledge. Further, it disrupts racial and visual knowledges that frame "the very definition of blackness as problem, as perplexing, as troubling to the dominant visual field."[36] Of particular interest in this vein is an essay by Kenneth B. Clark, whom we will remember as the co-architect of the "doll study" that influenced the Court's decision in *Brown v. Board of Education*. Entitled "What Motivates American Whites," Clark's essay for the *Ebony* special issue reaches a conclusion about white psychic interiority that bears a striking resemblance to his findings in the doll study. White minority identity, he explains, shapes white people's behaviors and conceptions of self. Here minority identity does not function as a collective referent for the familiar line-up of racial and ethnic groups who tend to represent normative conceptions of minoritiness. Rather,

Clark breaks through the discursive norm of the white "majority" to excavate the repressed fact of white people's own minority status; that is, as people who have historically come to the New World as the dispossessed and the expelled. Clark finds that these habits of repression produce psychic damage and desires to subjugate precisely because of white people's insecurities about their own "otherness."

Clark was not alone in interrogating white psychosocial motivations for anti-black racism. In his 1967 address to the American Psychological Association, Dr. Martin Luther King Jr., who also wrote an essay for the *Ebony* special issue, argued for more careful investigations of white psychic interiors, or what black writer Richard Wright referred to as "the psychological reactions of whites."[37] "If the Negro needs social sciences for direction and for self-understanding," King proclaims, "the white society is in even more urgent need. White America needs to understand that it is poisoned to its soul by racism and the understanding needs to be carefully documented and consequently more difficult to reject. . . . Negroes want the social scientist to address the white community and 'tell it like it is.'"[38]

James Baldwin was also among the luminary artists and activists who contributed essays to *The White Problem in America*. Like King and Clark, Baldwin—both in his essay for the special issue and throughout his wider corpus of writing—worked to reveal the "soul" of "White America." This radical endeavor is certainly the goal in his 1964 work of theatre, *Blues for Mister Charlie*. The play is loosely based on the tragic murder of Emmett Till. But in removing the boy's corpse from the visual field of the theatre, Baldwin grants the murdered black body access to a space of black opacity. Whereas Mamie Till-Mobley effectively used Till's injured corpse to portray white supremacy's capacities for gratuitous violence, Baldwin joined other black playwrights in using theatre and performance to destabilize the iconicity of the telescopic black body, to visualize whiteness and white people, and to frame white supremacy as the source of modernity's "racial problem."

James Baldwin's Visual Theory: Theatre and the Art of Seeing

Blues for Mister Charlie opens in darkness, staging a mise-en-scène that disrupts the embodied acts of surrogation that normally animate exhibitions of the telescopic black body. Following the sound of a gunshot,

the lights come up slowly, revealing Lyle Britten, a white actor and the first character that audiences meet. Reaching down to pick up a human body "as if it were a sack," Lyle then travels upstage, deposits the body into a mass of weeds, and offers the first line of the play: "And may every nigger like this nigger end like this nigger—face down in the weeds."[39] Lyle's startling death wish maps a parallel relation between black people and weeds. What links these living organisms is their shared fight to survive within social milieus that relegate them both to economies of excess. Perceived as disruptions to carefully crafted physical and social landscapes, their management and erasure become justified in the name of order and discipline. Linking the sonic terror of the gunshot to Lyle Britten, the audience recognizes that Lyle endorses the management and erasure of black bodies, and is likely the murderer who had killed a black person as easily as he would a weed.

While the terrorized black body is part and parcel of the play's opening sequence, it is quickly removed from the stage and therefore removed from the audience's line of vision. The audience hears the sound of terror and even catches a glimpse of the murdered black body at the "scene of subjection."[40] And yet, darkness prohibits them from visually observing the act of murder. When the lights come up, what audiences behold then is not the injured or terrorized black body, but rather Lyle Britten, a white murderer who wishes death upon "every nigger like this nigger." In developing this opening scene, Baldwin refuses to assign the murdered or injured black body a telescopic functionality. He chooses instead to focalize whiteness, a white person, and white impatience within the visual field of the stage. These early dramaturgical choices set in motion a countervisual aesthetic that invites and forces Baldwin's audiences to see and to better understand Lyle Britten, the white murderer whom Baldwin refers to as the "wretched man."[41]

Blues for Mister Charlie opened on April 23, 1964, at the ANTA Theater on Broadway in New York to mixed reviews. The play is set in fictional "Plaguetown, U.S.A., now." The plague is race and Christianity. Divided spatially into "BLACKTOWN" and "WHITETOWN," the symbolic architecture of the play's set folds into its material configuration the structures of racial-spatial segregation that haunt the landscapes of the Jim Crow South, to be sure, but also of the US nation-state writ large. Taking "Plaguetown, U.S.A." as its setting, Baldwin's substitution

of a nation-state ("U.S.A.") for a state renders the problem of white supremacy a national tradition rather than a regional phenomenon. At the same time, the play's temporal setting ("now") contests any attempt to frame white supremacy as a passé system of racial violence, contained to a prior historical moment. Taken together, the play's settings suggest that the problem of whiteness transcends any arbitrary boundaries of time and space.

Blues for Mister Charlie is a visual thought experiment in understanding whiteness and white people and in probing how a white man can murder black people with impunity, because the nation has "locked him in the prison of his color."[42] But Baldwin sidesteps the popular praxis of conscripting telescopic black bodies into serving as a damaged surrogate for seeing whiteness and white people. Instead, he develops an innovative set of countervisual strategies that assign the work of translating and portraying white violence to white people rather than injured black bodies. In mounting these types of countervisual experiments on the theatrical stage, the playwright inverts the racial subject that typically occupies the center of the Civil Rights Movement's visual field, further developing what we might understand as *Baldwin's visual theory*.

As Baldwin crafted *Blues for Mister Charlie*, he was deeply apprehensive about mastering dramatic techniques. He attributed this "fear of the form" to his anxieties about using theatre to envision whiteness.[43] "I absolutely dreaded committing myself to writing a play," he explains. "There were enough people around already telling me that I couldn't write novels—but I began to see that my fear of the form masked a much deeper fear. That fear was that I would never be able to *draw a valid portrait of the murderer*."[44] For Baldwin, the theatrical project was a visual project as well. As a visual theorist working across genres, Baldwin understood the power of vision and visuality and their defining role in modernity's procedures of racial formation. From his essays to his drama, he consistently framed the problem of race as a problem of white supremacy and the problem of white supremacy as a problem of seeing. A devoted civil rights activist, Baldwin even framed integration as a thoroughly visual phenomenon. "If the word *integration* means anything," he averred, "this is what it means: that we, with love, shall force our brothers to see themselves as they are, to cease fleeing from reality and begin to change it."[45] In this nimble conceptual move, the writer of-

fers a theory of the visual in which the performance of seeing opens up potential for social and political transformation.

For Baldwin, theatre was an especially useful genre for tapping into the sociopolitical power of the visual, especially by looking at whiteness and the gratuitous violences of white supremacy. In an essay entitled "Theater: The Negro In and Out," he writes, "I know how it sets the teeth on edge to try to create, out of people clearly incapable of it— incapable of self-examination, of thought, or literally of speech—drama that will reveal them."[46] The visual project of revealing whiteness was, for Baldwin, a radical exercise in developing innovative black political aesthetics that could alter the racial conventions of visual modernity. As Baldwin wrote *Blues for Mister Charlie*, he believed that the task of drawing "a valid portrait of the murderer," and of portraying whiteness more broadly, would necessitate a break with orthodox theatrical aesthetics. In order "to get [their] story told," he contends, dramatists must do "violence to theatrical forms."[47] A part of the aesthetic violence for which Baldwin calls, and that he performs throughout *Blues for Mister Charlie*, involves novel theatrical experiments in race and visuality. Refracting the racial economies of vision that conventionally structure black social movements—namely their use of telescopic black bodies—Baldwin uses theatre to zoom in on whiteness, to expose the prevalence of white impatience, and to demonstrate how this structure of racial time and affect is germane to the making of modernity's racial order.

On the heels of *Blues for Mister Charlie*'s opening scene, the action shifts abruptly to a black church. There audiences meet a group of civil rights activists who are preparing to face an angry, impatient white mob. Led by the Reverend Meridian Henry—the father of the young man whom Lyle Britten has murdered—the activists rehearse a sociodrama designed to prepare them for the violent acts of white impatience that they will likely face in the moment of live civil rights protest. Whereas some participants perform the role of protester, others, including one named Tom, imitate the white mobs who routinely antagonize activists and disrupt civil rights demonstrations. Displeased with Tom's performance of whiteness, Meridian breaks the action:

> MERIDIAN: No, no, no! You have to say it like you mean it—the
> way they really say it: nigger, nigger, nigger! Nigger! Tom, the way

you saying it, it sounds like you just might want to make friends. And that's not the way they sound out there. Remember all that's happened. Remember we having a funeral here—tomorrow night. Remember why. Go on, hit it again.[48]

What provokes Meridian to break this scene is his commitment to mastering the art of performing whiteness and white impatience. That this interruption follows on Lyle Britten's act of murder, and his deathly wish that "every nigger like this nigger end like this nigger," draws a symmetrical relation between the play's opening scene and this act of rehearsing civil rights protest. These scenes are linked by a chain of racial expletives that lend credence to Meridian's framing of white impatience as a racialized performance of affect that is far more deadly and venomous than Tom's performance suggests. Making another attempt to enact whiteness with a greater fidelity to "the ways of white folks," Tom steps into character:

TOM: You dirty nigger, you no-good black bastard, what you doing down here, anyway?

MERIDIAN: That's much better. Much, much better. Go on.

TOM: Hey, boy, where's your mother? I bet she's lying up in bed, just a-pumping away, ain't she, boy?

MERIDIAN: *That's* the way they sound!

TOM: Hey, boy, how much does your mother charge? How much does your sister charge?

KEN: How much does your *wife* charge?

MERIDIAN: Now you got it. You really got it now. That's them. Keep walking, Arthur. Keep *walking*!

TOM: You get your ass off these streets from around here, boy, or we going to do us some cutting—we going to cut that big, black thing off of you, you hear?

MERIDIAN: Why you all standing around there like that? Go on and get you a nigger. Go on!

(*A scuffle.*)

MERIDIAN: All right. All right! Come on, now. Come on.

(*Ken steps forward and spits in Arthur's face.*)

ARTHUR: You black s.o.b., what the hell do you think you're doing? You mother—![49]

This performance of whiteness by a group of civil rights activists can seem to reify the qualities of the telescopic black body. By serving as an optic onto whiteness, the black bodies in this scene perform the translational labor of illuminating whiteness and white violence for viewing publics. Although they ultimately function as surrogates, however, these bodies circulate within a decidedly different economy of surrogation. Their metonymic depictions of whiteness are not geared toward mass media, nor do they seek to curate empathetic access among their viewers by staging spectacular images of damaged black people. Here surrogation functions instead as a radical tool of rehearsing civil rights protest, one that within the context of the play narrows the field of vision to the enclosed racial-spatial boundaries of a black church. Further, rather than beckoning audiences to look at damaged black people, this scene prioritizes black sentience and live-ness over black death and injury. One result of Baldwin's refusal of a telescopic relation is that it cultivates for white audiences the experi-ence of being seen, mimicked, and scrutinized by a black playwright and a live and sentient cast of black actors. These aesthetic choices engender a countervisual relation between Baldwin's mainly black cast and white audiences, fostering among those audiences the expe-rience of "looking-at-being-looked-at-ness."[50]

Baldwin's theatrical portraits of whiteness are radical insofar as they unsettle traditional methods of situating whiteness outside the visual frame. As visual theorist Shawn Michelle Smith observes, the "paradoxical nature of white representational privilege [is] to be so ever present and yet so invisible." "In order to begin to dismantle this privilege," Smith observes, "one must continue to look at whiteness."[51] Baldwin recognized how this tactical relation of invisibility affords whiteness and white people access to an exclusionary mode of racial opacity that mitigates opportunities for observing them. It is against this backdrop that Baldwin used theatre and performance to "look at whiteness"—that is, to subject whiteness to aesthetic scrutiny and sociopolitical interrogation by positioning white people as performa-tive objects of the black gaze.[52] By bringing forth whiteness and white people from their silos of invisibility, Baldwin crafted "drama that [would] reveal them," and in doing so revealed the problem of white impatience.[53]

Impatient Art, Impatient Artists, Impatient Audiences

The temporal and affective relations of racial power that drive performances of white impatience were not confined to Baldwin's script. They also surfaced among *Blues for Mister Charlie*'s white audiences and reviewers, and among the theatre professionals who helped to produce the play. For many of them, Baldwin's play was far too long and much too angry. This consolidation of black affective and temporal excess produced a potent cocktail of (white) impatience among *Blues for Mister Charlie*'s observers on both sides of the Atlantic. In his *New York Times* review of the play, noted music and theatre critic Howard Taubman takes issue with the play's rendering of white characters. According to Taubman, "Mr. Baldwin knows how the Negroes think and feel, but his inflexible, Negro-hating Southerners are stereotypes. Southerners may talk and behave as he suggests, but in the theater they are caricatures."[54] Taubman's conflation of southerners with whiteness notwithstanding, his use of the term *caricature* to describe Baldwin's portraits of whiteness is instructive. Connoting excess and exaggeration, *caricature* implies that Baldwin has stretched whiteness beyond the parameters of what Taubman accepts as reality. If Baldwin has portrayed both black and white people as they "behave," a point that Taubman concedes, then what motivates his claim that white people are caricatured while ascribing to Baldwin's depictions of black people an absolute verisimilitude? For him, Baldwin's blackness performs an epistemological function. It furnishes a requisite knowledge for staging authentically black people. As a black man, Baldwin "knows how the Negroes think and feel." This same mastery of the psychic and affective terrains of blackness, however, effectively constrains Baldwin's capacity to represent whiteness within the dramatic form. Taubman presumes that there is "no representation of whiteness in the black imagination, especially one that is based on concrete observation or mythic conjecture."[55]

Further, if we juxtapose *Blues for Mister Charlie*'s panoramic portraits of white characters—liberals wrestling with their own complicities in anti-blackness, women who falsely accuse black men of rape, ministers and communities who use law and religion to sustain anti-black oppression, men who murder black people for transgressing the sexual boundaries of racial separation—with the historical record, we realize

that Baldwin's portraits of whiteness are hardly caricatured in the ways that Taubman claims. Ultimately, Taubman's review of *Blues for Mister Charlie* evinces a visceral discomfort with Baldwin's portraits of whiteness and white people, even as he couches his personal unease in the lexicon of objective theatre review. In this way, Taubman lends credence to Baldwin's claim that "what is most terrible is that American white men are not prepared to believe my version of the story. . . . In order to avoid believing that, they have set up in themselves a fantastic system of evasions, denials, and justifications."[56] In the final analysis, Taubman's grammar of aesthetic shortcomings masks his aversion to the white image in the black mind."[57]

Taubman was not alone in leveling this type of searing criticism at Baldwin's visions of whiteness and white people. American fiction writer Philip Roth was so aghast at these images that he opened his extensive review of *Blues* by castigating Baldwin's portraits of "Mr. Charlie." I quote Roth at length:

> In the brief note James Baldwin has written as an introduction to the published version of *Blues for Mister Charlie*, the only character he [Baldwin] mentions at any length is the man appearing in the play as Lyle Britten, a white store-owner in a southern town who murders a young Negro. Baldwin says of the killer, "We have the duty to try to understand this wretched man." But in the play that follows, the writer's sense of this particular duty seems to me to fail him. The compassionate regard for the character that Baldwin means to convey by the adjective "wretched" is not the same quality of emotion that informs his imagination when he is examining the man in his wretchedness. . . . Rather a conflict of impulses—duties towards a variety of causes of which, unfortunately, the cause of art seems to have inspired the weakest loyalty—prevents Baldwin from fixing his attention upon his subject and increasing "understanding," his or ours.[58]

That Roth begins his roving review of *Blues* by lambasting the play's portrayal of "Mr. Charlie" is telling. Preceding his detailed summary of the plot, this critique of Baldwin's portraits of whiteness is so urgent for Roth that he grants this criticism priority of place in his lengthy review. Manifesting as cathartic release, as frontmatter that performs a prefatory function, Roth's introductory paragraph takes the form of a grievance in

which he betrays how deeply Baldwin's images of whiteness have cut and troubled him. As he saw it, and likely needed to see it, *Blues for Mister Charlie* suffered from a want of compassion in drawing its portrait of "Mr. Charlie." Like Taubman, Roth is discomforted by Baldwin's visions of whiteness, but couches his visceral distress and impatience for these images in the frontage of aesthetic critique. In this vein, he asserts that in *Blues* "the cause of art seems to have inspired the weakest loyalty."

As Roth's review proceeds, his uneasiness with Baldwin's portraits of Lyle Britten, and of whiteness more broadly, becomes more obvious and animated. Whereas Baldwin conceives of his play as a blues song for "Mister Charlie," Roth would rather that Baldwin sing the blues for the "Negro." The "real blues," he writes, "might have been sung in the end for the Negro rather than those spurious blues for Mr. Charlie, who is the white man."[59] What Roth wants, in essence, is to reposition the "Negro" as the subject for whom the blues should always already be sung. Such an inversion of the racial and visual logic of Baldwin's play would effectively reinstate the normative protocol of positioning the "Negro" as spectacle, as was normally the case in the political and visual iconography of the Civil Rights Movement. This gesture would effectively shift the gaze from white people to black people, and thereby shelter whiteness from the full scope of Baldwin's "black looks."[60] Mimicking the visual economy of the Civil Rights Movement, Roth yearns for white opacity while working to refocalize black people and black bodies within the visual field of the theatre.

By the conclusion of Roth's review, it is apparent that what irks him most is his sense that Baldwin has portrayed white people as inferior while rendering black people comparatively superior. In *Blues*, he laments, "Negroes . . . make love better. They dance better. And they cook better. And their penises are longer, or stiffer. . . . Finally one is about ready to hear that the eating of watermelon increases one's word power."[61] Taking a clue from the affective tone of his review, it is clear that Roth is not happy, and appears to be teetering around the edges of anger. He is so impatient with Baldwin's portraits of whiteness that he finally invokes the racist imagery of magical, watermelon-eating "Negroes" to describe Baldwin's black characters. In a moment of startling transparency regarding his impatience for the play's portraits of whiteness, Roth recommends that Baldwin change the title of his play from *Blues for Mister Charlie* to *A*

Study in the Banality of Evil. Based in the curious claim that in Baldwin's play evil is not racial but rather universal, Roth's suggested title would shift the gaze away from Mr. Charlie and hail black people back into the center of the visual frame. His recommended revision would enfold the racial particularities of white supremacist violence into a more capacious paradigm of human violence that regards the singularity of white racial power as immaterial. Evil is, in this sense, the unifying force that finally brings black people into the fold of the universal family. But this troubling paradigm of human inclusion is blatant subterfuge, designed to divert Baldwin's black gaze from looking at whiteness and to thus neutralize the playwright's radical practices of counter-visuality. Roth's "lament" is certainly "a predictable one" that "oscillates between a familiar 'sense of disorientation and loss' and 'an obsessive urge to discover an "authentic" black body in the wilderness of theatre culture.'"[62]

In this same review, the critic follows his biting assessment of *Blues* with a cutting review of LeRoi Jones's one-act play *Dutchman*, which also opened in 1964 in New York. Here, too, Roth is critical of Jones's "Negro anger," asserting that Jones "has not patience or strength enough."[63] "I am not too happy," Roth confesses, "to see Mr. Jones being hailed in the papers and on television for his anger. . . . For it is not an anger of literary value, and he is a writer. Rather it is rage, it is blind, and, artistic considerations aside, it may well have made it nearly impossible for him to write an important play."[64] Curiously, at the same time that Roth critiques Jones and Baldwin for their fugitive affect, or for being "rich with anger," his own anger and impatience run amuck, here in the form of theatre review.[65] As historian Carol Anderson explains, the "overwhelming focus on black rage" often misses and obscures "what [is] really at work . . . white rage."[66] This racialized unevenness between Roth's own performance of anger and his attempt to suppress and regulate black anger gestures toward the affective protocols of black patience, the irony and pervasiveness of white impatience, and their importance to the constitution of modernity's racial order.

When The Actors Studio took *Blues for Mr. Charlie* to the 1965 World Theatre Festival in London, these interconnections of race, affect, and theatrical performance continued to color receptions of Baldwin's play. If Taubman and Roth were impatient with *Blues for Mister Charlie*'s portraits of whiteness, their affective sentiments were revivified during live

performances of *Blues* in London. At the Aldwych Theatre, where the play was running, a gang of fascist hecklers once interrupted. Members of the conservative British National Party, the fascists rose from their seats at the start of act 2 and began to taunt the cast.[67] They hurled a stream of racist insults and vulgar expressions such as "Go back to Africa."[68] Unfolding in the wake of Roth's and Taubman's impatient and racially charged reviews, this act of white impatience was, by now, a familiar response to *Blues*. Steeped in anger, such receptions of the play index a paradigmatic reaction to Baldwin's countervisual portraits of whiteness, one grounded in white impatience and the racialized structures of affect that nourish and sustain anti-blackness and white supremacy. At this crossroads of race, theatre, and affect we can better understand the affective lineaments of modernity and their significance to the process of racial formation.

The London production of *Blues for Mister Charlie* was, by most accounts, a flop. The reasons for its failure included, among other things, light malfunctions at the Aldwych. But in a press conference the following morning, Lee Strasberg, the play's white director, reduced its failure to one primary cause: the play's anger. Whatever their biases and motivations, such declarations about Baldwin's and *Blues for Mister Charlie*'s anger illuminate the widespread desire for black patience as well as the swelling tide of black impatience that was building among black citizens, and throughout black art, in this era of sociopolitical transformation. Strasberg's remarks gesture toward an expanding refusal of black patience that had begun to deepen as the Civil Rights Movement gained traction and as calls for "Black Power" became more prevalent. *Blues for Mister Charlie* was emblematic of this large-scale challenge to the violent cultures of black patience. In his 1987 eulogy for Baldwin, in fact, Amiri Baraka declared that "it was *Blues for Mister Charlie* that announced the black arts movement."[69]

By all accounts, Baldwin's fugitive anger and impatience were not limited to his script. Like his art object, he too was often characterized as angry and impatient. In the months leading up to opening night, Baldwin became increasingly impatient with the Studio production of *Blues*. Shirking the affective obligations of black patience, he was unabashed in voicing his qualms. According to Baldwin biographer James Campbell, on one occasion Baldwin was so infuriated with Strasberg that he

mounted a thirty-foot-high ladder and began to scold the white director. On another occasion, Baldwin allegedly threatened to kill white actor Rip Torn—who played a leading role in *Blues*—if he entered the theatre after Baldwin had warned him against doing so. In other words, alongside audiences', critics', and theatre professionals' angst about the anger of *Blues for Mister Charlie*, there was also a palpable uneasiness with Baldwin's own performances of anger and black impatience.

Through his impatient performances of self and creation of impatient black art, Baldwin disturbed the racialized logics of endurance and long-suffering that strive to manage and discipline black being and to constrain black political possibility through the regulation of black affect. In this, he troubled the affective orthodoxies that normally structure the modern world and that safeguard the relations of racial power this affective management of the world enables. Though routinely admonished to "tone down" the play's "polemical temper," Baldwin persisted in his refusal of black patience as well as in the production of impatient black art.[70] One significant result of these transnational encounters with Baldwin's and *Blues for Mister Charlie*'s fugitive affect was the glaring revelation of how white impatience operates as a key mechanism for manufacturing racial difference and for engineering the racial order of things. Under these conditions, the impatient black artist and the genre of impatient black art pose an existential threat to whiteness and to the social infrastructure that nourishes and sustains this invented category of being.

Race and the Running Time of Black Performance

If audiences, reviewers, and theatre professionals were impatient with *Blues for Mister Charlie*'s portraits of whiteness, they were as impatient with the play's "excessive" running time. For them, *Blues for Mister Charlie* was too long. At the same time, The Actors Studio tried to limit the play's run on Broadway, attempting to shutter the production just one month after its opening. I am interested here in these two different modes of theatrical time, specifically how these disparate but related attacks on the play's running time are imbricated in the historical violences of racial time. By "running time," I mean both the time of the live performance as well as the time of *Blues for Mister Charlie*'s run

on Broadway. Considering these discrete units of theatrical time further illuminates the social life of *Blues for Mister Charlie* as well as the complex intersections of race and patience. While this chapter has foregrounded the affective dimensions of black patience and white impatience, I want to pivot to think more directly about the temporal dimensions of these projects, while maintaining a focus on whiteness. This attention to the racial politics of time continues to illuminate the precarious lives and futures of black theatre as well as the precarious lives and futures of black people.

As James Baldwin completed *Blues for Mister Charlie*, he paused to give an interview to the *New York Herald Tribune* in which he praised the theatrical form for pushing him to be more "laconic" and "economical."[71] Baldwin would have been hard pressed to find many others who would use these particular adjectives to describe a play whose initial running time topped five hours. According to Arthur Waxman, the general manager of the ANTA Theatre, *Blues for Mister Charlie*'s running time "horrified everyone."[72] Blasting the play's "excessive length," Waxman warned Baldwin that it was "absurd to expect people to remain in their seats from seven o'clock until after midnight."[73] Contesting the temporal parameters that Waxman tried to place on the running time of *Blues*, Baldwin pointed out that Studio had staged Eugene O'Neill's *Strange Interlude*—which lasted for three hours and forty minutes and nine acts—only one year prior to its production of *Blues*. Waxman reminded Baldwin that he was not O'Neill, which further angered the playwright, driving him to proclaim that Waxman was only "doing this to [him]" because he was a "nigger."[74] But even Baldwin's closest associates, like the French actor and director Robert Cordier, cautioned him that "you cannot expect people to be enthralled by a string of speeches, certainly not five hours' worth."[75] Baldwin ultimately agreed to cut the play's running time, reportedly in exchange for his brother David being allowed to play the role of Lorenzo, a fiery proto–black nationalist character.

Such acknowledgments of *Blues for Mister Charlie*'s "excessive" running time were not limited to white critics and theatre professionals. In its June 1964 review of the play, *Ebony*, a staple black-owned magazine, references the play's "verbose five hours."[76] The reviewer points outs, however, that much of the criticism being levelled at Baldwin's play—

especially accusations that *Blues* was a "mere hymn of hate" brimming with "unfair stereotypes" of white people—has generally "been confined to white observers."[77] What becomes clearer upon closer examination of these reviews is that many critics' qualms with the play's running time stemmed from their contentions with its "angry," countervisual portraits of whiteness. To grant Baldwin a turn in temporal excess, or the freedom to take up time in the theatre, would enable an extended performance of looking at and drawing a portrait of whiteness. Studio producer Cheryl Crawford recognized these thick connections among *Blues for Mister Charlie*'s running time, its fugitive affect, and its countervisual images of whiteness. If the play's "running time" did not "keep people from coming," Crawford declared, its unsparing use of expletives certainly would.[78] What Crawford understood, and what the impatient responses of the play's white audiences and critics confirmed, is that Baldwin's radical portraits of whiteness activated a visceral discomfort because what was at stake in these images was nothing less than the ontology and the future of whiteness.

Staged under this cloud of controversy, *Blues for Mister Charlie* would have to fight tooth and nail to stay alive, much like the Free Southern Theater and LeRoi Jones's queer civil rights plays. Just one month after its opening, in fact, Crawford ordered a one-week closing notice be posted outside the theatre, a decision that enraged Baldwin. A part of *Blues for Mister Charlie*'s commercial shortcomings likely stemmed from Baldwin's insistence that ticket prices remain affordable, especially for "uptown" audiences who could hardly afford the luxuries of a Broadway theatre exploit. But the play's premature closing—its imminent death, as it were—had as much, if not more, to do with its biting portrayals of whiteness. This is certainly what Baldwin believed, as he waged a well-coordinated campaign to save the life of his play; to avert the death of the black theatrical object; to improve possibilities for black theatrical futures. The play's cast was "aware that every night might be the final night."[79] Such conditions of impending death haunting the black theatrical object were emblematic of a broader structural relation between black being and death. As I have argued throughout this book, this relation between blackness and death has not only compromised black people's futures but has jeopardized possibilities for black theatrical futures as well.[80] With the help of celebrity support and donations, poster

and leaflet campaigns, meetings with theatre management, newspaper advertisements, and two sound-campaign trucks, *Blues for Mister Charlie* managed to live for another three months.[81] In this fight for the life of black art, like the fight for the life of black people, the nearness of death urges a tighter embrace of the "now," a more intimate connection to the possibilities of the Afro-present.

Staging Black Disappearance

Like Baldwin, black dramatist Douglas Turner Ward turned to theatre during the Civil Rights Movement to examine whiteness and the workings of white impatience. After seeing images of the 1950s bus boycott in Montgomery, Alabama, Ward was inspired to write a one-act play entitled *Day of Absence* (1965). Opening off-Broadway in November 1965 at St. Mark's Playhouse, the play had a healthy run of 504 performances. In describing the boycott's impact on Ward's theatrical vision, literary critic Stephen M. Vallillo observes that "the image of empty buses continuing to run their routes remained with [Ward], until he translated into theatrical terms the economic importance of blacks to the country."[82] Vallillo rightly recognizes Ward's acknowledgment of black people's value to local and national economies. I would add that those "empty" buses also spotlighted white people in the way that Douglas Turner Ward does in *Day of Absence*. The playwright's translation of this startling absence of black bodies is not only, or even primarily, about black people. Rather, Ward uses the boycott's spectacular acts of black disappearance to create a theatrical work that, like those "empty" buses in Montgomery, directs audiences' line of vision to whiteness and white people.

As the Montgomery bus boycott unfolded, coverage of this campaign routinely emphasized the absence of black bodies on the city's buses. It tended to frame this act of black disappearance as a more total absence, as if the white people who continued to ride the buses were somehow imperceptible or outside the field of vision. This conceptual maneuver ultimately frames blackness as the field of vision's condition of possibility. But a brief glance at these images reveals how, more than depicting black absence, they call attention to the white passengers and drivers who were left to ride the buses alone. We need to reconsider, then, the prevailing claim that empty "buses bounced around for everyone to see."[83] During

Figure 4.1. Singular white woman on Montgomery bus, ca. 1956.
Photograph by Dan Weiner, reproduced courtesy of John Broderick.

this mass act of black disappearance, the white drivers and passengers
who continued to ride the bus assumed a spectacular quality. Approach-
ing this boycott with a lens that is calibrated to see a different racial sub-
ject reveals how white riders' isolation in the field of vision opens them
up to the gaze and to a mode of white spectacularity that facilitates a
countervisual view of whiteness and white people, and thus a way of
looking that destabilizes the normative mechanisms of visual practice in
this era, particularly a fetish for the telescopic black body.

In *Day of Absence*, Douglas Turner Ward transmuted the Montgom-
ery bus boycott's historical acts of black disappearance, and the condi-
tions of white spectacularity they engendered, into an innovative set of
theatrical strategies. In other words, he used theatre and performance
to aestheticize the racial optics that black Alabamians curated in and
through their mass performances of disappearance. In doing so, Ward
used theatre to unsettle common-sense paradigms of race and visuality
that thrived in this era, namely global obsessions with the telescopic
black body. One outcome of these performative enactments of black
disappearance—both in Alabama and on the theatrical stage—was a
profound exposure of white impatience.

In *Day of Absence*, Ward blends satire, fantasy, and whiteface min-
strelsy to craft a play that centers on the disappearance of a southern

town's black population. Staged under the radar of white surveillance, this mass act of black disappearance frustrates and bewilders the town's white population, just as Montgomery's white citizens were miffed by the boycott in their own town. The play's white citizens are as piqued by the absence of their black maids, butlers, porters, factory workers, drivers, and "miscellaneous dirty-work doers" as they are by the fact that this sudden act of black disappearance transpired with neither their knowledge nor their consent. This abrupt act of disappearance has struck a devastating blow to the town's operations as well as its social infrastructure. So severe is the impact that the Mayor declares a state of emergency and petitions the US president to intervene. Following an emergency meeting of his cabinet, the president agrees that this unauthorized act of black disappearance constitutes a major emergency. In addition to deploying the National Guard, he designates the town the "prime disaster area of the century."[84]

A shard of hope surfaces when a group of white citizens discovers a small cluster of black people in the town's segregated hospital. But their excitement wanes quickly upon learning that each of them is in a deep coma and has therefore disappeared psychically, even as their bodies are physically present. Under these conditions of total black disappearance, the town's white citizens are left to look at and interact with each other. The result is the emergence of a visual field animated by the same dynamics of white spectacularity that had characterized the Montgomery bus boycott nearly a decade prior.

During the Civil Rights Movement, black artists and activists like Douglas Tuner Ward and the Montgomery bus boycott participants tested how black disappearance might function as a tool of political activism and a strategy of aesthetic innovation. On this front, black writer William Melvin Kelley's 1962 novel, *A Different Drummer*, is a useful example. Here readers meet Tucker Caliban, a quiet, childlike protagonist who orchestrates a mass exodus of black citizens, creating the only state in the union that "[could not] count even one member of the Negro race among its citizens."[85] Like Baldwin and Ward, Kelley develops an innovative set of aesthetic strategies to zoom in on whiteness, whether through an incorporation of white narrators or a use of stream of consciousness to project the interior thoughts of white characters. Like these playwrights, too, Kelley refuses to traffic in the telescopic black body. While *A Different Drummer*

concludes with the lynching of a black leader—who is the state's only re-maining black citizen—Kelley refrains from narrativizing the gory details of the leader's lynching. In lieu of a narrative spectacle of his damaged black body, the writer incorporates a single scream to index the horrific act of murder. This fleeting sound of racial terror recalls the gunshot that opens *Blues for Mister Charlie*. It parallels Baldwin's use of an ephemeral semiotics of sound rather than a fetishistic semiotics of vision to draw a "valid" portrait of whiteness and white violence that does not demand a parasitic relationship to the spectacle of the damaged black body. Kelley ultimately refuses to conscript the leader's injured black body into a telescopic functionality. He refuses to cast it as a visual surrogate for the horrors of white supremacist violence.

Like Kelley's *A Different Drummer*, Ward's *Day of Absence* opens with a cadre of white men assembled in front of a town store. In both works, these men discover that they are undergoing a mass disappearance of their town's black population. *Day of Absence* commences with a rambling dia-logue between two of these men, Luke and Clem. As their conversation meanders from weather and family to women and the state of their busi-nesses, Clem interjects to query if Luke "feel[s] anything—funny."[86] Luke responds with a rather trite dismissal—"Maybe it's in your haid?"—but Clem continues to have a "funny feeling somp'ums not up to snuff . . . Like somp'ums happened—or happening—gone haywire, loony."[87] Still unconvinced and growing "increasingly annoyed," Luke responds, "Now look here, Clem—it's a bright day, it looks like it's go'n' get hotter. You say the wife and kids are fine and the business is no better or no worse? Well, what else could be wrong? . . . If somp'ums go'n' happen, it's go'n' happen anyway and there ain't a damn fool thing you kin do to stop it!" But soon after his tirade, Luke admits that he, too, believes "somp'um is peculiar."[88]

After this scene blacks out, the action shifts abruptly to the home of John and Mary, a married couple who, having been awakened by the piercing screams of their child, also sense that something is awry. While they ignore the baby's wails as long as possible—wails that seem wholly unfamiliar to them—these cries signal the absence of Lula, the couple's black servant. Lula's act of black disappearance enables John and Mary to confront dimensions of themselves that they could otherwise ignore if she were present. It thus enables possibilities for white self-examination and opportunities to acquire new self-knowledge. A part of what John

and Mary discover from Lula's disappearance is a disdain for each other as well as for their child.

Further, Ward's focalization of whiteness reveals that both John and Mary suffer from a striking degree of impatience. When audiences encounter John in the opening scene, he yells at and pushes his wife as she sleeps, and orders her to "get up and muzzle that brat before she does drive [him] cuckoo!"[89] Once awake, Mary echoes John's sentiments toward their child. Struggling to recover after a night of excessive drinking, she orders John to "SMOTHER IT [the baby]!"[90] It is not a coincidence that the script describes Mary as being "at the end of patience" and that it characterizes John as being on the verge of "los[ing] [his] patience," and in another instance being "beyond his [patience]."[91]

As *Day of Absence* unfolds, impatience becomes a defining characteristic of Ward's white characters. When the play shifts back to Luke and Clem, audiences learn that Clem is "irked" and "agitated" and that the source of these feelings is a realization that he "don't see no Nigras."[92] For Clem, black people's disappearance from the field of vision leaves him perturbed, recalling Philip Roth's angry response to James Baldwin's portraits of whiteness in *Blues for Mister Charlie*. Expressing these frustrations to Luke, Clem betrays his deep annoyance with how this act of black disappearance has positioned the town's black citizens beyond the reach of the white gaze. "There ain't a darky in sight . . . We ain't laid eye on nary a coon this whole morning. . . . They ain't nowhweres to be seen. . . . We haven't seen a solitary one."[93] To this Luke replies, "Let's go look."[94] Rife with a visual vocabulary (e.g., "eyes," "sight," "seen," "look"), this dialogue uncovers a palpable frustration with black people's escape from the hold of the white gaze. This act of black flight from the field of vision so unsettles the normative assemblage of race/power/vision that it ignites a search to restore the town's black population to the visual field and to the matrix of racial power within which it operates.

In Ward's play, such performances of white impatience in the face of black disappearance are not limited to John and Mary nor to Luke and Clem. Rather, this affective reaction circulates throughout the town's white population. For instance, when the mayor learns that "the Nigras have disappeared, swallowed up, vanished! All of 'em! Every last one," he reacts "angrily" and "impatiently": "You mean a whole town of Nigras just evaporate like this—poof!—Overnight?"[95] For Mayor, this radical

act of black disappearance is so unthinkable that he attempts to mitigate his angst by convincing himself that they are "probably playing hide 'n' seek, that's it!"[96] This framing is crucial to the Mayor's sense of racial and regional selfhood. "The South has always been glued together by the uninterrupted presence of its darkies. No telling how unstuck we might git if things keep on like they have."[97] Here Mayor admits Jim Crowism's deep reliance on the visual and material presence of black people. Within this performative web of racial co-constitution and inter-articulation, the black subject is necessary fuel for the fiction of whiteness. It is whiteness's supposed opposite, its negative. Because of the intersubjective nature of these relations, black disappearance thus jeopardizes and throws into flux whiteness as well as the illusion of white superiority. In the absence of the black negative, Mayor strains to contort this act of black disappearance into a game of "hide 'n' seek." He must regard it as a transient performance that will, in a reasonable amount of time, come to an end. This game of "hide 'n' seek" is an important conceptual device for the mayor's framing of black disappearance, because the one who "seeks"—white people in this instance—also controls the flow of time through the act of counting. Further, the game of hide 'n' seek conveys a sense of collective buy-in that can help Mayor to ignore the stealthy and agential nature of this radical act of black disappearance.

What is ultimately at stake in this mass removal of black people from the visual field is the essence of whiteness itself. In the wake of black disappearance, the play's white characters cope with their ensuing sense of racial loss by metamorphosing into zombies. "Slowly its occupants slinked off into shadows, and by midnight, the town was occupied exclusively by zombies."[98] By removing black people from the field of vision, Douglas Turner Ward's *Day of Absence* proffers whiteness as a spectacular object of the black theatrical gaze. His telescopic attention to whiteness frames this mode of racial being as so markedly different from its imagined sense of self that it is best captured in the non-human figure of the zombie.

Disappearing Behind Whiteface

Performance theorist Peggy Phelan has theorized how disappearance can function as an act of subversion and possibility. She identifies

disappearance as a strategy of resistance available to constituencies who have been devalued, and thus unmarked, but are nonetheless framed as spectacle. According to Phelan, "the unmarked shows itself through the negative and through disappearance. I am speaking here," she asserts, "of an *active* vanishing, a deliberate and conscious refusal to take the payoff of visibility."[99] The widespread reproduction and circulation of telescopic black bodies in the Civil Rights Movement effected a certain "marking" of black bodies that sometimes achieved a broader recognition of black sentience and humanity while generating support for the movement. And yet, Phelan invites us to ponder the utility of a visual paradigm that refuses to "take the payoff of visibility," but that still uses vision—here in the form of disappearance—to destabilize regimes of social domination. In *Day of Absence*, Douglas Turner Ward employs various performance and aesthetics techniques to experiment with disappearance as a way to focalize whiteness and white people. For him, disappearance operates as a countervisual strategy through which he "unmarks" black bodies by removing black characters from the visual frame. He achieves this absenting of black bodies through various plot innovations (as we have seen), but also through novel prop and costume choices—especially whiteface—that "trouble the field of vision precisely by presenting the black body as a troubling figuration to visual discourse."[100]

According to Ward, *Day of Absence* is "conceived for performance by a Negro cast, a reverse minstrel show done in white-face."[101] In this sense, whiteface allows the theatre to become a space in which Ward's black performers could "interrogate the gaze of the Other but also look back, and at one another, naming what [they] see."[102] By looking from behind the guise of whiteface, actors possess a unique vantage point that enables them to see how white audiences behave when confronted with portraits of whiteness that likely contradict their own perceptions of racial selfhood. By shifting the gaze to whiteness, black performers put white audience members into the position of "looking-at-being-looked-at-ness." Whereas newspapers, television, and other cultural media in this era routinely trafficked in black spectacularity, Ward's use of whiteface as a theatrical instrument unsettled this era's obsession with the telescopic black body. In the same way that Ward's script disappears black characters, his use of whiteface allows him to empty the theatrical

stage of visibly black bodies and in doing so to stage Afro-alienation acts that center whiteness within the visual field of the theatre.

Ward's use of theatre to visualize whiteness was amplified by his reliance on minimalist aesthetics. On this front, the playwright's "Notes on Production" are instructive: "No scenery is necessary—only actors shifting in and out of an almost bare stage and freezing into immobility as focuses change or blackouts occur."[103] He goes on to add that "all props, except essential items (chairs, brooms, rags, mop, debris) should be imaginary (phones, switchboard, mop, eating utensils, food, etc)."[104] I read Ward's intentional absence of scenery and props as a minimalist aesthetic gesture that, alongside his use of whiteface, more carefully focalizes whiteness and white people. By creating a theatrical environment marked by bareness, or one made with the "fewest possible resources," the playwright imagines a performance space in which the actors—here adorned in whiteface—become the play's visual focal points.[105] But more than seeing whiteness, Ward wants his audiences to understand something about the nature of whiteness and the fiction of white superiority. Because minimalism is "well suited to . . . contesting the repressive ways in which meaning, and even selfhood itself, are dictated by *a priori* construction," Ward's use of minimalist aesthetics allows whiteness not only to be seen but to be subjected to critical reflection.[106] It is almost as if the playwright strives to disappear any material objects, whether scenery or visibly black bodies, that threaten to steer attention away from the whiteface characters who occupy the stage. Using theatre as a visual technology, Ward wants his audiences to see whiteness, to reflect upon the "ways of white folk," and to understand the role of white impatience in the management and arrangement of the modern racial order.

5

Lunch Counters, Prisons, and the Radical Potential of Black Patience

This book has been concerned with how black patience has been used as a weapon of anti-black violence and political exclusion. As we have seen from our focus on theatre in the Civil Rights Movement, this use of patience is imperative to racial formation and to the making of the modern world. Alongside continuing to theorize black patience as a technology of anti-black violence, in this chapter I will show how black people have refashioned patience into a tool of radical resistance. That is, I am interested in how black people have wielded patience as a political resource and a counter-normative strategy of self-making. To explore this side of black patience, I turn to the sit-in and jail-in movements. As I have shown throughout this book, white supremacy has routinely marshaled black patience as a means to manage and discipline black subjects and subjectivity. But in the case of the sit-in and the jail-in, black patience is less an instrument of fiercely anti-black biopolitics and more a willful performance of black political action. It works to contest and rearticulate the compulsory modes of waiting and forbearance that organize the racial project of black patience. By tapping into the political potential of the black body in waiting, jail-ins and sit-ins transformed the historical violence of the hold, as both gesture and spatiality, into an insurgent political choreography and a dissident terrain of black political action. These brave experiments in waiting and forbearance, in time and affect, in stillness and quiet helped to reinvest black patience with revolutionary and world-making potential. And they demonstrate that the radical promise of black bodies in performance lies as much in their stillness as it does in their movements.

To begin this journey of exploring the limits *and* possibilities of black patience, I want to return to 1962 Mississippi—the time and place where we began our discussion of the Free Southern Theater in chapter 2. It was here, in the spring of 1962, that civil rights activist Diane Nash was

arrested and charged with contributing to the delinquency of a minor. The source of these charges was not drugs or alcohol, but rather Nash's efforts to train students in the art of nonviolent direct action. Preparing this coterie of young activists to participate in the Freedom Rides, Nash's workshops were deemed illegal by the state because they (supposedly) conscripted minors into committing a crime. In this case, the crime was Nash's bold violation of Jim Crowism and its laws of racial segregation. Charged with five counts of contributing to the delinquency of a minor, Nash eventually missed her trial, and a warrant was issued for her arrest. She surrendered to authorities on Friday, April 27, 1962, and appeared in court the following Monday, but was hardly repentant for her "crime." Nash compounded her offense, in fact, by daring to stage a sit-in in a Mississippi courthouse, and in the courtroom of the same Mississippi judge who, two years later, would preside over the trial that allowed the murderer of civil rights activist Medgar Evers to walk free. "When I got to the courtroom," Nash recalls, "I thought, *I'm here to serve two and a half years; I'm not going to move to the back of the courtroom, too.* So I sat in the front row in defiance of local segregation laws."[1] Unsurprisingly, the judge held Nash in contempt of court, and sentenced her to ten days in county jail. For the two male activists who had joined in this sit-in, he ordered a sentence of forty days on a prison farm.

After serving her ten-day sentence for sitting-in, Nash returned to court to face charges for contributing to the delinquency of a minor. Though she was fully prepared to serve two additional years, the judge announced that she was free to leave. The pregnant activist met this news with disappointment rather than relief. His decision had effectively hijacked another opportunity to transform the state's compulsory performance of waiting into a radical act of black patience.

During the Civil Rights Movement, Nash's journey from the sit-in to the prison was not an uncommon one. As civil rights activist Thomas Gaither observed, "the sit-in . . . inevitably would lead to the jail-in."[2] In an effort to dampen the sit-ins' challenge to the material, ideological, and juridical infrastructure of anti-blackness, local and State officials saw incarceration as the perfect antidote to activists' embodied expressions of "freedom now." As activists were marshaling the sit-in to unsettle the laws and customs of Jim Crowism, the stewards of this system—sheriffs, police officers, judges, mayors, and governors—

used imprisonment to sequester sit-in activists from society, and to isolate and hopefully destroy their radical visions and performances of Afro-presentism. But civil rights activists like Diane Nash transformed the prison, and its coercive process of doing time, into a lively but no less violent domain of embodied political action. As Nash explains, "staying in jail focuses attention on the injustice. It puts the financial burden on the state, making the state pay the cost for enforcing unjust laws. Posting bond puts the financial burden on our community of supporters and takes the authorities off the hook, defeating much of the purpose for going to jail."[3] With a palpable sense of "urgent patience," sit-in and jail-in activists harnessed the insurgent potential of patience as a way to combat the racial project of black patience and to demand "freedom now."[4]

By willfully performing and redeploying black patience, these activists engaged in a radical process of doing time otherwise. Whether waiting patiently at the lunch counter, or using the jail-in to transform the carceral time of imprisonment into the insurgent time of black political action, their embodied expressions of Afro-presentism disturbed the violent temporalities of racial-spatial segregation. Like the segregated lunch counter and its performative demands for black people to wait for full citizenship, the prison circulates within and helps to constitute an exploitative economy of time-based violence that reinforces US racial hierarchies. If the prison "exterminates time as we know it," this structural extermination of time has been especially pronounced for black people, who make up the majority of the US prison population.[5] Seen this way, prison time is also racial time, insofar as the carceral process of doing time within the US nation-state takes as one of its most salient features the exploitation of black people and their time. What I am suggesting is that the prison and the segregated lunch counter are both sites of racial holding designed to contain, regulate, and discipline black subjects and subjectivity. And yet, activists like Nash transformed the prison and the segregated lunch counter into theatres of civil rights activism in which they practiced strategies of doing time otherwise while repurposing the spatial and the gestural histories of the hold. But in addition to their novel transformations of racial time, the sit-in and the jail-in were also innovative acts of fugitive affect, of not feeling otherwise. More than altering the temporal economy of black patience, they revamped the af-

fective codes that organize this violent world-system. From tempering their fears of white supremacist violence while sitting-in to replacing the shame of incarceration with the joy of communal struggle, jail-in and sit-in activists felt over and against the affective protocols of black patience. In these acts of fugitive affect, they sidestepped the shame and fear that arrest and imprisonment normally engender. Eager to break unjust laws, they did their time with a level of pride and tenacity that baffled the carceral consciousness and unsettled the carceral power of the state. Reinforcing the Civil Rights Movement's radical demand for "freedom now," these strategies of fugitive affect conjured an oppositional, time-conscious, freedom-centered field of black feeling. It generated an insurgent "temporality of affect" that labored toward the high calling of black freedom (Now!).[6]

Performances of sit-ins and jail-ins like Nash's are linked by a shared investment in using the black body in waiting to challenge the racial project of black patience. A radical repertoire of embodied political protest, these acts illuminate how black people have used patience as a tool of black political action and an instrument of black self-making. At stake in these radical refigurations of patience is a daring attempt to revamp the racial project of black patience by putting its structures of racial time (waiting) and racial affect (forbearance) in the service of its own undoing. These counter-normative acts of patience were designed to achieve one lofty but transformational goal: to disassemble black patience *qua* black patience.

In what follows, I consider two seriously underexamined civil rights plays: Oscar Brown Jr.'s *Kicks & Co.* (1961) and C. Bernard Jackson and James V. Hatch's Obie Award–winning 1962 musical, *Fly Blackbird*. In addition to capturing how civil rights activists refused the demands of black patience, these plays reveal how they used patience itself to upbraid the racial project of black patience and to thereby alter the spatial and gestural logics of slavery's hold. Looking specifically at the sit-ins and the jail-ins, I show how these willful performances of calm, uncomplaining endurance inverted and radically redeployed the nefarious structures of racial time and racial affect that govern the racial project of black patience. Reading these plays alongside theatre reviews, photographs, prison writings, newspapers, and nonviolent direct-action training manuals, I argue that these works portray the sit-in and the jail-in

as stylized acts of embodied political performance through which activists imbued black patience with radical potential. Let's turn first to *Fly Blackbird*.

Fly Blackbird and the Archive of Civil Rights Activism

When C. Bernard Jackson and James V. Hatch wrote *Fly Blackbird* in the early 1960s, they were both professors at the University of California, Los Angeles. Jackson was a black man from New York City and Hatch a white man from Iowa. Their decision to collaborate on this play was inspired by their shared desire to corral the political ferment of the Civil Rights Movement onto the theatrical stage. After "walking a picket line," they "wanted to do something more."[7] For them, theatre—like marches, sit-ins, and rallies—was an important arm of the Civil Rights Movement that could help to achieve the political transformation of society. Believing that theatre should "concern itself with preaching about contemporary social issues," they turned to the theatrical stage to satisfy their yearnings for increased political engagement.[8] The result was a one-act musical inspired by a civil rights rally at which Dr. Martin Luther King Jr. appeared.

Fly Blackbird opened in the fall of 1960 at the Shoebox Theatre in Los Angeles. In a critical but encouraging *Los Angeles Times* review, theatre critic Charles Stinson describes the play as a meditation on the "unsatisfactory condition of Negro-Caucasian relations."[9] This "potent and complex" theme, he writes, required "subtle . . . mature and . . . professionally crafted dramatization." Hatch and Jackson "have tried mightily. They have not succeeded." Rounding out his largely tepid review with an encouraging but direct address to the playwrights, Stinson concludes, "Messers. Hatch and Jackson, you've got hold a good idea here. Give it time to ripen and you may yet have a musical on your hands."[10] These words were almost prophetic. After months of revising and expanding the script, the duo transformed their fledgling one-act into an exhilarating two-act musical that opened at the Metro Theatre in Los Angeles on February 10, 1961—the first anniversary of the Greensboro, North Carolina, sit-ins that ignited the 1960s sit-in movement.

Staged in the "heart of the Negro community," the revised play was a hit among local black residents in particular.[11] Like the Free Southern

Theater's audiences in Mississippi, many of those who visited the Metro had never been to a theatre before.[12] Though struggling to stay afloat, *Fly Blackbird* had finally "ripened" into the kind of complex musical that Stinson had thought possible. While he had found the original production "stridently didactic and oversimplified," he believed that the 1961 version possessed "a kind of young zest and moral purpose we haven't seen since Federal Theater and the 30s."[13] The connection that Stinson draws between *Fly Blackbird* and the radical politics of the Federal Theatre and the 1930s gestures toward the revolutionary thrust of the "short" or "classical" phase of the Civil Rights Movement. If recent civil rights historiography tends to frame this phase of the movement as the conservative counterpart of the supposedly more radical 1930s, one benefit of critically examining plays like *Fly Blackbird*—and archival ephemera like this review—is that it enables us to locate lines of radical politics and traditions of black political aesthetics where they might not, at first glance, seem present.

It is certainly telling that this "hard hitting musical" appealed to the Ostrow family in California—an influential family of liberal philanthropists who used their stake in the Sealy Mattress franchise to fund a number of left-wing causes.[14] So impressed were the Ostrows with *Fly Blackbird* that they thought it deserved a wider audience, and believed more specifically that the play was "fare for New Yorkers."[15] At an event hosted at their mansion in Beverly Hills, the Ostrows invited the interracial conclave of prospective backers to buy shares in the production, kicking off this campaign with a $10,000 contribution of their own. Having procured enough cash, *Fly Blackbird* was off to New York City, where it opened at the Mayfair Theater, just off Broadway, on February 5, 1962—the second anniversary of the Greensboro sit-ins. On the whole, critics found the New York production to be "a provocative and exhilarating musical."[16] After an impressive run of 127 performances, the play earned the coveted 1962 Obie Award for Best Musical. It would seem that *Fly Blackbird*'s categorical success would ensure its preservation in historical memory. But the play has been largely forgotten and is curiously absent from critical discourse. What rare treatments of the play exist have been limited, for the most part, to a handful of important black theatre anthologies and reference works.[17] That such an impactful, award-winning play can fall victim to the whims of historical forgetting

illuminates the urgency of bringing these works back to the center of public consciousness and intellectual engagement.

If we were to take *Fly Blackbird*'s white coauthor, James V. Hatch, at his word, we would believe that the play is about the "reasonable" elements in society who understand the need for "'caution, patience, restraint and due process.'"[18] We would believe that the play is about the "young and foolish—the immature—who, because they have no vested interests . . . can dare to demand instantaneous correction of evil—'Freedom Now.'" Finally, we would believe that "although many of the play's central characters are black . . . one of the authors is black . . . [and] the work grew directly out of the mid-twentieth century struggle of blacks and their allies," *Fly Blackbird* "does not properly belong in a black theater anthology."[19] When considering *Fly Blackbird*'s characters, authorship, sociopolitical context, and uses of black cultural strategies like call-and-response, Hatch's conclusion that it does not "properly" belong in a black theatre anthology is curious. What concerns me more than this, however, is Hatch's framing of the play's relationship to the racial project of black patience. As he sees it, *Fly Blackbird* prioritizes "caution, patience, and restraint" over "Freedom Now." Whereas Hatch perceives the play's student activists as "immature," as the "young and foolish" who "dare to demand instantaneous correction of evil," I argue that the play applauds their commitment to the insurgent temporality of the "instantaneous," and in fact joins them in championing the political logic of Afro-presentism. We see this in the opening scenes of the 1961 and 1962 productions of the play, both of which critique the violent cultures of black patience and advocate for black politics grounded in the revolutionary time of "Freedom Now."

In the opening scene of the 1961 production of *Fly Blackbird*, audiences meet a young black character named Girl who wanders into a local library as she hums a children's song. Eager to share what she has witnessed on her commute, Girl informs the librarian (named Librarian) that she saw "people with signs," and "some of them were fighting."[20] The librarian responds with a glib dismissal: "And did you see any lions and bears?"[21] Framing the girl's observations as the product of an outsized imagination, Librarian resumes her preparations for Story Hour. Soon after, a black character named "Boy" dashes into the library, attempting to flee two white hecklers who are chasing him. Having successfully in-

vited Boy to join her for Story Hour, Librarian hands him a sign emblazoned with the topic of the day's program: "THE NEGRO AND YOU."[22] Intended to celebrate "Brotherhood Week"—whose motto is "Be kind to your colored friends"—Story Hour commences. The sounds of "Old Black Joe," a staple song in the cultural trove of white supremacy, plays in the background. The song's aching nostalgia for the "head . . . bending low," "feel no pain," "so happy and so free" black subject serves as prologue and accompaniment for the white librarian as she begins her story: "Down through the ages the Negro has endeared himself to us all as an entertainer and musician. His simple childlike nature, his sweet gentle disposition . . ."[23] Noticing that Boy and Girl appear to be leaving, she pleads, "Don't go. I have such a nice story about Uncle Remus."[24] What links "Old Black Joe," Uncle Remus, and the "sweet gentle disposition" of the Negro that emerges as the cherished protagonist of Librarian's story—and the paradigmatic protagonist of Story Hour more broadly—is that they all activate the trope of plantation nostalgia to pine for the figure of the patient Negro who, at least on the face of things, acquiesces to the violent protocols that govern the racial project of black patience.

As the opening scene blacks out, however, the play shifts to a "street scene" that is throbbing with the revolutionary ethos of black *impatience*. Carrying "sit-in and civil rights signs," an integrated group of student activists offer the first song of the musical, tellingly entitled "Now":

> NOW! Not another hour
> NOW! Not another day
> NOW! Not a minute longer
> But now. Right now. Right now!
>
> We've waited two hundred years or more
> But the time is drawing near
> When we will stand up and say
> Today is the day. The time is here.
>
> NOW! Not another hour
> NOW! Not another day
> NOW! Not a minute longer
> But now. Right now. Right now!

We've got to do something
To let people know how we feel
Right! As long as we
Keep our mouths shut
Things'll stay just as they are
See no evil. Hear no evil.
Think no evil. Know no evil.

We've waited two hundred years or more
But the time is drawing near
When we will stand up and say
Today is the day. The time is here.

NOW! Not another hour
NOW! Not another day
NOW! Not a minute longer
But now. Right away.

In this inaugural song, the protesters offer an unflinching critique of black patience and a forceful demand for "Freedom Now." Refusing to wait another minute, hour, or day, they insist that they have already been waiting for "two hundred years or more." Further, as much as these activists are concerned with disrupting the temporal operations of black patience, they are as committed to contesting its attempts to discipline black affective expression. As Librarian makes clear, one key dimension of black patience is the management and regulation of black affect. By forcing black people to perform sweetness, gentleness, and simplicity, black patience seeks to keep at bay those "negative" affects that might provoke and manifest as the kind of black impatience student activists exhibit throughout *Fly Blackbird*. "We've got to do something / To let people know how we feel," the activists demand.[25] In addition to insisting that the "time is here," these activists show that defeating the racial project of black patience also requires the unfettering of black feeling, the liberation of black affect, from the hold of white supremacy and anti-blackness. Rather than inhabit the "simple childlike" disposition that black patience works to install as the affective habitus of blackness, they stage performances of fugitive affect that voice their anger and

their rage, and that articulate their dissident feelings about the racial and political order of things.

The opening scene of the 1962 off-Broadway production of *Fly Blackbird* is equally remarkable for its bold challenge to the racial project of black patience. In this instance, though, it is not white characters who advocate for black patience but instead the leader of a black fraternal organization. Whereas the 1961 script opens with a rousing refusal of black patience, the off-Broadway version begins with "All in Good Time," an anthem of black patience. The gentlemen of Royal Order of Caribou sing:

> Everything comes to those who wait.
> ALL IN GOOD TIME!
> Carefully choose the path you take
> And you will find
> The moon will be yours, the stars will be mine.
> Won't that be fine!
>
> The Heavens will light the darkness of night,
> the sun will shine.
>
> There may be times things go wrong
> and every sky looks cloudy and gray.
> But patience lives to see the day
> when all the clouds have gone away.
> And I am sure that come what may or might
> the stars will shine tonight.
>
> Everything comes to those who wait.
> ALL IN GOOD TIME!
> Carefully choose the path you take
> and you will find
> the moon will be yours, the stars will be mine.
> Won't that be fine![26]

This opening scene reflects the historical reality that black people have sometimes been accomplices in the racial project of black patience. Like the Caribous, some have embraced gradualism as a viable political strategy

and a preferred orientation to the world. "All in Good Time" is heavy on cosmic imagery that indicates that there is nothing between "the Heavens" and earth that black people will not achieve in "good time." "Now I have found and you'll find too . . . That patience is a blessing in disguise / Just you wait and you will see / how beautiful this world can be."[27] The song's temporal grammar highlights the deceitful manipulation of Afro-futures that underwrites the racial project of black patience. The song's call for black people to "wait," its use of a future-oriented grammar (e.g., "will" and "can be"), and its claim that black patience is a "blessing in disguise" ultimately defer black freedom to a time that is "not-yet-here" and perhaps will never come. This calculus of weaponizing black hopes and black futures, of encouraging pursuits of black freedom dreams that are designed to elude the black dreamer, is the structuring structure of black patience. It is the governing logic that imbues this racial project with staying power and the authority to strong arm the oppressed into prioritizing what "this world can be" in lieu of demanding what it must be, "Now!"

On the heels of this song, the fraternity's leader, celebrity entertainer Sweet William Piper, thanks the Caribous for electing him "Exalted Grand Master." He announces that the following day the Royal Order of Taurus—their white fraternal counterpart—will extend to him "an honorary membership," making him the "first one of our people" to become a member of the racially segregated lodge.[28] "Hear! Hear," the Caribous respond. Lifted by his brothers' robust affirmation, Piper declares, "My friends, this is the year nineteen hundred and sixty-nine, and we have finally arrived!"[29] Though Piper conflates his vulgar individualism with collective success, the Caribous roundly endorse his tokenistic paradigm of black optimism, showing their approval by launching into another round of "All in Good Time."

When the Caribous have exited, Carl, a black college student who works at the Lodge as a waiter, whispers the lyrics to "All in Good Time" as he empties the ash trays that the Caribous have left behind. Upon discovering a cigar case that belongs to Sweet William Piper—one engraved "Don't rock the boat!"—Carl assumes a "mock-dignified pose" and begins to address the audience.[30] "My friends, this is the year nineteen hundred and sixty-nine, and we have finally arrived. May I add to all of you brothers in the South—and in the North—who haven't arrived—be patient. Don't push."[31] Carl's act of impersonation is interrupted by the

sudden appearance of Sweet William Piper's daughter, Josie, who—as her father reminds us throughout the play—is a "Sarah Lawrence girl."[32] When Piper returns for his cigar case, he is pleasantly surprised to see Josie, who has just missed his coronation. As the trio begin to converse, Piper asks Carl what he is studying in college. Carl tells him political science. "Ah, they call it a science now, eh. To my way of thinking, politics is an art." "The art of the possible," Carl adds. Loyal to his unshakable faith in the racial project of black patience, Piper declares, "Yes, that's true. It's all in knowing what you can do and *when*. Twenty years ago I would never have been accepted as an honorary member of the Taurus Lodge. . . . But today . . . we've come a long way. In another fifty years . . . all of us may be members."[33] Firm in his commitment to delaying black freedom, Piper sketches an eschatological vision of black progress in which the mere passage of time will theoretically improve black people's lives and political futures. For him, the timing, or the "when," of black progress must honor the protocols of racialized waiting that govern the racial project of black patience, and that seek to install themselves as the metronome of black social and political transformation.

By the time Piper and Josie exit, Carl's disdain for Piper and black patience has grown to a fever pitch. Railing against the logics of gradualism, tokenism, and deferral that anchor the racial project of black patience, Carl seethes out loud to the now absent Sweet William Piper, "Sarah Lawrence girl huh. Maybe in fifty years we'll all be Sarah Lawrence girls. Piper, Sir . . . in fifty years I'll be dead. If there's a job, I want a chance to earn a decent living." Seeming to interrupt or more precisely to serve as an extension of Carl's soliloquy, a black teenage girl named Tag runs onto the stage and screams "Now!"[34] By layering this temporal modifier onto Carl's desires for a decent living—"I want a chance to earn a decent living, Now!"—Tag sets in motion a chain of call-and-response that undercuts the temporal and affective norms of racialized waiting; that embraces the now-time of Afro-presentism over the wait-time of black patience:

CARL
(*Removing waiter's jacket*) If there's a school, I want the best education I can get.
(*Another section of the Lodge is broken away. Gail, a young white girl, enters.*)

GAIL
Now!

CARL
(*Building in intensity*) If there's a house for rent, don't tell me
 "sorry but we don't rent to colored."

CAMILLE
Now!

CARL
It makes me mad!³⁵

From education and labor to housing, Carl maps the wide web of anti-
black discrimination that plagues black people's quotidian realities. Rather
than wait for even access to these dimensions of social life, Carl and his
colleagues demand equal access "Now!" In addition to his defiance of the
temporal protocols of black patience, Carl's announcement that these
injustices make him "mad" rubs up against the affective norms of black
patience as well. To be mad at these procedures of anti-blackness is to
stage a performance of fugitive affect. It is to refuse the "sweet gentle dis-
position," the "simple childlike nature," that characterizes the concept of
the Negro that this racial project desires and struggles to produce.

As the actors' demands for "freedom now" crescendo, the set of the
Caribou Lodge is slowly and dramatically disassembled. The demolition
of this fortress of black patience symbolizes and foreshadows activists'
efforts to likewise level the racial project of black patience. In the clos-
ing moments of this opening scene, this bold affront to black patience
intensifies when an even larger group of activists rushes onto the stage
singing the song that opened the 1961 version of the play, "Now." As the
play unfolds, the activists' spirited performance of "Now" serves as a
foil to the Caribous' prized anthem of black patience. The tension that
moves between these songs models and reflects a historical tensity that
moves between black patience and Afro-presentism, between the "wait"
and the radical possibilities of "freedom now."

In both versions of the play, this tension blossoms into an all-out
generational rift that pits Sweet William Piper's patient model of black

political progress against the urgency of activists' demands for "freedom now." At various points throughout the first and second acts, Piper sings a song entitled "Who's the Fool?"—a song that sheds light on the wide ideological chasm separating these camps:

PIPER

They think they've got the world by the tail.
Think they're gonna change things overnight.
Well, that's all right with me.
I've done things differently myself.

I learned a long time ago
That anger doesn't get you anywhere.
There's no use beating your head against a wall
if you intend to get anywhere
at all.

They're doing things so differently.
Who's the fool . . . them or me?

Yes. I've shuffled.
I had to.
Shuffled high, shuffled low.
Shuffled fast, shuffled slow.
But I shuffled my daughter
Right through one of the finest schools in the country
So she'll never have to shuffle for anybody . . .
white or black.[36]

Perceiving activists' demands for "freedom now" as imprudent, Piper identifies two distinct routes to black political progress: his own acceptance of black patience, on the one hand, and students' embrace of Afro-presentism on the other hand. In "Who's the Fool?" Piper makes clear that his dispute against the political logic of Afro-presentism stems from his qualms with the temporal and affective sensibilities that inform its goals and outcomes. He condemns the student activists for thinking "they're gonna change things overnight," and for failing to realize that

"anger doesn't get you anywhere."[37] Piper's critique of Afro-presentism is grounded in two primary complaints: 1) The students are moving too fast ("think they're gonna change things overnight"), and 2) They exhibit anger rather than patience ("anger doesn't get you anywhere"). These competing approaches to black political futures index and revolve around a fundamental difference in perceptions of which paradigms of racial time and racial affect are most viable for black political progress.

Central to this drama of racial time and racial affect is Piper's "friend" and civil rights antagonist, Judge Sidney Crocker, who makes his first appearance in the play as the activists are singing the reprise to "Now!":

> NOW! Not a minute longer but now.
> Right now!
> Right now!
> Right—

Before they can offer the final "Now!," Crocker, a white man in his fifties, saunters from the audience to the stage and disrupts their performance of protest: "Hold it! Hold it! Let's stop this before it goes any further."[38] When Crocker issues this order to "hold it," the script cues the student activists to become "frozen figures."[39] Climbing onto the stage, he gestures toward the frozen activists, and asks the audience, "What are they complaining about?"[40] As his anger thickens, Crocker launches into a song entitled "I'm sick of the whole damn problem."[41] Now raging, he sings:

> The whole damn thing has gotten out of hand.
> I can't bear another syllable on the subject.
> I've had about as much . . . as I can stand.
>
> It's driving me insane
> Driving me mad
> I simply can't believe the situation is that bad![42]

By the end of this song, Crocker has become so incensed that he throws his topcoat to the ground "in rage" and proceeds to trample it. As I argued in the previous chapter, even as the racial project of black

patience demands calm, uncomplaining endurance from black people, it allows, and in fact incentivizes, performances of white impatience. Crocker's rage, in other words, is a historical rage. It emerges from an age-old system of racialized affect that configures white impatience as essential to the successful operation of black patience. Relieved by the appearance of Sweet William Piper, Crocker laments to his "friend" that the "kids of today could learn a lot from you old-timers." "What's the matter with them?" he asks. "All this nonsense about freedom."[43] Crocker finds a captive audience in Piper, whose sweetness Crocker prefers over the student activists' impatient "complaining" about freedom.

But the students press forward in trying to dismantle the racial project of black patience. Hoping to bring an organizational structure to their efforts, they form "an action group," a move that recalls the formation of student-focused civil rights groups like SNCC, the Atlanta Student Movement, and the Student Movement for Racial Equality in Portsmouth, Virginia. Like these political collectives, the student activists in *Fly Blackbird* put their bodies on the line as a way to unsettle the material and ideological foundations of black patience, and to thereby work toward the structural transformation of society.

Performing the Hold: On Blackness, Movement, and Stillness

I want to pivot in this section to thinking about black patience as a liberatory strategy of black political protest rather than a tool of anti-black racial terror. Let's return for a moment to the forced position of the "hold" that Crocker demands of the student activists in *Fly Blackbird*. On the heels of his command to "hold it," the students become what the script calls "frozen figures." This coerced position of occupying and performing the hold is a paradigmatic feature of black life, one that emerged from the operations of transatlantic slavery: the pens, barracoons, castles, and ships in which the enslaved were held. As literary critic Hortense Spillers observes, enslaved Africans were rendered the "essence of stillness . . . fixed in time and space."[44] Even in the wake of slavery, the fixity of black bodies in time and space has continued to redound across modern black experience. From segregation laws to redlining and mass incarceration, the hold is a hallmark of anti-black

oppression and a vital dimension of black being. Read against this back-drop, Crocker's demand to "hold it" both conjures the hold of slavery and is as an animate expression of its afterlives. It is one link in a long chain of historical demands for black people to occupy the space, and to perform the gesture, of the hold.

Recognizing how stillness has functioned as a tool of racial domina-tion, black people have routinely engaged in everyday acts and staged political projects that strain against white supremacy's desires for black people to become "frozen figures." Performances of movement have been vital to these historic struggles against the "the tyranny of still-ness."[45] As scholars working in the field of black performance studies have shown, embodied movement has permitted black subjects to con-test the restrictions and demands that underwrite desires for "immobile blackness."[46] Within white supremacy's racialized environments of en-forced stillness, movement is often a technique of liberation and a basis for black world-making. To be sure, the coerced movements of black people forced to labor on chain gangs, for example, remind us that black movement is not immune to white supremacy, and is often a product of social domination and an enduring modality of anti-black racial vio-lence. Seen from this angle, mobility comes to operate as its own form of stillness in the sense that it attempts to immobilize black freedom. My intention, then, is not to frame movement as a performance of freedom unencumbered by the violences of anti-blackness. Such a move would overlook the tyranny of mobility.

Moreover, alongside using movement to counteract white suprem-acy's compulsory demands for black stillness, black people have also used stillness itself to destabilize the systems and structures that force them to be still. Such performances of stillness are as pivotal to the his-tory of blackness as black bodies in motion. To explore these dynamics, let's turn now to the 1960s sit-in and jail-in movements. Staged within the enclosures of prisons and segregated lunch counters, the sit-in and the jail-in were radical acts of waiting and forbearance that redeployed modernity's racialized "technologies of patience."[47] Reelaborating the compulsory modes of waiting and the "sweet, gentle disposition" that anchor the racial project of black patience, these radical performances of black stillness counterinvested the space and the gesture of the hold with revolutionary potential.

Reinvesting Black Patience: Oscar Brown Jr.'s *Kicks & Co.*

On Monday, February 1, 1960, Ezell Blair Jr., Franklin McCain, Joseph McNeil, and David Richmond took seats at a racially segregated lunch counter in Greensboro, North Carolina. Only in their first year of college at nearby North Carolina A&T—a historically black university that functioned as the "command center" for the sit-in movement in that area—their defiant act ignited a chain of local sit-ins that would attract scores of student participants by the middle of the week, and hundreds more by week's end. Greensboro was certainly not the first time that black citizens had mobilized sit-ins to contest racial segregation and to advocate for the rights, privileges, and protections of full US citizenship. Still, there was something about this particular instance of sitting-in that gave the Civil Rights Movement a jolt of energy—an infectious momentum that would grip surrounding cites in North Carolina and across the nation. Having witnessed firsthand the transformational power of North Carolina's sit-ins, Birmingham civil rights leader Reverend Fred Shuttlesworth phoned SCLC comrade Ella Baker, asking her to "tell Martin [Luther King Jr.] that we must get with this." The sit-ins, Shuttlesworth proclaimed, "can shake up the world."[48] King agreed.

The gravity and impact of the sit-in movement was certainly felt beyond established civil rights leaders like Baker, Shuttlesworth, and King. Spreading to over fifty cities, inspiring the founding of SNCC, and giving the Civil Rights Movement a timely cause célèbre, the sit-ins were a vital component of 1960s black political culture. At the same time, and as important, this movement also became a touchstone of the black artistic and cultural imagination. Here we might consider Margaret Walker's poem "Sit-Ins," in which Walker documents and pays homage to the Greensboro sit-in activists. She writes,

> *Greensboro, North Carolina, in the Spring of 1960*
> You were the first brave ones to defy their dissonance of hate
> With your silence
> With your willingness to suffer
> Without violence
> Those first bright young to fling your names across pages
> Of new southern history

With courage and faith, convictions, and intelligence
The first to blaze a flaming path for justice
And awaken consciences
Of these stony ones.

Come, Lord Jesus, Bold Young Galilean
Sit Beside this Counter, Lord, with Me![49]

What is especially intriguing about Walker's ode to the Greensboro sit-in activists is its acknowledgment of how this cohort of "bright young" freedom fighters transformed black patience into a tool of civil rights protest. Emphasizing how their "silence" and "willingness to suffer / Without violence" helped to "blaze a flaming path for justice," the poem signals how activists revamped the affective protocols of black patience and put them in the service of black freedom. But even as Walker names and praises these radical acts of patience, she concludes with a couplet that moves the reader beyond the surface of the patient body in waiting. In doing so, she provides a rare aperture into the interior life of the sit-in activist. What we discover from Walker's trek into the black interior is a lively domain of black affective expression that upends and stretches the sanctioned codes of black affect—the racialized logics of patience—that generally scripted the performance of sitting-in. Pushing beyond the iconic "silence" that defined performances of sitting-in, the poem's concluding couplet is a fiery prayer and command to Jesus, an excited utterance whose exclamatory affect does not move in opposition to the body's exterior performance of patience but rather accords with the exclamatory affect of the sit-in itself. In other words, what perhaps registers as a profound performance of silence, as a strategic enactment of the quiet, is at the same time an excited utterance and a performative demand for "Freedom, Now." These quiet performances of embodied protest lend credence to literary critic Kevin Quashie's claim that the quiet often functions in black cultures as a form of expressive interiority that is "articulate and meaningful and has social impact."[50] Seen this way, the sit-in is a performance of silence that speaks, a stillness that moves, an enactment of excited feeling that mirrors the intensity of feeling conveyed by the exclamation mark that concludes Walker's couplet and the poem itself.[51]

Like Walker, black writer and civil rights activist James Baldwin was also drawn to the sit-in movement. In August of 1960, Baldwin published an essay on the topic in *Mademoiselle*, a popular women's magazine, that lauded the Greensboro sit-ins for launching a "decade of political activism" and for being "on the cutting edge of social change."[52] Entitled "They Can't Turn Back: History Is a Weapon," this essay chronicles Baldwin's trip to Tallahassee, Florida, as the sit-ins started to pick up steam in that community. Though brief, the writer's stay revealed how deeply the violent cultures of black patience cut into the racial geographies of Florida's capital city. From the "waiting ways" of the black chauffeur that Baldwin notices upon arrival at the airport to his discovery that state officials predicated appropriations to black colleges on their presidents' abilities to ensure the "docility of the students," Baldwin catches a glimpse of how the racial project of black patience manages and regulates black subjects through the management and regulation of black time ("waiting ways") and black affect ("docility").[53] The sit-ins afforded black Tallahasseans a means of confronting and redirecting the compulsory times and affects that underwrite the racial project of black patience. They invited and enabled black citizens to use their "waiting ways" and "docility" to unlock the radical capacities of black time and black affect, the revolutionary potential of black patience.

While the sit-ins led Walker to poetry and Baldwin to the essay, they were also a source of aesthetic inspiration and political concern for black playwrights as well. Among them was Oscar Brown Jr., an artist who "made no secret of his commitment to the civil rights movement."[54] In the late 1950s, as the movement gained steam, Brown was hard at work on a choral collaboration with jazz composer and drummer Max Roach, which was set to be performed for the 1963 Emancipation Proclamation centennial. Impelled by the energy of the 1960 sit-in movement, Brown and Roach decided, however, to record a version of the suite that could be released posthaste. The result was *We Insist: Max Roach's Freedom Now Suite* (1960), on which Brown worked as a lyricist. Recalling suites like Duke Ellington's *My People*, this musical odyssey from slavery to the Civil Rights Movement tracks the long history of anti-black oppression, which is also to say the long history of black patience. But it also conveys the ballooning tide of black impatience taking hold across the global geographies of the African Diaspora. On this front, the album's liner

notes open with a telling quotation from civil rights leader A. Philip Randolph that captures the tone of black people's radical demands for "freedom now": "A revolution is unfurling—America's unfinished revolution. It is unfurling in lunch counters, buses, libraries and schools—wherever the dignity and potential of men are denied. . . . Masses of Negroes are marching onto the stage of history and demanding their freedom now!"[55] As Randolph points out, the sit-in movement was critically important to staging this revolution. In fact, the album's cover is dominated by an iconic photograph of three Greensboro sit-in activists. As they sit at the racially segregated lunch counter, their performance of stillness—the choreography of their hold—unlocks the radical potential of inverting and redeploying black patience, highlighting its function as a key weapon of civil rights activism.

Set in the Spring of 1960—as sit-ins were garnering international attention—Oscar Brown Jr.'s *Kicks & Co.* calls attention to the sit-in as an embodied critique, refusal, and radical redeployment of black patience, one that energized the Civil Rights Movement's world-making demands for "freedom now." It opens by framing the sit-ins as a powerful tool of black political protest and a nagging source of white supremacist anxiety. So exigent is this racial angst for Mr. Kicks, a white "Mephistopheles-like" character, that he engineers a plot to suppress the sit-ins.[56] For this, he enlists the help of Will Wenchin, a photographer and owner of a porn magazine. Barging into Wenchin's office, Kicks finds his future accomplice making a slide-show pitch to Laurie, a prospective model for *Orgy: The Magazine for Men*. Having hurried the woman out of Wenchin's office, Kicks then changes the slides in Wenchin's projector. Images of "scantily clad" women are replaced by photographs of "negro students seated at a dime store counter."[57] There they are "pummeled," "herded into [a] police van," and then placed "behind bars."[58] Such a seamless transition from trafficking in women's semi-nude bodies to consuming spectacles of black bodies in protest hints at the habits of "pornotroping"[59] the black activist body that became a hallmark of photojournalistic and televisual practice in this era. In the previous chapter, I considered this fraught relationship between race and visual culture, and argued that theatre is a visual technology that helped to forge a different relationship between race and visuality during this era of civil rights activism. But in addition to Kicks's usefulness for understanding the discursive linkage

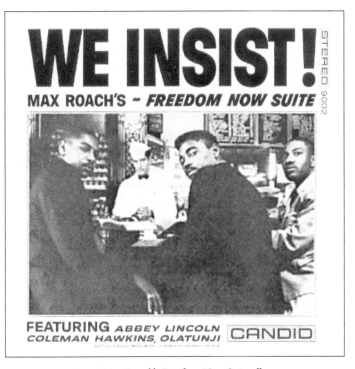

Figure 5.1. *We Insist! Max Roach's Freedom Now Suite* album cover.
Candid Records, 1960.

between race and vision in the Civil Rights Movement, this abrupt transition in the script reveals how quickly sit-in activists went from the lunch counter to the "police van" and the prison, underscoring the historical connection between the sit-in and the jail-in.

Wenchin and Kicks have good reason to fear the sit-ins and the burning appetite for political revolution that motivated this movement. At Freedmen University for Negroes—the epicenter of student activism in *Kicks & Co.*—the sit-ins are a foundational dimension of student culture, so much so that Freedman students have invented "steps" like "the sit-in" and "the Woolworth."[60] A hallmark of black fraternities and sororities (as well as historically black college and university dorm culture), these innovative steps use the sit-in as a muse for their embodied political aesthetics. The sit-ins help them to choreograph modes of racial collectivity, and to curate environments of black embodied collaboration, in and through the performance of stepping. These politicized acts

of stepping accord with the larger field of embodied togetherness and rhythmic experimentation that came to define performances of embodied protest like marching and singing that formed the core of modern civil rights activism. These steps certainly help to energize the brave coterie of Freedmen University coeds who go on to stage a sit-in at the lunch counter of a local dime store that is reminiscent of Woolworth's, the five-and-dime store in which the 1960s sit-in movement began in Greensboro, North Carolina. In this journey from stepping to sitting-in, we see, once again, the mutual importance of movement and stillness to the choreographies of black performance and therefore to the critical concerns of black performance studies.

During their sit-in, Ernest and Eggy, two of the Freedmen student activists, attempt to order food. Using the same, obviously scripted request, they place their orders politely with the store's white waitress: "Hot dog and an orange drink, please."[61] Not only does the waitress ignore both orders, but she also cautions a white patron to refrain from eating with the sit-in activists because, according to her, "they ain't clean."[62] That the waitress is plagued by a "violent fit of coughing which spews millions of germs" onto a customer's plate highlights the comic irony that was a hallmark of Oscar Brown Jr.'s performance aesthetics. But it also calls attention to the outright racism of the waitress's claim. These hostilities are exacerbated when a violent mob begins to antagonize the student protesters. In addition to spouting obscenities like "Nigger! My pappy and the Klan are gonna stop this sittin' in!"; "her Mammy only met her Pappy once"; and "Ought to send the mongrelizin' bitch back to Russia," the mob also destroys the students' possessions and even burns them with a cigarette.[63] In the face of this gratuitous violence, the student activists remain faithful to their training in nonviolence. Under these conditions of extreme duress, they challenge the racial project of black patience by using patience itself as a weapon of civil rights protest. Through an impressive execution of self-discipline and restraint, sit-in activists radicalized patience as a way to undercut modernity's historical transmutation of patience-as-virtue into a charged arena of anti-black violence and sociopolitical exclusion.

Choreographing the Hold

But these acts of patient protest began well before activists took their seats at the lunch counter. In this regard, a part of *Kicks & Co.*'s appeal is its depiction of the intricate process through which activists like Ernest and Eggy prepare to engage in patient acts of civil rights protest like the sit-in. It elaborates the complex pedagogies of nonviolent activism that were critical to training civil rights activists in the revolutionary art of black patience. Central to these curricula was a series of rehearsals, or sociodramas, that allowed them to stage dry-runs that primed their minds and bodies to suffer the indignities of white supremacist violence. Used by civil rights groups like SNCC and CORE, the sociodrama was the first step in setting the stage for the live performance of nonviolent protest. As James Lawson, a major architect of the sit-in movement, observed, the "role-playing experience . . . tries to set the stage for an actual demonstration, for an actual sit-in."[64]

In examining how role-playing exercises laid the groundwork for actual scenes of nonviolent protest, we might recall the opening scene of James Baldwin's *Blues for Mister Charlie*, which we considered in the previous chapter of this book. We will remember that the Reverend Meridian Henry leads a group of young activists in a role-playing exercise that was designed to rehearse for an upcoming non-violent protest. While some characters like Arthur play the role of protester, others like Tom play the part of angry mob member. As the two parties begin to clash, Reverend Henry interrupts the action to critique Tom's delivery of his lines, namely those that direct him to spout the racial epithet "Nigger." "No, no, no!" Reverend Henry interrupts. "You have to say it like you mean it—the way they really say it: nigger, nigger, nigger! Nigger! Tom, the way you saying it, it sounds like you just might want to make friends. And that's not the way they sound out there."[65] Giving it another go, Tom revs up his performance of white supremacist violence. Growing increasingly vicious, his verbal and physical attacks eventually earn the praise of Reverend Henry: "Now you got it. You really got it now. That's them."[66] At the same time that Reverend Henry, the director of this sociodrama, celebrates Tom's performance of what I call in the previous chapter white impatience, he directs Arthur—the victim of these attacks—to "keep walking," or to continue performing black patience.[67]

But when a mob member spits in Arthur's face, he loses his patience and ultimately breaks character: "You black s.o.b., what the hell do you think you're doing? You mother—!"[68]

Arthur's flaming reaction is precisely the kind of impatient response to white supremacist violence and provocation that such role-playing exercises were designed to contain. By simulating the live performance of non-violent protest, and the experience of racial violence, sociodramas furnished methods for learning and rehearsing the radical art of black patience. They equipped activists with techniques to manage and manipulate affect as a way to achieve the social and political goals of the movement. But what distinguishes the sociodrama's experiments in regulating black affect from those that underwrite the racial project of black patience is that their desired outcome was the liberation, rather than the domination, of black people. In this context, patience is anything but a "minor" or "secondary" virtue. Patience is courage. Patience is an embodied expression of insurgent black politics. Patience is a worldmaking transformation of black people's long-suffering from a vector of racial compliance into a radical strategy of altering the racial order of the modern world. Black patience, we might say, is black rage.

Mr. Kicks is keenly aware of the threat this inversion of black patience posed to existing relations of racial power. Having obtained a pamphlet from June, a student protester, he steals a glimpse into the complex pedagogies of nonviolent protest that were used to train civil rights activists during the movement. Titled "Instructions to Sit-in Demonstrators," the pamphlet outlines the following instructions:

1. Always be intelligent and orderly.
2. Accept violence without retaliation.
3. Do not be provoked to hate.
4. Love your enemies.[69]

This pamphlet is reminiscent of the expansive body of nonviolent direct-action training literature that circulated during the movement. Civil rights groups like CORE and SNCC developed complex curricula through which they prepared activists—like those in *Kicks & Co.* and *Blues for Mister Charlie*—to participate in nonviolent direct-action protests. While

these curricula varied, their primary learning outcome was the same: to teach activists the radical art of performing black patience.

For example, a CORE pamphlet directed activists to "meet the anger of any individual or group in the spirit of good will and creative reconciliation"; to "submit to assault"; and to "not retaliate in kind either by act or word."[70] In a similar vein, members of the Atlanta Student Movement—the group that sparked the Atlanta sit-ins—were required to sign an "Oath to Non-Violence," in which they agreed to honor the "six basic principles of non-violence."[71] Signing this contract indicated their "willingness to accept suffering without retaliation."[72] As I have argued throughout this book, patience is by definition a performance of suffering. Under the gratuitous violences that organize the racial order of the modern world, black people's suffering—their patience—has generally been coerced rather than willful, a product of force rather than intention. Indeed, the overriding ambition that drives the racial project of black patience is its singular desire for black people to suffer, and to do so without complaint. What is so striking about the sit-in and the jail-in is their spectacular refusals of these coercive logics of black suffering. In these embodied acts of political protest, the performance of black patience manifests as a willful and insurgent act of long-suffering, a performance of fugitive affect, that poses a challenge to the compulsory paradigms of black suffering that structure the racial project of black patience. Through these insurgent acts of patience, activists converted waiting and long-suffering into vectors of political expression and embodied demands for "freedom now."

As sit-ins and jail-ins unfolded across the country, there was no shortage of workshops and conferences that were dedicated to teaching the political philosophy of nonviolence and the embodied art of black patience. On the heels of the Greensboro sit-ins and their spread to cities across the nation, activists were inspired to collaborate, pooling their resources and energies into a collective effort to demand "freedom now" in and through the mechanics of nonviolent protest. A foundational moment in the emergence of this campaign was an April 1960 Youth Leadership Meeting, hosted at the historically black Shaw University in Raleigh, North Carolina. Although "youth-centered," the conference enjoyed the sponsorship of the SCLC, led by Dr. Martin Luther King Jr. In an announcement to prospective participants, King and SCLC Execu-

tive Director Ella Baker, a Shaw alumna and valedictorian, proclaimed that the sit-ins had inspired this meeting. This "great potential for social change," they write, "now calls for evaluation in terms of where do we go from here. The Easter week-end conference is convened to help find the answers. Together, we can chart new goals and achieve a more unified sense of direction for training and action in Nonviolent Resistance."[73] Attracting attendees from Washington, DC, to Florida, the Shaw Conference marked the founding of SNCC, established "nonviolence" as SNCC's "creed," and solidified the group's dedication to "going to jail rather than accepting bail."[74]

Another key mandate of the Shaw conference was to hold a second conference in the US South. On September 2, 1960, inaugural SNCC Chairman—and future Washington, DC, Mayor—Marion S. Barry Jr. invited activists to this meeting, whose theme would be "Nonviolence and the Achievement of Desegregation." Hosted in Atlanta in October 1960, the conference featured workshop leaders, speakers, and resource personnel who had been "drawn from persons knowledgeable in the philosophy of nonviolence."[75] In this, the conference did not disappoint. Alongside hearing Barry speak on "The Sit-In Success Story," attendees also heard talks like Ella Baker's "After the Sit-Ins, What?" and Martin Luther King Jr.'s "The Philosophy of Nonviolence." They were also given opportunities to participate in ten nonviolence workshops, led by noted nonviolence activists like James Farmer of the NAACP, Wyatt Tee Walker of the SCLC, and James Lawson of SNCC.

While all of these leaders were seasoned in the philosophy of nonviolent protest and the embodied art of black patience, Lawson was perhaps the most notable sage of nonviolent direct action. Having moved to Nashville, Tennessee, to attend the Divinity School at Vanderbilt University, Lawson directed countless workshops in nonviolent protest, training activists like Diane Nash and future US Congressman John Lewis, both of whom helped to spearhead the first sit-ins in Nashville. According to civil rights activist Reverend C. T. Vivian, Lawson's workshops taught participants how to "take the blows."[76] But as the Atlanta Student Movement's "Oath to Nonviolence" points out, "Non-violent resistance avoids not only external physical violence but also, internal violence of spirit."[77] It was at this intersection of body and spirit that the radical project of reinvesting black patience was situated. As we

learn from *Kicks & Co.*, *Blues for Mister Charlie*, and nonviolent protest curricula like Lawson's, this training of mind and body, of flesh and spirit, in the insurgent art of black patience helped to forward the Civil Rights Movement and to disrupt the violent world that black patience helps to engender through its machineries of anti-blackness and white supremacy.

At nonviolence workshops like Lawson's, role-playing was a key strategy for rehearsing and honing one's capacity to perform patience in the face of provocation. These dynamics are evident, for instance, in Martin Oppenheimer's instructive guide to organizing nonviolent direct action training, entitled "Workshops in Nonviolence—Why?" A member of the Philadelphia branch of CORE, Oppenheimer details nine "scenarios," including the "march," the "cell," and the "picket line," in which activists were likely to find themselves in the moment of live civil rights protest. Among these scenarios is the "sit-in," whose "cast" includes a group of six demonstrators who are preparing to stage a sit-in at a lunch counter in a "southern community."[78] Predictably ignored by the white waitress, like Ernest and Eggy, the protesters are then taunted by a mob of "troublemakers." A police officer watches with disregard.

Activists' rehearsal of scenarios like the "sit-in" was key to learning and refining the embodied art of black patience that would be critical to staging actual scenes of civil rights protest, and therefore to transforming the shape of US democracy. Performance theorist Diana Taylor has argued that the scenario is a key heuristic for understanding performances of power in the Americas. These ventures in pursuing and solidifying power, she contends, entail plots, casts, and a general sense of theatricality. The "scenario" is both "setup and action," and revolves around possibility, conflict, crisis, and resolution.[79] What becomes apparent in the plays and non-violence workshops that we have considered is that the scenario operates in these instances as a counter-normative strategy of black embodied performance. It disrupts rather than reinforces the operations of white racial power. From the "setup" of rehearsing these scenarios to deploying their methods at actual scenes of protest in the moment of live performance, the embodied enactment of black patience helped to upbraid and rewrite the conventional roles, scripts, gestures, and stagings this system of anti-black racial oppression had assigned. Using the black body in performance, sit-in activists engendered

an environment of conflict and crisis as a way to spotlight and challenge the failings of US democracy and to resist the violent enclosures of black patience.

In these instances, "the wait" is less a province of white supremacist maneuver and more a tactic of reconfiguring the sign of the black body while reelaborating its relationship to the affective common sense and the normative time-space of the modern racial order. It is a means of transforming black people's "ontological dislocation" into tactics for becoming "agents of their own liberation."[80] Simultaneously flouting and reinvesting modernity's racialized logics of waiting, the performance of sitting-in struck a powerful blow to black patience *qua* black patience. It allowed black activists to stake a claim to the rights and privileges of US citizenship "Now," even as the laws of racial segregation constrained their access to this category of political being. To be sure, the outcome of the sit-ins was often arrest and imprisonment. We might recall civil rights activist Thomas Gaither's claim that "the sit-in . . . inevitably would lead to the jail-in."[81] Thus, the enjoyment of these rights was often ephemeral, attenuating any hope of enjoying the "good life" ad infinitum.

And yet, that transgressive moment, or that radical instant, of sitting-in at a legally segregated lunch counter, whether for one minute or ten, marked an embodied claim not only to the space of a lunch counter, but more than this to the space of a region and a nation as a citizen. In this vein, we can usefully understand the sit-in as a performative enactment of black citizenship. Though fleeting and ephemeral, these embodied doings in Afro-presentism were also embodied doings toward an imagined black (political) future. In positing the sit-in as a performative enactment of black citizenship, I do not intend to overlook or downplay the structural force of anti-black violence. Nor do I mean to suggest a finality and ease with which black people can claim and perform citizenship. The seamless and violent removal of activists by police from the lunch counter to the prison requires that our accountings of black resistance and political agency reflect the realities of such scenes of spectacular violence and the infrastructure of racial antagonism from which they emerge. With this in mind, I understand these performative enactments of black citizenship in relation to this book's claims about the importance of the here and now for black people, black politics, and

black cultural production. As we learn from the previous chapters of this book, whether delaying black freedom and citizenship in the wake of emancipation, whether foreclosing black queer futures, or whether bombing, boycotting, and shuttering black plays to suppress their racial, sexual, and political content, the futures of black lives, black politics, and black art have always been precarious and often unrealized. Taken together, these dynamics signal the operations of a racialized structure of ephemerality that threatens the event of black life, the making of black art, and the shape of black political futures.

Under these conditions, any expression of black political possibility, any shard of the good life in the here and now—whether at the lunch counter or in the prison—must be valued for what it unlocks in the present as much as for what it opens up for a time that is "yet to come." Even as we necessarily figure these instants through a conceptual calculus that accounts for the relational dynamics between these fleeting moments and the violent networks of ephemerality that have historically assailed black political, ontological, and aesthetic futures, we must not overlook the value that inheres in the moment. Like citizenship, these instants are a series of performative acts. They are never actualized into a stable and resolved whole. As the mass arrest of sit-in activists demonstrates, these moments hold no guarantees for what black citizenship or black life might or will be in the future. But, somewhere in the break between the start of the sit-in and the commencement of the jail-in, we discover the transformative power of the here and now. We encounter the political utility of the Afro-present.

Jail-Ins: Reelaborating the Temporal and Affective Economies of Imprisonment

In the same way that sit-in activists revamped the racial space of the lunch counter and converted black patience into a strategy of embodied political protest, jail-in activists likewise transformed black patience and the carceral environment of the prison into tools and spaces of black political engagement. The jail-in is in no need of recovery in civil rights historiography and cultural criticism. But my interest in revisiting it here is motivated by my belief that it harbors under-tapped theoretical resources that further highlight the centrality of black patience—of

racial time and racial affect—to the Civil Rights Movement, and to the making of the modern racial order. More specifically, like the sit-in, the jail-in was a willful and counter-normative act of black patience. It challenged the racialization of time and affect that underwrites the operations of the prison, and that helps to suture the racial fabric of modernity's carceral constitution.

By arresting and imprisoning civil rights activists, state officials hoped to exploit the temporal and affective economies of imprisonment. They hoped that the shame and fear of incarceration would demoralize and suppress the movement. To their minds, the experience of incarceration—of doing time, as it were—would help to discipline civil rights activists and thereby to extinguish the flames of their urgent demands for "Freedom Now!" As legal scholar Michelle Alexander has pointed out, on the heels of *Brown v. Board of Education*, southern officials framed civil rights protest as criminal, and cast the Civil Rights Movement as a "breach of law and order."[82] As Alexander and others have observed, the mass arrest of civil rights activists "provided a dry run for mass incarceration," giving states "an early taste of what it would mean to arrest, prosecute, and imprison large groups of people (and to do so as pure punishment rather than coerced labor)."[83] But despite the racial terror of the state's carceral maneuvers, and its gross weaponization of time and affect, jail-in activists used this flagrant miscarriage of justice as an opportunity to reengineer the affective economy of imprisonment and thereby to reshape the very process of "doing time." Through their inventive strategies of doing time otherwise and importantly of feeling otherwise, they challenged the forced acts of waiting and the affective codes of comportment that structure the carceral environment of the prison as well as the violent cultures of black patience.

Dr. Martin Luther King Jr. was among those who used the jail-in to challenge the prison's disciplinary structures of time and affect, and to unsettle the paradigms of racialized waiting in which they are grounded. Having been arrested in Birmingham, Alabama, for participating in an illegal civil rights march, King—like scores of other activists—used the jail-in to transmute his imprisonment into a radical mode of embodied political protest and a counter-normative strategy of black patience. It was during this jail-in that King wrote "Letter from Birmingham Jail," an unrelenting critique of black patience that is now perhaps his most

canonical essay. The rhetorical and political brilliance of "Letter from Birmingham Jail" is well documented in scholarly discourses across disciplines. Less has been offered, though, about the essay's relationship to the political and rhetorical brilliance of King's jail-in—itself an act of performative writing, an embodied mode of political critique that staged a philosophical interrogation of black patience. I am interested in how both King's letter and his jail-in mobilize time and affect as political resources and as sites of sociopolitical critique. In both cases, King marshals these resources to expose and contest the racial project of black patience. At the same time, though, he uses his body and his pen to turn the normative logic of black patience on its head, such that black patience comes to function as a tool of black political thought and action rather than a lever of racial regulation. King's letter was begun on the margins of a newspaper that had been smuggled into his cell. And both his letter and his jail-in were produced in the marginal space of a jail. In this way, they were both illicit acts of black political insurgency, staged on the "outskirts" of society and the margins of western epistemology.[84]

King drafted "Letter from Birmingham Jail" as a response to an open, coauthored letter that was published by a cross-denominational clan of clergymen in the April 12, 1963, issue of the *Birmingham News*. Forcefully critiquing the Civil Rights Movement and its uses of nonviolent direct action, the authors posit, "We the undersigned clergymen are among those who, in January, issued 'An Appeal for Law and Order and Common Sense,' in dealing with racial problems in Alabama. We expressed understanding that honest convictions in racial matters could properly be pursued in the courts, but urged that decisions of those courts should in the meantime be peacefully obeyed." "We are now confronted," they continue, "by a series of demonstrations by some of our Negro Citizens, directed and led in part by outsiders. We recognize the *natural impatience of people who feel that their hopes are slow in being realized*. But we are convinced that these demonstrations are unwise and *untimely*."[85] From the perch of the white moderate, this clan of clergymen admonished black people to be peaceful and patient. They urged them to entrust their freedom to the courts, a division of liberal democracy whose record of failing black people was far longer than its history of protecting and honoring them as citizens. In addition to this clarion call to wait on the courts, the clergymen's letter was also an exhortation for

"restraint" and "forbearance." Heaping praise on "local news media and law enforcement" for the "calm manner in which these demonstrations have been handled," it is clear that the gentlemen's calls for restraint and forbearance were intended for black people and black political desire. In the final analysis, this distinguished panel of clergymen had written and published a petition for black patience. They had called once again for black people to wait, and to exercise "restraint" and "forbearance" in their waiting. Although claiming to recognize the "natural impatience of people who feel that their hopes are slow in being realized," the clergymen ultimately weaponize time and affect as a means to enforce and reinforce black patience and thereby to preserve the relations of power that organize modernity's racial order.

Despite these efforts to drape their racially charged demands for black patience in the garb of white political altruism, King called the clergymen's bluff. Of all of their spurious claims and recommendations, he took particular umbrage with their contention that the movement was "untimely." On this front, he writes, "While confined here in the Birmingham city jail, I came across your recent statement calling our present activities 'unwise and untimely.' Seldom, if ever, do I pause to answer criticism of my work and ideas. If I sought to answer all the criticisms that cross my desk," he submits, "my secretaries would have little time for anything other than such correspondence in the course of the day, and I would have no time for constructive work. But since I feel that you are men of genuine good will, and that your criticisms are sincerely set forth, I want to try to answer your statement in what I hope will be patient and reasonable terms."[86] King, the "outsider" to whom the clergymen were most certainly referring, makes the racial politics of time the focal point of his response. As the letter unfolds, he critiques the racialized logics of cruel optimism—the "blasted hopes and the dark shadow of deep disappointment"—that fuel the violent cultures of black patience. "Frankly," King asserts,

> I have yet to engage in a direct-action campaign that was "well timed" in the view of those who have not suffered unduly from the disease of segregation. For years now I have heard the word "Wait." It rings in the ear of every Negro with piercing familiarity. This "Wait" has almost always meant "Never." We must come to see, with one of our distinguished jurist,

that "justice too long delayed is justice denied." We have waited for more than 340 years for our constitutional and God-given rights.[87]

Like Langston Hughes, John Oliver Killens, Judge Edith Sampson, and many others that we have encountered in this book, King reminds the clergymen that black people have been waiting for freedom and full citizenship for centuries. But rather than place the blame for this perpetual delay on the arrant white supremacist, King reserves his most biting critique for the white moderate, who (like the clergymen) "paternalistically feels that he can set the timetable for another man's freedom; who lives by the myth of time; and who constantly advises the Negro to wait until a 'more convenient season.'" King makes clear, however, that black people had tired of waiting for freedom. He rightly situates their demands for "Freedom, Now" within a broader Afro-diasporic and third world movement that found minoritarian peoples—from Africa and Asia to South America and the Caribbean—fashioning their "legitimate and unavoidable impatience" into a global revolution. As these nations moved "with jet-like speed toward the goal of political independence," individuals like the clergymen insisted that black US citizens remain patient, that they "creep at horse-and-buggy pace." King, nonetheless, joined the international chorus of black people who fiercely resisted the racial terror of white time and the slow black death it engendered.

But even as King was miffed by the clergymen's violent call for black patience, he remained remarkably patient himself. Despite the gravity and the sometimes biting effect of his reply to the clergymen, he takes great care to be patient. He deploys patience in fact as a political and rhetorical resource, as an instrument to articulate his demands for "Freedom, Now." Black patience is not then in this instance a tool of anti-blackness and white supremacy. It is instead a performance of fugitive affect, a vector through which King's black impatience finds articulation. It is a willful and intentional mode of relating to and critiquing a political antagonist, and of imagining racial and democratic possibilities that are grounded in the time of the here and now—in the radical ethos of the Afro-present. It is important to note, however, that while King strategically answers the clergymen's letter in "patient and reasonable terms," and even solicits their forgiveness for any "unreasonable impatience," he nonetheless indexes the limits of his patience. In fact, he

holds space in his own rhetorical, affective, and political repertoire for what he understands as a reasonable impatience. For King, reasonable impatience is an oppositional deployment of time and affect. It is a refusal of waiting and forbearance, and the modes of black nonbeing their compulsion strives to engender. Reasonable impatience is, in the final analysis, a political duty and an ethical imperative that, when violated, requires nothing less than the forgiveness of God. It makes sense, then, that King closes his letter by asking God to forgive him if he should ever perform a "patience that makes [him] patient with anything less than brotherhood"—with anything less than a recognition of his humanity.[88]

In the same way that King uses black patience as a weapon of black political critique in "Letter from Birmingham Jail," so too does he in his jail-in. Like his written treatise on black patience, King's embodied performance of being jailed-in was a daring experiment in racial time, and a willful expression of black patience that doubled as a radical performance of black impatience. His stillness was nothing less than a bold and spectacular demand for black movement, and for black "freedom, now." At one point in "Letter from Birmingham Jail," King suggests that having to "pause" his political work to respond to the clergymen's criticisms was a waste of his and his secretaries' time and thus a distraction from the black freedom struggle. In the case of the jail-in, however, the pause affords King a moment of radical possibility. Choosing to willfully and patiently serve his sentence, or to inhabit the pause, the hold, or the wait, King put carceral time in the service of black freedom dreams. His decision to remain suspended in the confining space of the prison transformed the ministers' violent calls for patience into a radical mode of black political protest. By rerouting the historical flow and function of black patience, King used this habitually violent genre of racial performance as a resource for black political world-making rather than its destruction.

As innovative as King's embodied experiments in racial time were, they were matched by equally novel innovations in the affective economy of imprisonment. As King saw it, the jail-in "transformed jails and prisons from dungeons of shame to a haven of freedom and justice."[89] Recalling his experience of being arrested and imprisoned for civil rights protest, fellow activist John Lewis put it this way: "I felt no shame or disgrace . . . I felt exhilarated . . . I felt high, almost giddy with joy . . . I felt

elated."⁹⁰ King's and Lewis's comments about their feelings of being arrested and imprisoned capture how civil rights activists used the jail-in to upend the economy of negative affect in which activists' experiences of incarceration should have been mired. Even as the state cultivated carceral landscapes that were designed to engender negative affects like "shame," "stigma," and "terror" among the imprisoned, jail-in activists produced alternative carceral environments that enabled them to curate and revel in positive affects like joy. Through these modes of fugitive affect, jail-in activists were able to feel over and against the carceral power of the state, and beyond the affective enclosures that are vital to the prison's production of docile black bodies.

Civil rights activists like Ruby Doris Smith echoed King's and Lewis's claims that the jail-in helped to revamp the affective economy of the prison, and to thus reconfigure the dreaded experience of doing time. Smith's involvement in the Civil Rights Movement began as early as her time as a student at Spelman College in Atlanta. As a member of the Atlanta Student Movement, she participated in pickets and sit-ins. She was also a part of the Atlanta delegation that traveled to Rock Hill, South Carolina, to support the Rock Hill Nine, a group of activists who staged a sit-in at the segregated McCrory's lunch counter in Rock Hill and were subsequently arrested. Along with activists like Diane Nash, Smith backed members of this local sit-in by joining their protest, being arrested, and then choosing to refuse bail and therefore to do her time. Reflecting on her experience of being jailed-in, Smith references the flurry of laudatory letters that she and other jail-in activists received praising their brave and sacrificial decision to remain imprisoned. She admits, however, "I feel so guilty and untrustworthy because we are really enjoying ourselves." "This isn't prison, it's paradise."⁹¹ Smith's remarks shed light on the ensemble of otherwise feelings that jail-in activists deployed to survive and reconstitute the affective environment of the prison. Like King, she unveils the joy and the pleasure, the fugitive affect, that was often key to surviving the jail-in during the Civil Rights Movement.

To those attuned to the gratuitous violence of the prison, perhaps the tone of Smith's, Lewis's, and King's remarks seem off-kilter, and to downplay the structural violences that undergird the state's carceral regime. Activists like Ruby Doris Smith were all too familiar with these violences from personal experience. Not only did Smith do thirty days

of hard labor on a chain gang in Rock Hill, but in 1963, after being arrested for participating in the Freedom Rides, she served a forty-five-day sentence at Mississippi's notorious Parchman penitentiary—a prison that historian David Oshinsky has described as "worse than slavery," and one that Mississippi writers William Faulkner and Jesmyn Ward have referred to as "destination doom" and a "place for the dead."[92] Smith certainly understood that prison was no utopia. Thus, rather than reading these remarks as a softening of the prison's structural violences, we should instead regard them as a rare window into the affective economy of the prison during the Civil Rights Movement. These reflections contain epistemological value that illuminates the scale and significance of activists' efforts to escape the affective enclosures of the state's carceral regime. Infusing pleasure and joy into an affective environment that thrives on terror and shame, jail-in activists curated practices of fugitive affect that were pivotal to feeling their way to freedom.

These performances of feeling and doing time otherwise are just as important to the history of the long black freedom struggle and the history of black radicalism as the jail-ins themselves. Such willful acts of black patience allowed activists to alter the temporal and affective anatomy of prison, and to intervene into the broader configurations of racial time and racial affect that have imperiled black life since the moment enslaved Africans were forced to wait in coffles, barracoons, slave castles, and the bellies of slave ships. In the final analysis, the insurgent wait-time of the jail-in unsettled the compulsory wait-time of imprisonment as well as the historicity of black patience.

We get a glimpse of the jail-in's political utility in *Fly Blackbird*. By the end of act 1, scene 2, the play's student activists have been arrested, and are imprisoned behind "huge jail bars." Like hundreds of civil rights activists, they were willing to pay the high price of imprisonment to forward and energize their radical campaign for "freedom now." In the course of willfully waiting in a jail cell, these activists instrumentalized black patience as a radical tool of black political protest. These oppositional acts of waiting against the grain of white supremacist power forcefully redefined the political character of patience and the nature of racialized waiting within the context of US democracy.

The distinction between these radical performances of black patience and the obligatory acts of waiting and long-suffering that shape the vio-

lent cultures of black patience becomes apparent as the prison scene unfolds. Particularly illuminating in this regard is an interior drama that the playwrights weave into this scene. Entitled the "Dr. Crocker Medicine Show," the show is set in the same jail in which the student activists are imprisoned. At the center of this show is a "power potion" called "Dr. Crocker's Love Elixir,"[93] a tonic that had been pioneered by "world-famous physician and healer" Dr. Sidney J. Crocker. Pitching his elixir to the audience, Crocker claims that what distinguishes his potion from others is its ability to "cure the ills of an agonized soul, a tempest tossed mind . . . an aching heart."[94] Whereas other elixirs might cure ailments like "lumbago, arthritis, and painful back ache," Crocker's serves as a tonic for the heart, the soul, and the mind.[95] Its body-healing properties are designed to target the physiological motherboard (i.e., the heart, the soul, and the mind) of the body's production of affect. But this medicinal management of human affective expression is designed more specifically to dampen the global tide of anti-colonial and anti-racist struggle that saturated this world historical moment of political transformation. The "tempest tossed" hearts and minds that concern Crocker most are those of African-descended peoples, whose global performances of political rage and outrage, of fugitive affect, were beginning to strike at the core of the racial project of black patience. Describing this dilemma, Crocker laments:

CROCKER
 They got a whole lotta trouble in Africa,
 they got trouble in Tennessee,
 because the colored man is gettin' outta hand,
 my friends, you better listen to me.

 He's got to be pacified!
 He's got to be dominated!
 He's got to be willin' to do what I tell him to
 'cause this is the order that God created.[96]

The overarching goal of Crocker's elixir is to transform the "tempest tossed" hearts, souls, and minds of black political dissidents; to implode the vectors of fugitive affect fueling the anti-colonial and anti-racist

politics that colored black political culture in this period, from Tennessee to Africa. Claiming a unique ability to pacify and dominate black people who were "gettin' outta hand," this potion would effectively bring these fugitive subjects into compliance with the affective codes of black patience, and thus delay the event of black freedom.

But Carl interrupts this artful sales pitch, and then stages a jail-in that turns Crocker's scheme of racial pacification on its head and that imbues it with radical potential. Addressing the audience, he declares Crocker "a fraud . . . a fake!" "Listen to me! Don't be fooled! What he's selling has nothing to do with love."[97] Feeling the weight of this challenge, Crocker tries to contort Carl's dissent into an endorsement of violence. But Carl confutes this claim by launching into a performance of nonviolent direct action. Moving a bench to the center of the stage, he initiates a sit-in in the jail cell, or what is effectively a jail-in. "Are you just going to sit," Crocker asks? "Just sit," Carl answers. Growing increasingly angry at Carl's willful performance of stillness, Crocker orders Carl to "get that cotton-pickin bench out of the way so we can go on with the show! . . . Boy, if you want to sit . . ."[98] Before Crocker can finish, Carl interrupts again, informing him that the proper term is "Sit . . . in!"—not "sit."[99] "Why don't you do as everyone else does and sit in the audience," Crocker suggests. Carl explains, however, that sitting in the audience is like "sitting still," while "sitting-in is like moving!"[100]

Like Diane Nash, Carl stages a sit-in that angers a white judge, and then uses the space of the prison as an innovative site of black political action. His jail-in is an embodied political experiment in waiting and long-suffering. It is a radical exercise in Afro-presentism and fugitive affect that allows him to rewrite the temporal and affective codes that govern the racial project of black patience. His stillness and waiting become movement. His restraint becomes action. His patience becomes rage. Though nonviolent, the jail-in is a quiet manifestation of the very "agonized soul," the "tempest tossed mind," the "aching heart" that Dr. Crocker strives to suppress with his elixir. Pantomiming the act of starting a car, Carl drives toward the "promised land," hitting an occasional bump in the road along the way. The bumpiness of his journey signals the reality that black movement and progress toward the "promised land," toward an imagined black future, are not without jolts and challenges. There is also the historical reality that black subjects are routinely

prevented from reaching the promised land, or denied access to the improved black futures that loom on the "horizon," that are imminent but not-yet-here. In exercising the jail-in as an insurgent technique of black patience, jail-in activists strained against this historical foreclosure of black futures as well as the temporal and affective tactics that shore up the racial project of black patience. Using the wait to demand "freedom now," they marshaled the radical possibilities of black patience to labor toward the destruction of black patience via black patience.

ACKNOWLEDGMENTS

I have had the good fortune of being supported, loved, mentored, nurtured, and sustained by some of the most wonderful people with whom one can hope to cross paths. Thadious M. Davis, my dissertation director, graduate school advisor, and forever mentor, has been generous, encouraging, and supportive. She has maintained her faith in me even when my own faith in myself was running short. She models so much of what I love about this profession and hope to become. Herman Beavers has been tremendously formative to my intellectual and personal development. His insights and commitment have made me a better scholar and taught me to be a good citizen of the world and the academy. John L. Jackson Jr. has significantly informed my ways of thinking and existing. His mentorship has made this journey more possible and enjoyable.

As an undergraduate at Tougaloo College, I was fortunate to be mentored by Candice Love Jackson. My deep love of African American literary and cultural production is a product of this life-changing relationship, which continues to teach me to this day. Candice is also the reason I became a Mellon Mays Undergraduate Fellow and was lucky to be supported and mentored by Cynthia Neale Spence, Donna Akiba Sullivan Harper, Cally Waite, and Armando Bengochea.

My sincerest thanks to Soyica Diggs Colbert, Erica R. Edwards, Farah J. Griffin, and E. Patrick Johnson for their encouraging and pivotal feedback at manuscript workshops. These interactions taught me so much about the art of constructive feedback and critical generosity. This project also benefitted from my tenure as a Carter G. Woodson Post-doctoral Fellow at the University of Virginia. Deborah McDowell was always brilliant and generous, and curated an environment in which black study could thrive. This book is better because of her. Marlon Ross helped me to rethink the project at just the right time and remains a guiding light. Maurice Wallace's kindness and support have been lasting.

I owe thanks to Talitha LeFlouria, Kwame Otu, Ashon Crawley, Mrinalini Chakravorty, and Lawrie Balfour as well.

For the opportunity to present this work and receive valuable feedback, many thanks to Soyica Diggs Colbert and Robert Patterson at Georgetown, Robin Bernstein at Harvard, Stephanie Batiste at UC Santa Barbara, McKinley Melton and Hakim Williams at Gettysburg, Tekla Bude and Ana Milena Ribero at Oregon State, Jeffrey McCune at Washington University and the University of Rochester, Alex Weheliye at Northwestern, Jarvis McInnis (then at Princeton), Omari Weekes at Willamette, Cynthia Neale Spence at the Mellon Mays Undergraduate Fellowship Program, the Black Performance Theory Workshop (especially Thomas F. DeFrantz), and the Anna Julia Cooper Workshop in Black History.

The research for this book was supported by fellowships from the Mellon Foundation, the Woodrow Wilson National Fellowship Foundation, the Carter G. Woodson Institute for African American and African Studies, the Summer Institute on Tenure and Professional Advancement at Duke University (special thanks to Kerry L. Haynie and my faculty mentor, Karla F.C. Holloway), the Beinecke Rare Book and Manuscript Library at Yale, the Stuart A. Rose Manuscript, Archives, and Rare Book Library at Emory, and the University of Maryland, College Park.

I am grateful also for my amazing community of support at Penn during my graduate studies: the Fontaine Society, the Penn MMUF program, the Departments of English and Africana Studies, Salamishah Tillet, Tsitsi Jaji, Amy Kaplan, Barbara Savage, Camille Charles, Guthrie Ramsey, Mecca Sullivan, Daniel Fryer, Omari Weekes, Cameron Brickhouse, Diana Burnett, Khwezi Mkhize, Venise Adjibodou, Sarah Mantilla Griffin, Isabel Geathers, Gary Bertholf, Marina Bilbija, Sunny Yang, Aundeah Kearney, Anthony Pratcher, Thomas Dichter, Phil Maciak, and Sal Nicolazzo.

How wonderful it has been to work in archives whose staff are as kind as they are resourceful. Many thanks to the Amistad Collection at Tulane University, the Stuart A. Rose Manuscript, Archives, and Rare Book Library at Emory University, the Chicago Public Library, the Illinois State Archives, the Indiana State Archives, the Mississippi Department of Archives and History, and the International Institute of Social History in Amsterdam.

This study has also benefited from the support and keen insights of my colleagues at UMD. Many thanks to Dean Bonnie Thornton Dill and Associate Dean Daryle Williams. I found excellent department chairs in Bill Cohen and Amanda Bailey. My faculty mentors—Mary Helen Washington, Bob Levine, and Zita Nunes—have been unceasing in their wisdom and support. GerShun Avilez came to UMD at just the right time. He has been kind and generous at every turn. Mary Helen, Bob, Zita, GerShun, Merle Collins, Chad Infante, Tita Chico, I. Augustus Durham, Sangeeta Ray, Theresa Coletti, Scott Trudell, and Laura Rosenthal have read my work with care and have provided valuable insight. La Marr Jurelle Bruce has been a constant source of friendship and intellectual community. Many thanks also to Faedra Carpenter, Elsa Barkley Brown, James Harding, Rashawn Ray, Quincy Mills, and Doug Kern.

Jarvis McInnis, La Marr Jurelle Bruce, Beau Gators, Daniel Fryer, Ernest Gibson, Javon Johnson, Jeffrey Coleman, Jasmón Bailey, and Brian McGowan: you are the best academic brothers-cum-friends for which one could hope. I am also grateful for Stefan Wheelock, Randi Gil Sadler, J. T. Roane, Shaun Meyers, Regina Bradley, Petal Samuels, Kaneesha Parsard, Ryan Jobson, Shana Redmond, Riché Richardson, Elliot H. Powell, Darius Bost, Joshua Bennett, Brittney Cooper, Robert Bland, McKinley Melton, Marshall Green, Isaiah Wooden, Deron Williams, Justin Hosbey, Khalid Long, Brandon Manning, C. Riley Snorton, Uri McMillan, Nicole Fleetwood, Koritha Mitchell, Kevin Quashie, Kiese Laymon, Scott Heath, Robert Reid-Pharr, Dagmawi Woubshet, Regine Jean-Charles, Margo Crawford, Ivy Wilson, Carter Mathes, Evie Shockley, Imani Perry, Cheryl Wall, Trudier Harris, Michelle Wright, Michael Hanchard, John Lowe, Charles Rowell, Paul Carter Harrison, Paige McGinley, Harvey Young, Michelle Elam, Harry Elam, Emily Lordi, Anthony Reed, Christopher Freeburg, Candice Jenkins, Lindsay Reckson, Kenton Rambsy, Marlon Bailey, Frank Roberts, Jon Smith, and so many others.

To my DC crew: Carlton, you are my brother for life. The way you show up for me is extraordinary. Cam, life is richer because of your friendship. Brandon, my brother, you have been light in the dark, and are a living manifestation of what it means to live at the edge of life and to bask in all of its infinite possibilities. To my homeboys from Missis-

sippi—Renaldo Williams, Joshua Green, and John Purnell—our bond is eternal. To have best friends like you is nothing short of a blessing.

It is hard to imagine this intellectual journey and life without my best friend, brother, and primary thought partner, Jarvis C. McInnis. Since our days at Tougaloo College, he has been nothing short of family. He has seen the darkest days and has been there for the wins, cheering me on as if the victories were his. He is selfless and brilliant, funny and serious, a scholar par excellence and an everyday homeboy from the Sip. I am forever grateful for his feedback on this manuscript and his unwavering brotherhood.

This book was completed during the COVID-19 pandemic, which touched my family in deep and world-altering ways. Through the loss, grief, and healing, my editor, Eric Zinner, and series editors—Stephanie Batiste, Robin Bernstein, and Brian Herrera—have been supportive beyond what I could have ever expected. They are the best examples of kindness and critical generosity.

I have been blessed with an amazing family. My maternal grandparents, Billy and Rachel, did not live to see this book published. But they remain a source of strength and profound happiness. Their presence is in the textures, cadences, and ideas that animate this work. Lisa, Tina, Amber, and Tim: you are amazing, and have always had my back. Deunte, Brittany, and my other little cousins are like brothers and sisters. My brother, Mario, was my first friend. He continues to motivate and inspire me. I owe my parents, Julius Fleming Sr. and Sharon Fleming, the world and so much more. They have always seen the best in me, pushed me to new limits, and ensured that I would be in a position to leave this world better than I found it. My mother-in-law, Pamela Foster, has been wonderful. And last, but certainly not least, my wife, Phylicia (Lisa) Fitzpatrick-Fleming, renews me, and has been my closest friend since our days at Tougaloo College. She teaches me how to live, and for that I am grateful. Because of her, I know the beauty of breath. To my parents and Lisa, I dedicate this book.

NOTES

INTRODUCTION

1 For more on Fannie Lou Hamer's speeches and singing during the Civil Rights Movement, see Meagan Parker Brooks and Davis W. Houck, eds., *The Speeches of Fannie Lou Hamer: To Tell It Like It Is* (Jackson: University of Mississippi Press, 2011); and Kay Mills, *This Little Life of Mine: The Life of Fannie Lou Hamer* (Lexington: The University Press of Kentucky, 2007).

2 Thomas Dent, Gilbert Moses, and Richard Schechner, eds., *The Free Southern Theater by The Free Southern Theater* (New York: Bobbs-Merrill, 1969), 53.

3 Ibid.

4 I borrow the term *cultural front* from Michael Denning. By this he means the "cultural industries and apparatuses" and the "alliance of radical artists and intellectuals" who shaped the Popular Front. My use of the term is intended to highlight the cultural front of the Civil Rights Movement. See Michael Denning, *The Cultural Front: The Laboring of American Culture in the Twentieth Century* (New York: Verso, 1997).

5 For excellent analyses of photography and television in the Civil Rights Movement, see, for example, Sasha Torres, *Black, White, and in Color: Television and Black Civil Rights* (Princeton: Princeton University Press, 2003); Sasha Torres, ed., *Living Color: Race and Television in the United States* (Durham, NC: Duke University Press, 1998); Aniko Bodroghkozy, *Equal Time: Television and the Civil Rights Movement* (Urbana: University of Illinois Press, 2012); and Leigh Raiford, *Imprisoned in a Luminous Glare: Photography and the African American Freedom Struggle* (Chapel Hill: University of North Carolina Press, 2011).

6 For media coverage of the firebombing of William Chapel Baptist Church, see "Burnings," *Student Voice*, July 22, 1964, 3; and "The Increasing List of Burned," *Jet*, October 8, 1964, 20.

7 Rebecca Schneider, *Performing Remains: Art and War in Times of Theatrical Reenactment* (New York City: Routledge, 2011), 30.

8 Samuel Beckett, *Waiting for Godot* (New York: Grove Press, 1954 (1952)), 70.

9 Denise Nicholas, "A Grand Romantic Notion," in *Hands on the Freedom Plow: Personal Accounts by Women in SNCC*, ed. Faith S. Holsaert, Martha P. N. Noonan, Judy Richardson, Betty G. Robinson, Jean S. Young, and Dorothy M. Zellner (Urbana: University of Illinois Press, 2010).

10 "Wife Tours Nation Singing," *Jet*, March 25, 1965, 44.

11 "Tape U.S.A.," *Jet*, October 26, 1961, 13.

12 See Victor Turner, *From Ritual to Theatre: The Human Seriousness of Play* (New York: PAJ, 1982).

13 E. Patrick Johnson, "Black Performance Studies: Genealogies, Politics, Futures," in *The Sage Handbook of Performance Studies*, ed. D. Soyini Madison and Judith Hamera (Thousand Oaks, CA: Sage, 2006), 446.

14 Harvey Young, *Embodying Black Experience: Stillness, Critical Memory, and the Black Body* (Ann Arbor: University of Michigan Press, 2010).

15 Frantz Fanon, *Black Skin, White Masks*, trans. Richard Philcox (New York: Grove Press, 2008), 120.

16 Kara Keeling, *The Witch's Flight: The Cinematic, the Black Femme, and the Image of Common Sense* (Durham, NC: Duke University Press, 2007), 30.

17 Ibid., 30 and 36.

18 Jackie Robinson, *First Class Citizenship: The Civil Rights Letters of Jackie Robinson*, ed. Michael G. Long (New York: Times Books, 2007), 56–57.

19 W. H. Lawrence, "President Urges Patience in Crisis," *New York Times*, September 11, 1957; Felix Belair Jr., "Eisenhower Bids Negroes Be Patient about Rights," *New York Times*, May 13, 1958.

20 Belair, "Eisenhower Bids Negroes Be Patient about Rights."

21 Ibid.

22 Ibid.

23 Jackie Robinson, "Robinson to Dwight Eisenhower," in *First Class Citizenship*, 56–57.

24 Ibid., 40.

25 Giorgio Agamben, *Infancy and History: Essays on the Destruction of Experience* (New York: Verso, 1978), 91.

26 This book contributes to recent scholarship in the field of virtue ethics that has begun to acknowledge the importance of patience. See, for example, Nicolas Bommarito, "Patience and Perspective," *Philosophy East and West* 64, no. 3 (2014): 269–286; Michael Slote, *From Morality to Virtue* (New York: Oxford University Press, 1992); Eamonn Callan, "Patience and Courage," *Philosophy* 68, no. 266 (1993): 523–539; Robert A. Kaster, "The Taxonomy of Patience, or When Is 'Patientia' Not a Virtue?" *Classical Philology* 97, no. 2 (2002): 133–144; and Joseph Kupfer, "When Waiting is Weightless: The Virtue of Patience," *Journal of Value Inquiry* 41, no. 2–4 (2007): 265–280.

27 Jürgen Habermas, "Modernity: An Unfinished Project," in *Habermas and the Unfinished Project of Modernity: Critical Essays on the Philosophical Discourse of Modernity*, ed. Maurizio Passerin d'Entrèves and Seyla Benhabib (Cambridge: MIT Press, 1997), 38–55.

28 Frank Wilderson, *Red, White and Black: Cinema and the Structure of U.S. Antagonisms* (Durham, NC: Duke University Press 2010), 28.

29 Langston Hughes, *Jericho-Jim Crow: A Song Play*, in *The Collected Works of Langston Hughes*, vol. 6, ed. Leslie Catherine Sanders (Columbia: University of Missouri Press, 2004 (1963)), 254.

30 Ibid., 255.

31 Ibid.

32 Ibid.

33 Ibid., 272.

34 Ibid., 255.

35 Ibid., 258.

36 I borrow the concept "afterlives of slavery" from literary critic Saidiya Hartman, who seeks to account for how "black lives are still imperiled and devalued by a racial calculus and a political arithmetic" that were entrenched during slavery. The result, Hartman contends, is "skewed life chances, limited access to health and education, premature death, incarceration and impoverishment." See Saidiya V. Hartman, *Lose Your Mother: A Journey Along the Atlantic Slave Route* (New York: Farrar, Strauss and Giroux, 2007), 6.

37 Ralph Ellison, *Invisible Man* (New York: Vintage, 1995 (1952)), 8.

38 Denise Ferreira da Silva, "Toward a Black Feminist Poethics," *The Black Scholar: Journal Of Black Studies and Research* 44, no. 2 (2014): 81–97.

39 Johannes Fabian, *Time and the Other: How Anthropology Makes Its Object* (New York: Columbia University Press, 1983), xxxiv.

40 Hartman, *Lose Your Mother*, 125–136.

41 Julius B. Fleming Jr., "Sound, Aesthetics, and Black Time Studies," *College Literature* 46, no. 1 (2019): 281–288.

42 As literary critic Anthony Reed argues, "conceptualizing and otherwise attending to time is politically urgent." See Anthony Reed, *Freedom Time: The Poetics and Politics of Black Experimental Writing* (Baltimore: Johns Hopkins University Press, 2014), 1. For examples of recent scholarship that I locate within the field of Black Time Studies, along with Reed, see Carter Mathes, *Imagine the Sound: Experimental African American Literature After Civil Rights* (Minneapolis: University of Minnesota Press, 2015); Achille Mbembe, *On the Postcolony* (Berkeley: University of California Press, 2001); Shane Vogel, *Stolen Time: Black Fad Performance and the Calypso Craze* (Chicago: University of Chicago Press, 2018); Calvin Warren, "Black Time: Slavery, Metaphysics, and the Logic of Wellness," in *The Psychic Hold of Slavery: Legacies in American Expressive Culture*, ed. Soyica Diggs Colbert, Robert J. Patterson, and Aida Levy-Hussen (New Brunswick, NJ: Rutgers University Press, 2016), 55–68; Gary Wilder, *Freedom Time: Negritude, Decolonization, and the Future of the World* (Durham, NC: Duke University Press, 2015); Michelle Wright, *Physics of Blackness: Beyond the Middle Passage Epistemology* (Minneapolis: University of Minnesota Press, 2015); Keeling, *The Witch's Flight*; and Daylanne K. English, *Each Hour Redeem: Time and Justice in African American Literature* (Minneapolis: University of Minnesota Press, 2013).

43 See Wright, *Physics of Blackness*, 3. Wright's concept of "epiphenomenal time," like my concept of Afro-presentism, calls attention to the importance of the "now" for thinking about the ontology of blackness. My concern with the present, or the now, is focused not only on black ontology but also on its specific utility for

theorizing black political culture and cultural politics as well as the ontology of black performance. My examination of the modern Civil Rights Movement—an era characterized by the iconic phrase "freedom now"—gives this attention to the present a unique conceptual and theoretical value that is, nonetheless, not limited to this period of social transformation. Similarly, literary critic Daylanne K. English's concept of "strategic presentism" recognizes the importance of the historical present for Black Arts Movement artists and activists. See English, *Each Hour Redeem.*

44 Henri Lefebvre, *Rhythmanalysis: Space, Time and Everyday Life* (London: Continuum, 2004 (1992), 15.

45 Ibid, xii.

46 Martin Luther King Jr., "The Other America," speech, Stanford University, April 14, 1967 (KQED TV Archive by Stanford University). Transcript available: "Martin Luther King and Economic Justice: The Fortieth Anniversary Commemoration of Dr. King's 'The Other America' Speech at Aurora Forum at Stanford University," November 2, 2014, www.crmvet.org.

47 Ibid.

48 Ibid.

49 Ibid.; emphasis added.

50 See *OED Online* (2021), s.v. "patience."

51 Frederick Douglass, *Narrative of the Life of Frederick Douglass, an American Slave* (New York: Modern Library, 2004 (1845)), 34.

52 Clare Hemmings, "Invoking Affect: Cultural Theory and the Ontological Turn," *Cultural Studies* 19, no. 5 (2005): 548–567.

53 Patricia T. Clough and Jean Halley, eds., *The Affective Turn: Theorizing the Social* (Durham, NC: Duke University Press, 2007), 2.

54 See, for example, Saidiya V. Hartman, *Scenes of Subjection: Terror, Slavery, and Self-Making in Nineteenth-Century America* (New York: Oxford University Press, 1997); Tyrone S. Palmer, "What Feels More than Feeling? Theorizing the Unthinkability of Black Affect," *Critical Ethnic Studies* 3, no. 2 (2017): 31–56; and Sara Ahmed, *The Cultural Politics of Emotion* (New York: Routledge, 2015).

55 I borrow the term *affective economies* from feminist theorist Sara Ahmed. See *The Cultural Politics of Emotion.*

56 Palmer, "What Feels More than Feeling?" 32.

57 Tavia Nyong'o, "Trapped in the Closet with Eve," *Criticism* 52, no. 2 (2010): 243–251.

58 Martin Luther King Jr., "To Sammy Davis, Jr.," in *The Papers of Martin Luther King, Jr., Volume VII: To Save the Soul of America, January 1961–August 1962*, ed. Tenisha Armstrong and Clayborne Carson (Oakland: University of California Press, 2014), 582.

59 "Oscar Brown Musical Gets Warm Reception in Windy City," *Jet*, October 12, 1961, 58.

60 "Unusual Appeals Bring Broadway Cash," *Ebony*, June 1961, 74.

61 Ibid., 73.

62 King, "To Sammy Davis, Jr.," 582.

63 See Houston Baker, "Critical Memory and the Black Public Sphere," *Public Culture* 7, no. 1 (1994): 16.

64 See, for example, Elizabeth Abel, *Signs of the Times: The Visual Politics of Jim Crow* (Berkeley: University of California Press, 2010); Martin A. Berger, *Seeing Through Race: A Reinterpretation of Civil Rights Photography* (Berkeley: University of California, 2011); Maurice Berger, *For All the World to See: Visual Culture and the Struggle for Civil Rights* (New Haven, CT: Yale University Press, 2010); Nicole Fleetwood, *Troubling Vision: Performance, Visuality, and Blackness* (Chicago: University of Chicago Press, 2011); Waldo E. Martin Jr., *No Coward Soldiers: Black Cultural Politics in Postwar America* (Cambridge: Harvard University Press, 2005); Ingrid Monson, *Freedom Sounds: Civil Rights Call Out to Jazz and Africa* (New York: Oxford University Press, 2007); Raiford, *Imprisoned in a Luminous Glare*; Shana L. Redmond, *Social Movements and the Sound of Solidarity in the African Diaspora* (New York: NYU Press, 2014).

65 For an excellent analysis of black theatre in the "Long Civil Rights Movement," see Jonathan Shandell's *The American Negro Theatre and the Long Civil Rights Era* (Iowa City: University of Iowa Press, 2018). My book builds on this history of black theatre. But whereas Shandell concentrates on the landmark American Negro Theatre and the Long Civil Rights Movement, *Black Patience* focuses on the "short" or "classical" phase of the movement and the transnational culture of theatre and performance it generated.

66 Diana Taylor, *The Archive and the Repertoire: Performing Cultural Memory in the Americas* (Durham, NC: Duke University Press, 2003).

67 See Glenda Gilmore, *Defying Dixie: The Radical Roots of Civil Rights* (New York: W. W. Norton, 2008), 1.

68 Jacquelyn Dowd Hall, "The Long Civil Rights Movement and the Political Uses of the Past," *Journal of American History* 9, no. 4 (2005): 1235.

69 Proponents of the "long" civil rights movement have rightly acknowledged the ways in which the legacy of the modern civil rights movement is quite frequently distorted by advocates of color-blind ideology who often cite Martin Luther King Jr.'s desire to end racism as "proof" that New Right logics of color blindness are the natural outcome of modern Civil Rights activism. I echo this criticism of these kinds of historical appropriations.

70 Hall, "The Long Civil Rights Movement and the Political Uses of the Past," 1235.

71 See Koritha Mitchell, *Living with Lynching: African American Lynching Plays, Performance, and Citizenship, 1890–1930* (Urbana: University of Illinois Press, 2011).

72 See Cedric Robinson, "Capitalism, Marxism, and the Black Radical Tradition: An Interview with Cedric Robinson," *Perspectives on Anarchist Theory* 3, no. 1 (1999): 6.

73 Ibid., 2.

74 See Robin D. G. Kelley, *Freedom Dreams: The Black Radical Imagination* (Boston: Beacon Press, 2002), 11. Considering these propositions within the immediate

context of the Civil Rights Movement, Robinson goes on to add that "the Movement was more than sit-ins at lunch counters, voter registration campaigns, and freedom rides; it was about self-transformation, changing the way we think, live, love, and handle pain."

75 For a discussion of "radical aesthetics," see GerShun Avilez, *Radical Aesthetics and Modern Black Nationalism* (Urbana: University of Illinois Press, 2016).

76 Oscar Brown Jr., *Kicks & Co.*, box 67, folder 8, Lorraine Hansberry Papers, 1947–1988, Schomburg Center for Research in Black Culture, Manuscripts, Archives and Rare Books Division, New York Public Library.

77 See Thomas Sugrue, *Sweet Land of Liberty: The Forgotten Struggle for Civil Rights in the North* (New York: Random House, 2008), xiv and xxi.

78 Ashon T. Crawley, *Blackpentecostal Breath: The Aesthetics of Possibility* (New York: Fordham University Press, 2017), 2.

79 Walter Benjamin, "On the Concept of History," *Walter Benjamin: Selected Writings*, vol. 4 (Cambridge, MA: Belknap, 2003), 395.

80 Martin Luther King Jr., "I Have a Dream," August 28, 1963, The Martin Luther King, Jr. Research and Education Institute, Stanford University, kinginstitute.stanford.edu.

81 Ibid.; emphasis added.

82 For concepts of "black time" and "white time," see Warren, "Black Time"; and Charles W. Mills, "The Chronic Injustice of Ideal Theory," *Du Bois Review* 11, no 1. (2014): 27–42.

83 John Lewis, "Speech at the March on Washington," August 28, 1963, Voices of Democracy, The U.S. Oratory Project, University of Maryland, College Park voicesofdemocracy.umd.edu.

84 D. Scot Miller, "Afrosurreal Manifesto," *San Francisco Bay Guardian*, August 3, 2017.

85 Ytasha L. Womack, *Afrofuturism: The World of Black Sci-Fi and Fantasy Culture* (Chicago: Lawrence Hill Books, 2013), 9.

86 See José E. Muñoz, *Cruising Utopia: The Then and There of Queer Futurity* (New York: NYU Press, 2009), 29.

87 Lauren Berlant, *Cruel Optimism* (Durham, NC: Duke University Press, 2011), 54.

88 Fred Moten, "The Case of Blackness," *Criticism* 50, no. 2 (2008): 179.

89 Gaston Bachelard, *The Intuition of the Instant* (Evanston, IL: Northwestern University Press, 1932).

90 David Scott, *Omens of Adversity: Tragedy, Time, Memory, Justice* (Durham, NC: Duke University Press, 2014): 1.

91 Henri Lefebvre, *Critique of Everyday Life: Foundations for a Sociology of the Everyday* (New York: Verso, 2002), 342.

92 For scholarship on black pasts and futures, see, for example, Genevieve Fabre and Robert O'Meally, eds., *History and Memory in African American Culture* (New York: Oxford University Press, 1994); Houston A. Baker, *Critical Memory: Public Spheres, African American Writing, and Black Fathers and Sons in America* (Ath-

ens: University of Georgia Press, 2001); Renee C. Romano and Leigh Raiford, eds., *The Civil Rights Movement in American Memory* (Athens: University of Georgia Press, 2006); Jonathan Scott Holloway, *Jim Crow Wisdom: Memory and Identity in Black America Since 1940* (Chapel Hill: University of North Carolina Press, 2013); Kimberly Juanita Brown, *The Repeating Body: Slavery's Visual Resonance in the Contemporary* (Durham, NC: Duke University Press, 2015); Alondra Nelson, ed., "Afrofuturism," *Social Text* 20, no. 2 (2002); Womack, *Afrofuturism*; Reynaldo Anderson and Charles E. Jones, eds., *Afro-Futurism 2.0: The Rise of Astro-Blackness* (Lanham, MD: Lexington Books, 2016).

93 See, for example, Lynn Hunt, "Against Presentism," *Perspectives on History: The News Magazine of the American Historical Association*, May 2002, www.historians.org.

94 Richard Schechner, "What Is Performance Studies Anyway?" in *The Ends of Performance*, ed. Peggy Phelan and Jill Lane (New York: NYU Press, 1998), 361.

95 See Peggy Phelan, *Unmarked: The Politics of Performance* (New York: Routledge, 1993), 146.

96 Schneider, 89.

97 Phelan, *Unmarked*, 146.

98 Ibid.

99 See Fred Moten, *In the Break: The Aesthetics of the Black Radical Tradition* (Minneapolis: University of Minnesota Press, 2003), 18; and Philip Auslander, *Liveness: Performance in a Mediatized Culture* (New York: Routledge, 1999), 5.

100 Phelan, *Unmarked*, 118.

101 "Unusual Appeals Bring Broadway Cash," *Ebony*, June 1961, 73.

102 "The Last Laugh," *Ebony*, December 1961; and "Oscar Brown Musical Gets Warm Reception in Windy City," *Jet*, October 12, 1961.

103 Loften Mitchell, *Black Drama: The Story of the American Negro in Theatre* (New York: Hawthorne Books, 1967), 225.

104 Fred Moten, *Stolen Life* (Durham, NC: Duke University Press, 2018).

105 William Branch, *A Medal for Willie*, in *African American Scenebook*, ed. Kathryn Ervin and Ethel Pitts-Walker (New York: Falmer Press, 1999), 39–44.

106 Kyla Schuller, *The Biopolitics of Feeling: Race, Sex, and Science in the 19th Century* (Durham, NC: Duke University Press, 2018).

107 Alice Childress, *Trouble in Mind*, in *Selected Plays: Alice Childress*, ed. Kathy A. Perkins (Evanston, IL: Northwestern University Press, 2011), 106–107.

108 Fleetwood, *Troubling Vision*, 7.

109 "A General Prospectus for the Establishment of a Free Southern Theater," box 6, folders 12–13, Free Southern Theater Papers, 1960–1978, Amistad Research Center, Tulane University, New Orleans.

110 Katherine McKittrick, "Plantation Futures," *Small Axe* 17, no. 3 (2013): 1–15.

111 Audre Lorde, "Uses of the Erotic: The Erotic as Power," in *Sister Outsider: Essays and Speeches* (Freedom, CA: The Crossing Press, 1984), 88.

112 Avery F. Gordon, "Some Thoughts on Haunting and Futurity," *Borderlands* 10, no. 2 (2011): 16.

113 Martin Luther King Jr., *Why We Can't Wait* (New York: Signet, 2000 (1963)), 13.

114 Ibid.

115 Ibid., 19.

116 Booker T. Washington, *Up From Slavery: An Autobiography* (Garden City, NY: Doubleday, 1963), 32.

117 Ibid.

1. ONE HUNDRED YEARS LATER

1 Christina Sharpe, *In the Wake: On Blackness and Being* (Durham, NC: Duke University Press, 2016), 5.

2 John H. Johnson, "A Statement from the Publisher," *Ebony*, September 1963, 19.

3 Hartman, *Scenes of Subjection*, 126.

4 Johnson, "A Statement from the Publisher."

5 Duke Ellington, "What Color Is Virtue," 1964, track 8 on *My People*, Contact Records, LP.

6 Ibid.

7 Ibid.

8 Ibid.

9 "Dramatize Progress of Negro in Court: Lawyers Present Documentary at Exposition," *Chicago Tribune*, August 25, 1963.

10 "ANECANS Help Cleveland Chapter to Organize," *Chicago Daily Defender*, November 30, 1961.

11 "Executive Order No.: Proclamation for Emancipation Centennial Day," January 1, 1963, S1506, box 1, folder 1, American Negro Emancipation Centennial Authority, Rare Books and Manuscripts, Indiana State Library, Indianapolis.

12 Ibid.

13 Ibid.

14 "Unfinished Business: After 100 Years," n.d., S1506, box 1, folder 2, American Negro Emancipation Centennial Authority, Rare Books and Manuscripts, Indiana State Library, Indianapolis.

15 "ANECA: American Negro Emancipation Centennial Authority, Indianapolis Chapter," n.d., S1506, box 1, folder 1, American Negro Emancipation Centennial Authority, Rare Books and Manuscripts, Indiana State Library, Indianapolis.

16 Ibid.

17 Ibid.

18 Prior to founding the Laderson Players, Mose had organized two theatre troupes and starred in productions of plays like *Cry the Beloved Country*, *The Boy with a Cart*, and *Constrained by Love*.

19 "A Raisin in the Sun," *Playbill*, May 10–11, 1963, S1506, box 1, folder 1, American Negro Emancipation Centennial Authority, Rare Books and Manuscripts, Indiana State Library, Indianapolis.

20 Ibid.

21 Langston Hughes, "Harlem," in Lorraine Hansberry, *A Raisin in the Sun* (New York: Vintage 1995 (1959)).

22 Amiri Baraka, "A Critical Reevaluation: A Raisin in the Sun's Enduring Passion," in Hansberry, *A Raisin in the Sun*, 10.

23 Ibid., 11.

24 Frank Rich, "An Appreciation: A Raisin in the Sun, The 25th Anniversary," in Hansberry, *A Raisin in the Sun*, 7.

25 Hansberry, *A Raisin in the Sun*, 25.

26 Ibid.

27 Ibid., 59.

28 See, for example, GerShun Avilez, "Housing the Black Body: Value, Domestic Space, and Segregation Narratives," *African American Review* 42, no. 1 (2008), 135–147; and Rashad Shabazz, *Spatializing Blackness: Architectures of Confinement and Black Masculinity* (Urbana: University of Illinois Press, 2015).

29 Shabazz, *Spatializing Blackness*, 53.

30 Hansberry, *A Raisin in the Sun*, 27.

31 Ibid., 45–46.

32 Ibid., 45.

33 Ibid., 46.

34 Lee Edelman, *No Future: Queer Theory and the Death Drive* (Durham, NC: Duke University Press, 2004), 11.

35 Ibid.

36 Hansberry, *A Raisin in the Sun*, 73.

37 Hansberry, *A Raisin in the Sun*, 46.

38 Imani Perry, *Looking for Lorraine: The Radiant and Radical Life of Lorraine Hansberry* (Boston: Beacon, 2018), 98.

39 Hansberry, *A Raisin in the Sun*, 115.

40 Ibid.

41 Ibid.

42 Ibid., 117.

43 Ibid., 118.

44 Ibid., 117.

45 Ibid., 119.

46 Ibid., 116.

47 Ibid., 26.

48 Ibid.

49 Ibid.

50 Ibid., 99.

51 Ibid., 100.

52 Ibid., 102.

53 See William J. Maxwell, *F.B. Eyes: How J. Edgar Hoover's Ghostreaders Framed African American Literature* (Princeton, NJ: Princeton University Press, 2015), 103.

54 "A Simple Story: Triumph of Negro Pride," *London Times*, August 5, 1959.

55 See Saidiya V. Hartman, "The Time of Slavery," *South Atlantic Quarterly* 101, no. 4 (2002): 757–777.

56 Hartman, *Scenes of Subjection*, 116.

57 Wilderson, *Red, White and Black*, 58.

58 "ANECA: American Negro Emancipation Centennial Authority, Indianapolis Chapter."

59 "After 100 Years," *Indianapolis Star*, October 28, 1963, S1506, box 1, folder 2, American Negro Emancipation Centennial Authority, Rare Books and Manuscripts, Indiana State Library, Indianapolis.

60 Ibid.

61 "Indiana: A Century of Negro Progress Exhibition," 25–27 October 1963, S1506, Box 1 Folder 1, American Negro Emancipation Centennial Authority, Rare Books and Manuscripts, Indiana State Library, Indianapolis, IN.

62 Ibid.

63 During this widely publicized affair, Orval Faubus, who was then governor of Arkansas, denied nine black students entry to the racially segregated Little Rock Central High School. The Governor's actions provoked the US government to deploy the 101st Airborne Division of the US Army and to federalize the Arkansas National Guard in order to protect the "Little Rock Nine."

64 "Indiana: A Century of Negro Progress Exhibition."

65 Ibid.; emphasis added.

66 "Church Program," 10 February 1963, S1506, box 1, folder 1, American Negro Emancipation Centennial Authority, Rare Books and Manuscripts, Indiana State Library, Indianapolis.

67 "Duke Plans to Revive 'My People' Following Tour," *Jet*, January 16, 1964, 57.

68 Though unsuccessful, this attempted coup led to the establishment of the Progressive National Baptist Convention in November 1961, a group unabashedly more supportive of nonviolent direct action.

69 "Dickerson Replaces Dr. Jackson," *Jet*, August 22, 1963, 50.

70 Ibid.

71 Ibid.

72 Ibid.

73 "House Bill 1409," "One Hundred Years After: Biennial Report of the American Negro Emancipation Centennial Commission," April 1, 1963, Illinois Centennial Commission Papers, Abraham Lincoln Presidential Library.

74 "Davis' Great Lincoln Day Speech Thrills Champaign Audience," *The Crusader: Militant Voice of the People*, February 18, 1956.

75 Corneal A. Davis, "Speech to the Regional Council of Negro Leadership," 26 April 1957, M1968.0733, box 1, June 1957–1958, Corneal A. Davis Papers, Chicago History Museum.

76 Corneal A. Davis, *Memoir* (University of Illinois at Springfield), vol. 1, part 2, 141. It is worth noting that Davis was speaking to the RCNL, a radical civil rights group that had been founded in 1951 in the Mississippi Delta. Often referred to

as a "homegrown" NAACP, the organization intervened in social problems that ranged from police brutality to voter suppression.

77 James K. Polk to Corneal A. Davis, 23 February, 1961, M1968.0733, box 2, May–December 1961, Corneal A. Davis Papers, Chicago History Museum.

78 "One Hundred Years After: Biennial Report of the American Negro Emancipation Centennial Commission."

79 "Speech of Mrs. Edith S. Sampson," 21 September 1962, M1968.0733, box 2, May 1961–December 1962, Corneal A. Davis Papers, Chicago History Museum.

80 Ibid.

81 Ibid.

82 Ibid.

83 Ibid.

84 Hartman, *Scenes of Subjection*, 126

85 "McCormick Place: Showplace of the World," *Official Souvenir Program: A Century of Negro Progress*, August 16, 1963, Corneal A. Davis Papers, Chicago History Museum.

86 Albert N. Logan to Corneal A. Davis, July 6, 1962, M1968.0733, box 2, May 1961–December 1962, Corneal A. Davis Papers, Chicago History Museum.

87 Donald I. Foster to Corneal A. Davis, July 6, 1962, M1968.0733, box 2, May 1961–December 1962, Corneal A. Davis Papers, Chicago History Museum.

88 James W. Fitzpatrick to Corneal A. Davis, July 6, 1962, M1968.0733, box 2, May 1961–December 1962, Corneal A. Davis Papers, Chicago History Museum.

89 "27 Nations to Take Part In Negro Centennial," *Jet*, June 21, 1962.

90 "'Salute to Women' Planned for Negro Progress Exhibition," *Chicago Defender*, July 20, 1963.

91 "Progress Fair to Cite Negro Foreign Role," *Chicago Tribune*, August 29, 1963.

92 Ibid.

93 "Century of Negro Progress," *Jet*, August 29, 1963, 58; emphasis added.

94 "House Bill 1409," "One Hundred Years After: Biennial Report of the American Negro Emancipation Centennial Commission."

95 John F. Kennedy, welcome letter, *Official Souvenir Program: A Century of Negro Progress*, July 27, 1963, Corneal A. Davis Papers, Chicago History Museum.

96 James Farmer, *Lay Bare the Heart: An Autobiography of the Civil Rights Movement* (Fort Worth: Texas Christian University Press, 1985), 206.

97 Earl B. Dickerson, welcome letter, *Official Souvenir Program: A Century of Negro Progress*, August 16, 1963, Corneal A. Davis Papers, Chicago History Museum.

98 Ibid.

99 "The Crowds View Exposition," *Chicago Defender*, August 20, 1963.

100 Ibid.

101 John Franceschina, *Duke Ellington's Music for the Theatre* (Jefferson, NC: McFarland, 2001), 108.

102 Ibid.

103 Harvey Cohen, *Duke Ellington's America* (Chicago: University of Chicago Press, 2010), 383.

104 Ibid., 380.

105 Ibid.

106 Ibid., 398.

107 Ibid., 391 and 403.

108 Franceschina, *Duke Ellington's Music for the Theatre*, 108.

109 Cohen, *Duke Ellington's America*, 393.

110 Avilez, *Radical Aesthetics and Modern Black Nationalism*, 12.

111 Duke Ellington, "King Fit the Battle of Alabam," 1964, track 7 on *My People*, Contact Records, LP.

112 Erica Edwards, *Charisma and the Fictions of Black Leadership* (Minneapolis: University of Minnesota Press, 2012), 3.

113 Cohen, *Duke Ellington's America*, 393.

114 Ibid., 394.

115 Ibid., 382.

116 Mark Tucker, ed., *The Duke Ellington Reader* (New York: Oxford University Press, 1993), 1962.

117 Corneal A. Davis to De Lafayette Reed, June 14, 1962, M1968.0733, box 2, May 1961–December 1962, Corneal A. Davis Papers, Chicago History Museum.

118 De Lafayette Reed to Corneal A. Davis, June 27, 1962, M1968.0733, box 2, May 1961–December 1962, Corneal A. Davis Papers, Chicago History Museum.

119 Ibid.

120 Florence Nichol to Corneal A. Davis, July 11, 1962, M1968.0733, box 2, May 1961–December 1962, Corneal A. Davis Papers, Chicago History Museum.

121 Corneal A. Davis to Gertrude Gscheidle, July 13, 1962, M1968.0733, box 2, May 1961–December 1962, Corneal A. Davis Papers, Chicago History Museum.

122 Ibid.

123 Ibid.

124 Gertrude Gscheidle to Corneal A. Davis, July 16, 1962, M1968.0733, box 2, May 1961–December 1962, Corneal A. Davis Papers, Chicago History Museum.

125 Ibid.

126 Sharpe, *In the Wake*, 113.

127 Taylor, *The Archive and the Repertoire*, 2.

128 Cohen, *Duke Ellington's America*, 382.

129 Ibid.

130 Duke Ellington, "My People," 1964, track 5 on *My People*, Contact Records, LP.

131 Ibid.

132 Mitchell, *Living With Lynching*.

133 Cohen, *Duke Ellington's America*, 380.

134 See Kelley, *Freedom Dreams*, 11.

135 Corneal A. Davis to ANECA Trustees, June 1962, M1968.0733, Box 2, May 1961-December 1962, Corneal A. Davis Papers, Chicago History Museum.

136 Ibid.

137 "A Summary of Agreement Between the Commission and ANECA to Correct Objections to the Constitution and Other Documents," n.d., M1968.0733, box 2, May 1961–December 1962, Corneal A. Davis Papers, Chicago History Museum.

138 Ibid.

139 Corneal A. Davis to Samuel Stratton, November 5, 1962, M1968.0733, box 2, May 1961–December 1962, Corneal A. Davis Papers, Chicago History Museum.

140 Corneal A. Davis to John O'Neal, June 13, 1962, box 1, folder 3, John O'Neal Papers. Amistad Research Center, Tulane University, New Orleans.

141 Ibid.

142 "Corneal A. Davis Interview and Memoir," 1979 and 1982, Archives/Special Collections, Norris L. Brookens Library, University of Illinois at Springfield, Springfield, Illinois, 12, www.idaillinois.org.

143 Jarvis C. McInnis, "'Behold the Land': W. E. B. Du Bois, Cotton Futures, and the Afterlife of the Plantation in the US South," *Global South* 10, no. 2 (2016), 70–98.

2. BLACK TIME, BLACK GEOGRAPHY

1 William Faulkner, "A Letter to the North." *Life*, March 5, 1956, 51–52.

2 Legal scholar Charles Ogletree notes that when civil rights lawyers consulted the dictionary to uncover the meaning of "all deliberate speed," they concluded that the Court's phrase meant slow. Charles Ogletree, *All Deliberate Speed: Reflections on the First Half Century of Brown v. Board of Education* (New York: W. W. Norton, 2004), 299; Faulkner, "A Letter to the North."

3 John Oliver Killens, "How Long is a Moment, Mr. Faulkner?: A Letter to William Faulkner and His Middle Grounders," box 56, folder 7, John Oliver Killens Papers, Stuart A. Rose Manuscript, Archives, and Rare Book Library, Emory University, Atlanta.

4 John Oliver Killens, "How Long is a Moment, Mr. Faulkner?: A Letter to William Faulkner and His Middle Grounders."

5 John Oliver Killens, *'Sippi* (New York: Trident Press, 1967), ix.

6 Ibid.

7 Ibid, vi.

8 McKittrick, "Plantation Futures," 4.

9 Killens, *'Sippi*, xii.

10 Ibid., xiii.

11 Ibid.

12 I borrow the term "black-south body" from literary critic Houston Baker. See Houston A. Baker Jr., *Turning South Again: Re-thinking Modernism/Re-reading Booker T.* (Durham, NC: Duke University Press, 2001).

13 Killens, *'Sippi*, viii.

14 Albert Murray and John F. Callahan, *Trading Twelves: The Selected Letters of Ralph Ellison and Albert Murray* (New York: Vintage, 2000), 117.

15 See James Baldwin, "Faulkner and Desegregation," *Partisan Review*, Fall 1956, 23, 568–573; and Lola Jones Amis, "The New Nigger, or Who's Afraid of William Faulkner," 1975, box 1, folder 7, Camille Billops and James V. Hatch Collection, Emory University, Atlanta, GA.

16 Glenford E. Mitchell and William H. Peace III, *The Angry Black South: Southern Negroes Tell Their Own Story* (New York: Corinth, 1962), 1.

17 Ibid., 27.

18 Ibid., 143.

19 Lerone Bennett Jr., "Of Time Space and Revolution: Historian Assesses the State of Black Rebellion at the Crossroads," *Ebony*, August 1969, 31–39.

20 "Free Southern Theater Acting Brochure: Interested?" box 33, folder 2, Free Southern Theater Papers, 1960–1978, Amistad Research Center, Tulane University, New Orleans.

21 John O'Neal, "Motion in the Ocean: Some Political Dimensions of the Free Southern Theater," *The Drama Review* 12, no. 4 (1968): 71.

22 Ibid.

23 Ibid.

24 Ibid.

25 "A General Prospectus for the Establishment of a Free Southern Theater."

26 Ibid.

27 "Special Report on the Free Southern Theater," 1964, box 52, folder 2, Free Southern Theater Papers, 1960–1978, Amistad Research Center, Tulane University, New Orleans.

28 The Free Southern Theater's relationship to the Civil Rights Movement remained an open question. Even the theatre's members harbored shifting opinions on the question, sometimes seeing the theatre as a part of the movement and other times not.

29 Holsaert, Noonan, Richardson, Robinson, Young, and Zellner, *Hands on the Freedom Plow*, 259.

30 Ibid.

31 According to Schechner, "SNCC was part and parcel of the theater. That's how we got our contacts and venues, knew where to go when we came into a town, who to see to help us get established. This was not like a conventional touring show; we needed to be immediately welcomed into the community. We needed safe places, especially since we were blacks and whites, men and women, traveling together. Without the movement we wouldn't have had the physical wherewithal. And then ideologically, the movement gave us a goal, a way of choosing our repertory." See Jan Cohen-Cruz, "Comforting the Afflicted and Afflicting the Comfortable: The Legacy of the Free Southern Theater," in *Restaging the Sixties: Radical Theaters and Their Legacies*, ed. James M. Harding and Cindy Rosenthal (Ann Arbor: University of Michigan Press, 2006), 289.

32 Annemarie Bean, "The Free Southern Theater: Mythology and the Moving between Movements," in Harding and Rosenthal, *Restaging the Sixties*, 272.

33 Ibid.

34 "Free Southern Theater Acting Brochure: Interested?"

35 See "Doors of Tougaloo Open for Inspection," *Hattiesburg American*, February 18, 1964 ("hangout"); "Offer Bill to Revoke Charter of Tougaloo," *Hattiesburg American*, February 20, 1964 ("so called").

36 "Free Southern Theater Acting Brochure: Interested?"

37 Ibid., 1.

38 Ibid.

39 "Mississippi Burning," Federal Bureau of Investigation, vault.fbi.gov.

40 "Free Southern Theater Acting Brochure: Interested?"

41 Ibid., 1.

42 Dent, Moses, and Schechner, *The Free Southern Theater by the Free Southern Theater*, 35.

43 Holsaert, Noonan, Richardson, Robinson, Young, and Zellner, *Hands on the Freedom Plow*, 260.

44 Dent, Moses, and Schechner, *The Free Southern Theater by the Free Southern Theater*, 26.

45 Ibid., 86.

46 Ibid., 87.

47 Raiford, *Imprisoned in a Luminous Glare*, 70.

48 Ibid., 110.

49 "A General Prospectus for the Establishment of a Free Southern Theater."

50 Ibid.

51 Farai Chideya and Denise Nicholas, "Author Denise Nicholas, 'Freshwater Road,'" *NPR*, October 11, 2005, www.npr.org.

52 Gilbert Moses, John O'Neal, Denise Nicholas, Murray Levy, and Richard Schechner, "Dialogue: The Free Southern Theater," *Tulane Drama Review* 9, no. 4 (1965): 68.

53 Penny Hartzell Journal, December 9, 1964, Richard Schechner Papers and The Drama Review Collection, Princeton University Library, Princeton, NJ.

54 Moses, O'Neal, Nicholas, Levy, and Schechner, "Dialogue: The Free Southern Theater," 68.

55 Ibid.

56 Martin B. Duberman, *In White America* (Boston: Houghton Mifflin, 1964), 2.

57 Ibid., 4.

58 Ibid., 4.

59 Ibid., 5.

60 Stephanie E. Smallwood, *Saltwater Slavery: A Middle Passage from Africa to American Diaspora* (Cambridge, MA: Harvard University Press, 2007), 7.

61 Duberman, *In White America*, 66.

62 Ibid., 68–69.

63 Nicholas, "A Grand Romantic Notion," 259.

64 Nina Simone, "Mississippi Goddam," 1964, track 7 on *Nina Simone in Concert*, Philips, LP.

65 See Hartman, *Scenes of Subjection*.

66 Nina Simone, *I Put a Spell on You* (Cambridge, MA: Da Capo Press, 1991), 88–90.

67 Ibid., 89–90.

68 Malcolm X, *Malcolm X Speaks: Selected Speeches and Statements*, ed. George Breitman (New York: Grove Press, 1965), 90.

69 Ibid., 479.

70 Fanon, *Black Skin, White Masks*, 91.

71 Constructions of the South as a distinctively problematic region are often an exercise in "imaginative geography"—that is, a practice of "designating in one's mind a familiar space which is 'ours' and an unfamiliar space beyond 'ours' which is 'theirs.'" Edward Said, *Orientalism* (New York: Vintage, 1978), 54–55.

72 Houston A. Baker and Dana D. Nelson, "Preface: Violence, the Body, and 'The South,'" *American Literature* 73, no. 2 (2001): 236.

73 Robin Bernstein, *Racial Innocence: Performing American Childhood from Slavery to Civil Rights* (New York: NYU Press, 2011), 11–12.

74 Katherine McKittrick, *Demonic Grounds: Black Women and the Cartographies of Struggle* (Minneapolis: University of Minnesota, 2006), ix.

75 For geographer Nigel Thrift, the time-geographic approach is a "concerted attack on the kind of thought process which thinks time and space equals physics rather than time and space equals society." In other words, time and space are social resources. See Torsten Hägerstrand, "What about People in Regional Science?" *Papers in Regional Science* 24, no. 1 (1970): 7–24.

76 Ibid., 4.

77 Ibid., 14.

78 McKittrick, *Demonic Grounds*, xii.

79 Thadious M. Davis, *Southscapes: Geographies of Race, Region, and Literature* (Chapel Hill: University of North Carolina Press, 2011), 77.

80 See Sarah Jane Cervenak and J. Kameron Carter, "Untitled and Outdoors: Thinking with Saidiya Hartman," *Women & Performance: a journal of feminist theory* 27, no. 1 (2017): 45–55. For Cervenak and Carter, who borrow this concept from Toni Morrison, the black outdoors is a space of alterity, a place outside of home, a place that is "unmoored from the certitude of its location and locution." But outdoors is also a site of otherwise possibility, particularly for forging alternative modes of ecological relation, whether in the grove, the clearing, or—for the purposes of this chapter—in the cotton field of a former plantation during a theatrical production.

81 Elizabeth Sutherland, "Theatre of the Meaningful," *The Nation*, October 19, 1964, 254.

82 Ibid.

83 Ibid.

84 Dent, Moses, and Schechner, *The Free Southern Theater by the Free Southern Theater*, xii.

85 Ibid.

86 Ibid., 17.

87 Ibid., 63.

88 See Davis, *Southscapes*, 81; Trudier Harris, *The Power of the Porch: The Storyteller's Craft in Zora Neale Hurston, Gloria Naylor, and Randall Kenan* (Athens: University of Georgia Press, 1996), xii; and Zora Neale Hurston, "How It Feels to Be Colored Me," in *I Love Myself When I Am Laughing . . . and Then Again: A Zora Neale Hurston Reader*, ed. Alice Walker (New York: Feminist Press at the City University of New York, 1979), 49.

89 According to bell hooks, sites of "radical openness" are spaces that enable an opportunity to "redeem and reclaim the past, legacies of pain, suffering, and triumph in ways that transform present reality." bell hooks, *Yearning: Race, Gender, and Cultural Politics* (Cambridge, MA: South End Press, 1990), 147.

90 Baker, *Turning South Again*.

91 Bruno Latour, *We Have Never Been Modern* (Cambridge, MA: Harvard University Press, 1993), 82.

92 Mark M. Smith, *Mastered by the Clock: Time, Slavery, and Freedom in the American South* (Chapel Hill: University of North Carolina Press, 1997), 2–5.

93 Nina Simone, "Mississippi Goddam."

94 Shabazz, *Spatializing Blackness*, 1.

95 Langston Hughes, *Simple's Uncle Sam* (New York: Hill and Wang, 1993 (1965)), 143.

96 Simone, *I Put a Spell on You*, 89–90.

97 As scholarship on race and leisure has demonstrated, slaves were given limited amounts of time for black leisure. But this time was often filled with personal chores like gardening and washing and was often under surveillance. See, for example, Jearold W. Holland, *Black Recreation: A Historical Perspective* (Chicago: Burnham, 2002); Stephanie M. H. Camp, *Closer to Freedom: Enslaved Women and Everyday Resistance in the Plantation South* (Chapel Hill: University of North Carolina Press, 2004); and Stephanie Batiste's discussion of "the availability of leisure" in *Darkening Mirrors: Imperial Representation in Depression-Era African American Performance* (Durham, NC: Duke University Press, 2011), 32.

98 Vogel, *Stolen Time*, 11.

99 Dent, Moses, and Schechner, *The Free Southern Theater by the Free Southern Theater*, 63.

100 Fannie Lou Hamer, "I'm Sick and Tired of Being Sick and Tired," in Meagan Parker Brooks and Davis W. Houck, eds., *The Speeches of Fannie Lou Hamer: To Tell It Like It Is* (Jackson: University of Mississippi Press, 2011 (1964)), 58.

101 Ossie Davis, *Purlie Victorious* (New York City: Samuel French, 1961), 3; emphasis added.

102 Ibid., 5; emphasis added.

103 Ibid.

104 Ibid., 6.

105 Ibid., 9.

106 Ibid., 8–9.

107 Ibid., 80.

108 Dent, Moses, and Schechner, *The Free Southern Theater by the Free Southern Theater*, 52–53.

109 Ibid., 55.

110 Ibid., 55.

111 Nicholas, "A Grand Romantic Notion," 263.

112 McInnis, "'Behold the Land,'" 74.

113 I make this claim while keeping in mind the prescient reminder from scholars like Saidiya Hartman that leisure itself has often been a site of anti-black violence. Detailing "slaveholders' managing of black 'leisure,'" Hartman explains that the "orchestrated amusements of the enslaved" worry the "distinction between joy and sorrow and toil and pleasure." Recognizing the afterlives of these dynamics, I do not offer up the time of black leisure as a temporal structure that exists outside of power and ideology. See Hartman, *Scenes of Subjection*, 45, 36.

114 Newsletter, September 1964, box 91, folder 9, Free Southern Theater Papers, 1960–1978, Amistad Research Center, Tulane University, New Orleans.

115 Beckett, *Waiting for Godot*, 1.

116 Ibid., 6.

117 Ibid., 2.

118 When the play opened on January 3, 1956, at the Coconut Grove Playhouse in Miami, Florida, for example, nearly half of the audience walked out before the performance concluded.

119 Dent, Moses, and Schechner, *The Free Southern Theater by the Free Southern Theater*, 53.

120 Notes on Godot, November 17, 1964, notebook 1, folder 174.5, Richard Schechner Papers and The Drama Review Collection, Princeton University Library, Princeton, NJ.

121 Notes on Godot, December 7, 1964, notebook 1, folder 174.5, Richard Schechner Papers.

122 Notes on Godot, November 26, 1964, notebook 1, folder 174.5, Richard Schechner Papers.

123 Dent, Moses, and Schechner, *The Free Southern Theater by the Free Southern Theater*, 53.

124 Ibid.

125 Ibid.

126 Penny Hartzell Journal, November 29, 1964, Richard Schechner Papers and The Drama Review Collection, Princeton University Library, Princeton, NJ.

127 Beckett, *Waiting for Godot*, 70.

128 Tom Dent and Jerry W. Ward, "After the Free Southern Theater: A Dialog," *The Drama Review* 31, no. 3 (1987), 120–125.

129 Ibid., 120.

130 Ibid., 121.

131 Ibid., 124.

132 The very nature of performance has been a point of serious discussion throughout performance studies discourses. See, for example, Taylor, *The Archive and the Repertoire*; and Phelan, *Unmarked*.

133 Ibid., 27

134 Like Ward and Dent, O'Quinn dates the death of the Free Southern Theater much earlier than its funeral.

3. BLACK QUEER TIME AND THE EROTICS OF THE CIVIL RIGHTS BODY

1 As Baraka's politics began to align more with black cultural nationalism and the Black Arts Movement, he changed his name from LeRoi Jones to Amiri Baraka.

2 Anthony D. Hill and Douglas Q. Barnett, *The A to Z of African American Theater* (Lanham, MD: The Scarecrow Press, 2009), 238.

3 Lorde, "Uses of the Erotic: The Erotic as Power," 89.

4 Moten, "The Case of Blackness," 179.

5 Amiri Baraka, *The Autobiography of Amiri Baraka* (Chicago: Lawrence Hill, 1984), 251.

6 Federal Bureau of Investigation, Everett L. Jones, SAC Newark, April 25, 1958, 13.

7 "A Poet Laments Time Lost in a Courthouse," *New York Post*, October 19, 1961.

8 Aaron Henry with Constance Curry, *Aaron Henry: The Fire Ever Burning* (Jackson: University Press of Mississippi, 2000), 122.

9 *Henry v. State*, 253 Miss. 263 (1963).

10 Lorde, "Uses of the Erotic: The Erotic as Power," 88.

11 Ibid., 89.

12 For excellent work on black leadership, see, for example, Edwards, *Charisma and the Fictions of Black Leadership*; and Robert J. Patterson, *Exodus Politics: Civil Rights and Leadership in African American Literature and Culture* (Charlottesville: University of Virginia Press, 2013).

13 Carla Freccero, "Theorizing Queer Temporalities: A Roundtable Discussion," *GLQ: A Journal of Lesbian and Gay Studies* 13, no. 1 (2007): 193.

14 Bayard Rustin, *I Must Resist: Bayard Rustin's Life in Letters*, ed. Michael G. Long (San Francisco: City Lights Books, 2012), 155.

15 Dana Luciano, *Arranging Grief: Sacred Time and the Body in Nineteenth-Century America* (New York: NYU Press, 2007), 9.

16 As Kobena Mercer and Isaac Julien have observed, the "prevailing Western concept of sexuality already contains racism" ("Race, Sexual Politics, and Black Masculinity: A Dossier," in *Male Order: Unwrapping Masculinity*, ed. Rowena Chapman and Jonathan Rutherford (London: Lawrence and Wishart, 1988), 106. Or as literary critic Aliyyah Abdur-Rahman puts it, "not only does sexuality fundamentally underlie racial logics, but . . . racial identity is itself conceived, regulated, and disciplined through sexuality." Aliyyah I. Abdur-Rahman, *Against the Closet: Black Political Longing and the Erotics of Race* (Durham, NC: Duke University Press, 2012), 2.

17 For excellent engagements with these histories, see Abdur-Rahman, *Against the Closet*; and Siobhan B. Somerville, *Queering the Color Line: Race and the Invention*

of Homosexuality in American Culture (Durham, NC: Duke University Press, 2000).

18 Robyn Wiegman, *American Anatomies: Theorizing Race and Gender* (Durham, NC: Duke University Press, 1995), 96.

19 Marlon B. Ross, *Manning the Race: Reforming Black Men in the Jim Crow Era* (New York: NYU Press, 2004), 5.

20 See Edwards, *Charisma and the Fictions of Black Leadership*.

21 Ibid., 20.

22 See, for example, Heather Love, *Feeling Backward: Loss and the Politics of Queer History* (Cambridge, MA: Harvard University Press, 2007); Julia Kristeva, *Powers of Horror: An Essay on Abjection* (New York: Columbia University Press, 1982); Darieck Scott, *Extravagant Abjection: Blackness, Power, and Sexuality in the African American Literary Imagination* (New York: NYU Press, 2010); and Kathryn Bond Stockton, *Beautiful Bottom, Beautiful Shame: Where "Black" Meets "Queer"* (Durham, NC: Duke University Press, 2006), 24.

23 Elizabeth Freeman, "Introduction," *GLQ: A Journal of Lesbian and Gay Studies* 13, no. 2–3 (2007): 164.

24 For civil rights histories that engage the sexual politics of civil rights activism, see, for example, Danielle L. McGuire, *At the Dark End of the Street: Black Women, Rape, and Resistance—A New History of the Civil Rights Movement from Rosa Parks to the Rise of Black Power* (New York: Vintage, 2010); Rosalind Rosenberg, *Jane Crow: The Life of Pauli Murray* (New York: Oxford University Press, 2017); John D'Emilio, *Lost Prophet: The Life and Times of Bayard Rustin* (New York: Free Press, 2003); and John Howard, *Men Like That: A Southern Queer History* (Chicago: University of Chicago Press, 1999).

25 Howard, *Men Like That*, 161.

26 Henry, *Aaron Henry: The Fire Ever Burning*, 124–125.

27 Sigmund Freud, *Civilization and Its Discontents* (New York: Penguin, 2004 (1930)).

28 Robert Allen, "An Interview with LeRoi Jones," in *Conversations with Amiri Baraka*, ed. Charlie Reilly (Jackson: University Press of Mississippi, 1994), 20.

29 Judy Stone, "If It's Anger . . . Maybe That's Good: An Interview with LeRoi Jones," in *Conversations with Amiri Baraka*, 11.

30 Debra L. Edwards, "An Interview with Amiri Baraka," in *Conversations with Amiri Baraka*, 153.

31 William J. Harris, "An Interview with Amiri Baraka," in *Conversations with Amiri Baraka*, 173.

32 Jerry Tallmer, "LeRoi Jones Strikes Again," *New York Post*, March 24, 1964.

33 Langston Hughes and Milton Meltzer, *Black Magic: A Pictorial History of the African-American in the Performing Arts* (Englewood Cliffs, NJ: Prentice-Hall, 1967), 251.

34 Emphasis added.

35 See E. Patrick Johnson, *Appropriating Blackness: Performance and the Politics of Authenticity* (Durham, NC: Duke University Press, 2003), 61.

36 Amiri Baraka, *The System of Dante's Hell* (New York: Akashic Classics, 2016 (1965)), 84.

37 Ibid., 85.

38 Ibid.

39 Ibid., 86.

40 Alexis Lothian, *Old Futures: Speculative Fiction and Queer Possibility* (New York: NYU Press, 2018).

41 Muñoz, *Cruising Utopia*, 11.

42 Ibid., 11-12.

43 Ibid., 1; emphasis added.

44 Ibid., 11.

45 Ibid.

46 Nadia Ellis, *Territories of the Soul: Queered Belonging in the Black Diaspora* (Durham, NC: Duke University Press, 2015), 3.

47 Baraka, *The System of Dante's Hell*, 88.

48 Ibid.

49 Ibid., 89.

50 Ibid., 91.

51 Ibid., 90.

52 Ibid., 91.

53 Ibid.

54 Ibid., 91–92.

55 Ibid., 92–93.

56 Ibid., 86.

57 Stone, "If It's Anger . . . Maybe That's Good: An Interview With LeRoi Jones," 2.

58 "Theater: An Angry Man," *New York Times*, December 17, 1964.

59 Amiri Baraka, *The Baptism and The Toilet* (New York: Grove Press, 1967), 47.

60 Ibid., 50–51.

61 Ibid., 52

62 Ibid.

63 Ibid.

64 Ibid., 60.

65 Ibid.

66 The technique of doubling that frames the dramatic tension between Ray and Foots is a key dimension of Jones's queer aesthetics. Doubling serves, for Jones, as a method for mapping the complexities of sexual desire and a means of indexing how society regulates and suppresses these desires. Foots, to be sure, is not the only member of the gang who possesses two names and who exhibits the layered forms of erotic desire Jones's technique of doubling comes to signify. Rather, he shares these qualities and behaviors with Ora, who, like himself, exudes attach-

ments to same-sex desire but cannot, in the final analysis, linger in these yearnings or openly embrace possibilities for queer futures.

67 Baraka, *The Baptism and The Toilet*, 35.

68 Baraka, *The Baptism and The Toilet*, 62.

69 Ibid., 52; emphasis added.

70 Ibid.; emphasis added.

71 Ibid., 62; emphasis added.

72 See, for example, Muñoz, *Cruising Utopia*.

73 Whatever the complexities of Jones's memory, *The Toilet* was, without question, a deeply personal play for the artist. In an interview with Judy Stone, he recalls that the play "came so much out of [his] memory, so exact." Written in only six hours, the play's swift creation accords with the political aesthetics of speed characterizing black expressive and political cultures in this era—whether demands for "freedom now" or Nina Simone's hasty production of "Mississippi Goddam," which was written in just an hour. See Stone, "If It's Anger . . . Maybe That's Good: An Interview with LeRoi Jones," 10.

74 See Mel Watkins, "Talk with Leroi Jones," *New York Times Book Review*, June 27, 1971, 26.

75 Ibid.

76 Ibid.

77 Fuller, "About the Toilet and the Slave," 49–50.

78 Ibid., 49.

79 "'Jones' Play, 'The Toilet' Shocker, if Nothing Else," *New Journal and Guide*, January 30, 1965.

80 *Los Angeles Times*, March 4, 1965: "2 Plays Slated for Las Palmas. -The Los Angeles Times and the Hollywood Citizens-News had decided that they would no longer accepts ads for the plays." The Comstock Act was enacted March 3, 1873. It was an "Act of the Suppression of Trade in, and circulation of, Obscene Literature and Articles of Immoral Use." Anthony Comstock was a social reformer and worked with the New York Society for the Suppression of Vice, and lobbied Congress for stricter federal obscenity laws.

81 There were preview performances of *The Toilet* the Friday before opening night starting at 8:30. "Previews Slated for Two Jones Plays," *Los Angeles Times*, March 18, 1965.

82 "L.A. Vice Squad Closes 2 LeRoi Jones Plays," *New York Amsterdam News*, April 3, 1965.

83 "'Harassment' Hurts Le Roi Jones Plays," *New York Times*, April 6, 1965.

84 "Concept-East Director Terms Vice Squad Ticketing of *The Slave* and *The Toilet* Pretentious Piety," *Black World/Negro Digest*, April 1967, 91.

85 Ibid.

86 Ibid.

87 William Barrow, "Introducing the Concept," *Black World/Negro Digest*, May 1963, 76–79.

88 Baraka, *The Baptism and The Toilet*, 32.

89 Ibid.

90 Ibid., 30.

91 Ibid., 31.

92 Austin Clarke, "An Interview with Leroi Jones," in *Conversations with Amiri Baraka*, 36.

93 Baraka, *The Baptism and The Toilet*, 11.

94 Ibid.

95 Ibid.

96 Ibid.

97 Ibid., 12.

98 Ibid., 9.

99 Ibid., 13.

100 Ibid.

101 Ibid.

102 Ibid.

103 Ibid., 15–19.

104 Ibid., 20.

105 Ibid., 29.

106 Ibid., 17–23.

107 Ibid., 12.

108 Ibid., 15–17.

109 Ibid., 15.

110 Ibid., 16.

111 Ibid., 22.

112 Ibid., 19.

113 Hill and Barnett, *The A to Z of African American Theater*, 238.

114 In my interview with Harrison, he says the march began with approximately 30 participants. In his unpublished memoir in progress, he says a dozen. Paul Carter Harrison, *Don't Woke Him, Let Him Slept: A Vamp on the American Wet Dream*, collection of Paul Carter Harrison.

115 Ibid.

116 Ibid.

117 Ibid.

118 Ibid.

119 Ibid.

120 Ibid.

121 Steven R. Carter, "Paul Carter Harrison," in *Afro-American Writers After 1955: Dramatists and Prose Writers*, ed. Thadious M. Davis and Trudier Harris, vol. 38 of *Dictionary of Literary Biography* (Detroit: Gale Research, 1985), 134–139.

122 Paul Carter Harrison in discussion with the author, October 2015.

123 Paul Carter Harrison, *The Experimental Leader*, box 13, folder 9, MCN 927, Paul Carter Harrison Papers, Hatch/Billops Collection, Manuscript and Rare Book Library, Emory University Libraries, Atlanta.

124 Ibid., 8.
125 Ibid., 9.
126 Ibid.
127 Ibid., 10.
128 Ibid., 13.
129 Ibid., 15.
130 Ibid., 16.
131 Ibid., 18.
132 Ibid., 15.
133 Ibid.
134 Ibid., 19.
135 Ibid.
136 Ibid., 20.
137 Ibid., 21.
138 Ibid., 23.
139 Ibid., 24.
140 Ibid., 25.
141 Ibid., 25–26.
142 Ibid., 26.
143 Ibid., 29; emphasis added.
144 Ibid., 35.
145 Ibid., 35–37
146 Ibid., 37

4. PICTURING WHITE IMPATIENCE

1 Roland Barthes, *Camera Lucida: Reflections on Photography* (New York: Hill and Wang, 1981), 43.
2 Ibid.
3 According to visual theorist Nicholas Mirzoeff, countervisuality is "the means by which one tries to make sense of the unreality created by visuality's authority from the slave plantation to fascism and the war on terror." In addition to "proposing a real alternative," countervisuality is "the attempt to reconfigure visuality as a whole." See Nicholas Mirzoeff, *The Right to Look: A Counterhistory of Visuality* (Durham, NC: Duke University Press, 2011), 5–24.
4 "The Play's the Thing," *Black World/Negro Digest*, July 1964, 50.
5 Reckless eyeballing laws have historically aimed to regulate how black subjects can look at their white counterparts. Under these conditions, certain ways of looking at white people are unlawful and constitute criminal acts.
6 James Baldwin, *The Fire Next Time* (New York: Vintage, 1963), 10.
7 Daphne Brooks, *Bodies in Dissent: Spectacular Performances of Race and Freedom* (Durham, NC: Duke University Press, 2006), 5
8 W. J. T. Mitchell, *What Do Pictures Want: The Lives and Loves of Images* (Chicago: University of Chicago Press, 2005), 345.

9 Edwards, *Charisma and the Fictions of Black Leadership*, 107.

10 Nicholas Mirzoeff, "On visuality," *Journal of Visual Culture* 5, no. 1 (2006): 54.

11 Elin Diamond, *Unmaking Mimesis* (New York: Routledge, 1997): 52.

12 Edwards, *Charisma and the Fictions of Black Leadership*, 107.

13 Maaike Bleeker, *Visuality in the Theatre: The Locus of Looking* (New York: Macmillan, 2008), 3.

14 *Chicago Sun-Times* quoted in Timothy B. Tyson, *The Blood of Emmett Till* (New York: Simon and Schuster, 2017), 71.

15 Moten, *In the Break*, 198–199.

16 Maurice O. Wallace and Shawn Michelle Smith, eds., *Pictures and Progress: Early Photography and the Making of African American Identity* (Durham, NC: Duke University Press, 2012), 4.

17 *Brown v. Board of Education*, 347 U.S. 483 (1954).

18 Jayna Brown, *Babylon Girls: Black Women Performers and the Shaping of the Modern* (Durham, NC: Duke University Press, 2008), 73.

19 Fleetwood, *Troubling Vision*, 3.

20 See, for example, Hartman, *Scenes of Subjection*; Brown, *Babylon Girls*; and Abel, *Signs of the Times*.

21 Hartman. *Scenes of Subjection*, 3

22 Langston Hughes, *The Ways of White Folks: Stories* (New York: Vintage, 1933).

23 Lorraine Hansberry, *Les Blancs*, in *Les Blancs: The Collected Last Plays of Lorraine Hansberry*, ed. Robert Nemiroff (New York: Vintage, 1972), 42; original emphasis.

24 Ibid., 96; original emphasis.

25 Ibid., 91.

26 Ibid., 164; original emphasis

27 Fatimah Tobing Rony, *The Third Eye: Race, Cinema, and Ethnographic Spectacle* (Durham, NC: Duke University Press, 1996), 213.

28 Childress, *Trouble in Mind*, 108.

29 James Baldwin, *Blues for Mister Charlie* (New York: Vintage, 1964), xiii.

30 Childress, *Trouble in Mind*, 108–109.

31 Ibid., 111.

32 See, for example, Kathlene McDonald, *Feminism, the Left, and Postwar Literary Culture* (Jackson: University of Mississippi Press, 2012); Mary Helen Washington, "Alice Childress, Lorraine Hansberry, and Claudia Jones: Black Women Write the Popular Front," in *Left of the Color Line* (Chapel Hill: University of North Carolina Press, 2003); Donna Lisker, "Controversy Only Means Disagreement: Alice Childress's Activist Drama," in *Southern Women Playwrights: New Essays in Literary History and Criticism* (Tuscaloosa: University of Alabama Press, 2002); E. Barnsley Brown, "Celebrating the (Extra)Ordinary: Alice Childress's Representation of Black Selfhood," in *Black Women Playwrights: Visions on the American Stage*, ed. Carol P. Marsh-Lockett (New York: Garland, 1999); and La Vinia Delois Jennings, *Alice Childress* (New York: Macmillan, 1995).

33 Joseph Roach, *Cities of the Dead: Circum-Atlantic Performance* (New York: Columbia University Press, 1996), 2.

34 Alice Childress, "A Candle in the Gale Wind," in *Black Women Writers: Arguments and Interviews*, ed. Mari Evans (London: Pluto, 1985), 112.

35 John H. Johnson, "Publisher's Statement," *The White Problem in America* (Chicago: Johnson, 1966), 3.

36 Fleetwood, *Troubling Vision*, 7.

37 Raymond Barthes, "Interview," in *Conversations with Richard Wright*, ed. Kenneth Kinnamon and Michel Fabre (Jackson: University of Mississippi Press, 1993), 167.

38 Martin Luther King Jr., "The Role of the Behavioral Scientist in the Civil Rights Movement," *American Psychological Association*, September 2011 (1967), www.apa.org.

39 Baldwin, *Blues for Mister Charlie*, 2.

40 Hartman, *Scenes of Subjection*.

41 Baldwin, *Blues for Mister Charlie*, xiv.

42 Ibid.

43 Ibid.

44 Ibid.

45 Ibid., 10; original emphasis.

46 James Baldwin, "Theater: The Negro In and Out," in *The Cross of Redemption: Uncollected Writings*, ed. Randall Kenan (New York: Vintage, 2010), 23.

47 Ibid.

48 Baldwin, *Blues for Mister Charlie*, xiv.

49 Ibid., 3.

50 Elin Diamond, *Unmaking Mimesis* (New York: Routledge, 1997), 52.

51 Shawn Michelle Smith, *Photography on the Color Line: W. E. B. Du Bois, Race, and Visual Culture* (Durham, NC: Duke University Press, 2004), 126.

52 As Nicole Fleetwood reminds us, "the visual sphere is a performative field where seeing race is not a transparent act; it is itself a 'doing.'" *Troubling Vision*, 7.

53 Baldwin, "Theater: The Negro In and Out," 23.

54 Howard Taubman, "Theater: Blues for Mister Charlie," *New York Times*, April 24, 1964.

55 bell hooks, *Black Looks: Race and Representation* (New York: Routledge, 2015), 168–69.

56 James Baldwin, "The White Problem," in *The Cross of Redemption*, 95.

57 Mia Bay, *The White Image in the Black Mind: African American Ideas About White People*, 1830–1925 (New York: Oxford, 2000).

58 Philip Roth, "Channel X: Two Plays on the Race Conflict," *New York Review of Books*, May 28, 1964, 1.

59 Ibid., 3.

60 hooks, *Black Looks*.

61 Roth, "Channel X: Two Plays on the Race Conflict," 5.

62 Daphne Brooks, *Bodies in Dissent*, 6. Brooks is quoting Ali Behdad, *Belated Travelers: Orientalism in the Age of Colonial Dissolution* (Durham: Duke University Press, 1994), 13.

63 Ibid., 10.

64 Ibid.

65 Ibid., 2.

66 Carol Anderson, *White Rage: The Unspoken Truth of Our Racial Divide* (New York: Bloomsbury, 2016), 2–3.

67 For an excellent study of the history of such problematic modes of response among white audience members, see Marvin E. McAllister, *White People Do Not Know How to Behave at Events Designed for Ladies and Gentlemen of Color* (Chapel Hill: University of North Carolina Press, 2013).

68 David Leeming, *Baldwin: A Biography* (New York: Knopf, 1994), 199.

69 Amiri Baraka, *Eulogies* (New York: Marsilio Publishers, 1996), 96.

70 James Campbell, *Talking at the Gates: A Life of James Baldwin* (Berkeley: University of California Press, 1991), 195.

71 Nat Hentoff, "'It's terrifying,' James Baldwin: The Price of Fame," *New York Herald Tribune*, June 16, 1963.

72 Campbell, *Talking at the Gates*, 194.

73 Ibid.

74 Ibid.

75 Ibid., 195.

76 "Blues for Mister Charlie," *Ebony*, June 1964, 193.

77 Ibid.

78 Campbell, *Talking at the Gates*, 209.

79 Ibid., 212.

80 Ibid., 197.

81 Ibid., 198.

82 Stephen M. Vallillo, "Douglas Turner Ward," in *Afro-American Writers After 1955: Dramatist and Prose Writers*, 267.

83 William J. Bennett, *Book of Virtues: A Treasury of Great Moral Stories* (New York: Simon and Schuster, 1993), 491.

84 Douglas T. Ward, *Day of Absence* (New York: Dramatists Play Service, 1966), 40.

85 William M. Kelley, *A Different Drummer* (New York: Anchor, 1962), 4.

86 Ward, *Day of Absence*, 32.

87 Ibid.

88 Ibid.

89 Ibid., 33–34.

90 Ibid., 36; original emphasis.

91 Ibid., 37.

92 Ibid., 35.

93 Ibid.

94 Ibid., 36.

95 Ibid., 39–44.

96 Ibid., 40.

97 Ibid., 51.

98 Ibid., 56.

99 Phelan, *Unmarked*, 19; original emphasis.

100 Fleetwood, *Troubling Vision*, 18.

101 Ward, *Day of Absence*, 29.

102 hooks, *Black Looks*, 116.

103 Ward, *Day of Absence*, 29.

104 Ibid.

105 Eric Strickland, *Minimalism: Origins* (Bloomington: Indiana University Press, 1993), 7.

106 Maurice Berger, *Minimal Politics: Performativity and Minimalism in Recent American Art* (New York: Distributed Art Publishers, 1997), 16.

5. LUNCH COUNTERS, PRISONS, AND THE RADICAL POTENTIAL OF BLACK PATIENCE

1 Diane Nash, "They Are the Ones Who Got Scared," in Holsaert, Noonan, Richardson, Robinson, Young, and Zellner, *Hands on the Freedom Plow*, 79.

2 Thomas Gaither, *Jailed-In*, ed. Jim Peck (New York: League for Industrial Democracy, 1961).

3 Nash, "They Are the Ones Who Got Scared," 82.

4 Gordon, "Some Thoughts on Haunting and Futurity," 16.

5 Dylan Rodriguez, *Forced Passages: Imprisoned Radical Intellectuals and the U.S. Prison Regime* (Minneapolis: University of Minnesota Press, 2006), 212.

6 Clough and Halley, *The Affective Turn*, 4

7 Lynn Grossber, "Fly Blackbird Wings Across the Nation," *Los Angeles Sentinel*, February 22, 1962.

8 Ibid.

9 Charles Stinson, "Fly Blackbird is Grounded as Drama," *Los Angeles Times*, October 5, 1960.

10 Ibid.

11 Grossber, "Fly Blackbird Wings Across the Nation."

12 Ibid.

13 Ibid.

14 Ibid.

15 Ibid.

16 Milton Esterow, "Fly Blackbird' Opens at the Mayfair," *New York Times*, February 6, 1962.

17 See, for example, Hill and Barnett, *The A to Z of African American Theater*, 182; James V. Hatch and Ted Shine, eds., *Black Theatre USA: Plays by African Americans, the Early Period 1847–1948* (New York: The Free Press, 1996 (1974)); Bernard L. Peterson Jr., ed., *A Century of Musicals in Black and White* (Westport, CT: Greenwood, 1993); Bernard L. Peterson Jr., ed., *Contemporary Black American Playwrights and Their Plays* (Westport, CT: Greenwood, 1988); and Henry D.

Miller, *Theorizing Black Theater: Art Versus Protest in Critical Writings, 1898–1965* (Jefferson, NC: McFarland and Company, 2011).

18 James V. Hatch, ed., *Black Theater U.S.A.: Forty-Five Plays by Black Americans, 1847–1974* (New York: The Free Press, 1974), 671.

19 Ibid.

20 C. Bernard Jackson and James V. Hatch, *Fly Blackbird*, in Hatch, *Black Theater U.S.A.*, 672.

21 Ibid.

22 Ibid.

23 Ibid.

24 Ibid.

25 Ibid.

26 C. Bernard Jackson and James V. Hatch, *Fly Blackbird*, in *The Black Teacher and the Dramatic Arts: A Dialogue, Bibliography, and Anthology*, ed. William R. Reardon and Thomas D. Pawley (New York: The Free Press, 1974), 143.

27 Ibid.

28 Ibid., 144.

29 Ibid., 145.

30 Ibid.

31 Ibid.

32 Ibid., 147.

33 Ibid.

34 Ibid., 148.

35 Ibid.

36 Ibid., 227.

37 Ibid.

38 Ibid., 157.

39 Ibid.

40 Ibid.

41 Ibid., 158.

42 Ibid.

43 Ibid., 159.

44 Hortense Spillers, "Mama's Baby, Papa's Maybe: An American Grammar Book," in *Black, White, and in Color: Essays on American Literature and Culture* (Chicago: University of Chicago Press, 2003), 224.

45 Brooks, *Bodies in Dissent*, 6.

46 Ibid.

47 Berlant, *Cruel Optimism*, 28.

48 Taylor Branch, *The King Years: Historic Moments in the Civil Rights Movement* (New York: Simon and Schuster, 2013), 16.

49 See Margaret Walker, "Sit-ins," in *This is My Century: New and Collected Poems* (Athens: University of Georgia Press, 1989), 58.

50 Kevin Quashie, *The Sovereignty of Quiet: Beyond Resistance in Black Culture* (New Brunswick, NJ: Rutgers University Press, 2012), 6.

51 For an excellent analysis of the performative capacities of punctuation marks, see Jennifer DeVere Brody, *Punctuation: Art, Politics, and Play* (Durham, NC: Duke University Press, 2008).

52 James Baldwin, "They Can't Turn Back," *Mademoiselle*, August 1960.

53 Ibid.

54 Scott Saul, *Freedom Is, Freedom Ain't: Jazz and the Making of the Sixties* (Cambridge, MA: Harvard University Press, 2003), 90.

55 Nat Hentoff, liner notes, *We Insist! Max Roach's Freedom Now Suite*, 1960, Candid Records, LP.

56 Mephistopheles is a demon-like character in German folklore.

57 Oscar Brown Jr., *Kicks & Co.*, box 67, folder 8, Lorraine Hansberry Papers, 1947–1988, Schomburg Center for Research in Black Culture, Manuscripts, Archives and Rare Books Division, New York Public Library.

58 Ibid., 10.

59 Spillers, "Mama's Baby, Papa's Maybe," 206.

60 Brown, *Kicks & Co.*

61 Ibid., 31.

62 Ibid.

63 Ibid., 33.

64 James A. DeVinney, Julian Bond, and Henry Hampton, *Eyes on the Prize: America's Civil Rights Years, 1954–1965* (Alexandria, VA: PBS Home Video, 2010).

65 Baldwin, *Blues for Mister Charlie*, 2.

66 Ibid., 3.

67 Ibid.

68 Ibid.

69 Ibid., 27.

70 Dan Chasan, "All About CORE," pamphlet, 1965, *Civil Rights Movement Archive*, www.crmvet.org.

71 "Oath to Non-Violence," 1963, *Civil Rights Movement Archive*, www.crmvet.org.

72 Ibid.

73 Martin Luther King Jr. and Ella J. Baker, "Youth Leadership Meeting, Shaw University, Raleigh, N.C.—April 15-17, 1960," in "The Call," document, *Civil Rights Movement Archive*, www.crmvet.org.

74 Ibid.

75 "The Student Nonviolent Coordinating Committee Conference: 'Nonviolence and the Achievement of Desegregation,' October 14-16, 1960, Atlanta, Georgia," September 28, 1960, *SNCC Digital Gateway*, snccdigital.org.

76 DeVinney, Bond, and Hampton, *Eyes on the Prize*.

77 "Oath to Non-Violence."

78 Martin Oppenheimer, "Workshops in Nonviolence—Why?" March 1964, *Civil Rights Movement Archive*, www.crmvet.org.

79 Taylor, *The Archive and the Repertoire*, 28.

80 Brooks, *Bodies in Dissent*, 3.

81 Gaither, *Jailed-In*.

82 Michelle Alexander, *The New Jim Crow: Mass Incarceration in the Age of Color-blindness* (New York: The New Press, 2010), 40–41.

83 Dan Berger, *Captive Nation: Black Prison Organizing in the Civil Rights Era* (Chapel Hill: University of North Carolina Press, 2014), 44.

84 For a discussion of the "outskirts" as a location for radical politics, see Malik Gaines, *Black Performance on the Outskirts of the Left: A History of the Impossible* (New York: NYU Press, 2017).

85 S. Jonathan Bass, *Blessed Are the Peacemakers: Martin Luther King Jr., Eight White Religious Leaders, and the "Letter from Birmingham Jail"* (Baton Rouge: Louisiana State University Press, 2001), 235–236; emphasis added.

86 King, *Why We Can't Wait*, 76.

87 Ibid., 80–81.

88 Ibid., 95.

89 Berger, *Captive Nation*, 40.

90 John Lewis, *Walking with the Wind: A Memoir of the Movement* (New York: Simon and Schuster, 1998), 100.

91 Dan Berger, *Captive Nation*, 40.

92 See David M. Oshinsky, *Worse Than Slavery: Parchman Farm and the Ordeal of Jim Crow Justice* (New York: Free Press, 1996); William Faulkner, *The Mansion* (New York: Vintage, 1959), 53; and Jesmyn Ward, *Sing, Unburied, Sing* (New York: Scribner, 2017), 96.

93 Jackson and Hatch, *Fly Blackbird*, in Reardon and Pawley, *The Black Teacher and the Dramatic Arts*, 204.

94 Ibid.

95 Ibid.

96 Ibid., 208.

97 Ibid., 211.

98 Ibid., 213.

99 Ibid.

100 Ibid.

INDEX

Page numbers in italics indicate illustrations.

ABOUT THE AUTHOR

JULIUS B. FLEMING JR. is Assistant Professor in the Department of English at the University of Maryland, College Park, where he specializes in African American literary and cultural production and performance studies.